elle

elle

Elle Macpherson

BenBella Books, Inc.
Dallas, TX

BenBella Books, Inc.
10440 N. Central Expressway
Suite 800
Dallas, TX 75231
benbellabooks.com
Send feedback to feedback@benbellabooks.com

BenBella is a federally registered trademark.

Printed in the United States of America
10 9 8 7 6 5 4 3 2 1

Library of Congress Control Number: 2024944543
ISBN 9781637746684 (hardcover)
ISBN 9781637746691 (electronic)

Cover and interior design by Penguin Random House Australia Pty Ltd
Front cover photograph by Gilles Bensimon
Back cover photograph by Ellen von Unwerth
Author photography from Elle's personal collection
Printed by Lake Book Manufacturing

CONTENTS

I dedicate this book to my two sons,

Flynn and Cy,

who have courageously witnessed and experienced
the twists and turns, triumphs and trials in my life and theirs;
they have been my biggest teachers. Through their birth, they
taught me the meaning of unconditional love.
Through everything since, they have respected my choices,
even those that affected their own comfort zones.
Flynn and Cy, you are a credit to yourselves.
I am so very proud of you both and
in awe of the men you have become.
I love you.

Mum

AUTHOR'S NOTE

You hold in your hands not an autobiography so much as a collection of life-changing truths and insights gained through my real experiences.

Essentially, my life has been a journey from my head to my heart: from thinking life was happening to me until the transformational realisation that it happens through me. Since then, I've been learning to master that power every day of my life.

As I've walked this beautiful, fun, crazy, scary, fascinating and fulfilling life, along the way I have created astonishing experiences for myself and met the most extraordinary people. I am eternally grateful.

Every life has a purpose and finding that purpose might seem distant at times but it is not. It's right there in front of you in every day-to-day circumstance, just waiting for you to feel it move you.

This book encapsulates all of my life learnings. I share my story so you can see that all things are possible if you embrace, believe, love and trust yourself.

Elle

ACKNOWLEDGEMENTS

A grateful thank you.

Such an epic co-creation between the Universe and my heart-led experiences has called for a remarkable collaboration fuelled by the love and commitment of those involved.

This book would not have been possible without my writing guide, Shea Saunders. She found a way to help bring together my life's story in a comprehensive, cohesive and powerful way. Her grace, patience and diligence have been the cornerstone in this adventure. Her tender heart and fierce commitment encouraging me to bring my voice and words to life have been an unprecedented gift.

To Paul Darrol Walsh, my exquisite, elegant teacher, mentor, friend of twenty years and extraordinary editor. An accomplished writer, Paul's first book, *From Atoms to Angels*, changed my life and inspired me on my own journey of self-realisation. Paul helped bring to light the gems in my life so I could experience, learn, express and master them, and then share them with you, my reader.

A special thank you to Gilles Bensimon and Ellen von Unwerth, who lovingly and supportively provided the imagery for the covers of this book.

And a big thank you to my agents, Mark Cowne and Adrian Sington, from Kruger Cowne, who believed in and unconditionally supported my vision of writing a book of meaning and purpose rather than a record of events and experiences.

Thank you, Universe, my wise and loving friend.

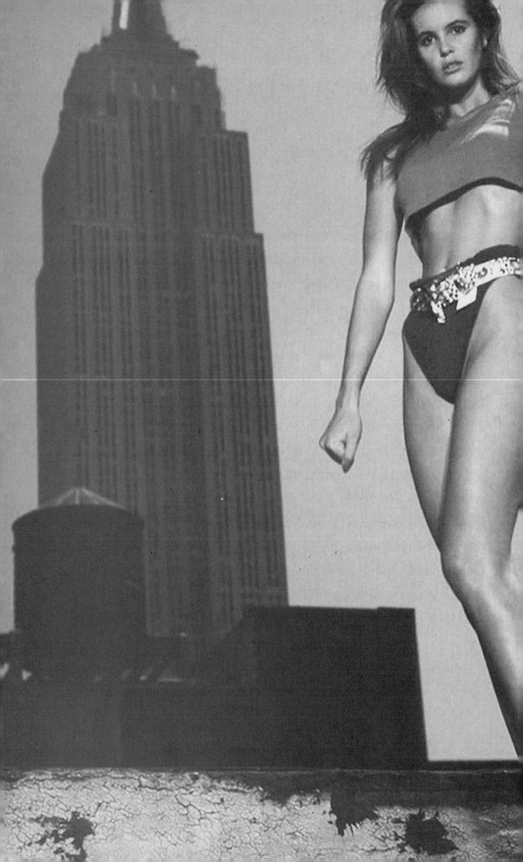

1

NEW YORK CITY

Give it a go

Arriving alone in New York City in January 1983 on the red-eye from Los Angeles was a shock. Getting off the plane at 6 a.m., I was confronted by a cold, dusty, unwelcoming JFK Airport. It reminded me of eerie subway stations that I had seen in the movies. I was feeling hyper-vigilant because everybody had told me New York was dangerous. There were muggings, killings, people disappearing without a trace. So I'd better watch out. I remember the fear—fear of getting robbed and fear of the unknown. My heart was racing as I looked around, making sure I wasn't going to get jumped.

I was eighteen. I'd flown in from Disneyland, where I'd been with my dad, sister, brother and my boyfriend at the time. We'd set out from Australia on New Year's Eve 1982, excited to celebrate the New Year on a plane and with a plan. An overseas holiday. Simple. We'd visit Aspen and Vail on a ski tour, then do LA and Disneyland.

I would carry on alone to New York where, for the duration of our Aussie summer, I'd been invited to try modelling with Click Model Management.

Two things to note. First, I had never travelled overseas before, so this family trip was a significant first. Second, I went to New York alone with only an undated return ticket home to Oz and a few hundred bucks in my pocket, which my dad had given me. And that core Aussie "give it a go" spirit.

Around me at JFK were scraggly people looking tired after the flight and a few who looked a bit shady. I was just another anonymous traveller among other anonymous travellers. I headed to baggage claim.

I couldn't help noticing an intense-looking woman coming towards me. She had a very determined look on her face. Unsure of what to do, and feeling overwhelmed, I hurried to the nearest bathroom and locked myself in a stall. I jumped onto the seat of the loo, managed to fold myself up to sit on the cistern and waited. For some inexplicable reason, I thought I would be safe hiding in the bathroom. In a bathroom! Really?

Sitting there, crunched up awkwardly in the stall, I asked myself, what am I doing here? My mind flicked back to the first time I was asked to come to America the previous year. I was in the kitchen at home in Sydney when the phone rang. It was the only one in the house and didn't ring often. I remember reaching for it and quickly trying to unravel the long curly cord. A woman with an American accent introduced herself as a representative of Ford Models in New York and said that while she was looking at photographs of models from around the world, she'd come across mine. She asked me if I would enter the Ford "Face of the '80s" contest. My heart skipped a beat with excitement. Yet I said no. I regretted it immediately. As

soon as the call ended, my heart sank. I ran into the bathroom and
threw up. I knew I'd made a blunder—I had gone against myself.

In the few minutes of that phone call, I felt a life-changing
dilemma deep down inside. I sensed a double-edged foreboding.
Saying yes carried the risk of finding out the offer wasn't legit, and the
subsequent feelings of disappointment and embarrassment. Saying no
might mean later discovering I'd missed out on a huge opportunity.

Ultimately, I didn't have the courage to be rejected. I said no to
protect myself. I wanted to feel in command of the situation and play
it safe, rather than say yes, only to find out later that the offer was no
more than a humiliating scam. I couldn't bear the idea of dealing with
laughter and ridicule. "She thought she could be a big-time model
but she was taken for a ride. Ha ha."

In essence, I didn't step forward with that "give it a go" attitude.
Remember, I was only eighteen. I didn't trust myself enough, I didn't
trust the situation and I didn't trust my capacity to cope if the situa-
tion was not what I had hoped for. I was afraid to go and find out. It
was the first experience I recall of me not being honest with myself;
not trusting myself when my excitement sparked in the moment. My
inner gut feeling silently told me that yes was the right answer. Trust.
But my pride won.

When Ford called, I not only doubted myself, I also doubted
modelling. I didn't want to be seen by my family and friends, by my
boyfriend, as whimsically following frivolous choices. And yet, if this
was a genuine opportunity, even though I had been modelling in
Australia casually for the past year, being asked by Ford Models to
join them in America raised the bar. In that bathroom stall at JFK,
I recalled the remorse I'd felt after saying no to the agency, and how
excited I was when Click Model Management called a few months
later, also asking me to come to New York. By then I was deeply

moved to take this leap of faith. I remembered the uplifting urge I'd felt when I eventually said yes—I wasn't going to let that crushing feeling flood over me again.

Even so, I was torn. I'd had a safe, sensible plan to study law at university, and now here was this exciting dream adventure of going to America and experiencing life in one of the most exhilarating, fast-paced cities in the world. What should I do? Stay in Australia and play it safe? Or go to America into the unknown? Australia would be predictable and sensible while modelling in New York seemed flippant and fanciful. I had to make a decision. My mum had scep-tically said to me, "Elle, do you want to settle down, have a family and a couple of kids when you're still young? Is that really the life you ultimately want for yourself?" I wanted adventure so what Mum said had encouraged and motivated me to give it a go.

And this time I did. I followed the excited flicker in my heart. Yet now here I was locked in a bathroom stall at JFK Airport doubting that decision. I realised there and then that I was just scared of being outside my comfort zone. As I sat in that cold public toilet far away from home, unconvinced and uncomfortable, I stopped and listened to my heart—my inner sense. In the momentary stillness, I felt that flash of excitement again. I trusted that I had made the right decision, no matter how things around me looked at that time. I just knew I was safe; I wasn't in harm's way. I knew I would be able to cope with the unexpected and unfamiliarity of new challenges and experiences.

Sure enough, the confirmation I needed was right there at exactly the right time.

"Elle. Elle, it's Bethann."

I looked under the door to see the long dress and boots of the woman calling my name. I sighed and thought to myself, "Crikey! I really need to get a grip."

There was nothing to be scared about. I wasn't being chased by someone out to get me. The determined woman was Bethann Hardison, one of the partners at Click who worked alongside Frances Grill and Allan Mindel. They had asked me to come to New York to join their books of quirky, unusual, unique-looking models. Bethann had come to the airport to pick me up. She was going to take me to her home—I would be staying with her while I was in New York.

It was extremely kind of Bethann to come to the airport so early in the morning to collect me, and to agree to host me during my time in the city. Knowing now that she was such a night owl, and judging by what she was wearing that morning, I think she might have come straight from a nightclub.

Before my family and I left Sydney, Bethann had called me to tell me how to spot her in the airport. She'd said, "I'm colourful." I had no idea that she meant she was a woman of colour. I was looking out for a woman wearing bright clothing, but Bethann was wearing black. She said she would look out for the tall young Australian girl. I was easy to spot, and when she called out my name, a rush of relief swept over me.

As I look back to those first few weeks, I'm still struck by Bethann's kindness and confidence in me. I don't think I felt them at the time because caution bound my heart; I was only able to muddle my way through the unfamiliarity of the situation as best I could. Later in life I discovered that, while the head and its analytical logic is a great administrator, only the heart has the ability to truly understand, expand and adapt to embrace any situation. And because it is sensory and knows no bounds, it has the capability to reveal truly intelligent steps that supersede, even defy, logic.

I remember seeing police flags out of the window of Bethann's one-bedroom brownstone in Manhattan and feeling momentarily comforted. Bethann lived right next to a police station on East 20th

Street, near the police academy! I called my mum to let her know I'd arrived and there were cadets on the street so I would be safe. Worried that she was worried, I wanted to put her fears to rest. I did so, but my own fear permeated deeply those first few days and weeks. At times, it engulfed my heart. I remember the feeling of trepidation and excitement the first time I went to meet Frances and Allan at the agency, a nook in an Upper West Side building. As I climbed up a spiral staircase to their office I thought to myself, will they still like me when they see me in person?

But with the Aussie "give it a go" flowing through my veins, I rose to the challenge of this new city and simply put one foot in front of the other. I was building the persistence that remains one of my core attributes. With every action, I was one step closer to finding the confidence within myself to take the next steps on my path to freedom, independence and self-reliance.

Having said that, utter terror is what I felt the first night I went out walking with Bethann's son, Kadeem, to get pizza. He'd told me New York is really safe . . . if you know where to be. I wondered how I could know where to be. "Where" is everywhere in New York. The potential of "where" was daunting. And when it's like that, when you've just arrived, there is no "knowing." I figured the only way to navigate that jungle of potentiality was by my inner knowing; my inner sense. My heart. The same urges that had guided me to the city in the first place.

As Kadeem and I walked to the corner of our street, across from the pizza place, I heard quickened steps behind us.

"Someone's following us," I whispered urgently, wanting to run.

Kadeem laughed and said, "Relax, everyone walks fast in New York. They're not coming after you. And besides, we live on the safest street in the city."

He seemed so sure, so secure; so at home in those concrete streets. He was two years younger than me and I was in awe of his elegance, poise and assuredness. He had an inner energy that I could only think of at the time as "presence." I wanted to have some of that myself.

As we walked for pizza that night, I got to appreciate what January in New York means. It was so cold. I was freezing. I remember the wind ripping down the streets. Wind tunnels of icy air, like a hurricane trapped between buildings that created a funnel, intensifying the cold. While walking over the subway grilles, an unexpected yet welcome warm wind would roar upwards with such force that I often felt I could be blown over.

For me, everything about New York was different. Concrete buildings and bleak, dirty streets, grey and full of people hanging out on the corners, cars and taxis streaming along the avenues. It was like nothing I'd ever experienced before, nothing I'd ever dreamed of. Despite the fear, I loved it. I loved the kinetic energy. I loved that I could be invisible, just another individual on the street. During the last year modelling in Australia, I'd been on the cover of magazines and was often recognised when I went out in Sydney. Now, being here in New York, nobody knew me and it was refreshing.

Walking the windy winter streets of New York City continued to be brutal and raw; so different from the wild bush and oceans I had grown up around. But it was real and I felt alive. I studied street maps and learned how the city was laid out. "It's like a grid," someone told me. "Easy to remember. You can walk a block a minute." This really helped because there was no way I could afford taxis and I was too scared to go on the subway. So I walked everywhere. Often alone. But of course, you're never truly alone in New York City.

I really did love the freedom. I could go to bed when I wanted, set my own alarm to wake up for work or meetings, spend my days

exploring. No school, no responsibilities to other people. All I had to do was look after myself. I had my determination, strength and inner sense. And I had gratitude. Gratitude blossomed in me.

I was always busy, always trying to catch up to something—to someone. New York—the city that never sleeps. All day and all night, a constant heartbeat. I'd never lived alone. Having moved straight from my mum and stepdad's three-bedroom home and a family of five all sharing one bathroom, now I was sharing a bed in Bethann's little New York apartment. I'd wake up during the night and feel her long soft dreadlocks. As she turned over in her sleep, I got their full impact as they covered my face. First time it happened, I froze. I lay there wondering what they were until it dawned on me . . .

During the day I lived on coffee, trail mix and the odd muffin here or there. I didn't have much money at all so I ate mainly when I went to work because there would always be food at the shoots. Most days I rushed around the city going from place to place; working, talking to agents, meeting other models; bookings, jobs, people everywhere; embracing a new culture; the buzz of the streets. Walking, walking, walking. An exhilarating journey of survival that became the greatest adventure. This was my life. And I loved it.

Whenever I wasn't working, I was at Bethann's. I enjoyed living at her apartment. It was full of black and white photographs and every-thing African. Bethann wore black mostly. Black was a New York colour and I'd never owned anything black in my life.

There were times when I was lonely. International phone calls were expensive so I mainly wrote postcards back home. But one evening I locked myself in the bathroom at the apartment and called Mum on the portable phone I'd snagged from the living room. Now that we were apart, I realised how much she meant to me. I loved to hear her voice, and when I said goodbye and hung up the phone,

the tears rolled down my cheeks and I sobbed. I felt so far away and even though I was caught up in a whirlwind of excitement, the young girl in me missed her mum. I dried my eyes as I didn't want Bethann to know I was crying. I was afraid she would send me back home if I seemed unhappy or ungrateful. And I wasn't. I was grateful that I had been given such an amazing opportunity.

The weeks went by. I relaxed into the pace, the space, the weather and the wind. I learned to take taxis. In the beginning, I was always so polite. I'd hail a taxi and then someone would jump in before me and I'd let them. Until I stood frozen stiff on the streets. I remember hailing a taxi the first time after I'd decided to stand up for myself. I ran across the street, jumped in . . . at the same time as someone else. I didn't move. Nope. I was here first, mate. You are cold but so am I, and I ain't giving up my taxis any more. I just gave him my best unflinching icy stare until he got out. Done. Lesson learned.

Adaptability. Precious superpower for survival.

Clothing was one of my biggest challenges, especially dressing fashionably for the New York winter. I didn't have anything suitable to wear. My wardrobe consisted of sweatpants, which, although fashionable today, at the time were simply the uniform of the typical Aussie schoolgirl. I did have a wonderful white down coat I'd borrowed from a friend in Oz, but nothing could've prepared me for the New York winter chills. I didn't have warm clothes. I didn't have cold clothes. And I certainly didn't have cool clothes. I had no idea what that meant, anyway. For me, warm was a sweater knitted by my nanna on huge knitting needles, so it looked wintry but actually had holes through it. Perfect for mild Australian winters but didn't cut it in the New York snow in January. This, coupled with skinny jeans and red pumps, was my schoolgirl idea of fashionable.

Self-conscious about the way I dressed, I wanted to look the part of a New York model. But I had no idea where to begin. My wish to dress to the situation wasn't just because I was involved in fashion, it was because I wanted to do my job well. Really well. I didn't look the part when I started out modelling but I became the part as time went on. I earned money so I could buy myself what I needed to survive and thrive.

When I arrived in New York, it was simple—survival. Managing life on life's terms. I just wanted to do what was in front of me and do it extremely well. I don't think I had any overpowering ambition other than to experience and create opportunities to learn and grow. I felt the blast of all that potential, the unknown of what was going to happen next. Everything was new. Nothing was familiar. From the money being all the same shape, size and colour, to the local lingo— unfamiliar terminology, words and expressions creating everyday language. Not the people, not the work, not the language, not the weather. Not even how to dress or how to be. And every day I was learning from my experiences. No matter how delightful or painful they were, I considered every one an opportunity to learn something valuable and grow. I was learning that adaptability was vital. As was willingness.

I wondered if I'd be able to cope.

I did cope. In fact, I flourished.

Everything was on fast track. But it never felt too difficult and I embraced my life. Each day had its challenges to navigate but I trusted myself and my in-tuition—the inner urges that were teaching me.

It was in those first days in New York that I began to really recognise the importance of trusting myself—trusting my gut and inner sense; the urges that we sometimes ignore, invariably at our own peril. Trusting the Universe to bring me opportunities and to show me the

next right step. Trusting myself to be able to see those steps and have the courage to act upon them. Trusting that life was on my side, not conspiring against me.

When I started working with Click, I was under the impression that I would be in New York City for six weeks and then return home to Australia to explore uni. At the same time, Click assumed I had come to stay and work permanently. I was quite surprised that they considered me worthy of permanent work. I hadn't realised I had to pay them back for the visa and other fees. Valuable lesson for my future—always read the fine print and know what I was signing up for; talk, ask and discuss exactly what that would be.

And so I stayed. I had a wonderful team of agents who were expert at their job. But it was Bethann who believed in me. She encouraged and guided me along the way. Bethann championed me. I grew fond of her quickly and respected her immensely. I don't know how I would have made it through the first few months without her love and kindness. She said she was my protector and felt her role was to develop the personal character of the models, to help bring out their very best attributes and teach them how to use those attributes wisely. And that's what she did. Yes, it was about the looks, she assured me, but it was also about your character and understanding modelling as a business.

During 1983, that first year living in America, I was gradually learning how to take care of myself while being on my own. I juggled jobs, finances and spending. And even though I had such an amazing team supporting me, I still had to find and develop the persistence, the willingness and the discipline to get out and actually do the work every day. I tried new things to see what worked. If something worked then I brought the learning to the next experience. If it didn't help, I learned to let it go; just not for me. I found my own

way by experimenting and exploring. I did so relentlessly, willingly, persistently. My inner strength guided and helped me and I learned quickly. You need to be a fast thinker, living in New York.

I fell in love with learning, growing and evolving. I fell in love with the city.

Keeping faith and not giving up was difficult at times. Being young, I found it challenging when I was criticised for my atypical features—my shape, my height, my weight, my broad shoulders, brown eyes and unusual gait. At times I just wanted to quit and go back home to my family. But my deep desire for freedom and self-reliance kept me going. I believed modelling would give me these things. I wanted to be free and independent, both financially and emotionally. I wanted to experience the adventure of life; the known and the unknown. At that point, modelling was the means and I wanted to become excellent at it because I wanted all the benefits it could offer. That meant digging deep within myself to find my personal commitment, courage, persistence. Grit.

There's no doubt, though, that most of the time I felt inadequate, uncomfortable and out of place. Different, as though everyone was speaking a language I didn't know. Out of sync. My Australian accent isolated me to some extent as well. People often didn't understand what I was saying, asked me to repeat myself. Later in life, I adapted my accent to be understood and then people criticised me for losing it. Can't bloody win! My dry sense of humour didn't seem to translate well into the vernacular, either, and American platitudes and effusive expressions would sometimes leave me a little dubious of their sincerity.

Embracing my unique self took time. Like a schoolgirl, I wanted to blend in. Yet I stood out. I wanted to be understood and appreci-ated but I didn't know how to make that happen. I felt like a fish out

of water. I was always aiming to be somebody else, always wanting to be that other girl . . . or wishing I could just wear that other outfit . . . or, if only my hair was just a bit lighter . . . if only my eyes were blue. I thought I had to be like everyone else. And, to make matters worse, it seemed that everyone else was wanting me to be somebody else too.

But it's never possible to be like anyone else, nor is it wise or healthy to try.

What I did learn was that my uniqueness is my asset. My success began the day I embraced my Amazonian physique, my authentic natural Australian character and perspective, my ballsy attitude, and my straight-shooting, hard-working, no-nonsense way of being.

These typical Aussie traits, once embraced, underpinned my ability to withstand the challenges of a business built around aesthetics and sometimes superficiality. They gave me a strong, grounded foundation on which to build my career and grow. They gave me the confidence to navigate by my heart, always checking in with what felt right to me, what resonated. I developed this heart connection because, in my logical mind, although my ability to integrate into American culture was limited, my "give it a go" Aussie attitude empowered me every single day to go within and pilot from my heart.

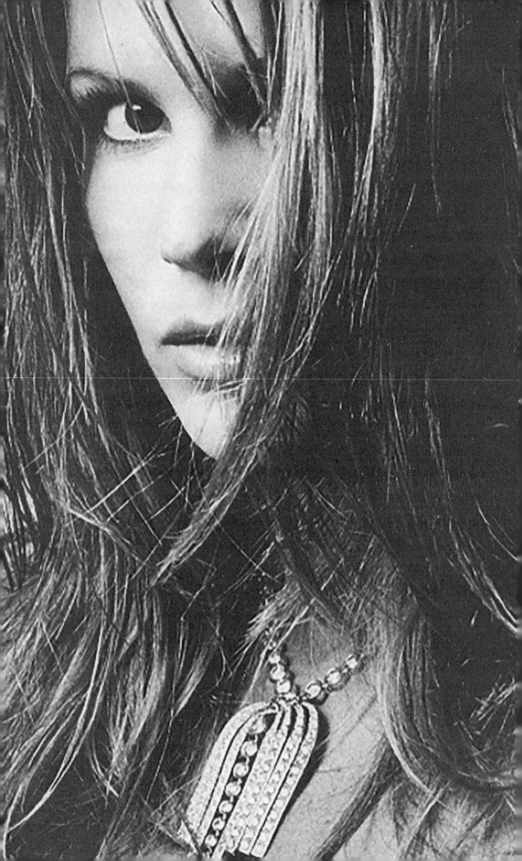

2

BILLY IN THE BAR

Take nothing personally

It might surprise you to know that I was never really comfortable in front of the camera. So much so that I couldn't even look into it when I first started out. Especially when the camera was, heaven forbid, only a few inches away from my face and I had to stare straight into the lens. It didn't come naturally to me; I was shy. I had to work at it and it was difficult in all sorts of ways. Looking into the camera, I'd think to myself, please don't see me. Don't see who I am because you might think I don't belong here. You might see me as an imposter.

I was afraid to be seen. Truly seen. I was afraid that if people peered at me in photographs, they would see me as just a shell. Because I was still finding who I was and who I was evolving into, that was how I thought of myself—just a shell. I felt like there was nothing there; like I didn't stand for anything. I had neither the time nor the know-how to begin the search for "who am I?" so I just kept feeling that way—disconnected from myself. And I was afraid of my

own essence. I was afraid of what people might discover if I looked straight into that lens.

When I did, I'd get a rush of self-consciousness and have to look away. In some ways this never quite faded: in my photographs throughout my career, you will see hair across my face, sunglasses, profiles, laughter off into the moment.

I'd had some success modelling in Australia, so a part of me knew I had potential, but in my heart I just couldn't see it in myself. And I was afraid that people in the industry would think I wasn't cut out for this. I really had to trust the vision of others for a long time. But once you put me in the job, boy was I going to do the best I could. The underlying reason I was uncomfortable was inexperience—I didn't really know how to be or what to do. I was being hired to do a professional job. I felt inadequate and I didn't want it to show. If you're comfortable with the way you look and you're presenting yourself as a model, that's one thing. But if you think you're not really cut out for modelling, yet you're trying to make a career of it, and you don't have the experience, then the job becomes daunting. I felt like a little girl trying to be all grown up in the modelling world while hoping not to get busted for inexperience and naivety. But I wanted what the job could bring. So I was going to learn how to do it and I was going to learn how to disguise my insecurities while I was learning how to overcome them.

My fear was that I would be sent back to Australia if Click saw I couldn't model, and I hadn't been in New York long before I knew I didn't want to go back. I wanted my parents to be proud of me and I wanted my friends at school to see how well I'd done for myself. I had grown up feeling inadequate so I thought that if I could become successful, maybe I could disguise my fear of failure.

Through my efforts to make it work, I found that the benefits of becoming excellent and successful outweighed my insecurities and

discomfort. Pushing through my fears enabled me to keep my focus on the big picture and my eye on the prize. I wanted to be financially independent so I could afford my own apartment, have a secure and fun life full of wonderful, exciting experiences, and acquire things that I wanted. In order to get these, I had to find ways to be able to cope with not knowing what to do—not knowing why, not knowing how. Just not knowing.

My first big shoot organised by Click in 1983 was in St. Barts. That February I flew there with the other models and the crew; we were staying at the posh PLM Hotel, shooting beauty for *Glamour* magazine.

When Click originally asked me to go, I thought I wouldn't be able to because I couldn't afford the airfare. I asked the agency, "How much is it going to cost me to go?" They were puzzled and asked me what I meant. I said, "Well, I don't have much money in the bank."

Yep. I thought I had to pay to go on the shoot. I hadn't realised the magazine would cover the cost. When they told me that they would take care of it, I thought, great! Even so, I assumed *Glamour* would cover just the plane ticket and the hotel room. When I got to the PLM Hotel, I took one look at the room service menu and saw that a hamburger was twenty dollars. I thought, "Jeez, I can't afford twenty bucks!" So the first day I was there, I didn't eat. The fashion editor probably thought I had some eating disorder. Having noticed I wasn't eating, she asked me why. I explained that I couldn't afford the food at the hotel.

Perplexed, she said to me. "But Elle, we pick up the tab."

I was gobsmacked. Straight away, I ordered a huge chocolate mousse. When it arrived, she looked at me like I was a crazy girl as I wolfed it down. I'd never had a dessert like that. I vowed to myself there and then that I would never again experience the fear of not

being able to look after myself; the fear of not having enough money. It made me even more determined to become excellent at my work and financially independent.

Being in St. Barts was wonderful. The sun was shining, the beaches were covered in powdery white sand and the water was crystal clear, sparkling in the blazing hot sun. It was freezing back in New York. Whitney Houston was one of the models on the shoot. This was before she was a famous singer. Patricia Van Ryckeghem was the other model I would be working with.

I was up at dawn having my hair and make-up done for the shoot at the swimming pool.

"Look into the camera," the photographer snapped.

"I'm trying. Truly. I really am trying," I pleaded.

"You're not trying hard enough."

"Can you please explain to me what you need so I can do it better?" I glared.

The photographer sighed. "Well, you should know! Can you at least look happy? Not so angry." He turned and shouted to the crew, "How can I shoot beauty with a girl who has brown eyes? And, on top of it, they're small. Can I have somebody I can really work with? This girl won't even look into the camera."

I felt so humiliated and upset that I couldn't do what he wanted, especially when I didn't know what I was doing wrong. I was stressed and self-conscious as I tried to hold back the tears—and indignant, looking angrily into the lens, extremely uncomfortable. When the photographer held the camera close to my face, it made me even more nervous. I was still learning facial expressions but what I thought was an assertive look was actually an intense stare.

Often my desire to look confident came across as fierce or angry. I wanted to be taken seriously but my face showed a different story.

My energy exuded tension. The photographer was capturing feelings I wanted to hide.

He found me difficult to photograph and didn't hesitate to make his views very clear. I was mortified but I could have learned right there and then not to take things personally. This was business and I had to be detached and professional if I was going to become excellent at my work, the way I was striving to be.

By the evening, I was exhausted and collapsed into bed. I was just drifting off to sleep when the bedside phone rang. It was Patricia calling me from the bar downstairs. I heard music in the background as she excitedly whispered, "Billy's in the bar!"

"Billy? Billy Who?" I asked.

"Billy Joel!" she gushed. "*Theee* Billy Joel! He's playing the piano. Come quick!"

I leaped out of bed and hastily got dressed, grabbing my red baseball shirt that had "All Australian Girl" emblazoned on it; a play on the "All American Boy" theme that was popular at the time. I hoped I might catch Billy's eye if I wore something unusual. The top was red. He was going to notice me no matter what! I wanted to stand out so he could see that I was from a land down under, a proud Australian far from home.

In the bar, the crew were hanging out and drinking cocktails. Christie Brinkley was there. She too was staying at the hotel, shooting promotion for her *Outdoor Beauty and Fitness Book*. She was an icon. I'd heard a lot about her while I was in New York. She had her annual swimsuit calendars, posters, and her book was coming out soon. I admired how she had evolved her business from modelling. She seemed so in command of her career and, looking back, I guess you could say she was the closest thing to being a role model for me (excuse the pun). She was the first woman who showed me that modelling

could mean more than just being on the pages of a fashion magazine. I remember when I saw her I thought to myself, wow, she's really got it together. I can still recall what she was wearing—a miniskirt and cowboy boots. She looked like a star. She was an inspiration for me.

Whitney was also at the bar with Patricia. I joined them and we listened to Billy sing. I was in awe. I was listening to a star play the piano. In the flesh. Live. I'd grown up listening to Billy Joel singing hit after hit when his songs came on the radio. I knew all their lyrics and I couldn't believe I was actually seeing him and hearing him play all those songs. It was difficult to take in the fact that he was right there in front of me; surreal.

By the end of the night, most of the crew had drifted away. Christie, Whitney and I sat around the piano and sang along while Billy played. It was a pinch-myself moment; like a scene out of a movie, when I recall it. Billy playing and singing, having a few late-night drinks. All I could think was, oh god, I can't believe this is happening.

Turned out, it wasn't the only surreal evening. Billy was there on holiday for a week and each night we all got together, had dinner at one of the restaurants and hung out afterwards. One evening, when Billy and I were on our own, he played a cassette for me. He explained it was Whitney Houston singing. It was one of her demo tapes. He said, "This kid's going to be a star!" He was right, of course: shortly afterwards, Whitney's singing talent catapulted her to fame.

During that *Glamour* shoot, I remember how I just wanted to be finished so I could hang out with Billy. I loved being around him—he was mature, interesting, funny, charming and a wonderful storyteller. I found that if somebody successful acknowledged me, the little girl inside me wanted that validation. I felt drawn to Billy. I could relax and be myself around him and he treated me with respect.

The photographer, on the other hand, continued telling me I was difficult to photograph. All I kept thinking was, well, why did you ask me to come? You knew what I looked like.

"Listen," I eventually said to him. "Clearly I'm not adding any value here because, as you yourself said, beauty is not my thing and you're finding it challenging to photograph me. So I hope you don't mind but I think I'll get a lift home with Billy tomorrow."

Billy had said he was leaving a day before the shoot finished and he'd offered me a lift back to New York. I didn't want to stay in St. Barts, and the prospect of flying in a private plane was pretty tempting—an adventure.

"What do you mean you're going to leave?" the photographer demanded incredulously.

I replied bravely, "Well, I get up every day at 4 a.m. to be ready for the shoot and most days you don't even use me. I just think it's better that I go home."

He was furious. "You can't do that!"

Next day, I got on the plane and left.

My ballsy Australian attitude had reared up in full flight and I had let my emotions get the better of me. When I arrived back in New York, Bethann said to me, "Elle, I don't teach my girls to behave like that."

"Like what?" I gasped.

Her calm, deep look stopped me in my tracks. In an effort to defend myself, I protested, "Bethann, they were so horrible to me. I just wanted to leave and come home."

She sat me down on the sofa and, with concern in her voice, gently told me, "Look, if you accept a ride with somebody, they are obviously going to think there's something more to it. So if you don't want there to be something more to it then just don't open yourself up to that possibility. Billy is going to think you want to be with him. And if you

don't want to be with him then you've given him the wrong impression. Plus, you left everybody at work when they were counting on you, and you didn't adhere to the rules of the business. You're supposed to go to the shoot with your crew and come back with your crew. You're part of a team. Elle, you made your own rules. Misguided rules."

Sadly but firmly, she continued, "You need to find your own way now. It's time for you to go out on your own, Elle. You'll have to find other living arrangements."

That was the moment I saw my lesson clearly.

I saw that I had let my personal whims override my professionalism.

I saw that I'd unnecessarily taken the photographer's attitude personally.

I saw that I hadn't fulfilled my work commitments.

I saw that I had let down the magazine, not to mention the photographer and the other models.

I saw that I had misrepresented Click, who'd invested their trust in me. I hadn't valued that trust.

I saw that I had run away from what I felt was an uncomfortable situation simply because I lacked the confidence and willingness to deliver what the photographer needed.

It was painfully obvious that I had let Bethann down.

But worst of all . . . I saw that I had let myself down and I had nobody to blame but myself.

That could have been a long list of mistakes, had I refused to learn from them. But they were not mistakes because I did learn. That was the day I vowed I'd never sabotage myself again by behaving in such an unprofessional manner.

It was a powerful lesson for me in work ethic and valuing others as part of a team. It grounded in me the realisation that it was a privilege to represent a magazine, an opportunity deserving my respect.

I learned that sometimes it's wise to do the things that, on the surface you don't necessarily like, but whether you like them or not, may well have value and be worthwhile.

I learned that I can't just get up on an impulse and leave people in the lurch, people who are depending on me to do a job. There will be ramifications.

I learned to uphold my own personal values.

It was a timeless lesson to be discreet in my private life.

Now I was on my own. It was all up to me. Time to start looking for a place to live.

Billy said to me, "Why don't you come and stay at my place until you find somewhere else?" He was living in a beautiful apartment on Central Park West that belonged to the famous Australian film producer and music manager Robert Stigwood.

So I moved in with Billy for a while. He had a floor and I had a floor. His was the penthouse. I guess we were dating but we were mostly friends. Since that *Glamour* shoot, my modelling had taken off and I was travelling so much that we passed like ships in the night.

I remember that 1983 Easter Sunday, Billy said he would pick me up from the airport as I was flying in from Paris. I had been excited to go there—that's where all the editorial girls went to create magical avant-garde images for French *Vogue*. It was prestigious and I was longing to be included in "real fashion" images and magazines. And it was Paris, the city of lights! But for me, I found it dark and mercurial, and saw nothing like the professional business attitude of New Yorkers. It was a mystery to me—from the sketchy relationships between models and agents to the gloomy old cobblestone streets and language barrier. And although I didn't stay in the run-down and cramped model apartments rented by the agencies for the young girls from around the world trying to make it in the fashion world, I thought the whole experience was quite seedy.

So when I got back I was excited to see Billy and happy that he would come all the way to the airport to meet me. I got down to baggage claim and I was greeted by a huge pink rabbit with an Easter basket! Billy was inside that costume—incognito! Here I was, thinking it was cool being met off the flight by Billy Joel, and I found myself very uncool with a gigantic pink rabbit holding my hand . . . And so it goes, as his song says. That was Billy to a tee—fun, irreverent, kooky, sentimental.

In the end Billy started courting Christie Brinkley while I was away on a shoot. When I came home, all my belongings were on the landing outside the apartment. Christie stood in the doorway with her arms folded. "I'm just his roommate," I spluttered.

I knew it was time to go. Again.

I appreciated Billy helping me out and giving me a place to stay but I understood I couldn't live there any more. I was quickly learning so many things from so many experiences. I was learning my lessons instead of repeating them because I was beginning to realise that if I were to ignore them, they would repeat, compound and grow in intensity. This would only lead to a situation becoming more difficult to handle and sort out. I was grasping the dynamics of living life on life's terms; learning from life experiences rather than trying to avoid the difficult ones.

I learned to be more worldly, not naive or evasive; to appreciate another's point of view and try to stand in their shoes; to remember that what seemed in plain sight to me, might not be so obvious to others. I learned to use common sense as well as my own inner sense. And everything—no matter how it looks at the time—happens for a reason, a helpful reason; a supportive reason that will become clear as long as I firmly apply that understanding, no matter the circumstances.

My life was changing. I had to find yet another place to live!

Having already worked a few times with a successful model I liked, named Beth, I decided to contact her. I told her what had happened and she said it was perfect timing as she was in the process of looking for somewhere to live too. It made sense to get a place together. We looked around and found a studio loft apartment, which—wouldn't you know it—had only one bed!

Beth said she'd been casually seeing Mick Jagger. I was still working with Click and remained friends with Billy. Billy Joel was the pop star. Mick Jagger was the rockstar.

Mick would come over quite late at night. Actually, early hours. I never saw him, though, so who really knows? Beth would let me know he was on his way and I would get up and get dressed and leave the apartment. I would go to some nightclub and dance until six or seven in the morning. Then, when I guessed he had gone, I'd come home and grab a few hours sleep before going to work.

Still, it worked quite well for us both. Beth and I used to take turns with who would sleep in the bed and who would take the couch. Or, if one of us had a bloke over, the other had to go out. I paid half the rent, and since we were both away so much working on shoots, we were seldom there at the same time. In those days in the 1980s, living in New York, I was always on location, rarely in the studio. I was basically paying rent to drop my bags.

Note to self: I can't keep doing this; I need to get my own place.

My inner voice was whispering to me again and I heard it. I decided to act on what it was telling me. I had to trust myself.

My life was about to change once again. I'd been in America for ten months when I received a letter from Mum asking me to come home. I explained to Click that I was taking a few months off and would be back after Christmas. I booked my flight, packed my bags and headed to the airport for the long flight home to Oz.

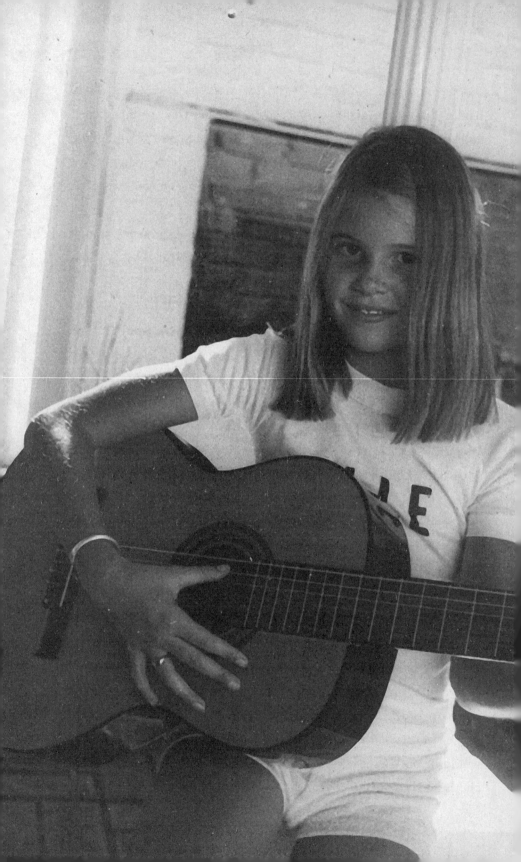

3

NO TURNING BACK

Every experience is a valuable gift

A pivotal point in my life was upon me. One of those life-changing crossroads that works only one way; when you realise that things are now going to change for good. Forever. My family's home was going up for sale.

My flight arrived in Sydney and I was excited to be back in Oz. Dad picked me up from the airport. Forty years later my dad still comes to the airport to collect me when he can. He's the first person I see. He's the one who takes me to the airport when I'm leaving again and waves me farewell.

Dad drove me to Mum's house in East Lindfield, north of the city, and dropped me off. Mum had asked me to come home to help her pack up as she was moving to Asia and needed a hand. We had really missed each other and were looking forward to spending some time together. I had lived in that house the second half of my childhood years. But, I now realised, America was going to be

my home away from home, and I would have to stand on my own two feet.

Mum and my stepfather, Neill, were moving to Hong Kong with my sister, Mimi, my brother, Ben, and little baby sister, Lizzie, who was only eighteen months old. My mum was overwhelmed by the upheaval of moving to Asia, packing up the house and taking care of Lizzie, which was a full-time job. Neill was already in Hong Kong, having gone there a few weeks earlier. He had taken a position of barrister and was working for the Hong Kong government as a Queen's Counsel.

I was returning from a pretty successful time abroad. I was proud of what I'd achieved and I wanted my family to see how I was different—grown up; I felt like I was coming back a new girl. As excited as I was to see everyone again, having really missed them, I also felt a strangeness. I'd experienced so much while I was away and I wanted to connect and share my adventures with everyone but things felt different to me now; like we were worlds apart.

Jetlag took a few days to get over, during which I spent time adjusting. As soon as I was back on form, Mum and I got stuck into packing. There was a lot to sort out as we arranged which items would be shipped to their new house and which ones would be put into storage. While I was packing up our life, my thoughts drifted to my childhood and memories flickered through my mind.

Before we moved to East Lindfield, I grew up in a place called Caringbah, a southern suburb of Sydney. I lived there with my mum and dad, Mimi and Ben until I was ten, when Mum and Dad divorced. We had lived in the prettiest house on the street. We did actually. It was facing a park and not far from a bay where the boats bobbed on the water. It was a neighbourhood where all the kids on the street played together. Afternoons and summers, we'd congregate in the park

and go wild. We played in the woods, made mud pies, climbed trees, played spin-the-bottle, rode our bikes and sometimes fell off them. Nobody watched out for us and there was no babysitting. There was a sense of self-reliance and feeling safe. Mum would always say, "Go outside and play. Be back for dinner when it starts to get dark." The era was a time of childhood freedom that has long since passed.

I loved that house in the cul-de-sac. My dad built it with unwavering care and passion. It was a mid-century house inspired by Frank Lloyd Wright, whom my dad greatly admired. The house was elegant, split level, opening up to a big atrium living room with double-height ceilings. It had exposed brick walls and it was decorated in the colours that were popular at the time. The house had pistachio-green carpet, furniture in a colourful splash of orange, and olive-green doors throughout. Beauford Avenue. I remember spelling it out to someone on the telephone once when I was only about five years old and marvelling at how the "Beau" made a "bow" sound like a bow in my hair. I'd heard my parents say it and spell it out so many times. I loved that it was a French word—maybe a cosmic wink to things French that would later play such a significant role in my life.

The outside of the house was beautiful and it had a pretty path that led through a yard and up to the front door. But I remember a home filled with chaos, tension, stress, fighting and fear. The house was really a reflection of my own inner turmoil.

I thought that, since things were awful inside me, just like the house, I could mask it by making everything perfect on the outside. And that's what I set out to do. I wanted that outside perfection. It was important to me. Basically, I was trying to bring stability and order to my life. They weren't present in my home nor in my family and I didn't find them within myself. I thought if I could calm the chaos and insecurity that I felt, if I could just get it all neat and organised,

then maybe peace would flow in and I wouldn't feel so stressed. But of course, that's not how it worked out.

There was something amiss. I always sensed it. As it turned out, I was right. Later in life, I found out that I was unexpected. My mum was only seventeen when she became pregnant with me. That inner sense I'd been feeling grew into a harrowing impression that I was unwanted because I was unplanned.

There had been a lot of trauma in the family surrounding my mum's pregnancy. My grandmother was embarrassed, but she was mostly worried about my mum's youth and the consequences Mum may face, not to mention the responsibility of raising a baby. My grandmother suggested they go away together to Queensland, where my mum would have the baby, away from everybody they knew. Away from everyone. Then, after they returned, my grandmother would say that the baby was hers and she would raise me. Mum would then be free to go off and live her life.

Mum was young. She refused and instead insisted on marrying my dad. I think he felt trapped but I believe he also wanted to do the right thing by my mum. I reckon she was a rebel and having a child was her way of gaining independence from her family. My parents always told me they wanted me, otherwise they would have had a termination or given me to my grandmother. So as much as I thought I was unplanned and unwanted, my parents always said they did have a choice and they chose to have me. But I never felt that, only the tension.

I was born on Easter Sunday 1964. My grandmother had been mourning the death of her daughter, Rachel, who had died the year before. Rachel was only six years old at the time. She was killed by a car on Good Friday, right in front of her mother, my grandmother, who was understandably devastated. Having also lost two

other children, grief compounded her dedication to religion and she distanced herself as she tried to come to terms with her pain.

My mother's side of the family were all born with blue eyes and blond hair except for Rachel. And me. We both had deep brown eyes and dark hair. I think I filled the emptiness my grandmother felt losing her little girl. I believe, when I was born, she saw me as the reincarnation of Rachel. So I was always very close to my grandmother because she looked at me like her own child and I felt I could have been her child. She loved me and I loved and adored her so much. We always had a strong bond. The day she died, she came to me in spirit, sat at the edge of my bed and told me I was going to be okay and not to worry.

So it was felt that my mum was way too young to get married and that made my dad insecure, suspecting that my mum's family thought he was from the wrong side of the tracks. Throughout their marriage, they often reminded each other of that. My dad had lived in a suburban area when he was growing up and came from a working-class family. My mum came from a more professional background.

My parents had three young children by the time they were in their mid-twenties. Mimi was born three years after me, and Ben nearly four years after that. My dad had mouths to feed. He was like a lot of young men working around the clock to provide for their families. He taught me the difference between hard work and smart work. He also taught me that working so hard in your life you miss out on what's really important, have regrets about that later on and wish you had done things differently. I think my dad was frustrated because he wanted to spend more time with his family, but in order to be a good father, he felt he had to provide.

He was an ardent lover of music and a sound engineer by profession. He began his career fixing audiovisual equipment in government

schools, then created Miranda Hi-Fi Sound and Vision—that was the name of his business. He started off with one store at a shopping centre in Miranda, a suburb next to Caringbah. Through the years, he expanded his business, opening more outlets. He'd make his own TV commercials for his stores, often buying affordable late-night airtime. He took courses in graphic design to learn how to illustrate because he thought it was cheaper to do the work himself than to hire somebody else to do it for him. He was really resourceful—I learned this trait from him. Dad was unwittingly teaching me to become an entrepreneur!

My dad insisted all his staff dress in a professional manner because he believed it showed respect for his customers and for the business. He was always impeccably dressed himself in a white short-sleeve button-down shirt with a skinny black tie. I think he was worried that otherwise he would be seen as unbusinesslike. He wouldn't accept staff coming to work scruffy. He was zealous about presentation and first impressions. That really touched my heart and resonated with me. He strove to look the part and have the outside perfect. Just as I did.

Dad was five feet nine-ish, good-looking, lean, and he loved to ride motorbikes. He was fit; never had an ounce of fat on his body. He was fiery, hot-headed, opinionated, volatile, passionate, incredibly sensitive, sentimental, and sometimes judgemental. And huge laughter, huge heart. He was brilliantly successful because he had discipline and drive and worked hard to get results. And he figured things out. Nothing was too hard for him. A lot of his characteristics are apparent in me today. He firehoses and so do I.

He loved sports and was the president of the Cronulla Sharks rugby league football club. We were huge Sharks supporters and going to football with Dad was a big family bonding time. He

was their number one supporter, helping raise money and running the club.

Jokes. Dad loved to play practical jokes on us. It drove Mum bonkers. She thought he was the stupidest, silliest man in the world, but we loved his childish games. I reckon it was really about understanding that laughter is a great heart-opener. I think he was unconsciously trying to crack open his own heart as well as others' around him.

My dad had an extraordinary gift for attention to detail, which I inherited and apply to this day. Maybe obsession is a better word. Growing up with that exacting nature, from a child's perspective, on one hand was something I was really proud of because everything he did, he did meticulously. On the other hand, it was very difficult to live with. It meant that I thought I too had to do everything perfectly. As an adult, it's been helpful in business but, unfortunately, at times I've unwittingly harmed myself with it, which has been really painful.

As Mum and I packed more boxes, I reminded her of when I was little and one day drew hopscotch on the driveway with chalk. Dad came home late from work, stressed, and was furious. He told me to go and wash it off immediately because he didn't want the mess on the path. As I was cleaning it in the dark, I tripped and fell, cutting my head. I went to the hospital and had to have stitches; I still have a very faint scar above my left eyebrow.

From the experience, in my child mind I think I learned to be hyper-vigilant about making no mess. I felt that I was not allowed to play because if I did, the repercussions were that I could hurt myself or, worse, I could be punished. So growing up, I was a very serious child. I conditioned myself to keep my life as neat and tidy as I possibly could. Everything had to be in its place. I made sure nothing would upset my dad, particularly when it came to the house.

I remember Dad showing me in a colouring book how to colour inside the lines. He taught me how to cross-hatch, drawing lines one way and then the other way to create a perfect finish so you wouldn't see the white spaces in a drawing. I still remember watching him draw the lines and saying to him, "Dad, you can't do that, it'll look messy."

He said, "No, no, no, watch and see, Elle. It's called cross-hatch."

I learned from my dad that if something is worth doing, it's worth doing thoroughly and carefully. And I incorporated that lesson into my life. To this day, in my work I find that I ardently follow products and projects right through from concept to final result. Sometimes people don't like that and consider it controlling. I prefer to think of it as diligent attention to detail. Care. Impeccability. Getting it right.

I always wanted to get it right for my dad, but as a kid I sometimes couldn't manage to do it. I even got cross with myself if I coloured outside the lines. Sometimes I couldn't control my little hand and would have to start all over again because I thought it wasn't good enough. I didn't want to see it messy, I wanted it to be perfect. And I wanted my parents to tell me I was perfect.

I grew up feeling a weight of responsibility, not wanting to let either of my parents down. I felt I had to be really good for Mum because she was trying to juggle coping with three young children while helping Dad with his shop. On the weekends, Mimi and Ben would wake up early and I would usher them over to the park because I wanted Dad and Mum to have a sleep-in, they were so tired from working all week.

Dad was a workaholic. Mum, on the other hand, was a free spirit. She wanted to step into her own individuality, while Dad was a bit more about trying to conform to his own preconceptions of success.

As much as my parents fought, they were a team and I think Mum helped Dad be Dad. She was good like that. She was resentful and rebellious for it but she did do it. She did the job.

Mum was going to nursing school when she met Dad. She was naive in life, book smart, well read and interested in a variety of views and subjects. Books were her sanctuary, her solitude and her saviour. In the 1970s, as she matured, she was a hippy kind of woman who gave out flyers for women's lib. She was outspoken and she worked. She wasn't the typical Suzie-home-maker-1950s housewife. She was born in the late 1940s and became a mother in the 1960s. I remember her free-spirited years in the '70s the most. My formative years.

She didn't like doing things the way everybody else did them. My dad was a sort of rebel with a cause, whereas Mum was just a rebel. From the cool clothes she wore to the choices she made, she dared to step outside the box. When I moved to America, she was the one who said "go explore" and she helped me do just that. She inspired me to have courage. My mum had the guts to bring me into the world when she was only eighteen, and that was back in the day when getting pregnant, if you were unmarried, was typically frowned upon. Mum didn't care what people thought, she cared about what mattered to her. She was an adventurer and was happy not conforming, not because she wanted to be different but because she didn't feel constrained by conventional behaviour and values.

Mum and I were very close as we were only eighteen years apart. I loved having her as my mum. She was the cool mum and the pretty mum, the fun mum, the social mum. She was young, vibrant and all my friends loved her because she was like one of the girls. A wise older sister.

Despite being like a best friend, Mum was strict. I think she needed to feel in control because having kids at an early age meant

she had to cope with stresses she wasn't really emotionally equipped
to handle. The result was that we had to be good. Very good, so
she could manage. I learned early on to help her with chores, and
that didn't leave much space for goofing off. My mum unwittingly
taught me how to be self-sufficient, responsible, diligent, reliable and
capable. I'm so grateful because when I left home I was able to take
care of myself.

One day, as we took a break from packing, I told Mum one of my
most precious memories of her was Friday nights. Dad wouldn't come
home until late as he was either working or had stopped off at the
pub, as Aussies would often do. Mum and I would cosy up together,
having put Mimi and Ben to bed, and we'd watch *Mission Impossible*
or *M*A*S*H* on TV. We'd make a cup of builder's tea, strong with
milk and sugar, and snack on Ryvita Crispbread with lots of butter
and a little Vegemite. I'd dip mine in the tea; even today, the combo
of sweet and salty stirs the memory—one of my favourite childhood
recollections. I can't make tea like that in America, it just doesn't taste
the same. Must be the water!

Mum and Dad. I think they were locked in a sort of co-
dependent, symbiotic, victim–tyrant polarity drama. She was the
victim, he was the tyrant; she was the tyrant, he was the victim. And
they did that dance for about ten years until they'd nearly killed each
other. It was a hiding to nothing with those two.

Sometimes opposites attract and sometimes they repel. When we
are in such situations, actually living them, we don't necessarily see
those truths, only their effects in our life at the time. It was diffi-
cult for me growing up. I just wanted to be safe and loved but often
I didn't feel it. I just wanted my parents to be happy and care for me
and not leave us kids alone to fend for ourselves. It was painful, listen-
ing to my parents arguing, and I wanted to know that they were not

going to harm each other. I know they did their best. I just wished they could work through their differences so they could focus on us.

First three years of my life, my parents didn't document much of anything to do with me. My child within interpreted that as me being unimportant, unwanted. Then, when my beautiful sister Mimi came along, they took countless photographs of her. No photos of me but plenty of my sister only strengthened my belief that I was not beautiful, cherished, treasured or loved. I grew to feel empty inside while, on the outside, I continued to try to make everything perfect and beautiful, controlling to create order and to feel worthy and appreciated. That storm of self-punishment within me seemed relentless, eventually affecting almost everything I did.

Now I see it was my own struggle. Those being my thoughts and feelings as a child, I sometimes wonder if, subconsciously, this was why as a young adult I chose to become a model—to find that feeling of worthiness, acceptance and recognition.

Looking back, I realise my mum and dad were starting from scratch at playing house. They barely had money to buy furniture, let alone a camera. So they were not able to fill albums with photos of me. It's not that they loved my sister more than me, it's just that they couldn't afford frivolous things during those first few years of my life. I see that now but it took me a long time to realise it, to understand how little my parents had and how they struggled through those early years raising a family. That's why Dad was stressed and worked so hard. That's why Mum struggled under the weight of having to cope with three young children while helping Dad run his business. No wonder she became rebellious. I understand what they went through and it's made me appreciate all that they have done for me.

Kids. I'm sure we were a bit of a handful. Mimi and I, right from when we were little, were so different from each other. Some of my

most cherished times were early-morning fishing trips with my dad's mum, Nanna, whom I absolutely adored. She was the fun nanna who sneaked chocolates under the pillow before bed and took us to our favourite Royal Easter Show when we were growing up.

Sometimes when we went fishing, Mimi came with us. We would get up around 4 a.m. and leave in the heat or cool of the morning, depending on the season. We had a little dinghy and Nanna and I would take her out so we could fish for breakfast. The night before, we would prepare "burly," a mixture of bread and other ingredients. I don't know exactly what Nanna put in it but the fish loved it. It worked like magic and she swore by it.

Mimi has always been such an animal lover. Whenever she came out fishing with us, we would be catching the fish and she would be putting them back into the water behind us. When we noticed what she was doing and asked her to stop it, she'd complain, "How dare you! Don't be mean to the fish!"

I would hit the fish over the head, gut and clean them. Mimi would cry, "You're the worst person in the world!"

"Well, why did you come fishing with us?" I'd demand. "I warned you not to come fishing, Mimi."

"I wanted to be with you," she'd cry.

"You can't keep letting the fish go. We've got to kill the fish to eat them but you don't want us to kill them."

Mimi would pout, "Well, can't you do it nicely?"

"How do you "nicely" kill a fish?" I'd quiz her. "You have to cut them open!"

"Oh, you're so horrible," she'd cry.

By which time I would want to throw her in the water.

To this day, Mimi loves animals with her gentle heart. In tribute to that love, she built a very successful career in the 1990s with a

whale-watching business in Hervey Bay, Queensland. In 1996 she won the Queensland Tourism Award, and the following year was named the National Businesswoman of the Year by the Women's Network of Australia. I'm so proud of her.

Mum did matching, so everything Mimi and I had looked the same. And, of course, I wanted Mimi to match me—for uniformity, order. But no, not my sister. She had her own views of how she wanted to be and I would get annoyed when she insisted on having her way. "Don't you understand that we have to match?" I'd glare, shaking my head and throwing my hands in the air.

"I don't want that bow in my hair," she'd reply, pointing at my head.

"It doesn't matter. Just put the bow in your hair, Mimi."

Or she'd go for a bigger deal, wincing and saying, "I don't want to wear that dress like yours."

"Yes, you do," I'd insist, hands on hips. "We have the same, remember—same, same, same. Equal, you and me."

For some odd reason, she seemed unable to comprehend and accept that I was the real fashion leader and she ought to be following my style without question.

Our school uniform had regulation shoes but Mimi loved her patent leather Mary Janes. She would tuck them into her school bag and change into them in the bus on the way to school. No matter how often she got into trouble with the school principal, she still did it. She was a free spirit wanting to express herself her own way. Certainly not my way.

Funny times, looking back. It's wonderful how kids find their own paths to relating with others and building their individual values and boundaries, the essence of which become part of their life's foundations.

Mimi and I shared a room from when I was ten until I left home. I thought she was wild. She had an old record-player for vinyl LPs. She was totally into music and would sing as she listened to The Police, Sting and Dire Straits. Mimi loved punk rock. I'd listen to James Taylor; she'd listen to Sid Vicious and The Clash. She'd put on her music and I'd say, "Jeez, I can't stand this," and would pointedly put on mine. Immediately, Mimi would cringe and say, "Get with the times. You really are such an old fogey," even though she secretly loved James Taylor and ABBA too.

It was relentless and of course I insisted on having the last word. I'd come back with, "Well, you're just a rebel," and smile smugly.

She'd retort, "Oh, you're such a goody-two-shoes. You have to be perfect for everybody." Then she'd jeer, "Everything you do is oh-so-perfect."

"Well, I care," I'd reply indignantly. "You just don't seem to care about anyone else."

Unfazed, she'd grin and say, "Yep. And why would I?"

Good question, in essence. Mimi was so confident, courageous and honest. She was very bold, truly the brightest and funniest of the whole family. And she did care. Deeply. I always admired her character. Silently, of course ;-)

She was longing for my approval but she never got it because she was just so obstinate, and I quickly became cross with her (and was obstinate too, if I'm honest). I was tired of picking up the pieces after her rebellions when she was a teenager. I'd want the house tidy by the time Mum came home from work. My life after school consisted of juggling homework, cleaning the house and helping to prepare dinner. Mimi wouldn't help me because she was playing records. I would be angry with her for not giving me a hand—I felt I had all this responsibility and I needed her help.

If I mentioned it, she'd just say, "If Mum wants the house tidy, get her to do it."

I would plead with Mimi, "Give me a hand. We're going to get into trouble. We have to make it all nice!"

Mum never actually asked me to help out, I just felt I had to. As usual, I was trying to excel because I wanted order. I was longing for peace. And approval. If I did the job and was self-disciplined and got it all done, there would be no chaos and everyone would appreciate it. Right? I was afraid of chaos but Mimi didn't mind. She was free-spirited like Mum.

Undoubtedly, my commitment to perfection must have been really irritating and difficult for my sister. For anybody, I suppose. I think she was actually trying to loosen me up, but all she did was wind me up. The more she did that, the more things went out of control. The more they went out of control, the harder it was to weave through the conflict and uncertainty I felt in my life. It taught me to be really good at navigating uncharted waters. A great start on the journey to trusting life—trusting the flow of creation in which I was an active participant.

Mimi has always had the most beautiful voice. She sings like an angel and even entered a celebrity singing competition on TV, *It Takes Two*. Were it not for her nerves, I reckon she'd have won. I remember living in London when the show streamed online. I watched her week after week, hoping and praying she would win. She had the best voice by far.

When we were little, we loved to do concerts together for our parents, grandparents and friends. We commandeered them to sit and listen to us perform the latest ABBA songs. Their praises were a true delight. "Oh Mimi, you sing so beautifully, and Elle does the harmonies well, too," they'd applaud. But I thought I was singing the melody, not the harmonies!

Funny thing, though—I've noticed that as I've become more balanced and in harmony with my own world, my singing voice has improved. I'm now able to sing the melodies. The physical manifestation of being in tune with life. I kid you not!

My brother, Ben, "the golden boy," was born on the cusp of the New Year, 30 December 1970. Ben—Brendan—was named after Brendan Behan, the Irish author of the book my mum was reading at the time. Ben's big brown eyes, mop of blond hair and dimples gave him more than his fair share of charisma. From day one, he captured our hearts and was the apple of my mother's eye.

I love my little brother, who's now not so little at six feet two. As a toddler, he would often get out of his cot early in the morning and walk the cul-de-sac where we lived. We would wake up to the day, realise he was gone, and often spend ages looking for him. Sometimes we would find him asleep in the neighbour's yard or in their big dog house with the pups. He had a bit of a habit of going walkabout without a nappy and hiding, an inclination that continued throughout his toddler years.

Ben loved to tinker in my dad's workshop at the back of the house. It was filled with boxes of equipment for Dad's hi-fi shop; it was where Dad kept his stock. When Ben was very young, he created a sock warmer by wiring two batteries together so the current between the two would generate heat. He was a super bright boy and I liked to think of him as a nerdy little inventor.

I remember one day going to football with Ben. Gosh, I reckon he must have been about four. We were wearing our Sharks football jerseys in their colours of pale blue, black and white, along with team scarves around our necks. We were cheering for the team, standing underneath the boxes where the richies and VIPs sat. Dad loved to be in the thick of things; right there and up close, watching the game. Ben was standing next to me saying, "What's that on my head?"

"What's what on your head?" I asked him as I looked over. "There's nothing there, you're all right."

He just shrugged and said, "Oh, okay."

We were jumping up and down excitedly during the game and Ben kept saying, "I'm *sure* there's something on my head," but I kept telling him, "No, there's not, Ben."

We won the game—go Sharkies!

And at the end, he turned around, only to reveal half a meat pie on his face! It must have fallen down from the spectator boxes overhead and I'd only been able to see one side of his face. We were so into the game, I'd just kept saying, "You're fine, you're fine," because he did look fine . . . from my angle. Handy lesson on perspectives!

I have some wonderful childhood memories with Mimi and Ben. My absolute favourite time of year when I was a child was, of course, Christmas. Growing up in Oz, the feeling of Christmas was coupled with days so hot there were waves of heat dancing on the asphalt roads; the sound of cicadas screeching from the early morning as temperatures soared well into the thirties by nine in the morning. Christmas marked the end of the school year; the opportunity for a fresh start to the following year. New uniforms, books, school shoes. New attitude. New promises made to myself about how I would be different, better. More organised. More perfect.

Christmas was also the time when my parents made a huge effort to make things special for us and, more importantly, made a huge effort towards each other. I looked forward all year to the festivities. Santa comes on Christmas Eve and we celebrate on Christmas Day. We would leave a beer and cookies for Santa with a note and carrots for the reindeer. How we believed reindeer would fly from the North Pole to Oz, I don't know! Unless it was that time portal some say runs through the Earth between the North and South Poles . . .

Usually, we each had one big present under the tree, like a bicycle, and then a Santa sack at the foot of our bed. The sack was a pillow case. We each decorated our own sack and Santa filled it with things like pyjamas, a new dress, board games, pencils for school. Stuff we wanted or really needed. I would get so excited I could barely sleep for days before. I loved the surprise but most of all I loved the feeling of the family together. I loved seeing Mum and Dad happy.

One year Dad forgot to buy a Christmas tree. Mum was furious because the lay-by tree plan had run out. Dad, ever industrious, went across the street that night, chopped down a wattle tree and stood it in a pot at the bottom of the stairs. Mum was so disappointed. But in hindsight it was the best tree ever. A wattle—the original Aussie Christmas tree! We all had fun decorating it. Dad bought fake snow and we sprayed it on its dark green leaves. Mum thought that was ridiculous but we all loved it.

That's Dad in a nutshell—working late, last minute, but always creative, finding solutions, natural, courageous and willing to do whatever it took to get the job done. Mum wanted things to be beautiful for us, creating memories and making occasions special. She always wanted the best for us.

One Christmas, she stayed up all night alone while Dad worked, as usual. She erected an above-ground swimming pool—Santa's surprise for us on Christmas morning. We'd longed for a pool as we used to sneak out the back through the fence to swim in the neighbour's in-ground pool when they went out. I remember a mixture of fear and exhilaration as we crept into their backyard to swim. We were constantly spying on them and checking their comings and goings, hankering for a cool swim to beat the heat. Mum really wanted a built-in swimming pool but we could only afford one of those that resembled a big cake tin: an amazing conglomeration of blue plastic

lining and blue tubes fitted together and clipped onto the frame that kept the whole cake tin in place. She'd spent all night erecting it, leaving no time to fill it with water. So it was empty when we saw it on Christmas morning. We had to wait for hours until there was enough water for us to have a swim—a real swim, without touching the bottom.

That year was the last of my innocent childhood beliefs about Santa and Christmas. The year after, I found out there was no Santa, and it really impacted on me. I was eight or nine years old and I was playing hide and seek at home. I climbed up into the loft so nobody could find me. It was the best hiding place. While I was there, I found a case with a red bow on it. I opened it and there was a guitar inside. I put it back and didn't mention anything as I didn't want to get into trouble. On Christmas Day, the guitar was under the Christmas tree. It was a present from Santa and it was addressed to me. I was devastated. I felt conned, fooled, disappointed and distraught that my beliefs were not true.

There was no such thing as Santa. It was like I grew up that Christmas. My parents had kept this huge secret from me. They didn't know that I had found the guitar and now I knew that Santa wasn't real. They had fibbed, which was hard to take in. But on top of that was the disappointment that life was not what I thought it was and never would be again. Because it was around that Christmas that I also found out my parents would be separating.

That was such a turning point for me. Parts of my childhood were being torn away like the beautiful wrappings on the Christmas presents. I felt everything was a façade. It shocked me to the core and I held the sadness within me. I remember having to fake it that Christmas Day and I'd feel sad every time I remembered about Santa. It has stayed with me over the years.

Today, I give myself the gift of knowing I do my best and I let go of the "perfect Christmas" so I can also have fun, relax and be in the Now. Being with my boys is the best gift I could have. I'm sure it's the same for every mother.

Mum and I laughed when I related to her another one of my fondest childhood memories—when I was little and I told her I wanted a new cozzie. A bikini. At which time, Mum gave me two clear points: "Children don't wear black, and nine-year-old girls don't need a two-piece, they just need a bottom. And you have a perfectly good one and don't need a new one. Understand?!" So Australian. But I wanted something new and pretty so I got hold of scissors, cut up my singlet, altered my panties, put ribbons on the side and made myself and then my friends new bathing suits from our underwear. At such a young age, I was already finding my resourcefulness and creativity. I wasn't into fashion, I was into beauty. I invariably looked for ways to achieve an aesthetic quality to improve things.

On my ninth birthday, I had a party and invited my friends. I wanted all the girls to look fabulous for the pictures and to wear the same '70s long dresses with flowers on them. I had specifically put that on the invitation. Even at that age, I was telling people what to wear. I wanted the photos to be special, beautiful, memorable. I wanted people to look at the pictures and think, "What gorgeous girls. What a great time."

But I didn't have a great time. My close friend Vicky came straight from school to the party wearing her uniform. I decided that she didn't care enough about my party being special; I didn't like the fact that she hadn't bothered to wear a beautiful dress. I recall thinking, how rude that she hasn't taken the time to get dressed properly for this party when I clearly said we all have to match. She's messing up

the pictures. She's ruining everything because she isn't doing what I told her to do. Didn't she even read the invitation?

It's not that Vicky wasn't doing what I told her to do, I was upset because I wanted the girls to look great in the pictures and I wanted us all to be like a team. Of which I'd be the leader, of course! I wanted us to feel like we were best friends wearing the same dresses. That matching twin thing signified community to me. I wanted community with my girlfriends. I've always wanted that sense of tribal belonging. I still do.

When anyone had a loose tooth, they would come to me. When anyone had a pimple that needed popping, they would come to me. That's what I did. I was Pimple-Popper Tooth-Puller. I took command of the situation because I wanted people to look good. My childhood innocence, pure and true.

And then everything came crashing down when I was ten. My parents got divorced. It was the end of my family's life together. Even before my parents had told us they were separating, I'd known it was going to happen because, deep down, I felt they couldn't keep going the way they were. They were both so unhappy, fighting all the time. We all felt anxiety and tension from living in such a stressful situation. It was like walking on eggshells. Parents think the kids don't know exactly what's going on but we felt everything. We felt every grudge they had against each other, every bitterness, every resentment. I knew they truly loved each other but they just couldn't live together. I think that was the sad thing with my mum and dad—they came together too young and there was way too much pressure on them raising a young family. They were only kids themselves.

Worrying about why they were the way they were, fighting all the time, got me thinking that the conflict was because of me. Now I realise that was not actually the case. I'd always worried that they stayed

together and got married because of me—not because they loved or wanted each other, but because they felt that they had to have me; that life demanded it of them. Now, though, I realise that was my own misunderstanding. Everything was the way it was in my life for a very valuable reason—so I could learn to love myself; so I could learn by my own experience that I was enough.

I was distraught when my parents divorced. I felt sorry for my dad and I felt sorry for my mum. I felt compassion for both of them. Living without us, my dad was incredibly lonely. At that time, fathers were not given the same rights as mothers. Fathers were given visiting rights every other weekend. So Dad was upset because he couldn't get to see us every day and our family life was in pieces. I was worried about him.

After they split, my mum struggled too because she didn't feel she had the financial support and security she needed. She applied herself and took on several jobs to support us but it was still a strain financially.

For a long time, I felt angry with Mum for making the decision to leave my dad, even though I knew she had to. I felt sorry for him, yet at the same time I understood that my mum couldn't have lived like that any longer. But that didn't make it any less conflicting or disconcerting. I cried about my dad and I cried for my mum and I cried about how difficult it was for us all to adjust. But we managed and we got through it. We got on with it.

To this day, my dad still wishes it never happened. Mum says, "Why didn't I do it sooner?"

I wouldn't have the resilience I have today without having witnessed their struggle. I learned I can't control my parents. And I shouldn't even try to. There was nothing I could do to make it okay for them. You cannot, and should not, control another person

or their path. All you can do is adapt and evolve on the path that you are on. And nobody is to blame. I don't blame my mum, I don't blame my dad. It just was. It wasn't anyone's fault. Blame is just a self-righteous attitude that prolongs conflict and pain. Blame is how self-responsibility is seen by someone who mistakenly believes they're a victim of life, not a creator of it.

So I learned that these things happen and then you get on with life. And good things do come from change. Wonderful opportunities come from changing your thoughts and attitudes and being proactive in your life. That's self-determination in action. Like deliberately choosing to feel happy. I couldn't rely on my parents to make me happy. It wasn't their job, nor their responsibility. And my parents' happiness was not my responsibility. I could have stayed sad but what would that achieve other than misery? I chose to move on. It was my spiritual responsibility and gift to myself.

Silver lining. Things may not always seem to be working out but they do in the end. If they haven't worked out yet, then trust that it's not the end yet.

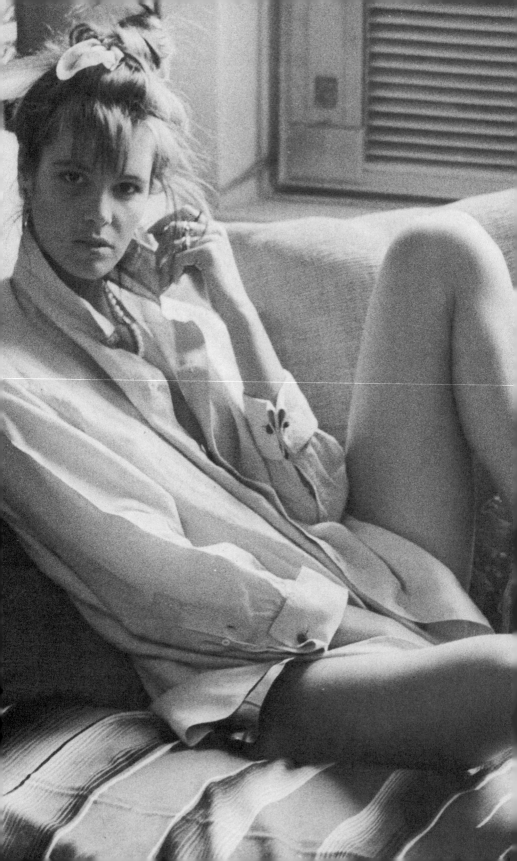

4

CROSSROADS

There are no accidents, no coincidences

School bells.

I heard them one day as we were packing for Mum's move to Asia. Being back home after ten months away in New York City, memories flooded my mind when I heard those bells chime.

One memory in particular was the time I was launched into an unusual new chapter in my life. When my parents separated, Mum, Mimi, Ben and I moved in for a time with my grandparents and we started going to a new school. I had left my old school abruptly. One day, Dad picked me and Mimi up from school, and that was it; we never went back to that school.

A year later, Mum married my stepfather, Neill, and we moved to a new home near my Mum's mum and I went to a new high school. New home, new school, new situation—daunting and yet refreshing, affording me a fresh start; a chance to redefine myself and be a "new" version of me. When I registered at the high school, an administrative

mix-up changed my last name: I was registered in Mum's new married name, Macpherson, instead of Dad's name, Gow.

As a young kid, I didn't know how to process that. I certainly didn't know how to fix it. I didn't know how to deal with it. I didn't want my dad to know my name was changed. To this day I feel awful about it and I know that it's caused him a lot of pain.

So then school reports became a critically sensitive issue for me— I wanted to share them with my dad but I didn't want him to see my stepfather's name on them. I went so far as trying to scratch out Neill's name and write my dad's name in its place. It was a horrible situation. A part of me saw the name change as part of this chance to start my life with a new blank slate, but another part of me was absolutely mortified that when Dad found out, he would feel hurt. At the time, I thought I was responsible for hiding the truth from him; for covering it up because I felt responsible for how he'd feel about it. But, of course, I was labouring under a child's misunderstanding. None of us can be responsible for how anyone else chooses to feel about life circumstances. I was not responsible for my dad's feelings, only for my own feelings and taking actions to the best of my understanding and compassion at the time. That's how we take responsibility in life and give others their own responsibility. In fact, Dad didn't find out for many years, but when he did, he was devastated. And so was I. I wish I'd known then what I know now. If I'd known these life principles at that time, I wouldn't have tried to hide the truth and would never have carried the weight of those issues, causing the effects of stress and inner conflict rippling through my life.

When I was growing up, before my stepfather came along, my parents were so busy raising a family and running a business that the last thing on their minds was my education. Back then, it seemed as though my parents were just taking us kids to school, dropping us

off and launching into their day. All the while, I was panicking about my grades and fibbing to my mum, saying I was an A student when I was really a B student. I was thinking that if I were an A student, she would love me more. I wanted her to be proud of me.

Unfortunately, everything compounded and I became over-whelmed when it came to studying, so my grades suffered. Except for art. I was really good at that subject. But maths and English—particularly spelling—terrible. I was so preoccupied by the chaos and dysfunction of my home life that I couldn't give 100 per cent to my lessons. I doubted myself and, when I feared not getting perfect A results, I panicked and didn't put in the extra effort that would've made the difference. I didn't understand what it took to get the results I wanted. What's more, I didn't have the know-how to study. In my own mind, I became a victim of my fears and I didn't have confidence in my ability to succeed, so I gave up too easily.

Back then I couldn't relax. I was trying to be the good girl. I was trying to survive. I'd get to school and still be stressed and wouldn't be able to concentrate. I was trying to create friendships with people but I wasn't socially adept. I didn't know how to just play, so I wasn't fun to be around. I was serious, self-conscious, anxious and awkward.

Everything changed when Neill came into Mum's life. Neill and Mum were introduced to each other by a mutual friend who had a record store around the corner from my dad's hi-fi store in the mall. I loved that store! I remember the grooviest artwork on the walls. Mum and Neill were friends first for a long time until they became partners after my parents separated. She was a different person around him. She was less stressed, more relaxed and we settled into a new, more easygoing way of life.

Mum introduced me to Neill about a year after they had been dating. He had a beard and long hair. He was wearing trendy '70s

overalls and no shirt. He was six feet two and wore platform clogs—
very fashionable at the time—making him even taller. He played the
acoustic guitar and was laidback and cool. He looked like a rockstar
to me. He was witty, he was intelligent, he was fun.

One day Mum was driving her orange Volkswagen Beetle with
me in the front and Mimi and Ben squashed in the back. She said to
us, "Neill asked me to marry him. I love him. How do you feel about
that? Because I wouldn't marry him unless you kids agree." I felt really
grown-up that Mum was asking us what we thought. We saw her
happy. We all said YES!

Neill was an avid and high-achieving student. When he was still
in university, he took on a young woman and her three children who
weren't naturally his. That says a lot about what type of man my step-
father is, and shows me how much he loved my mum, me and my
siblings.

When my stepfather graduated, it was with honours. All the hard
work he'd put into his study had paid off. He ended up being one of
the youngest lawyers in Sydney to become a barrister. He was brilliant
at what he did and he worked smart, and seeing that success made a
huge impact on me. It taught me that if you believe in yourself and do
the work, you get the results. If you don't do the work, you don't get
the results. Simple. And I adopted that philosophy in my life.

As a teenager, I was self-reliant. I would wake up early in the
mornings and go swim training at 5 a.m. When I finished swimming,
I'd come home for breakfast and help get Mimi and Ben off to school
then head there myself. After school, I'd come home and do house-
work, study, then often sit down with Neill and he would quiz me
on my homework. I learned how to take tests. He taught me how to
highlight point facts, remember phrases, read Cliffs Notes. He taught
me how to study methodically and calmly; he taught me the value of

education. He also would remind me of the consequences of a lack of education and that, without good grades, it would be hard to get into a professional career. I now believe that education is extremely important to foster, not so much knowledge as discipline, persistence and confidence in a child's life.

It wasn't the education per se that gave me confidence. Excelling in school gave me self-confidence. And that's what I desperately needed. I felt like I didn't understand anything and then, when I began doing well in school, I started to build self-confidence from actually getting better grades and not lying about them. I gained confidence from the skills of studying and remembering information, understanding concepts, delivering work on time, meeting deadlines and taking exams.

While Neill was studying diligently for his bar exams, he was mentoring me too, helping me study for my high-school exams. We'd study together, and sometimes I would lie down underneath the table where he was working and fall asleep on the floor at his feet, too tired to go to bed. I enjoyed being in that quiet academic space; it was so different from the chaos in my head. He showed me how to use my brain properly. I was used to fear and anxiety, reacting to situations and trying to figure things out. Neill, on the other hand, was relaxed, quiet, methodical, focused, studied and rhythmic. His way made sense to me. I felt more settled. His energy soothed me.

Neill was a very patient, grounding influence in my life. I developed a stillness within, which helped me to focus on my studies. It helped me to apply myself to my work and to achieve results. Having decided to put all that frantic brain energy into my studies, I was determined to achieve excellent grades that my parents would be proud of and I would be too; results that were tangible and I would benefit from. Come test time, I achieved the grades I wanted. I got

my As. That inspired me to keep going and I've never looked back since. I love to set goals and achieve them. It empowers me to excel in what I do.

On a Friday night, once or twice a month, Mum wouldn't have to cook: Neill and I would go to the local pizza parlour to get takeaway. I would order my favourite Hawaiian, ham and pineapple pizza, sweet and salty. While waiting for our order, we would play a few rounds on the pinball machine. Then we would play a few more while our food sat getting cold. But that's how it was with Neill. He was my step-father, but was also like a big brother to me.

He'd say mischievously, "Ahhh, it's okay, don't worry," as I'd point out to him that Mum would likely get really mad if we didn't get home soon. With a grin, he'd whisper, "Let's have another game."

He mastered the balance between doing what needed to be done and having fun. He was like my partner in crime. I'd always wanted a big brother, probably because I didn't want the responsibility of being the eldest child.

Neill helped me in all areas I needed, yet he also teased me constantly. When I got dressed up to go out with a boy I liked, he would tease me about the boy. He teased me about the way I dressed. He would tease me about everything, like a big brother would tease his kid sister. It was exasperating and annoying but, at the same time, I loved it. I admired, respected and revered him.

Mum and Neill seemed to have a really good time together. I think my mum was able to be a bit more of a free spirit with him without being rebellious. I too was enjoying life, not stressed out the way I had been, and it showed. I was getting good grades at school and I was making friends.

As a teenager, physically I grew head and shoulders above everyone else in my class. My legs went on forever and I developed

these broad shoulders as they became enhanced and athletic from my morning swim training. My schoolmates never really talked about the way somebody looked. Beauty was in nature. It was never part of the vernacular. I feel like it's not an Australian thing, more an American thing. In Australia, you are who you are. I believe Aussies tend to be more down to earth.

It's not that the kids would tease me when they called me "Legs 11," but from time to time they'd make some sort of observational comment like, "Jeez, you've got long legs, like some sort of animal. Must be hard to find school shoes your size!" Or, "Do you have to order your school clothes three sizes bigger to get the right length?" Or, "Your socks only come up to your calves. That must be really uncomfortable, mate."

But that was the mentality when I was growing up. Very Aussie. You've got to be able to give back what you get. And laugh at yourself. Which I never achieved because I was never relaxed enough.

When I was in high school, I worked a few jobs to get extra spending money. I started working in the local chemist and then at a theatre restaurant. I noticed my girlfriend Hannah got more tips than I did. I asked her, "How come you get more tips than me?"

Hannah shrugged and said maybe it was because she wore a blouse that was kinda sexy.

I noticed a couple of her buttons were undone. Obviously, being attractive and flirtatious pays.

Hannah said to me that if I dressed like that, the guys would notice and tip more.

I replied, "Oh, wow—okay!" I had no idea; it had never occurred to me. I was quite naive when it came to matters like that. As I became older and more confident, I embraced my womanhood, had fun and teased the boys. I worked in the pharmacy for a few years. When the

blokes came in to buy condoms, I would get them to say really loudly
what they wanted. Then I'd tell them to speak up, and ask them,
"Do you need the large size? Or medium, or small?" They had no
idea I was referring to the package size—large being a pack of nine,
medium pack of six or small pack of three. So I'd just smile and wait
as they'd glance down, ponder a few seconds, and usually mumble,
"I'd better go for the medium, thanks."

Hannah Jane Thorley became my best friend. I met her in 1974
when I moved from Laguna Street Public School in Caringbah to
Lindfield East Public. Hannah was assigned to look after "the new
girl" on my first day. She took me by the hand and said, "I'll be
your friend."

She's still my friend today. I loved her from the moment we met.
She was a born leader, confident, pretty, popular, relaxed, kind, funny
and the cool girl. I was the opposite. Tense and awkward. Every-
body loved Hannah. As she walked around the school showing me
the layout, everyone seemed to know her and wave. She played field
hockey and still does, representing Australia in the over-fifties team.
We've been friends for forty years. She was the girl I wanted to be
when I was growing up. She was the girl all the boys wanted to go out
with and I was the girl all the boys talked to about wanting to go
out with Hannah.

She was the first to smoke, drink and wag school while still achiev-
ing great grades and never getting caught or getting into trouble. She
was fun and sensitive and a great listener, all the while calling a spade
a spade. I had so many firsts with her—first time I kissed a boy, first
spliff, first drink. We shared so much together. As I became famous,
she never shied away from my celebrity. We always called to check
in and she was the first person I phoned when something major
happened in my life. She's still the person I tell my deepest darkest

secrets to and she always listens without judgement. Never dramatic. Always totally natural and understanding.

One day after school, a mate of mine mentioned she was modelling and said I should check it out. She told me the money was better than I was making at the chemist and theatre combined, which encouraged me to give it a go. I went to her agency, Cameron's Model Agency, and they suggested I have professional pictures taken. I did a test shoot and after seeing the photographs, Cameron's decided to take me on.

Within a few months I started getting really busy. In Oz, you had to be able to do everything in order to make a living and survive as a model. Most often, when working for big department stores, I'd arrive with my own hair and make-up kit, shoes, accessories and jewellery. That's how we all did it in the '80s. The more experienced models I worked with showed me how to style the clothing and how to do my own make-up and hair.

Back then there were no mobile phones, of course, so I was frequently running home to check the answering machine for messages from Cameron's. One day I received a call. It was the agency—they had booked me to shoot a TV commercial for Tab cola drink. I showed up at the beach where we were filming and was given my outfit. It was a tiny red bikini—there was nothing to it. I held the flimsy pieces of material in my hand and wondered what it was going to cover.

The make-up and hair artists perfected my beachy look. The director explained my role to me. I had to walk along the beach and smile cheekily at a couple sitting on the sand. The boyfriend would gawk at me and the girl would throw a bucket of cold water over his head. Seemed easy enough. But it wasn't. I was extremely conscious of the camera shooting so close up from behind that my walk was stilted. I kept thinking, "The camera is zooming in on my bottom." The camera

crew closely followed me down the beach. The sand was hot as I took my steps, trying to hit my mark at just the perfect place and pace.

Anyway, the commercial was shot and aired and, before I knew it, I was "the Tab girl." I thought it was hilarious—Me! The Tab girl?!

I had no clue how important that TV commercial would be to my career; no clue that one day it would lead me to New York to embark on an international modelling career. There was never any crystal ball whispering what those shoots would represent or how they'd affect my future. Nobody ever said, "This job will change your life." I just did what was in front of me if it felt right. As each job came to me, I just did it to the best of my ability and then moved on and did the next one. With that Tab shoot, I was certainly in the right place at the right time—in alignment with my life path. You can tell when something's meant to be—it's in the flow; comes effortlessly, unplanned and tweaks your excitement.

Without realising it then, I was already working the role of a supermodel in Australia in the 1980s. When I say supermodel, I don't mean a super famous or sought-after model, I mean a model who can do anything with any look in any context for any product or brand utilising every self-attribute for the job. And do it perfectly. Every time.

We need a good pair of hands—yup.

Legs for stockings?—got those.

TV commercial?—sure can.

Runway?—okay, I can walk.

Magazine cover?—just show me where and when.

Girl next door in a bikini?—that's me!

On the days I wasn't working after school I would often hang out with Penny. She was one of my closest friends. She had a wonderful, dry sense of humour that I loved and loosened me up. We often slept over at each other's houses and her family were really cool.

We would go to the pool early in the morning and practise synchronised swimming together for the school team. Sometimes we would play handball. We loved to sing and had fun pretending we were Agnetha and Frida from ABBA while we danced down the stairs lip-syncing their songs using a hairbrush as a mic. Two crazy teenage girls having fun and living in the moment.

When I wasn't hanging out with friends, I was with my mum. It had always been that way and it still is. Just this time, coming home to Australia after being in New York most of the year, I was packing up my old life without knowing what was in front of me. A few years before, I had wanted life to stay the same. Of course, it never did. And now was no different. One more box packed; time for a break. Mum suggested we take Lizzie out in her pram, go to the local shopping mall and grab a bite to eat.

When we got to the mall, I told Mum I wanted to go somewhere else. I really didn't want to eat in the open foyer, where I felt everyone was staring at me. Plus, I knew the paparazzi were close by. I could feel them. I could always tell when they were around; my sixth sense was heightened.

I whispered desperately, "Mum, everyone is looking."

Mum said, "Don't be ridiculous. Just eat your lunch."

I'd ordered a salad sandwich and sat with it on my knees, clumsily trying to eat without it falling all over the place. I was furious at Mum, blaming her for my own agreement to eat in public when I knew better. I just wanted to please her and not make a fuss. Of course, the next day, there I was on the cover of a rag mag, sandwich everywhere.

I was finding it difficult adjusting to public recognition. I was learning that I had to be mindful of my every move in case it was captured on film and displayed for the world to see. At times,

I felt I was being scrutinised wherever I went. Suddenly the most mundane things seemed important and had to be done perfectly. I was self-conscious on one hand, yet on the other I was grateful as I began to notice the seeds of recognition; it was a barometer of my public profile and I seriously wanted to succeed. Failure was not an option. I realised I was going to have to get used to such situations. So was Mum.

We'd just returned home from the mall when the phone rang. It was Cameron's with a new booking. This job was a first, unlike any I'd ever done before. I looked at Mum in disbelief. They wanted me to make a guest appearance as the Tab girl and open a nightclub in Perth called Hannibal's. I asked Mum to come with me. Her eyes lit up with excitement and she had the biggest smile on her face. It was going to be so much fun.

The agency flew us first class to Perth. We arrived late afternoon and went to our hotel to get ready. That night, a limo picked us up and drove us to Hannibal's. When we pulled up to the club, we were astonished by the crowd. The entrance was sealed off by ropes and security guards. There must have been well over a thousand people queueing to come inside. Stepping out of the limo, we were suddenly swarmed by the paparazzi. They were shouting, "Elle, Elle—look this way!" Their cameras flashed as we walked the red carpet into the club.

I was asked to sign autographs that night. First time it had ever happened. Mum and I were treated like stars. And as I stood by the DJ booth, smiling and waving to the crowd, I couldn't believe I was getting paid, in cash, to have so much fun—to just show up and be me. Never before had I seen this type of promotion. It was such a surprise and so exciting. It was then I began to understand the power of celebrity and the flicker of an idea sparked my thoughts. I wondered if I could use this type of promotion to grow a business.

It was something to think about for the future. I was enjoying being a celebrity at nineteen but I was also able to see the true value beyond the fame.

It was shortly after Hannibal's that I spoke to Stuart Cameron, who was a regular guest at our family get-togethers. He was a close friend of my auntie Mari, Neill's sister. Mari and Stuart worked for a modelling agency called Chadwick; Stuart was a partner.

Chatting with Stu after dinner one night, I decided to change agencies in Oz. I felt he could represent and better handle my business as Chadwick Australia was more experienced. And he was family. It felt right to make the move and I listened to my inner sense. Stu became a big part of my life—my manager for the next twenty years, playing a major role in my career.

I realised the time for change had arrived. Life was calling. With a new manager on board, a bigger variety of modelling experiences under my belt and learning to come to terms with my rising celebrity, I was excited about my future and looking forward to returning to America. I felt ready to start a new phase of my life; ready to embrace my career with new experiences and new prospects. I was ready to fly.

But first, Mum and I still had to finish packing up before saying goodbye to the family home in East Lindfield. And, just like that, we were on the last box. All the memories stored away. A few days later, it was bittersweet as we all said goodbye to Oz—to family, friends and country. It was sad but inspiring—another pivotal point in life.

Just before Christmas 1983, we boarded the plane and left for Hong Kong. I wanted to help Mum with Lizzie during the flight but I slept most of the way, I was so exhausted from work and lack of sleep. I'd been on the go for weeks without a break and it had all caught up with me. The trials and tribulations of becoming a celebrity had landed!

On our arrival into Hong Kong, I woke to feel the buzz of anticipation from the passengers. The energy was heightened. It was exhilarating. I looked out of the window and saw the lights of Hong Kong in the distance. We flew along the coast of the New Territories, slowly making our descent. As we approached the runway, the plane glided over the city, seeming as though it was weaving around the skyscrapers. At one point, I could look into the windows of the people living in their high-rise apartments. It was unbelievable. Victoria Harbour was magnificent and was lit up with millions of lights. The plane made a last-minute right turn before we touched down at Kai Tak Airport. I thought we would over-shoot the runway into the harbour but the pilot pulled up with a sharp reverse thrust and we came to an abrupt stop. We'd landed in Hong Kong and it took my breath away.

Over the next few days, while Mum unpacked and settled into her new home, I played with my baby sister, Lizzie. She was the most beautiful little girl. There are eighteen years between her and me and I found it wonderful to have a little sister who I could love and shower with affection. My mum had Lizzie at thirty-five—she was the gift my mum gave Neill; she came into the world born of their love.

Lizzie's upbringing was exotic, quite different from mine. My little sister grew up in Hong Kong. She learned to play piano and to speak Cantonese. She was a really bright and aware child, always softly spoken and incredibly intuitive. I loved to spend time with her whenever I visited my family in Hong Kong, marvelling at how beautiful and intelligent she was. Many years later, she went on to study immigration law and is making this her career.

Lizzie got the best of me. I was the elder sister who travelled the world, bought the pretty clothes, and gave her fun and unusual gifts. I dressed her up and did her hair and make-up. I was more relaxed

at that time, and also because Lizzie and I were so many years apart I was able to have a relaxed relationship with her that I'd not had with Mimi. I no longer had my childhood misunderstanding of having to keep the family together, so I felt free to be a more natural sister. Mimi suffered from my stresses of trying to keep it all under control for the family. I love her and deeply regret having been a contentious sibling to her at times.

But Lizzie was alone. She suffered too. I could be a good-time sister, sometimes; I wanted to be there for her and to be more present when she was growing up, but I wasn't: I came and went through her life. Lizzie didn't have any siblings around her when she was young because after a few years Mimi and Ben moved back to Australia. She was sort of an only child and when my mum and Neill separated she had to go through that divorce. It was like history was replaying itself. I suspect Lizzie was trying to keep Mum and Neill together; trying to keep the status quo between them when things got rough. So ultimately she and I had some stuff in common. Now that she's had children and is raising a family, we are closer. We connect and talk about parenting and I love seeing her be a good mum.

Lizzie was just a toddler that New Year. I recall us all watching the fireworks overlooking bustling Victoria Harbour. Later, Mum and I went to Lan Kwai Fong and partied. It was wonderful to see her so happy—I felt she had been given a second chance at life.

After New Year, I flew back to New York. While I was saving up to rent an apartment of my own, I stayed with my friends Emilin Tidings and Billy Wirth (when he was in town). I'd met Billy a few of months earlier while working on a shoot for *Glamour*. We were booked to be a couple—both of us were dark-haired, dark-eyed and unusual-looking. Billy looked like a Native American to me and I thought he

was so beautiful, playful, vibrant, interesting and intelligent. After that day, we hung out together a lot. As well as modelling, Billy acted and later starred in the movie *The Lost Boys*.

He sometimes stayed with his parents, who lived on Park Avenue, while he was going to Brown University, studying law like his father had. I went to visit him often on Brown's campus in Providence, Rhode Island, taking the shuttle up there on Thursday nights. Billy lived in a big dorm with a bunch of friends and I'd spend Friday on campus walking around with them and other students. I loved experiencing college life through Billy, the life I had chosen to walk away from in Oz. For the longest time, I'd pined for the college experience. I loved being with groups of students, discussing topics of the day, debating. It gave me a taste of what could have been and sometimes, for a split second, I wondered if I had made the right choice for myself. But my attitude is, there are no mistakes. Just adapt and keep navigating towards what seems most joyous, fulfilling and empowering.

Often I would see a tall, good-looking boy walking around the school with a gaggle of people following in his wake. In due course, I went to a party at that cool boy's place. I only knew him as John-John. When I arrived, I noticed lots of photographs of Jackie Kennedy on his walls and I wondered why he had them all. It took me a while to figure out that John was John F. Kennedy Jr. That beautiful woman was his mum!

Billy Wirth knew so many people, and having been born and raised in New York, he knew the city like nobody else. He was the ideal person to take me around town and show me the traps, from late-night basketball on the streets of 96th near where his parents lived, to roller-disco parties downtown at the Roxy nightclub. When he finished his study for the day, and after I had taken a nap from work, we'd get ready and go out clubbing around midnight. We

would bar-hop and dance until 3 or 4 a.m., after which I would crawl into bed for a few hours' sleep before work. I would, as you do when you're a teenager, calculate my sleep time and I figured I was getting about eight hours—four before midnight and then another four after. The bit in between didn't count, of course!

Billy was the best when it came to getting into clubs. He took me to the exclusive Palladium, the hot new nightclub from the guys who'd created Studio 54. I felt so alive and finally part of New York City. Even though I was nineteen and still a young girl, there was something about being at Palladium or out at other "in" hotspots that made me feel like I was becoming a woman. No doubt there were also plenty of times, seeing all those stars, when I felt out of place, like I didn't belong. Yet even then, something inside me knew that one day I would find my stride in crowds like these.

The Palladium was a place where music, film and art collided into a melting pot of artists, musicians, actors, celebrities. Everybody who was anybody went to Palladium, just as they had gone to Studio 54. There was a line out front every night and the bouncers wouldn't let you in unless you looked like somebody. I remember seeing Michael Jackson, Andy Warhol and Diana Ross there. They were somebody.

I always wanted to see the stars but I didn't know enough to recognise many of them myself. I always wanted to go to hip places but I didn't know which places they were. I wasn't part of the in-crowd. I was uncomfortable and shy around most famous people. I thought I didn't have anything meaningful to offer. In New York I wasn't famous so I thought they wouldn't want to hang with me.

At that time, when I was star-struck, I just ran away, not knowing how to be cool. I've never been the chilled-out girl, though I'm more easygoing now than I've ever been in my life. I think people always saw me as unusual and sophisticated, but I didn't feel cool or chic

in my heart. I was super courageous with the things I was doing but when it came to what people thought of me, my fear of not fitting in, of not being impeccable, was almost overwhelming. That fear of really being seen. Yet again.

What people thought of me mattered to me. Their opinions mattered. I wanted their opinion to be that I was perfect, just as I'd wanted my mum and dad to think I was perfect—colouring between the lines with no mistakes. I didn't want people to know what was going on inside me because I feared that if they asked, all my thoughts and feelings would flood out. My fear of being imperfect along with my persistent need and effort to excel—that struggle inside me persisted and I persisted in shielding my feelings from it.

Even when I was sensing it was time to embrace and value my uniqueness, not apologise for it or dilute it, a part of me was still trying to be inconspicuous. I felt that if I were to stand out, people might see my imperfect self. Just as I saw myself at the time. I was trying to protect myself. I didn't want people to judge. I didn't want anyone to know what was really happening behind closed doors. It was a smokescreen, a front—just like the perfect beautiful house I grew up in.

The thoughts and feelings that were mine when I was a child were also my thoughts and feelings as a young woman. It's taken me years to come to terms with the fact that my fears were unfounded, blown out of proportion, unrealistic. I learned to shift my consciousness by leaving behind me the mindset of being a victim; instead embracing the principle that I'm the creator. That took a while; many years, actually. But I did it.

So I felt I needed to be able to control the details of my life and, though living with Billy and Emilin was fun, I yearned for a place of my own, where I could be myself. I'd have to work really hard and really smart so that I could have my own space.

And that's what I did. That's what I learned—create what I want, not struggle to change or fix what is not working for me. And living with other people wasn't working. It didn't work when I lived with Bethann. It didn't work when I lived with Billy Joel. And it didn't work with Beth either. Those were inspirational steps; helpful trial and error from which I could learn; the nudges I needed.

The Universe helps you move on. Bethann held me accountable for my actions and I dealt with the consequences. She helped me move on to the next chapter of my life by saying I had to find my own place. Christie's clear boundaries helped me move on with the next chapter of my life too. Living with Beth helped me realise that I couldn't keep living that way if I was going to bring my dreams to reality. My guidance had signalled three times for me to create a different living circumstance for myself.

I didn't want a roommate nor to share a bed. I'd shared a room with my sister when I was growing up and now, becoming a young adult living away from home, I wanted independence and my freedom. But nobody was going to just hand me an apartment. I had to find a way to be successful enough to pay my own rent and expenses. Necessity is the mother of invention and I needed to invent an effective new working plan and living arrangement for myself.

It was not just the promise of peace from knowing I had a place to call home that led me to work extra hard and get my own apartment. I realised that if I was going to find my own place and thrive, I had to choose jobs that would not only pay me well but would also enable me to apply myself to achieve the excellence and professionalism I wanted in my work. Putting myself in others' shoes, I figured that my strategy would benefit all concerned; something to meet everyone's aims—excellent, professional, enjoyable, quality, profitable, supportive, effective, fulfilling . . . and lucrative.

I continued to spend long hours doing TV commercials and equally long stints modelling for catalogues. In the fashion world, these were not prestigious jobs, but they paid well. It's not that I was entrepreneurial in the beginning, it was that my choices were strategic. I asked myself, "How can I do the best paid jobs that consume the least amount of my time in front of the camera?"

Wanting a more balanced life, I chose carefully which jobs I would take—the ones that would be worth my while putting the effort into. I didn't want it to be all work and no play. I wanted time to relax and catch up with my friends. I was young and living in one of the most exciting cities in the world and I wanted to have fun and explore. I wanted to go dancing, listen to music, check out the nightlife.

So I found the hustle within myself. I became resourceful and industrious. I became excellent and in demand. I learned how to give the best possible performance in every single job I did. Many girls chose the glamorous fashion assignments. Many girls were more interested in being on the cover of *Vogue* or *Bazaar* than they were of being on the cover of a shopping mall catalogue. I was earning $1500 to $5000 a day working on catalogue shoots. The girls doing magazine work were earning $80 a day. After they paid their agency and their taxes, and were home from a long day working sixteen hours, they basically had thirty bucks in their pocket. That made no sense to me and it wasn't going to work for me either.

When I chose the less glamorous jobs, the agency would say, "If you want to be a successful model, you've got to do the prestigious magazine work." But of course, being a successful model wasn't my aim, not my prime target. It was just a means to reach the real target—my independence and freedom.

The agency had a hard time with me because I didn't listen to them when they advised me how to craft an illustrious career. But

they couldn't deny the fact that I was a huge money earner. I was in more demand than most models, plus soon I was becoming somewhat famous. In my modelling world, you built up recognition with the heads of consumer goods and blue chip companies, and that notoriety translated into more jobs; well-paying jobs every time. Perfect!

The way the regular modelling world worked, you did the fashion magazines and then you got the luxury beauty campaigns that made millions of dollars a year. And then you walked the runway—maybe. But I was unconventional. Typical Aussie. I wasn't doing it their way, I was doing it my way. I was listening to my inner sense that had guided me. I trusted it. And it was working.

At twenty, I held the key to my very own apartment in New York City. It was a 1200 square feet, flow-through design on the fourth floor of a brownstone. It was on 20th Street between 9th and 10th. I never thought, it's my first place. I never thought it was the first of many. I only thought, it's my very own place. Big difference. Target reached. My target.

It was heaven. Renting my own apartment was a symbol of my success and achievement. I could finally afford to do this after paying back the agency the money I owed them for visas and staying with Bethann, money I had borrowed for travel expenses, and money I had borrowed for getting around town. I felt truly free.

A short while after I moved in, my mum came to visit. She travelled all the way from Asia to help me decorate, which was fun and very bonding for us both. I remember Christmas that year. Mum and I bought a real Christmas tree, dragged it up four floors and into my apartment and decorated it together like we'd done when I was a child. Those are wonderful memories; precious moments spent together which I will always hold close to my heart.

So there I was, an Aussie girl, 16,000 kilometres from home, successful model, living in my very own apartment in New York, one of the most vibrant cities in the world. Give it a go. Adaptability. Self-trust. Learning from every experience. Finding practical wisdom in what could have become mistakes. Financially independent. Free. It was an empowering point in my life.

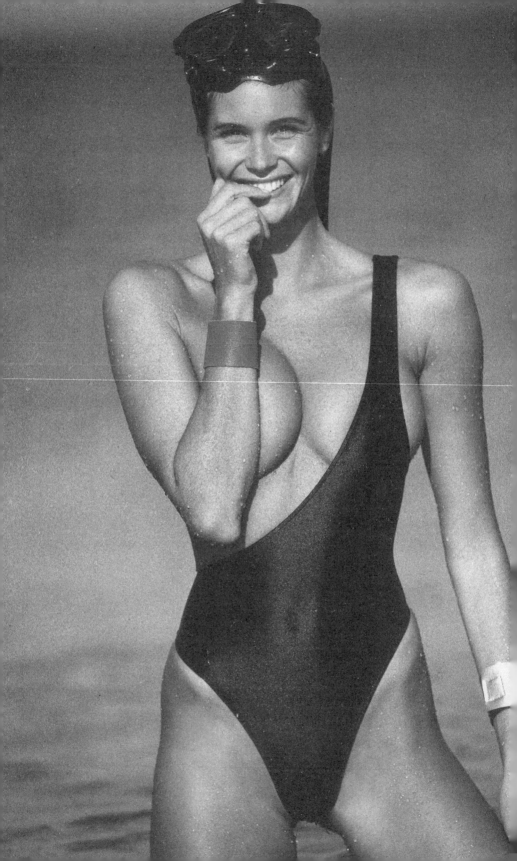

5

SPORTS ILLUSTRATED

Be the best version of yourself

Independence came in the form of *Sports Illustrated*.

Ultimately, it was *Sports Illustrated* that changed my career. The magazine was famous for its swimsuit editions, which were released in between sporting seasons when, without sport being played, the magazine's monthly space needed to be filled. André Laguerre, managing editor of the magazine between 1960 and 1974, introduced the swimsuit issue, announcing, "We're going to do a travel story. We'll put a pretty girl on the cover and that will bridge the midwinter gap."

The swimsuit issue came out each February. It arrived in the mail. It was thinly disguised as travel but it was really all about the girls. And every young boy in America grew up waiting for that magazine to come out so that they could check out the girls. The models were very wholesome and the shoot was always in beautiful locations around the world. A model became famous being on the cover of *Sports Illustrated* as their name was printed on the front of the magazine

alongside their photo. It was a coveted position to hold. When each year's cover was unveiled, it became an iconic, star-spangled media phenomenon.

Some of the most famous models in the world graced that cover. A few who paved the way before me were Christie Brinkley, Carol Alt, Cheryl Tiegs and Paulina Porizkova. I was on the cover of *Sports Illustrated* five times—and how did that happen? Well, let's talk about Paulina.

We met on a modelling job shooting clothes for a catalogue. I liked her immediately. Paulina reminded me of Audrey Hepburn. She was petite with long dark hair and always looking very mysterious with beautiful blue almond-shaped eyes. It was all part of her look. She disliked wearing her glasses but she couldn't see without them, so she squinted a lot. I liked to joke with her that she was blind as a bat.

She was born in Czechoslovakia and had come to America in the early 1980s from Paris, where she was a successful model. She worked through Elite Models and was so famous from being on the cover of *Sports Illustrated* that people would recognise her in public and stop her in the street.

Paulina glided through her life; success seemed to come easily to her. She was oblivious to what was going on around her and she didn't pay attention to work or to money. She didn't care about fame or the modelling industry. She didn't care about any of that. All she wanted was love; everything was for love. Love of art, love of music, love of poetry, love of a man.

She read Balzac. She played Rachmaninoff on the piano. And Chopin. She spoke six languages and was cultured. She was glamorous. She was fiery. She was funny. She was rebellious; she wanted people to see who she was. She didn't hide behind any image of who people thought she was. She had an Estée Lauder campaign and when people

asked her what products she used on her face, instead of saying Estée Lauder, she'd say, "I don't even take my make-up off, I sleep in it," or "Oh, I just cover my face in butter," or "I just use something I find in the fridge." She felt the image of herself was completely different to who she was so she would shock everyone by making radical remarks. Her biggest line to the press was, "Modelling sucks." Whenever that line came out, I'd tell her, "Paulina, you can't say that!" She'd smile and say, "That's just how I feel." She was the chilled-out girl. I, on the other hand, was Uptight Girl—miss goody-two-shoes trying to do everything right.

Paulina was my best friend and I loved her. She later said to me, "You came and you had a vision. You didn't know why you were doing what you were doing but you knew that you wanted to become successful. Whereas I didn't care. We both tried so hard in different ways to fill the cracks in our lives. But the reasons were the same. We both wanted to feel we were worth something; that we were valued."

Love was her motivation. Paulina wanted to be valued in love. I wanted to be valued in business as having achieved something in my life. We were two little hurt girls who were insecure about ourselves. Mine was about financial scarcity. Hers was about scarcity of love.

She had her own apartment not far from mine. I originally picked the area since that was where she lived and I wanted to be near to someone I knew in the city. She had a roommate but the living arrangement didn't turn out too well—the guy wasn't very nice. I'd been living on my own for a little while when Paulina moved in with me. This would be my fourth time having a roommate but I didn't mind as I was happy, having fun, and Paulina was a blast. She came to stay for a short time and then got her own place. During that time we became close friends. We were just two kids playing in the streets

of New York. The currency was beauty and opportunities flowed to us and paid well. Life was a thrilling, fun-filled adventure.

When we went to dinner, we sat at the best table in the restaurant and someone else always picked up the tab. You could hear the whispers of people saying, "It's Paulina," as we walked by. When people came to our table for an autograph, I would say to them, "Please don't bother Paulina, she's having her dinner." I felt incredibly protective of her. I was taller than her and stronger than her. I felt a little bit like her bodyguard.

Seeing that she was really well known, I thought to myself, I want to be able to go to these posh restaurants that I could never have afforded, never get a reservation at or have the confidence to go to myself. I wanted what Paulina had—access to that life. And she was relaxed. She couldn't care less. I wanted Paulina's irreverence and I wanted the doors that were opened to her.

Experiencing Paulina's energy, I surmised that in order for me to have a high profile, I would have to appear on the cover of *Sports Illustrated*. Paulina had done it and it had made her a household name. My thoughts whispered, "If she can do it, then so can I." Plus, I knew that I had a notable body with full boobs and long legs. I was lean and in athletic shape. When I looked in the mirror, I could see that I had potential and I might be able to wing it.

Together, Paulina and I went to see Jule Campbell. Feeling nervous, I walked into her office for the casting of *Sports Illustrated* and introduced myself. She asked to see my portfolio, which I kept in a large black magazine-sized book. It was filled with images from fashion shoots and campaigns, all expertly compiled in plastic sleeves arranged by the agency. But . . . Oh no, I'd forgotten it! Unperturbed, Jule said she needed to see my figure. At that point I didn't know what to do. Sensing my opportunity slipping from my fingertips,

I seized the moment, undressed and stood naked in front of her. I got the job!

Jule was the woman with a vision and had an extremely influential position. She was the senior editor at *Sports Illustrated*. In the business of a sports magazine that was made by men for men, she had found a niche for herself. Jule Campbell had redefined *Sports Illustrated*. She was responsible for a large percentage of the magazine's revenue; it was her swimsuit issue that generated enough to finance the rest of the year. And she took it very seriously as it was a remarkable money maker. She worked in an extremely sexist environment, which she forged her way through as a force to be reckoned with. What Jule says goes! And all those guys in suits were taking direction from a woman. That in itself was huge. My first impression of Jule was that she was a formidable woman, a force to be reckoned with. A powerhouse.

When Paulina and I found out that we were both booked to go to Australia on a shoot for the 1985 swimsuit edition of the magazine, we were so excited. I was looking forward to going home and spending time in Oz with Paulina, and thrilled to have been asked to shoot for the edition. When I arrived, she was already there and had been shooting a few weeks. She was the star and last year's cover girl. The weather should have been warm as it was coming into summer but it was freezing. We started out in the chilly desert of the Kimberley in Western Australia. And we were in bathing suits! We both ended up getting sick as dogs with the flu, and travelling huge mileage from shoot to shoot feeling crook. We went all over the country to beautiful locations such as the Pinnacles, north of Perth, Kangaroo Island off South Australia, and Uluru in the big red centre. I loved being back in Oz, I loved being home and I loved visiting parts of Australia I'd never seen before. How ironic that I had to leave Oz only to come back and visit the magnificent country most people only dream of seeing.

I worked really hard and did what was asked of me. One day I was painted for fourteen hours straight with Aboriginal Australian markings. I wore a pair of high briefs and had my hair pulled back in a severe bun while the make-up artist, Joanne Gaire, painted my naked body with the rich earthy colours of brown and ochre. She used real clay from the earth so the paints looked authentic.

Then Paulina shows up. She's wearing a teeny-weeny triangle bikini. She's the goddess and I'm the warrior with the big spear. I couldn't help thinking, I'm never going to get on the cover of *Sports Illustrated* dressed like this. I was often getting the statuesque, unsexy shots. Jule loved Paulina and, of course, we did doubles together that showed I was twice her size.

In my fantasy head, before I left to go on the trip I'd assumed I would get the cover because I was Australian. But when we got back to America, that February—boom!—Paulina is on the cover wearing a gorgeous blue sparkling bikini, a bikini that I wanted to wear. I felt like the girl at school who hadn't been allowed to shine; the girl at ballet class who didn't get to wear the tutu.

Paulina said to me, "Elle, you have to pay your dues. They never give it to any girl in her first year. Nobody gets to be on the cover first time shooting *Sports Illustrated*. But you should have got the cover because you're an Aussie and the Australian sweetheart. It would have been perfect for you to be on that cover and it didn't seem right that you weren't. You have the body, the looks and the recognition. You worked so hard for it."

Deep down, I felt the frustration. But also I felt really driven by that longing to excel and achieve. I swore there and then that I'd aim for next year's cover.

And I did. When next year's cover shoot loomed, I strategically, purposefully prepared myself before the shoot. I went to the

Bahamas and got tanned and in shape. Being that young, it didn't take much, and my genetics helped a lot. I wasn't versed in wellness back then. I guess I equated it to fitness. So I ran the beach every day at sunrise, swam in the afternoons and did various body workout exercises, like an athlete preparing for a tournament. I was ready to go. I ate healthily—a hearty breakfast, salad for lunch, fresh fish for dinner. Lots of sleep and quiet time. I was slim, toned yet not too skinny. Often the other models would get too thin before the shoot; maybe they ate, maybe they didn't, but mostly, it seemed, they thought you had to be skinny to look good in a bathing suit. I purposely put on a bit of weight so I was voluptuous but lean.

On the plane to Tahiti, I ate well, slept as much as I could and drank lots of water so that by the time I arrived at the location, I was ready to get started and in great shape mentally, emotionally and physically. In contrast, a lot of the girls were exhausted when they arrived, as they'd worked up until the day they took the flight. Also, they would be coming from the middle of winter. So by the time they got there, they had to try to tan and mentally prepare themselves. And I knew it. When I saw them get off the plane, I said to myself, "I've got this."

The shoot took place in French Polynesia. While it was running, I didn't really see what was going on with the other models as I was too busy focused on my own stuff. I was head down, bum up at this point, and trying to figure out what was right for the job.

At the start of the shoot, I lamented to Jule, "Girls with brown eyes don't get covers."

"Why would you say that?" she asked curiously.

"I've never seen a brown-eyed girl on the cover of a magazine," I replied. "I've been told since I came to America that I would never be a cover girl because I have brown eyes."

She looked at me and said, "We'll see about that."

"Do you really think it's possible?" I asked.

She looked me straight in the eye and said, "I believe anything is possible."

Her words rushed through every cell of my body, energising me right to my core; a truth rush that gave me the confidence I needed. I believed I could make a difference to the shoot and contribute. I had learned my lesson from the *Glamour* shoot in St. Barts when my lack of confidence had undermined me. Now, I was totally committed. I had prepared impeccably. But it was more than that. My willingness was strong, I valued what was in front of me, valued myself, and I fully embraced the opportunity. This was my chance to be the best possible version of myself.

I spent a lot of time talking with Jule. I worked with the other girls. "Now, who wants to go out there on the rocks, barefoot with the wild seals?" the photographer would ask. "I'll go," I'd reply courageously when the other girls cried, "I can't do it." When the photographer was lugging camera equipment around and needed a hand, I was happy to lend one. I was supportive to the team on shoots, helping out as much as I could. I learned to be patient; not to get upset when things were not going smoothly or when I didn't get to wear the teeny-weeny sexy bikini I wanted, or to shoot in my preferred location. I learned to be flexible, except when it would compromise what really mattered: quality and professionalism— mine, or the outcome of the shoot. I learned to remain mindful of what was actually required.

I fought for that cover because I wanted it. I wanted what Paulina had; I wanted that for myself. I wanted that recognition and I was willing to work really hard for it. That was the entrepreneur in me.

I got the cover.

I almost couldn't believe it when I was shown the magazine. My first *Sports Illustrated* cover. It was 1986. The cover was of me in a one-piece turquoise bathing suit, with the byline "Paradise Found." It was taken on Bora Bora, in full sunlight in the middle of the day. The only way to get sun on my face without the shadows was to put my head back. I closed my eyes to keep the sun out of them. I pinched the bathing suit really tight so it barely covered my breasts, and I pulled it down so I showed their fullness while my nipples remained hidden. I did the best I could with that bathing suit. I didn't think for one minute that it would make the cover.

Disappointment was what I felt when they first showed it to me. I learned that being on the cover of *Sports Illustrated* was one thing; liking the images was another. I didn't love that shot. I thought, you don't even see my face; I could be anybody. Now, years later, I look at that shot and I see it for what it is—gorgeous. Now I appreciate it.

Hoping I would get the cover was not the same as really believing I would get it. It's a different feeling. And it has a different effect, inside and out. Confidence enabled me to really believe. When you completely and utterly believe, it's compelled to manifest in your life.

What an empowering lesson. And all of this would not have been possible without the support and guidance of Jule. Having no girls of her own, I reckon Jule considered the models as her own daughters. I know that she loved every one of us. She took us under her protective wing and mentored us in our careers as well as in our growth as young women. She was an amazingly gifted and strong woman who powerfully influenced my life. She helped me build my character, just as Bethann had. She said to me, "Elle, when we first photographed you in Australia, you were so shy. I wanted you to have confidence in yourself and to know that beauty comes from within."

Those words became imprinted in my mind. Jule taught me that the work wasn't just about looks, it was about character; about kindness and helping people; about patience, consideration and courage. It was about being authentic. I had all those magazine covers, partly because of the way I looked but also because of who I had become. My essence shone through and was captured in photographs.

After being on the cover that year, I began mastering swimsuits for *Sports Illustrated*. I loved it and was enjoying it; my confidence was starting to grow and starting to show. I felt empowered. That lesson of getting ready for the *Sports Illustrated* shoot and it paying off stuck with me for the rest of my life. I tend to over-prepare for everything. I over-prepared for that shoot, taking a week off to get ready. The other girls thought I was nuts but I was successful in achieving my goal. I truly believe that if I had not done that, I wouldn't have been on the cover. That clinched the deal. Preparation and timing instil such confidence.

I went on tour with *Sports Illustrated* and I learned about the sponsors and advertisers who paid for space in the magazine. I learned the part that my work played in promoting their business, their products and their brands through the magazine. Once I'd grasped the business implications of the role I was in, I learned that the job was much bigger than modelling. I learned how to host and converse with the sponsors—it was important that every year they reinvested in advertising the next year. I developed a natural and keen understanding of what was critical from a business perspective. I became a valuable asset to the team, to the client, and to the result.

Up until then, I'd been working against my differences, ignoring my uniqueness. I always thought I had to be somebody else and look more like all the other models. But now, seeing value in my differences, I embraced them and used them. Instead of resenting

or regretting not being the same as everybody else, I leaned into my unique and strong Amazonian body and combined it with the "give it a go" Aussie attitude. When I embraced myself as the girl with the broad shoulders and lean hips, I started to be successful. I made a name for myself from that. I worked with my uniqueness instead of hiding it under a bushel of sameness and safeness. I was kinda ballsy, not kinda smooth. I was that raw Australian, pioneering, not-very-finessed energy. But effective. Very effective. The sort of energy Aussies have by nature.

What I learned was that looks are not like a skill you can hone and develop. You can't get better at the way you look; whether you've got brown eyes or blue eyes, or whether you're taller or shorter. You can't get better at those things. It's not like a game of tennis that you can actually practise really hard at and improve. It just is.

Nevertheless, I came to understand that you do get better in other, important ways. You get better at listening and truly hearing what is being said; better at not taking things personally. You get better at identifying what the photographer is going to need from you. And why. You get better at anticipating the required look with available light. And how. You learn how to work the angles of your body and your face so it becomes the most flattering or effective. And helpful. You get better at doing your hair and make-up so you look your best, and you get better at the way you dress. You get better at presenting yourself in more useful ways that make the job easier for everyone and ensure the success of the shoot. You get better at understanding the dynamics of a set. You learn how to work in a team. You learn how to create powerful images. You do get better at confidence. You get better at all this through practice.

Yet in the beginning, there were humiliations. That feeling of not knowing, not understanding. How I learned was by trying things and

seeing if they worked; asking questions, observing others, watching—always watching and experimenting. Trial and error method. But I turned the errors into wisdoms by learning from them. Now I know there is no such thing as a mistake as long as you learn something constructive and supportive from your experience and put that learning into practice next time. I now understand that the only real mistake is refusing to learn.

Originally, I just gave things a go. I wanted adventure so I could learn adaptability and gather experience. Then I practised my learning on what I could change. I was a fast study, always looking to apply what I learned and what worked and what didn't. Which angles, what feeling, big movements, subtle movements. I constantly used trial and error to find out how to be better at whatever I was doing, regardless of how I looked.

Being a successful model in the industry requires much more than knowing how to pose. It's about how you understand the dynamics of the set, who you spend your time with, your attitude, what you talk about. It's about how quickly you get changed, how quickly you understand and adapt to what the photographer wants. You have to be intuitive and you have to understand what they love, the feeling of the energy of what they want in their photographs, what they want the final images to convey.

One photographer I worked with often, Bill King, loved jumping shots. I studied every one of his photographs. I discovered the exact point when he took the picture. I noticed how far the legs were apart; if the face was looking at the camera; how far the neck stretched; how the hair was flowing. I analysed his photographic style so that I could recreate it quickly. So as well as a fast study, I was an intentional learner. Every photographer I worked with, I would scrutinise their work. I would find all the magazines I could in which it featured; not

easy at that time when there was no easy access to the internet. I'd ask my agency what kind of pictures each photographer liked to take.

Cutesy girl was not me. I couldn't do come-hither eyes and I didn't think of myself as a "pin-up-sexy girl." I was a "what-you-see-is-what-you-get girl" and it turned out that people found that very appealing. I had this way of being sexy without being overtly sexual. I was sexy because there was a bold Aussie rawness to it. I would stand naked as if I had clothes on. I was "Here I am." I was different. And I was productive to work with. Photographers liked it.

Mine was a combination of girl-next-door and "six-foot-tall, strong, natural goddess sporty girl." Nobody else was like that. I developed my own style which showed strength and presence. I would counteract everything with a huge toothy smile that was disarming. I smiled while I walked the runway. And I smiled all the way because I was so nervous. But nobody knew that. I played it to my benefit.

I trusted that, by appreciating and working with my unique qualities, I'd carve out an equally unique place in the modelling world. Time proved me right.

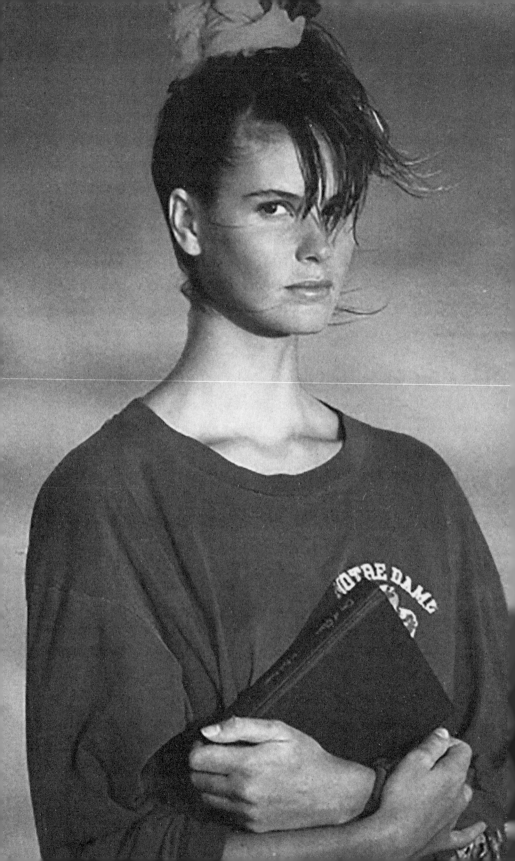

6

GILLES

Le moment de vérité

Gilles Bensimon brought out the goddess in me. He captured my essence and my heart.

He said to me, "Elle, this business is run by women, for women. Do not go to work looking to please the men. Please the women. Now, you have this incredible body. Don't go with a low neckline that shows cleavage. Wear a white T-shirt, grey T-shirt, navy blue T-shirt, navy blue sweater, burgundy sweater, blue jeans, loafers. Hair up in a bun, hair up in a ponytail. And no make-up. Chic."

"Don't threaten other women," he'd say. "Don't show what you have. Don't try to be sexy and seductive. Listen to other women. Compliment the stylist on what she's wearing. Notice the details. How does she dress? What does her face look like? What does she like? Go with a book, read. When you are spoken to, listen. Don't speak until you are spoken to. Don't try to be too much of a personality. Take a step back and be subtle."

"Elle, you walk into a room and you stop the room. You don't need to do anything. Don't do anything—because, heaven forbid, if you do then it'll just look like you're trying to show off and you're trying to take the attention away from other people."

Gilles had the whole picture clear. He taught me how to harness the power of sexuality so that it wasn't threatening.

I first met Gilles in 1983. We were shooting for *Elle* magazine in Tahiti. Gilles was the star photographer of *Elle* and later became its international creative director. He wasn't very happy with me at the time. I'd had a problem with my visa and arrived two days late. Usually, you get picked on by others on the shoot if you arrive late or cause some other kind of delay, or if you're not in great shape, or you're rude or difficult to work with. There's a lot of money invested in you and people are relying on you too. So if you don't make your flight, you're not very popular because they're expecting to shoot and there's a whole team waiting for you to arrive. It was expensive to send a team abroad so we had to show up on time and deliver. People bond on those trips in the first few days and I felt uncomfortable arriving after the other models. Again, I felt like I didn't fit in. If you arrive a week late at school, the kids have already made their friends, and it was a bit like that.

We were shooting on the beach. From the first moment I saw Gilles, I found him charismatic and mysterious. I was trying to do a professional job but I didn't really understand what he wanted. I would do too much, try too hard, and he would tell me, "Stop playing to the camera."

I didn't know I was doing that. I had picked up a lot of bad habits while modelling for TV commercials. I was doing cheesy expressions.

He would say to me, "Non non non, not that face, MacFierce. Encore plus vrai. Make it real. No fake shit."

Though I was trying to look *Vogue*-ish, my expressions were stern, so stern that he gave me the nickname "MacFierce." Maybe it was a challenge to see if I would then rise up and give him exactly what he wanted—the natural, real look. I can see now that I wasn't calm and collected within myself. "*Encore plus vrai*" . . . I needed to make it more real. Which was difficult because I didn't feel worldly, expert, practised; what I thought was needed to be a true fashion model. I wasn't centred or balanced. At the end of the shoot, I went back to New York knowing I had a lot to learn.

A short time after this, Gilles started to woo me. It was not long after I had moved into my apartment, and Paulina was living with me at the time. Gilles sent me gifts. He sent me beautiful clothes from fashion designer Azzedine Alaïa. One day an incredible flower shop arrived. I say flower shop because I'd never seen so many roses. On another occasion, he surprised me with a visit and brought with him a bottle of the best French wine and caviar. We sat on the floor of my apartment and talked for hours while Mephisto, Paulina's cat, licked the remains from the tin. Spoiled kitty!

I was hesitant to get involved because I didn't want to be hurt. He was much older and I wondered, what is this guy going to see in me? So in the beginning I was protective of myself. I knew in my heart that if I became involved with him, it would become serious and I could not mess about. He was a real man and you just don't play around with a real man. You don't just have a fling with someone like that and not mean it. Either you're in it or you're not.

I wanted to overcome that feeling of insecurity in a relationship with someone who was more experienced and worldly. I didn't know how to handle many kinds of situations; I often felt naive because I didn't know what to do. I felt like I was constantly on the back foot. I didn't speak French and I didn't feel sophisticated. So I knew

if I went down that road with him, my naivety and perceived weaknesses were going to be exposed.

Since my time with Billy Wirth, I'd been working non-stop and didn't really have any time to be with guys. I wasn't interested in dating. I wasn't meeting people my own age. I would meet photographers, people in the fashion industry, sometimes male models, people in the film industry, restaurant industry, real estate and travel people. But none of them caught my eye. Gilles had caught my attention as he was talented and charming. I was captivated by him. For a while I pushed him away but he was persistent. I was flattered and intrigued.

We started spending more time together and I increasingly found myself wanting to be with him. Gilles fascinated me and he challenged me. He was also tough. He didn't speak much English and I was mortified that I couldn't communicate properly with him, couldn't articulate my feelings or express myself in the way I wanted. My French was schoolgirl French, which made me feel even more disconnected. I decided I was going to learn to speak the language fluently. I was extremely impressionable and longing to learn so I asked him thousands of questions.

Not only did Gilles not speak fluent English, he didn't even speak French. He spoke "Bensimonian"—a language in itself; his very own parlance. It's just the way Gilles Bensimon speaks. He starts off with one train of thought, goes into another, and finishes with yet another; half-English, half-French—Franglais. If you don't understand who he is, you cannot understand his patter. Many people don't understand a word he says. I would interpret his French for other people because I knew he was talking about three different things all at the same time. He would begin one story and finish another and I would fill in the gaps. I think he enjoyed the playfulness and fluidity of it.

I was very intuitive and authentic, and that was quite disarming for him.

I loved everything about French people and their culture. I began to understand their subtlety and panache. I loved their exuberant immersion in beauty and creativity, arts and attention to detail. I just loved it. And I also think that, for them, I was a curious mixture of refinement and rawness; an unusual quality they couldn't get a handle on. Gilles mentored me in all the appropriate ways—how to be and what to do, all at the correct times. I began to dress like a French girl and I appreciated French things. But I wasn't complicated. I was still an authentic Aussie, kinda in-your-face-brash girl.

A part of me felt that being simply Australian wasn't enough when living overseas. Part of my inferiority complex when I first started out as a model was about being unworldly. I felt that I wasn't sophisticated because I was from so far away. I was proud to be an Aussie, but when I was a young adult I was desperately trying to be something more. Even though I was considered an Australian icon, I sought more depth, another layer. That became the French layer.

Gilles would teach me by giving me French versions of familiar fairytales such as Hansel and Gretel, Snow White, and the beautiful Hans Christian Andersen fables. It was possible for me to read them in French because I knew the stories and could deduce words and sentences using the limited vocabulary I was picking up from Gilles. I started to learn the words phonetically, simply listening to how they sounded. Over time, I took on more and more difficult challenges. I graduated to reading Marguerite Yourcenar. My favourite was *Mémoires d'Hadrien*, the story of the second-century Roman Empire under Hadrian's rule.

We would always listen to French music and I would learn the lyrics. I would also concentrate on long phrases in French; I would

listen to them over and over again and Gilles would translate them. It was survival. I knew that if I wanted to have an equitable relationship with this man, I had to learn his language. I also knew that if I wanted to be able to communicate with the people I was working with in Paris, and to be taken seriously and to be able to express myself fully, I had to speak French fluently. To me, it was imperative. It was bigger than me. I was driven and I was in love. When you're in love, you're motivated. I learned the language in six months.

And I loved being with Gilles. It was like an education—a Pygmalion story, to some extent. He taught me how to be a really excellent model and that meant everything.

He taught me about art and music, literature and French.

He taught me how to dress for any occasion; how to appreciate food and how to choose and identify wines; which wine to drink and when.

He taught me how to work most effectively in the studio and on location.

How to talk to people.

He taught me the importance of teamwork.

He taught me how to write a thank-you note. To this day I take the time to handwrite notes expressing my gratitude and thanks. It's important to me. I've taught my children to do the same, and it's become important to them, too.

He taught me how to be with people in any situation.

He taught me what the dynamics were with fashion editors and what fashion was about.

He educated my eye on editing photographs, layouts.

He taught me composition, style, aesthetics.

Gilles taught me how to be a woman; what it meant to be a woman.

He taught me how to work with other women so it wasn't about competition.

Yes, he did teach me how to pose. Chin down, focus, lift up your eyes, not too far in the air, smile slightly, open your lips, look to the left, further down, not the corner of your eye, shoulders back, gentle eyes.

And he would continually speak to me from behind the lens. Eventually we knew each other so well he would just make little signs behind the camera and I knew exactly what he meant and what he wanted me to do. So we had an unspoken language. I watched him intently when he was working with other girls and I learned. I saw what he captured because I edited with him so I saw thousands of pictures. It was the most remarkable education and I loved it.

Having said that, I realise I also taught Gilles along the way. People often thought he was a father figure to me. In fact, in many ways I felt I was the parent with my strong Aussie attitude, encouraging him to be more spontaneous.

Back then, photography was analogue, not digital, and film couldn't go through the X-ray machine at the airport without risking damage; it had to be hand-carried. Photographs were taken on 35mm or medium format cameras shooting on transparency film. After processing, images were individually mounted into slides to be scrutinised on a light box. Only the best would be selected. You had to have a really strong stomach to edit your own photos because you'd see a lot of awkward shots, expressions, angles. But you learn where you're good and where you're not. I saw so many images of myself and I found that Gilles loved the ones with natural movement, not the fierce expression or fake attitude or the forced affected pose. He sought images that had a symmetry to them. The ones that had a feeling. He would always say that in photography, "Look first."

Actually, I've found that to be a wise philosophy for life. I think of it as, use your heart as a compass to decide what to do, then give it to your head only to figure out how to do it. Train yourself to identify your heart messaging. See it first, then capture it. Train your eye. Educate yourself to see—to truly see the simplicity, authenticity, the beauty. The real. And only then, act.

For Gilles, photography was creating art, like doing a drawing. The fashion he was shooting was the focus and the star, not the model. The colours, the composition, the angle, the detail, the movement . . . the photography. The final image was the ultimate medium to show what really mattered, the real hero. It was as though the more you could be selfless and work for the common good of the image, the better you were, the more desirable you were. The more successful you became.

I loved his work, particularly as Gilles actually liked photograph-ing girls who were not too skinny. He always made us look beautiful. He liked a girl in a denim shirt, a lace bra, and you could see a cleavage and freckles on her chest; sexy, effortless. She was natural and there was a strong sense of femininity about her. He captured the moment, and time and again he said to me, "Elle, I'm always looking for *le moment de vérité*"—the moment of truth.

He taught me to know my place in a photograph. He taught me to also consider the image, not from my point of view or even his point of view, but from the point of view of an art director. He taught me to be real. He taught me that you don't have to always smile, it is perfectly fine to look away from the camera—to be present and to command the presence without having eye contact, or even to not have your face exposed in the shot.

On one of my covers for *Elle* magazine I had a fringe, was wearing sunglasses and a turtleneck—and all you could see was my mouth

biting my lip. Exasperated, I said to Gilles, "But you can't tell it's me." And he replied, "It's a bold picture. Who cares if it's you? You're part of a strong image. And besides, the subtlety of the lip bite is what everyone will remember."

There was no place for egotism with him and that was extremely healing for me. It allowed me to excel in the very area I was self-conscious about—"What if they truly see me? What if I'm not as pretty?" Because it was never about me, it was about the image. I was in heaven. Even to this day, when I look at photographs of myself, I look at the essence of the shot.

Is it a true movement? Is it honest; authentic? Is it strong?

I would look at it from a very detached perspective. Gilles taught me to see the industry as an industry and photography as an art form. He helped me develop my art director's eye. He helped me de-personalise my images so I was not only looking at me, I was looking at the image and its purpose. He valued my fresh perspective on things.

Also, I loved photographs in colour. They reminded me of home, maybe because Australia is full of bright colours. And Gilles shot colour beautifully. He used the Fuji film that was very good specifically at rendering blues. He photographed a lot by the sea. His blues were rich and radiant. You always knew his pictures because the sea wasn't just blue, it was fifteen shades of blue. He used Ektachrome for sunsets because it rendered warmth so well.

His photographs were deep and rich. They were striking and I loved being part of them. I felt emboldened being in them. Bold, strong and graphic, eye-catching. And it wasn't bullshit. It wasn't fake sexy. Those images made me feel present and strong. That was a beautiful gift he gave me that has stayed with me all my life. I have always preferred those kinds of photographs. When I look at the shots of

me that I love the most, they are all really natural. My eye became educated.

In the early stages of our relationship, we'd been fighting along the way because I think I wanted more—not more commitment, I wanted more recognition from him. I wanted to know what he really thought of me. I think I wanted things spelled out, but he was a very subtle man and I didn't understand him at times. The French have their subtle ways. He wasn't like a young, cute boyfriend going, "I love you. I want to get married." It wasn't like that. He spent all his time with me. Every day he would write me a postcard on which he would do drawings and in his beautiful writing he would script an endearing poetic sentiment. Art masterpieces in ink and watercolours or crayons or whatever he could find. He still sends them to me, now in digital form. Postcards from Gilles. A gifted artist from an artistic family; he'd always been surrounded by visual stimulation. He's a photographer and he loves drawing; he still draws and paints all the time. Years later, my dad returned some of my own postcards I had sent to him. Heartfelt snippets of my life evolving.

Two years later, in 1986, I walked down the aisle by myself, much to the dismay and disappointment of my dad and my stepfather. I couldn't choose between the two of them. I loved them both and didn't want to disappoint either one. And, I wanted to declare my independence. I was determined that nobody was going to give me away. I was marrying of my own free will. In hindsight, I now realise I could've had them both walk with me. I understand that regret is harmful to us, quietly damaging the heart over time, but I do wish I'd handled that situation more thoughtfully, with more wisdom.

Gilles and I were married in a little town called Dhuizon, in France's Loire Valley. My wedding dress was handmade specially for

me by Azzedine Alaïa. It was beautiful. It wasn't like the fairytale princess traditional wedding dress. It was white, long to the ground with a small train, tailored to my body shape. It had long sleeves with an elegant hood in place of a veil and was laced up the back like a corset, yet was fluid. It was incredible, and iconic. It was also sort of rebellious, irreverent and unexpected. We had asked Azzedine to create it because he was our close friend, not to mention the number one couturier in the world at that time. I loved the dress he made for me. I think my mother had other ideas of how a wedding dress should be.

The wedding guests included celebrities and people from the fashion industry. The ceremony was in French. I wasn't involved with the planning, it was all kindly arranged for us by the wives of Gilles' three brothers as he and I were on the road working all through the lead-up. They wanted the wedding to be traditionally French. It had to be the French way, the cultured way.

I wanted an Aussie barbecue reception and they said, "We don't do that in France."

I shyly asked, "Can the ceremony be in English?"

They replied, "We are French. We don't speak English."

It was fine for me because by then I spoke French, but my family didn't so they were left out.

My dad was asked to sign the register and they didn't even get his name right. It was terribly disappointing and downright embarrassing. I knew it hurt my dad and I didn't know how to mend that. I didn't know how to cope with any of it and, worse, I didn't know how to stand up for myself. Everything Gilles' family said, I did, because I thought they knew best. I wanted to be a grown-up. I did the same thing my mother did. My mum rebelled by having me at eighteen and I rebelled by getting married at twenty-one. That was my

independence and freedom call: I was going to be with my husband, have my own life and make my own rules.

We went to Marrakech on our honeymoon and within twenty-four hours Gilles wanted to leave. He didn't want to be there—he felt depressed and restricted. We didn't know how to have a good time together, we only knew how to work. I was so nervous about doing the wrong thing and I think he felt trapped that he had married this young girl who didn't really know much about life. We flew back to France the next day. I was so disappointed but I didn't dare show it, so we never really talked about it, just sort of swept it under the carpet.

Even so, I loved that we'd started off our lives together flying economy from New York to Paris and, in the end, we were flying Concorde. We grew together and we evolved. Our business evolved. He became more renowned. I became famous. We worked a lot with French *Elle* and then we decided we would bring the magazine to America. Everybody said it would never work. There's *Vogue*, *Bazaar*, *Glamour*, *Cosmopolitan*. There's no room for another magazine.

Gilles said, "We can do it, MacFierce." And of course it took off like crazy.

We lived in a brownstone on Ninth Street between Fifth and Sixth downtown New York City with the publication director and founding editor of *Elle* magazine, Regis Pagniez. Regis lived on one floor and Gilles and I lived on the floor below. We basically all lived together. I learned so much about magazine art direction. Regis treated me like a daughter. He mentored me on everything from photography to editorial content, cooking and art, philosophy and fashion—all mixed with a healthy dose of humour. I loved him dearly. We would put the magazine together on the floor, spreading out the contents and creating the page layouts. The guys would ask, "Do you like this picture? Why don't you like that story? What will work best on that

page?" They liked my opinion because I was young and I had a fresh visual sense. I knew what I wanted to see and what I thought young people wanted to see.

At the same time I was working for *Elle* magazine, I was also shooting for *Sports Illustrated*. But my main focus was on *Elle* with Gilles. He and I travelled the world and we were a team. I loved it. I always wanted to be a team. It was a highly stimulating time and I think it really shaped my wish to partner with somebody in business. For a time, Gilles and I were actually a very complementary couple. Our life was filled with work, photography, art, travel and adventure. My whole being came alive and I was happy and fulfilled in an enriching and enlightening marriage.

Being married to Gilles saved me from the '80s craziness of nightclubs, drugs and alcohol. I didn't do the things I saw other girls do. I didn't have the celebrity boyfriends. I didn't get drunk and throw up in my Hermès handbag outside Les Bains Douches. I kept my head down. I was working. I was learning and I excelled. I was making money. I was evolving and I was creating a foundation for my life that had substance.

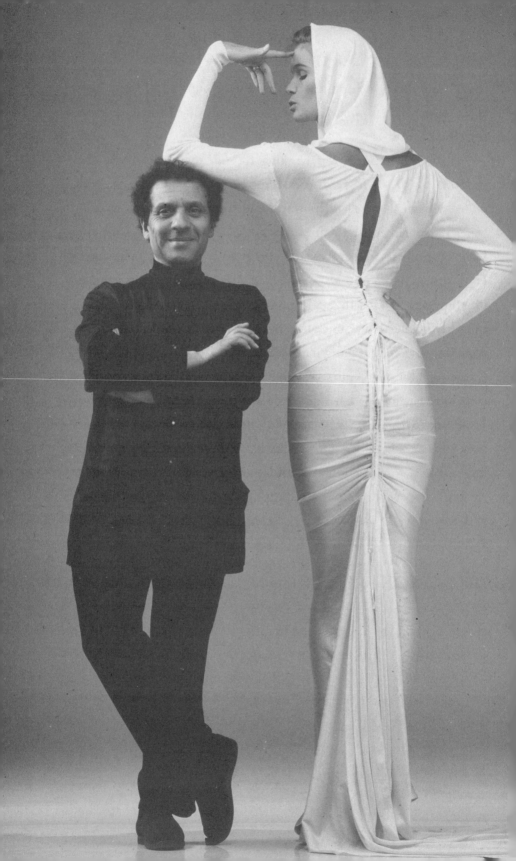

7

RUNWAY

Your uniqueness is
your superpower

One of the defining factors of being a supermodel was diversification.

When I first arrived in America, runway girls were a breed all of their own. They walked the runway and that's about it. But with the birth of the supermodel, we found girls walking for the highest-profile, most acclaimed designers like Chanel and Jean Paul Gaultier. Azzedine Alaïa and Gianni Versace took fashion and runway into new creative realms, dressing the girls in form-fitting sexy clothes, part rockstar, part statuesque deity; always glamorous and effortlessly cool. Models replaced movie stars as the new icons and Alaïa and Versace led the movement.

When I moved to New York City, having walked the runways in Australia, I was booked for designers including Calvin Klein and Anne Klein and later for Donna Karan, Oscar de la Renta and Ralph Lauren. In those days, shows were held on the floor of the designer's showroom and were really for buyers to preview the next season's collection.

I always found the shows in Paris extremely nerve-wracking, particularly Azzedine's. His collections, shown in his studios, drew so much attention. Fittings for his amazing clothes went on for days before his shows, as he literally made clothes on your body. I often stood for hours with him late into the night. At fittings before a show, he would listen to Umm Kalthoum as he meticulously pinned his creations and sewed by hand while I showed him where I wanted them to fit tighter, looser. When show day arrived, I felt that each outfit was truly mine and that I'd helped create it. Which of course wasn't the case because Azzedine was a genuine artist and nobody could create as he did nor contribute meaningfully to his genius.

One of the first shows I walked for Azzedine was before I married Gilles. I had been working shows back to back that day and had just finished runway at another fashion house. When I left, I went immediately to Azzedine's. I arrived at the last minute and rushed to get ready, then sat at the dressing-table mirror staring back at myself, trying not to look anxious. I panicked any time I had to do my own hair and make-up as I never thought I could do either professionally, even though, when I'd first started modelling in Australia, I used to do them all the time. I looked over at the girl next to me getting ready. She must have felt me staring as she said, "What are you doing?"

"Oh, nothing," I shrugged. "I was just looking at the shade of lipstick you're wearing for the show."

I often got it wrong—the wrong lip colour, the wrong lip shape. And then I'd smile so wide, I'd get lipstick on my teeth. I was frequently saved by the make-up artist who double-checked my face before proceeding to tackle my tresses.

At that time, hair was big. And I mean BIG. That morning I had teased my hair at the root, after it had been set in Carmen rollers,

making me even taller than six feet. I loved that, and yet, along with Azzedine's six-inch heels, it made me look like some larger-than-life goddess. I remember thinking, I'm not sure I can do this. I walked out into the back-stage passage petrified, peeped through the curtain and saw the fashion elite staring back at me. Of course, it wasn't me they were looking at; they were anticipating Azzedine's incredible designs.

After prep, the show was about to start. Backstage was frantic as the models hurried to get ready before joining each other to walk out onto the runway. Linda Evangelista, Christine Bergstrom, Naomi Campbell, Yasmeen Ghauri, Elaine Irwin, Veronica Webb, Michaela Bercu, Gail Elliott . . . the big names at the time were there, lining up in the first outfits, and I stepped into line with them. As I held my breath, I could feel the music vibrate through the electrified air. I remember trying to look elegantly detached but shaking on the inside. I watched Azzedine walk down the aisle back stage, straightening, pulling, adjusting, rearranging the clothes on the models.

The line producer pushed the models one by one onto the stage. As I reached the front, I let out my breath. There was a sort of hush behind the music. Everything seemed to go into slow motion and then the music rushed forward and blared. The lights shone in my face and I was jolted back from my panic. I was about to take my first steps when suddenly my confidence wavered. I'd practised in front of the mirror, studied the best like Naomi, and had taken some lessons with runway coaches. But now my shoes felt so tight, my heels so high, and I worried about waddling, falling, missing the beat of the music, missing the experienced-model walk; that special way we were taught by each other.

I stepped onto the runway, one foot in front of the other like walking a tightrope; legs crossing each other like stitching the catwalk.

Eyes straight ahead, hips swaying and arms slightly swinging, but not too much. A purposeful, confident walk to the end and then turn straight back down without missing a beat.

The trick was not to catch the eyes of anyone in the audience. I hadn't mastered that part and unfortunately I winked at someone. So not done! I saw people noticing and a mixture of self-consciousness and fear washed over me. I smiled nervously, looking around for a reassuring eye, making my runway walk seem either more personal or less professional, depending on your perspective.

But I didn't know how to do it any other way. I tried to walk the rest of the runway all composed, and as soon as I got to the end I exited, turned the corner and ran to my station. As I hastily took my clothes off, I tried not to show myself, but it was impossible. My assistant was lacing up my corset and helping me to dress in my next outfit. I had one shoe on and one shoe off as the hair and make-up artist was trying to do retouches.

"Elle, Elle, where are you?" I could hear a French accent calling my name. My heart was pounding as I raced to the line-up and struggled to put on my other shoe without falling over. I quickly checked myself to make sure my clothes were perfect then took another deep breath and turned the corner onto the runway again, walking as gracefully and professionally as I could, like I owned it.

I swore there and then that this would be my last walk. "I'm just not made for this," I said to myself. It was bedlam and I was stressed. I felt awkward and uncool. My hair didn't look like all the other girls' hair. And I had that stupid grin on my face that I couldn't, for the life of me, stop. No matter how much I tried, the nerves got the better of me and I smiled all the way down the runway. I thought I wasn't as professional as the other models. As it turned out, people loved my walk because it was unique, unusual.

As I'm taller than most, my gait is long. When I take a step, it's like two for the average person. My walk comes with a swing and roll of the hips, and my arms, also longer than most, often swing too high— part gangly teenager, part femme fatale. Learning to contain this natural movement to a refined, elegant walk took time. But I listened to my inner sense and was determined to embrace what runway was teaching me. In time, I improved and perfected my catwalk.

I learned to make the most of the outfits I was given and to make the clothes work for me, especially when I had the skimpiest clothes or the long coats the shorter girls couldn't wear successfully. I prac- tised my hair and make-up and, having watched the other girls time and time again, I became capable and skilled.

Azzedine paid us with clothes. After each show, the girls would flood to his little studio shop and raid the outfits because everyone wanted to be dressed in his remarkable creations. I was always too polite, never wanting to take too much. Not choosing the leather, the furs or the suits, while others stripped them off the hangers and stuffed their bags full. I wanted to be moderate, a little subdued. I don't know who I thought would notice or why I was so concerned about not looking greedy. I longed to wear Azzedine's outfits like all the other girls, but something inside me prevented me from acquir- ing a complete wardrobe by ransacking the showrooms. Afterwards, I always regretted it, as I had the time I was too proud to accept Ford's offer to come and work in America. I was too proud to snag all the expensive clothes. I guess I wanted to be modest. But who was going to notice?

Azzedine's shows were like no other. Often he did three in a day. They were super prestigious and watched by the most important people in the industry. The clothes were original masterpieces and only the best girls were chosen. Unlike the strong, confident, elegant

assuredness of Azzedine, other shows were more untraditional, such
as those of Jean Paul Gaultier or Thierry Mugler. Theirs were enter-
tainment; huge productions in theatres or on the street or platforms
with blaring music resembling a rock concert or dramatic dance show.

I usually found those shows easier because being on a stage
with the lights shining in my eyes, I couldn't see the faces and the
expressions of the audience. I found myself playing a character, often
wearing wigs and outlandish clothes so that, in those moments, I was
able to disguise myself and my self-consciousness.

Though I found the concept of being pedestalled quite abhor-
rent, requiring me to walk high above the audience on a raised stage,
in private shows like Azzedine's I found it was way more difficult
to hide. Being face to face with the audience demanded I portray a
confidence I didn't feel; a level of experience that I didn't feel I had;
a self-assuredness I only dreamed of; an elegance that I didn't yet know
and hadn't quite mastered. I was a girl playing a woman and I thought
it was obvious to one and all. That sense of being an imposter plagued
my peace and confidence. It was always there, lingering.

One of the models I became friends with in Paris was Farida
Khelfa. After we worked an Azzedine show together, followed by a
wine-infused lunch, we ran down Rue de Rivoli laughing our heads
off. Farida had grabbed a scarf from one of the street vendors and
wrapped it around my neck, saying, "Now you're a real French girl."
We ran as fast as we could after stealing that scarf.

Farida taught me verlan—back-to-front French street slang. It's a
language all of its own. Verlan is when you take the last syllable of the
French word and you put it in the front. So if in French you wanted
to say the equivalent of "Don't get caught by the *flic* [the cops]" then,
in verlan, you would say, "Don't get caught by the *keuf*." Just changed
back to front. I like to think of it as fun, bilingual mental gymnastics!

In the suburb outside Lyons where Farida was from, verlan was the language on the street. It was double slang. Slang on slang. Everybody laughed because I was one of the few models who attempted to speak French. And not only did I speak French, I spoke double slang. They also laughed at how well and colloquial my ability to communicate was. I learned from the best. That was Farida! French from the back streets.

Farida would say we were friends because we were both "misfits." She felt like she didn't belong in Paris; I came from the depths of the faraway land, Australia. Neither of us felt like we belonged in the fashion industry.

I loved Farida. I loved her story, her bravery, her complexity, her anxiety, her resilience, intelligence and brilliance. I loved her style, her heart, her mind, her journey. I loved her depth of character and perseverance. Farida was a star and once again I felt like the friend of the star in Paris. She was a life force for me. Rebellious and tough. Smart and courageous, despite her anxieties. I loved our times together. We both had a drive to succeed, something to prove. We were trying to find another way to live. We were creating a new life for ourselves. But we were young and didn't know how to interact with people. We connected with each other in the recognition of that awkwardness.

Farida and I knew everybody. We were widely accepted everywhere we went, but we just didn't *feel* it. We were revered. We were in relationships with two of the most influential men in the fashion industry. I was married to Gilles, a renowned photographer, and Farida was in a relationship with Jean-Paul Goude, a respected art and film director. To some extent, we were defined by the successes of the men we were with. We were adored as their muses, but we were too busy trying to cope with life to recognise we were ourselves super successful.

We were both well known in what we had achieved in our model-
ling careers. But we didn't see fame as being important because
somewhere deep inside of us, we knew that fame wasn't success. We
knew there was more to it. We were famous, we had money and
we had power, but we couldn't feel it because we innately knew that
success was deeper, more meaningful. Fame wasn't the solution to life.
We thought we would feel better for it, but we didn't.

At the time, I felt this way because I hadn't addressed some issues
within myself. I thought I could just cram my life full of experiences,
people, places, materialistic things, so I could avoid the truth of what
made me feel so unhappy; that never-ending feeling that happiness
was "out there," unreachable. Farida and I had both come from unset-
tled childhoods. When she was fifteen, she had fled her strict Muslim
parents, going to Paris where designer Christian Laboutin discovered
her. She had never looked back since, and I didn't want to look back
either. My self-punishing notion of not feeling wanted when I was
a child always seemed to haunt me; a silent voice within whispering
that I didn't deserve success just as I didn't deserve love.

In the same way that the Universe had brought Paulina and me
together some years before, it had now brought Farida into my life.
I'm sure it was because I felt alone, was longing for a friend. My
marriage with Gilles was already becoming strained. We worked well
together but I was lonely in our relationship, yearning for commu-
nication, discussions other than around work; sharing thoughts and
feelings. Gilles was a man of few words. Few and profound. I was
longing for a deeper connection with a girlfriend and I found that in
Farida.

She was aggressive, antagonistic even, because she was so afraid
that people would see that she was scared, wary. And the funny thing
is I "saw" her. I saw Farida for who she was and I loved her because

of it, not in spite of it. She preferred to be arrogant and in a way I did too. We had that in common. We didn't make friends very easily because on one hand we were desperate to play the game, but on the other we didn't know how to play the game. So we just decided we didn't want to play the game.

Not long after we first met in Paris, I called her up and asked, "Do you want to go for lunch?"

She replied, "No. Why would I want to go to lunch with you?"

"Because I'm asking you," I said.

"Well, I don't want to go," she retorted.

"Oh well, I'm going. I'll be at Le Loti at 1 p.m."

I didn't know if she would show but I trusted she would. And she did. She walked in dressed in a man's suit designed by Azzedine. The trousers were short at the ankles and the jacket was nipped in tight at the waist and had broad shoulders. She was wearing a pair of men's brogues with no socks. Her long jet-black curly hair was pinned up in a pompadour in front that she called "La Banane," with some tresses left loose behind her ears, which cascaded down her back. The style accentuated her lean, elegant body. She had red lips and dark eyes and arrived with a furious look on her face. She made me laugh.

I said, "What are you doing here?"

"Well, you asked me to come to lunch," she flung back.

"I did," I smiled. "Please sit down. Let's have grilled fish and a bottle of wine."

"Why did you ask me to lunch?" she insisted.

I looked at her and grinned, "Why did you come?"

And that was our friendship.

Two girls could not be more different and yet I felt closer to her than anyone. I felt she understood me and I her.

During that period, Gilles and I lived in New York and Paris but were mostly on the road. I incessantly worked long hours at myriad jobs. At that time I had a beauty contract for Biotherm, a French pharmaceutical company. Unlike traditional beauty companies, Biotherm focused on beauty from a scientific perspective, which was far from the regular glamour of other campaigns. The images were clean and almost medicinal. Not at all how I wanted to be portrayed. However, the steady income from this contract gave me some financial security and freedom to explore ways of expressing myself without having to worry about income.

I longed for projects that were unusual and yet still glamorous, and focused continually on finding and creating opportunities that were outside the box and challenging. I dreamed of unusual experiences. I was always willing to try something new. Not just anything but things that resonated with me. I walked to my own beat and took each day as it came. I lived in the Now.

I took myself seriously and it was many years before I realised I could take life seriously while at the same time not take it solemnly. So I grew to be more light-hearted, light-spirited but not light-weight.

As time went by, it became increasingly unappealing to walk the runway and go to the studio. I would wonder if the clothes were going to fit or if the photographer was going to find something redeemable in me. I'd wonder if the other girls were going to be nice and if the hair and make-up artist would do something glamorous with my look. I was so critical of myself. For years, I'd continued to feel teary because I was self-conscious in front of the camera. I thought to myself, I can't keep doing this day in and day out. I found it demoralising. I had to dig deep in order to perform.

Refocusing my efforts with an open mind and an open heart, I decided to devise a way to advance and prosper without such anxiety.

Making that self-caring decision triggered my memory of seeing other people licensing their name and image. I thought, hmm, is that something I could do? I wondered if I could put my name and image to a product that was synonymous with me and make a secondary income. That way I could have an income whether I was modelling or not. The product would become the commodity instead of just me modelling. Imagine getting paid while sleeping; doing something else and still making money. Win-win!

And so I set out to create my own brand. Just as nobody was going to give me an apartment when I first went to New York, nobody was going to make me successful in business either. Only I could do that. I'd learned from past experiences that I'm the one who must get up and go get it. I also noticed that I wasn't being booked to do the jobs that some of the other girls were getting: fashion, hair and jewellery campaigns, or high-profile editorials like *Vogue*. I wasn't receiving the recognition in the same way some other girls were. I wasn't being asked to do the things I really wanted to do and so I figured it was time to create my own work.

Bathing suits were my initial idea because I had experience with covers, like *Sports Illustrated*; at that time I had three—'86, '87 and '88. Almost immediately it occurred to me that bathing suits were seasonal so you could only sell them at a certain time of the year. I did my research and found that to be true. Swimsuits were also difficult to produce—there were not many places to manufacture them, making it difficult to find factories. Many retailers didn't carry swimwear and if they did, it was for summer months only. What's more, trying to fit all body shapes is difficult and finding fabrics that can resist salt water and sun was a technical challenge.

So I came up with another idea that I had long been passionate about: lingerie.

In Paris, all the girls were shopping at Sabbia Rosa, buying beautiful sexy underwear. However, I had these Australian 36C boobs, broad shoulders, and I couldn't find anything to fit. I was always longing for a beautiful bra my size; something alluring that I could wear underneath my clothes. I thought to myself, maybe I could make lingerie that looked like French lingerie but would fit like an Aussie bra. Influenced by designers like La Perla and the Sabbia Rosa lingerie that I loved, maybe I could create a collection of beautiful underwear that women of all shapes could depend on consistently.

There's no such thing as coincidence. I was manifesting my dreams and the Universe was obviously listening. Opportunity knocked when Bendon, a successful New Zealand lingerie company, contacted me. This was in 1989. Bendon were making corsets and sensible, functional underwear. They were trying to get into the Australian market so they approached me and asked if I would be the face of their brand.

Was I really willing to take the risk? I wondered. And did I have the courage to follow my dreams with this opportunity? To pursue a business career instead of just continuing with an ongoing string of jobs that paid me for my hours spent? My gut told me that nothing great came from being comfortable. That's not where the real prize was. I knew I had to get out of my own way and my comfort zone and give it a go.

After carefully considering my next steps, I said to Bendon, "You can't afford me."

I was in a lucrative working arrangement with Victoria's Secret at the time, but this opportunity to step out of my comfort zone and create my own way forward resonated deeply with me. So I suggested

to Bendon, "What if I work with you on the design? After all, I'm longing, aching for something beautiful that fits, and you're good at making quality, comfortable bras. I'll give you ideas inspired by all my own experiences and travels, and together we will create our own lingerie collection."

So I went for it. I helped design Elle Macpherson Intimates, produced in partnership with Bendon Manufacturing. It had my name on it and I was empowered and emboldened by that. Under the watchful and wonderful eye of my manager, Stu, and with his help and support, in 1990 we launched the collection.

I first tackled the sporty styles like those of Calvin Klein: crop top and high-cut briefs; one hundred per cent Aussie cotton with an elastic waistband with Elle Macpherson embroidered on it. But what I really wanted to explore was lace, two tone, pretty French Leavers lace. Three-piece cut-and-sew balconette bras with a front-forwarding bust and no round American padding. French, elegant, sexy and cool.

People went crazy for these and Intimates became a global success.

I was one of the first models to put my name on a licensing agreement. In 1989, I was already thinking, I won't beat them and I don't really want to join them. I have to stand out. I want to do things differently so people will have reason to say, "She's interesting. Look what's she's done."

More importantly, I wanted to feel that I was making a difference; that I was using my life and my perspective of beauty and love of creativity to contribute to the lives of others; I was determined to make a positive difference. Intimacy has always been important to me. In-To-Me-See. I think it was my release from that fear of being seen through the camera. I wanted to be deeply seen but by someone I had a deep connection with. And that's why I decided on the name Intimates for the brand. In my eyes, lingerie was not about sex but

about the sacredness of intimacy. I wanted to encourage women to embrace their femininity; become empowered by their sensuality and sexuality. We are sentient, creative beings, after all.

Elle Macpherson Intimates made great bras for all different body types and that's why we were so popular. It was important to me that my designs were accessible so every woman could wear them. I made comfortable sexy bras for women with bigger breasts and smaller breasts and no breasts. We had bras that went up to 38DDD, E, F, G. They didn't look pretty hanging on racks in department stores because they were so large and they also took up a lot of space, but they looked great on. Aussies call them "Over-the-shoulder boulder holders."

Building the business meant working long hours and travelling back and forth to New Zealand where the design and manufacturing teams were. This, coupled with shoots around the world for *Sports Illustrated*, catalogues and some editorial assignments, plus shooting for Biotherm, meant that I was on the road a lot. As a result, Gilles and I were spending less time together and he was spending more time with other models on location. We were both so busy trying to create a wonderful life and our dreams that it was easy not to notice that life was all work. By the time I was twenty-five, I felt like my life was so serious. I wanted and needed a change—more freedom. I felt as though it had been all work, no play.

The Universe answered me in the most astounding way.

One day, I noticed a model had the same dolphin tattoo on her ankle as Gilles had on his arm. I didn't need to know any more, really.

I called him and asked, "Do you love her?"

He said, "Yes."

I asked him, "Are you in love with her?"

He said, "Yes."

The pain was excruciating. I burned my Azzedine wedding dress.

I burned it because Gilles was having an affair with somebody and I felt destroyed so I wanted to destroy that dress, the symbol of our marriage. I burned it in our New York bathroom, in the bathtub. It burst into flames in a flash because it was made from a nylon material. So it also stuck to the bath. Like only nylon would stick! I was extremely distraught after realising what I'd done. I got up and left our home. Where I got the strength to leave without arguing, I do not know. I just left. I took nothing except my pride. I found an apartment uptown and stayed there. I spent my days trying to pull myself together and trying to comprehend what had happened.

Gilles wooed me back six months later. We tried to reconnect but he panicked and left. The second time was also very painful.

We didn't see each other for many years after that. The weird thing is, after we separated I had no idea how to live my life without him. I remember sitting on the floor of my closet looking at my clothes and thinking to myself, I don't know what to wear. My wardrobe was quite simple so it actually wasn't difficult to choose from, and normally that saved me from a huge decision-making process. I sat there for hours staring into space, mind blank, trying to comprehend my life without Gilles. The tears fell and my heart broke. I wept long, anguished sobs as I tried to come to terms with my grief over the loss of my husband, mentor and friend; the loss and disappointment of a failed marriage. The loss of Gilles.

I didn't realise how integral he was in my decision-making or how influential he had been in my life. Even though I had yearned for freedom, now that I had it, I didn't know what to do with it. I didn't know who I was or how to behave. I knew I was in trouble when it all seemed too overwhelming to dress myself. My friend Nicolas found me at home one day, once more sitting in the closet. He scooped me

up and took me to his apartment at 61st and Madison. I'd had a mini breakdown. For weeks he lovingly nurtured and looked after me. His kindness touched me. He will always have a place in my heart.

Since meeting Gilles, I had almost exclusively worked with him and for *Elle* magazine. I had become synonymous with his work, leaving very little room for me to connect with other magazines or photographers. I had become inaccessible to them; I was branded Gilles/ *Elle* magazine.

So after we separated, few other fashion photographers wanted to work with me. I was stereotyped as the bathing-suit girl on the beach in the Bahamas who does shots with five other girls for *Elle* magazine.

The loss of routine work with Gilles, Regis and the team at *Elle* felt so disheartening. It was as though my world had fallen apart. Having stopped this work, there was nothing to take its place. Also, I missed the collaborative creativity of editing and I missed the trips to exotic places with the other girls. And, of course, I missed Gilles terribly. I didn't have steady *Elle* work. I didn't have Gilles. And I didn't have freedom because I was so anaesthetised, I couldn't articulate myself in any way, shape or form. I didn't know what I liked or even what food I enjoyed. I couldn't discern what was me and what was the Gilles version of me. Who was I? Who was I in the fashion world? Who was I in business people's eyes? I found it really difficult and for a while I didn't work.

At the time Gilles and I separated, I realised how much I missed my family. Mum, Neill and Lizzie were back in Sydney by this time. I'd been going back to Oz and New Zealand regularly while creating Elle Macpherson Intimates, but I was constantly working while I was there. Ben, Mimi and Lizzie were growing up fast and I felt I had missed out on a lot of years with them while I was living between

Paris, New York and on the road. Through that busy period of my life, I also wish I'd spent more time with Dad, and I wish I'd been able to be more closely connected with Mum and Neill and the family. I did my best, carving out as much time as I could claw from work meetings and shoots during my trips back to Oz.

My lingerie business saved me in those years because I was able to express myself through it, and it brought me an income. I had *Sports Illustrated* so I had that identity as well. But it was really only in those two areas that my career was flourishing. When we separated in 1989, Gilles was nearly fifty and I was twenty-five. Some people said that in the years of our marriage, Gilles became eclipsed by my fame so the dynamics in our relationship changed and it didn't work for him any more. I was now the famous one. Wherever I went, people recognised me. In Australia, I was considered a national icon. I was launching my own business and flying around in private planes when working with *Sports Illustrated*. And yet deep inside I felt like I had no real identity without Gilles.

He taught me so much. He taught me so much about myself. His mentoring was a powerful stepping stone that guided me on to my life path, showing me that I had the strength within myself to achieve my dreams. He brought out the woman in me and through that I transformed my life with the tools he gave me to carry on without him.

Now I've come to realise you can't make someone love you. Or even be with you, for that matter. We all want so much for it to be true that only love makes a relationship, but it isn't true. It takes more than love. There have to be many other qualities, such as respect for each other's uniqueness, their individuality. A willingness to grow by accepting that you both reflect each other, so what we see as a partner's imperfections are exactly what we need to see and heal in

ourselves, and what we see as their merits and strengths are what we need to acknowledge and nurture within ourselves. We can then grow in the relationship, thriving in the inner connection rather than the outer attraction, and become the very best version of ourselves.

I learned that you can love someone for who they are right now, but you may not be able to live with them unless you're both willingly and naturally on the same page. Know that you can't force or control someone to meet your needs or expectations of them. And if the relationship doesn't work out, you can trust that as long as you stay on your own self-growth, expanding, rebalancing and being your authentically unique self, you will automatically magnetise into your life the person who represents your perfect next relationship on your journey to living pure, unconditional love.

In so many ways I thank Gilles for walking that road with me for those precious years and also for leaving me when he knew I was strong enough to walk alone.

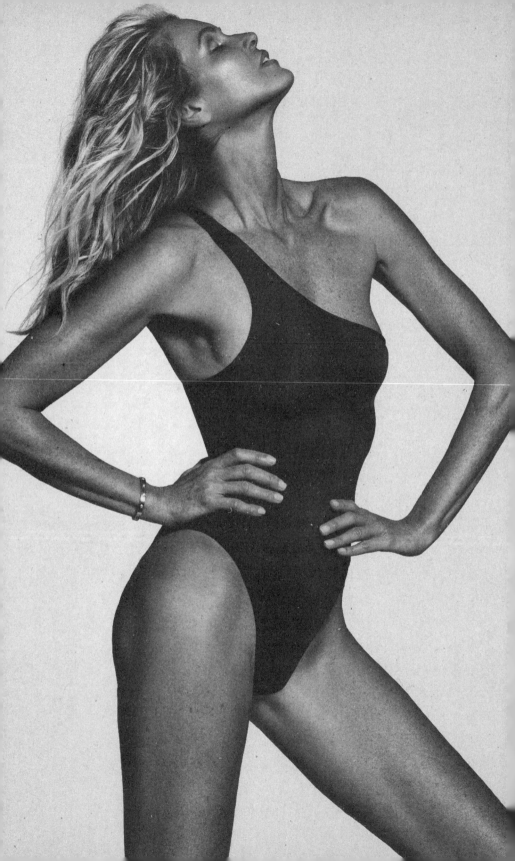

8

SUPERMODEL
Listen to your inner sense

I wanted to show myself, and the world, that I was no longer Gilles' muse. I continued to prove to myself that I was capable of many things, and was determined not to be destroyed by the breakdown and break-up of our marriage. Above all, I wanted to prove to myself that I could stand on my own two feet. Listening to my heart as it guided me after the initial shock of the split, I didn't falter, trusting that I was magnetising vital changes in my life for a beneficial reason.

Free to explore and expand my creativity, I immersed myself in developing Elle Macpherson Intimates. It was a huge challenge and I thrived on it. Together with Stu, I continued to build both my brands: Intimates and my personal brand, Elle Macpherson Inc.

By the beginning of the 1990s, I had moved into producing my own calendars, was involved in filming documentaries surrounding the shooting of those calendars, and was making TV appearances: either hosting programs or being invited as a guest on other entertainers'

programs. *The Tonight Show Starring Johnny Carson* was a favourite during this era, and after seeing me as a guest with Johnny, the team from Dave Letterman called. My first appearance on Letterman was in 1991. I was the second guest and did my best to promote another NBC program that was running at the time. I was presenting *International Swimsuit '91*. Dave was charming and I tried to be authentic and amusing, although sometimes I was neither. What I see mostly when I rewatch these appearances is a young girl promoting what she needed to, as well as being entertainment. In the beginning I felt awkward, nervous and being put on the spot and in the spotlight, though I do remember it got easier each time.

Practice makes progress. I began to feel valued as I was often asked to make a guest appearance if someone dropped out. I lived in NYC where the show was filmed and I was accessible. The producers trusted me and knew they could depend on me. There was always a bit of flirtation going on. People liked it. It was good for ratings. I started to see myself as a commodity in a detached way. I knew when David asked me on the show it wasn't just because he liked me, it was because someone had cancelled and he needed me, or the ratings were down and he wanted a bit of light humour and eye-candy!

I knew what my role was. Come on, look fabulous, plug whatever you're plugging, be funny, be beautiful, talk about a bra, flash your knickers at someone and flirt with Dave—because that's what they needed. And that's what I did. I knew what to do and I could deliver. I never ever thought it was about me. I was always a team player—Gilles had taught me that. I ticked the boxes on what needed to be done. And I think that's what saved me. I didn't believe my own press; I didn't believe my own hype. I believed *in* it but I didn't believe it. I was cognisant of what went on behind the scenes.

I wanted to be independent and I wanted to be a businesswoman making smart choices. I was learning that I had to take a chance and a risk. I had to invest in myself.

Stu was the mastermind behind many of my career moves and projects and was a huge inspiration in my life. He was one of the most, if not *the* most influential supporter of my career. He guided me, organising my fame and taking my name global. Stu had worked in retail before becoming a model agent and then my manager. He understood the value of a brand. He also understood fashion culture and influence in business. He managed me for more than twenty years through many ups and downs, often making decisions for me when I was finding it difficult to gain clarity. Stu had a vision and I was a willing partner.

He was loyal, loving and always had my back. He was my best friend, confidant and sounding board. He supported and encouraged me to make big decisions and helped guide me in making small decisions. He had an attention to detail that rivalled my own. He dreamed big and helped make things happen. He thought outside the box.

Stu left Chadwicks in Australia and moved to New York, where he worked as an agent for the modelling agency Women Management. They managed supermodels Naomi Campbell and Kate Moss. While Stu was working with Women, he managed me on the side. It was an unusual situation but we made it work for a time, until it didn't. He then left Women Management to manage my growing profile and business. Stu was my rock through shaky years and I leaned heavily on him to help activate and guide business opportunities. He magnetised and I performed. He saw in me things that others didn't. He gave me an infrastructure so I could dedicate my time and energy to being a supermodel. Really, the 1990s were the Stu years. He ushered

me onto those platforms—back on the runway and TV shows. And then film.

Stu knew that a director, John Duigan, was interested in casting me in a film he wanted to make, and that he'd sent me its script to read. One day Stu asked me, "Elle, have you read the *Sirens* script?"

I admitted I had not.

"No? Well, I think you should call John and tell him you couldn't be bothered to read it. You're losing interest in anything that's being offered to you. You can call him because I don't want to communicate that message. Clearly, you do. So you call him."

That jolted me and I thought to myself, crikey, I'd better read that script. I did. And I loved it. Though acting had never been a dream of mine, while reading John's script, the chance to explore acting sparked my interest and my excitement. Surprisingly, I felt like my heart connected to this opportunity, even though it was outside my comfort zone. Again, I listened to my inner sense and trusted. I went for it. I said to Stu, "I'll do it."

It was a huge thing for me to take two months off from modelling and Intimates work. I'd never done that before. I put on ten kilos so that I would be more believable as the voluptuous 1930 character I was playing. I moved to Australia, where the film was shooting, and polished my Aussie accent back up. Being the preparer that I am, when I memorised the script, I learned it all. The entire script! I didn't realise I only had to learn my own lines so I learned everybody else's as well. When someone said a word that was not in the script, I knew they had improvised. I ended up micro-managing everybody in my head!

We filmed *Sirens* in the beautiful Blue Mountains I had visited as a child with a friend of mine, Penny, and her family. It was magical being back in that big Aussie bush. But the first day on set was like

the first day of a new school. I didn't know what to do, where to go, how to be. Everything and everyone seemed so unfamiliar. Of course I'd seen Hugh Grant, Sam Neill and Tara Fitzgerald in movies, but witnessing them work and playing scenes with them was something altogether different.

Hugh was funny and irreverent. His performance turning a priest's embarrassment into real comic virtue was brilliant. I think he was confused, though, as to why my trailer—one of those big pop-out contraptions with a bedroom in the back—was as big as his, considering he was a movie star and I was a rookie on my first film. To be honest, so was I!

Sam was warm and encouraging. I was grateful for his humility and graciousness with my inexperience. The other "Lindsay models" in the script cast were Kate Fischer and Portia de Rossi—two young Aussie actresses with ambition and willingness to do whatever it took to get the scenes played well. I did a lot of scrambling, observing, trying to learn the dynamics of a film set while pretending I knew what I was doing.

Ultimately, *Sirens* was a lyrical film wonderfully directed by John Duigan as a follow-up to his 1987 autobiographical film, *The Year My Voice Broke*. I loved working with this talented crew.

Moving into acting set me apart from most other models. That was how I stood out. Not only because I was six feet tall but because of the choices I made. I was building my businesses, developing licensing deals, making films, and doing late-night-comedy guest appearances. I would never have made those courageous moves if I'd stayed with Gilles. So I'm grateful to him for our separation.

Later, Stu made the unusual decision with me to employ the creative music publicist Patti Mostyn to do my personal PR in Australia. Patti managed people such as Elton John, and she ran my

PR appearances in Oz like rock concerts. She was ahead of her time and so were we. It was fever-pitch publicity. Nobody in fashion had approached managing models this way. It really escalated the "Elle" phenomenon.

When I went home to Oz for work, my trips were orchestrated like a big brass band was walking into town. There were screaming fans, babies being held up to be kissed, press and security everywhere I went. It was frenzied and that fed the press. The crowds were organised with red velvet rope entrances. Patti created this rockstar status. I showed up in Australia with sunglasses and bodyguards; the paparazzi followed. Throughout this period in my career, no matter where I went, I was perceived as a star just through the attention that was created. It was planned and perpetuated and then it became a reality. Patti masterminded that.

We launched the Elle Macpherson Intimates lingerie brand on the steps of the Sydney Opera House. It was a major event and resembled a concert. There were thousands of people waving, music was playing, there was a huge autograph signing and ropes people couldn't get through unless they were VIP. Exclusivity. It was all larger than life. The whole era was larger than life. We were supermodels, rockstars, and movie stars all in one. It made me feel and look like a million bucks.

The press leaped around the world, catapulting me to heights of fame and recognition. By this time, my personal life was also rock 'n' roll. Late nights with dubious company, alcohol and drugs all seemed to go together. But then again, this was the early '90s when "anything goes" was the only rule.

It was nerve-racking at times because I was always on and everything seemed to matter—what I wore, what I looked like, where I was seen, who I was with, what I was doing. Of course, it's all much harder now with social media, but back then the paparazzi were intense.

The way I saw it, they had a job to do and so did I, so we developed a sort of mutual respect and worked together. I never felt invaded, simply that it was a give and take—in both directions. They promoted me and I made sure I was at my best and worthy of that promotion.

Often surrounded by teams of wardrobe, hair and make-up, I did feel a bit like a doll who was wound up and put out into the spotlight to perform; this constant 24/7 performance. And there came a point when I didn't know who I was any more because I was fulfilling the role of a celebrity and model and all the various contexts and backdrops that entailed. At those times, the greater the distance you had from the public, the more successful you were. The more aloof and pedestalled you were, the more valuable and in-demand people thought you were. I became exhausted by it all and put my daily rate up triple what it had been previously in order to weed out some of the things I was being asked to do. But it just made people want me more. She's more expensive—she must be better.

Around that time, I started dating Tim Jefferies, an art dealer in London. I would often fly back and forth between New York and London for work and to visit him. While I was there, I'd stay with him in his cool little Kensington apartment. We would go out to Tramp nightclub, have dinner and meet up with Kylie Minogue, Michael Hutchence, Elton John, Robbie Williams and George Michael, who were the hip crowd in London.

Tim was fantastic because he taught me how to have a great time—to just have a laugh, dress up and enjoy being a model and a star. He was connected, he was good-looking, incredibly charming, charismatic and everybody liked him. He was always comfortable in himself and that taught me how to be comfortable too. And I was so grateful to him for teaching me how to bring something to the table. Bring a sense of humour, bring your curiosity, bring your vision,

bring your creativity. With Tim, I learned that you can't just stand there and be pretty. And the more I brought something to the table, the more people wanted to hang out with me and the more I was invited out. I felt like I belonged, at last.

He taught me how to be an extrovert because he was an extrovert. I never realised how much fun I could have. So I blossomed with Tim. And we hung out with other famous models, musicians, actors and celebrities. We went to popular trendy clubs in London and we really enjoyed the stardom that the fashion industry was experiencing: we were in the midst of the supermodel and paparazzi era. We'd go for lunch at San Lorenzo in Knightsbridge, London. It was Princess Diana's favourite pizza restaurant and it was tough to get a reservation there but Tim and I never needed one. Every time we came down the stairs outside San Lorenzo's, there would be paparazzi waiting. The next day our picture would be splashed all over the rag mags and tabloids.

Many a night, we'd go to the nightclubs of St. Tropez and hang out with George Michael at his place afterwards. George would sing and play his latest albums. We were with Robbie Williams the night he was thrown out of Take That for being a bad boy. I recall Robbie was bewildered, saying, "I can't believe I got kicked out of the band!" George said to him, "Don't worry, you're going to be a star all by yourself." And he was!

One night I went to a party and found myself chatting about life and music with Princess Diana as she sat cross-legged on the floor. We talked about music she loved and she was just another girl in a pair of high-waisted jeans and T-shirt, having fun and socialising.

How did I feel? I felt free and excited that I was spending time with these fabulous, creative people. Yes, there were times I was starstruck, but at the same time I knew we were all on a similar path.

Looking back at those times, it's remarkable that I was friends with many of these people. We were a similar age and up and coming in our careers—and Duran Duran was the biggest thing since sliced bread.

I finally felt alive and relaxed instead of uncomfortable and awkward. I was the girl who went to premieres and balls in long Valentino dresses wearing gold flip-flops because I wanted to be comfortable and didn't want to tower over people. I'd jump out of the sea and blow-dry my hair quickly, salt spray still on it, and maybe pull it back on top of my head. I would wear very little make-up. That was me; I was known for that. It was a sort of ease. I'd put on a ballgown like it was a kaftan and that became my style. It wasn't because I was trying to make a statement, it's because I wanted the effortlessness. I couldn't stand the pretence. Falseness made me feel uncomfortable. I felt like a little girl who was trying to put on her mother's high heels to pretend she was grown-up. I was just into being me—the relaxed Aussie; real, natural and authentic. Chic.

Tim and I had so much fun together until one day we looked at each other and went, we're done. I think it was one of those moments when we both realised it was time to move on. We'd learned everything we could possibly learn from each other. In my memories, he will always be a man who taught me how to laugh and have fun.

I went from being a student in loafers and wearing a blazer with Gilles to rocking my own character and personality on the world stage. And being glamorous, beautiful and independent. Looking back, I see myself at my most beautiful during that time.

However, I was not one of the original supermodels. I was always on the outside because I was never that interested in fashion per se. The 1989 British *Vogue* cover by renowned photographer Peter Lindbergh captured the famous five in a fabulous group shot: Cindy Crawford, Christy Turlington, Linda Evangelista, Naomi

Campbell and Tatjana Patitz. Of course, Claudia Schiffer was also a rising star.

Linda's famous line was "I would never get out of bed for less than $10,000 a day." The supermodels were literally earning hundreds of thousands of dollars a week flying around the world and I was not included in that—at all. I had a recognisable name but I was not being called upon to be on prestigious covers for *Vogue* at that time because I had always worked with Gilles for *Elle* magazine. I was more athletic and was known as the sporty girl on the beach wearing a bikini. I wasn't a chameleon. It didn't matter what I put on, I was always Elle.

Cindy, Christy, Linda, Claudia and Naomi all had different characters and were chameleons. Linda especially. She was whoever you wanted her to be. One shoot she was Joan Crawford and the next shoot she was Audrey Hepburn. She could have been anybody with hair and make-up and wearing the right clothes and attitude. She was that kind of woman, and she had a profound understanding and love for couture and fashion in general. I admired her. Whereas, given my Amazonian frame, I wasn't really suited to that kind of fashion.

The famous five were extremely successful financially and in high demand. Stu had a pretty clear view of what was going on in the fashion and beauty world so he knew I wasn't considered one of the original supermodels. He knew I wasn't in that elite group. However, Stu said, in order for my brand to have longevity, I needed to be considered one of them.

In 1994, I had an opportunity to invest time and energy into a new business venture: Fashion Cafe. Italian entrepreneur and man about town in New York City Tommaso Buti approached me with the idea of opening a fashion-themed restaurant capitalising on the rise of the supermodel and the booming fashion industry. He asked if

I would be interested in joining him as a partner. I thought it was an intriguing opportunity.

Stu saw the potential in my being associated with the iconic super-models, and the idea of working with them was really appealing to me. I approached Naomi, Claudia and later Christy, and asked them if they wanted to join me and they said yes. I think the girls followed me because they trusted my business acumen and knew that I was making unusual business decisions, evolving my brand and doing well. I was beginning to develop a reputation as a businesswoman and I think they were interested in expanding their own interests without actually investing any capital. I was pleased to get to spend time with them. I really wanted Cindy to join too but she was busy with other ventures.

Restaurant licensing was a big gutsy move out of my comfort zone and experience. Along the way, I invested money in the enterprise with the promise from Tommaso of huge returns. The restaurant was sort of a Hard Rock Cafe–styled place, but instead of going to see rock 'n' roll memorabilia, you would see fashion memorabilia. It looked like Hard Rock Cafe but it was Fashion Cafe. And there were different sections. There was a Paris section and a New York section. A London section and a Milan section. They all had a theme of a designer who was well known from that city, with outfits that a famous fashion model, musician or a movie star had worn. For example, Madonna was in the American wing wearing the striking pointed bustier designed by world-famous Jean Paul Gaultier. We decided to acquire it because it was such an iconic fashion statement.

Fashion Cafe was a franchise, also opening in the UK, South Africa, Mexico, Philippines and Spain. There was a grand celebration of the construction of our first café in Times Square in December 1994. I loved our crazy hard-hat shots and the nutty pictures of the

supermodels in the kitchen. I mean, who puts fashion and food together?

The opening party, four months later, at the close of Fashion Week, was a huge success and the restaurant became crammed every night with people wanting to eat and get a glimpse of the famous four, plus me: other successful models would dine there and people loved to see us. That was part of the attraction so we ate there regularly, and lent our names and images to the merchandising. For me it was time to have fun, explore and hang with other girls. Time to take risks and learn through the process. Time to step out and be in step with my contemporaries.

I started being called a supermodel because I was hanging out with Christy, Naomi and Claudia. The *New York Times* then cited me as "Elle the Supermodel." So that's how I became perceived. And it stuck. In some ways it was absolutely warranted because in the true sense of the term, I did everything: runway, covers, bathing suits, TV, film. I was also super recognisable from being a multi-cover star of *Sports Illustrated*. Really, I'd been fulfilling the role of a supermodel since I was seventeen when I worked in Australia.

When Tommaso Buti stopped paying the bills, and started living large from the profits of Fashion Cafe, the whole business fell apart. In 2000 he was arrested on numerous charges of fraud and money laundering, and accused of embezzling money from the Fashion Cafe investors. Twenty years later, Tommaso ended up being granted a full pardon by the then president, Donald Trump.

Naomi, Claudia and Christy (who joined us towards the end) had depended on my judgement and I had convinced them to come on board. They had trusted me and my business acumen. Of course, they had their own advice and perspectives but when Fashion Cafe came crashing down after only three years, a lot of money was lost

along with my self-trust. I had never had egg on my face before or been associated with any shady business in my career. I remember thinking how on paper it had made perfect sense but the reality was quite different—something inside had felt subtly dissonant right back in the beginning and I'd ignored it simply because of the power of logical, rational thinking.

That was a lesson I learned the hard way—no matter how convincing something looks in rational terms, if it's not actually resonating with your inner sense, then stop. Stop and move on to something else. I learned to check financial balances, ask the hard questions and always follow the money. I also learned to create a solid business plan and execute it with trustworthy people.

That was then. Now I magnetise outer experiences that I can trust because I've learned that by being relentlessly trustworthy—trusting myself, my own inner sense—I will increasingly see my trust reflected to me in the circumstances of my life.

For me, I know I had flickers of doubt from time to time about the Buti brothers and their modus operandi, even early on; uncomfortable inklings that sent ripples through the calm of wishful thinking. But I brushed those doubts aside over and over, allowing my inner sense to be diluted by my hope for the project to be a raging success for everyone involved. I will always focus on the uplifting, empowering, joyous, loving aspects of anything, energising those qualities in my life. But I will never again ignore dissonant senses; those subtle wrinkles in the prettiest picture are there for a reason, a helpful reason, and we are unwise to ignore them.

I have recognised that there will always be ups and downs in life. Finding the lesson is important but not vital. Knowing there is indeed a powerful, positive, supportive lesson *is* vital, even if we are unable to find it. That trust is actually in your own creation—you

created that experience for a valuable reason and the trust you have in it builds experiences that will reward your trust, more and more strongly, more and more quickly, more and more often.

The 1990s was a fantastic era. I kept moving forward and embraced opportunities that opened up to me. One of my fondest memories is hosting and presenting the popular *Saturday Night Live* show in 1996. When I was asked to do this, I was thrilled. I look back now and realise what an honour it was: I was the first model who'd been invited to host—the slot was usually reserved for comedians, actors and musicians.

The lead-up was fascinating and engaging as I spent the week before with the team, writing and preparing the various skits I would perform in the live comedy show. For the first time I was truly co-writing, collaborating and co-creating with talented writers and performers. I thrived on this experience and enjoyed it immensely. The effect on my creative flow was empowering at the time, and it has stayed with me to this day, influencing many aspects of my life.

It's taken me twenty-five years to watch my *Saturday Night Live* skits and I confess I laughed hysterically when I did. I hadn't watched them before because I had the preconceived idea that I was really terrible and I was appalled at myself at the time because I didn't stick to the script. I thought I didn't do a good job of comedy. Now I look back and see that I actually did quite well.

My performance was simply the actualisation of the work done prior. The secret is in the preparation. You get out what you put in. I remember the satisfaction, fulfilment and joy in the run-up to the show. The more prep I did, the more confident I felt and the more it showed. The more I involved myself, the more connected and fulfilled I felt. I developed cellular memory from all that groundwork.

The performance was just the cherry on the cake. All I had to do was perform what I'd prepared. And that's what I did.

What I also learned was the energy I invest in any given activity is returned to me manifold. I have come to realise that what I put my heart into attracts other opportunities and experiences that I love in life. So commit to what you want. Put all your time, thoughts, feelings, emotions and actions into what you really want to fill your life with, while withdrawing time and energy from things that do not resonate with your joy or that you think need changing or fixing. Creation flows where your energy goes—what you think, what you feel, you make real. When you show the Universe what you love to experience, it gives you more such experiences.

My career was on a rollercoaster ride—from famous model to supermodel; entrepreneur businesswoman to TV host; guest on TV shows like Johnny Carson's *Tonight* show, the *Late Show with David Letterman* and *Saturday Night Live*. Fame catapulted me to new heights and I started to work as Elle. It was a time when fame reached dizzying peaks. I polished my persona and my look. I took risks, tried new things and thought in new ways. Elle Macpherson Intimates inspired my imagination and ignited in me a passion to express myself creatively. I was doing special highly paid bookings, whether it was TV commercials, hosting, producing or creating material for my own businesses.

Helping art-direct photoshoots and TV commercials was enriching and fun. A favourite was an Ellen von Unwerth TV commercial. The script read that I was in bed having breakfast with my lover, wearing my Elle Macpherson Intimates, and when I went to put the breakfast tray outside the hotel room door, a gust of wind blew the door shut. My man is in the shower and can't hear me knocking and kicking at the door to get inside. I'm in the hallway, scantily dressed

in lingerie. I pluck up the courage to shamelessly walk down the corridor to the elevator and to the lobby to get another key. On the way I encounter all sorts of women wearing the same bra as me. It was fun, sexy, sassy and totally on brand. The tagline was "Lingerie from The Body for Everybody."

By mixing with a whole combination of people, I found that beauty will get you sat at any table. But once there, you'd better have something of substance to contribute. Four things that can open doors in this world are creativity, artistic ability, sporting achievements and beauty. And so I was invited to a lot of wonderful venues with interesting people because I was curious and a popular entertainer; a successful woman, but also interested in a lot of different perspectives, so I could talk to anybody about anything. I made sure I had something to say, something to offer, something to give. Tim taught me that and to some extent Gilles did too. They'd both taught me to be aware. Don't rely on the way you look. Be interested in other people and of course be beautiful. Of course dress well. Of course make sure you're well groomed. Yes, be all those things . . . but have something going on inside.

No sooner was I becoming comfortable within myself when my life began to take yet another direction. After the movie *Sirens*, Hollywood beckoned. In the summer of '96, I jumped on a plane carrying my courage and curiosity and headed to LA.

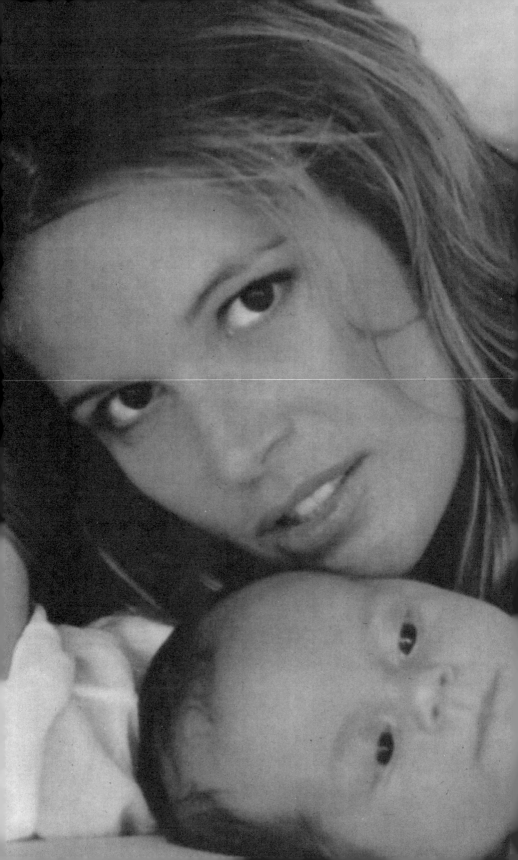

9

HOLLYWOOD

Allow the flow of life, and adapt

I was the accidental actress.

My career in film actually started before I did *Sirens*. In 1990, I was given a one-line role in Woody Allen's movie *Alice*. I remember going to the casting call in New York, arranged by my agency. When I arrived, I was astonished at the long line of people queuing up all the way down Madison Avenue. I took one look at the line and thought to myself, there's no way I'm standing in that. It's going to take hours to reach the front and I have stuff to do.

I called my agency and said, "This is not for me."

They replied, "Elle, they really want to see you."

I told them, "Then can they please give me a time when there's not a thousand people queuing out the door and down the street just waiting to meet Woody Allen?"

And they did. They gave me a time of 4 p.m. When I walked in, everyone who'd been queuing had already gone after waiting hours

for their five-minute casting call. I met with Woody and he said, "I'm sorry to have called you back. I just wanted to meet you."

I looked him straight in the eye and said, "Well, I just wanted to meet you, too."

After a wry smile and a bit of a pause, he asked, "Can you be here at nine o'clock tomorrow morning?"

I smiled and said, "Sure. See you tomorrow."

And that was it. I got the role of a girl changing her clothes. Funnily enough, my only line was very short: "Excuse me, there's heavy breathing in the dressing room." It was referring to Woody Allen's invisible character who was spying on me changing. And that's actually how my film career in Hollywood began.

When I was asked to be in movies it came at the right time in my life. It always took quite a lot of convincing from Stu, and my agents who represented me at the time, to get me to read a script. Acting didn't seem that important. That's me! I was always walking to the beat of my own drum. When I finished *Sirens*, I was offered a three-picture deal by Miramax. Stu thought it was a great idea and encouraged me to give it a go. I was hesitant in the beginning because I wasn't sure if I wanted to commit fully to a film career. Then, listening to my inner self, I knew it was the right thing to do. I had already been successful in modelling for twelve years and this felt like a calling for me to work in the field of film.

The lingerie business and calendars were recognised and becoming highly profitable by the mid '90s, leaving me time to focus on acting, so moving to California seemed like the most logical choice. I made up my mind to go to LA. Once that decision was made, I moved quickly and on the spur of the moment. I just got up and left and dumped the actual moving part onto Stu. This was a time when models were revered and ushered from place to place, looked after, managed. Perhaps me less than others because of my own innate desire to ultimately be in

command of my own life. But nevertheless I always had help from Stu, who was left cleaning up after my "spontaneous choices." At the time, I took it for granted, but now I am grateful for all the hard work, vision and patience he had in managing me.

My brother Ben was all grown up by then and he moved into my apartment in New York as he was offered a job by an American company to head a division, and I relocated to Mulholland Drive for an indefinite time. Before moving to the US and into my apartment, Ben, himself a budding entrepreneur, had started a franchise in Australia called Moviefone, a moving pictures listing and information service. Moviefone was eventually bought by AOL in the peak of the dotcom days.

LA gave me a chance to have a more normal life. When I lived in New York, I was unable to really put my roots down. Thinking back to living on Mulholland Drive, I remember feeling grounded. I'd often thought that having an actual house with a kitchen and a cat would help bring a sense of normalcy into my life, and even prepare me for being a wife and mother some day. Somehow, in New York I always felt like a student—a little apartment, restaurants every night, taxi rides, and no responsibilities other than to show up on time and be well prepared when I went to work. LA was different and I blossomed on Mulholland Drive. My house was fantastic. A mixture of hippy funk and Hollywood glamour. I loved it. I learned how to drive and went to fresh-food markets. I stocked a real kitchen and took care of my home.

Most of all, when an opportunity presented itself in my life, I listened to my heart and acted on it. I listened when my inner voice whispered, "Trust."

Having settled into LA, I signed up for acting school and started taking classes with a great teacher called Sharon Chatten. Acting

opened up a whole new way of how I viewed life. I began to read a lot. I slowed down. I started noticing and observing other people's behaviours. I started to really notice my own behaviours, feelings, thoughts; influences, past and present. I rehearsed; I practised; I studied and immersed myself in scripts.

I learned that subtext is extremely important, not only in acting but in all life's circumstances. What's not said—the space between the words. And I learned how powerful it is. The intention, the energy, the understanding; the inaction as important as the action. Acting taught me that. When playing a scene, before you walk into a room, you've got a whole story in your mind about why you are doing it. You're not saying anything, you're just walking into the room. You are carrying the energy of intention with you. I found in life that what is not said, what is not done, and why, is often more powerful than what actually is said and done. So acting classes, careful training and preparation also taught me to align my internal feelings and my external behaviour. Relating what I felt to how I behaved didn't come naturally. It's something I've had to practise. I couldn't be doing one thing and thinking about something else because if you do that, it shows on camera.

Training developed my imagination. Working as a model, there's really no room for imagination. You're on the shoot, you're turning around, you're changing outfits, you're making sure they look great. Imagination never really gets a chance to dance. Acting was the first time I gave myself that freedom. I learned that my imagination was something that I've used against myself in my life. Because I'd been shocked by certain things that I saw in my life, I believed that if I assumed the worst then I'd be prepared for the worst. But by assuming the worst, I was actually creating the worst. I'm the ultimate creator, right?

So now I practise joy within myself. In my imagination, I expect joy. And instead of imagining all the terrible things that could be

happening, I imagine the potential of wonderful things happening because that's the source of my creation stream—my imagination. Training in acting enabled me to understand the power of intention. This realisation was my first foray into understanding how to use that power, and act in alignment with it authentically.

Acting classes were extremely demanding. I committed myself to hours of intense work and discipline. I loved turning up to class. I loved analysing the script, the values of words, the cadence and rhythm of phrases. I loved eliciting my own emotions and experiences from other people's words and ideas in the scripts that I was given; digging deep within my own well of feelings and applying them to the role I was performing. I loved bringing the characters to life. I was bringing myself to life, really.

Acting brought another dimension to who I was and what my life was about. I started to become aware of the complexity of the emotions within myself. I took acting seriously. It was difficult for me because modelling demanded that I work towards the camera. The camera was my North Star. It's where I always turned when I heard the click of the shutter, like a sunflower that moves its head towards the sun and naturally follows it. That's what a model is trained to do and it becomes second nature. You can't tell the sunflower not to follow the sun. For a model who's had years of experience, when you hear a camera shutter, you feel it. A model innately moves her body to make sure that she's looking her best possible for the camera. Her face is at the perfect angle; she's thinking about the composition of the frame as it relates to the aesthetics. Every detail perfectly poised.

The movie camera, on the other hand, is an observer. The focus of the actress is on her scene. She is engrossed in the conversation and the interaction being played out in the scene. My skills and experience were the exact opposite of what was needed to be an actress.

So I found it both challenging and liberating to be able to relax in front of the movie camera. I guess I was one of the few models who had made a successful transition from model to actress.

Having said that, I was out of my depth. Acting definitely got me out of my comfort zone. This move was perfect timing for me as it gave me a chance to expand, explore and have confidence in myself to grow in other areas. I began to meet new people and examine the movie industry and my work on a deeper level. Modelling, while complex in its craft, is nothing compared to the craft of acting, which has more layers requiring skill and technique. I learned to be present without focusing on the observing camera. I learned to be in the moment to allow my feelings to flow, to trust that I had done the preparation. When it came time to play the role, I learned to just be. Another great lesson for life—allow the Universe to unfold. Allow the scenes to unfold. Allow the director to guide you. Listen. Be in the moment. Allow the feelings. Navigate by your heart.

Living on Mulholland Drive was really cool. My neighbours were directors, writers and actors, and I had the chance to get to know and spend time with them. That in itself was amazing. It was a different kind of lifestyle for me. My celebrity status as a successful model had opened up new doors and made the transition into acting more possible. I felt I had come a long way from the girl who'd run away from the stars at the Palladium club years before. My friend and love at one point, Sean Penn, taught me a lot—just through observing how he took on challenges. Watching him carefully find scripts that resonated, choosing them through his heart and not relying on logic, was a valuable lesson in refining trust in that inner sense. I watched him edit the movies he directed. His commitment to every detail, the script, the music, the persona of his characters, inspired me. He cut and cut and cut again, always editing to get to the truth and authenticity of the moment.

He wasn't afraid of his attention to detail and he certainly didn't criticise or punish himself for it. He used it to evolve his work. Great lesson for me, as I had often been embarrassed by my observation of and commitment to details. People maybe thought I was difficult— a perfectionist—and I'd learned to penalise myself for it, even if they didn't. But not Sean. As I watched him, unapologetic in his determination for excellence, I learned to embrace my own unique vision instead of constantly trying to explain it away or apologise for it.

Sean was never afraid of his feelings and he was affectionate, tender and courageous as he navigated life. He took risks. And went deep. He introduced me to a cast of characters like Marlon Brando and Jack Nicholson, who lived close by me. I would go to their houses for lunch, dinner, drinks or a swim. I suppose I was just another girl entertaining them, but really I was the one being entertained. Curious and observant as I was, I realised that these famous people were just like you and me—normal, messy, fun, insecure, living and learning life. It quickly just seemed normal, in a weird way, to be hanging out with a variety of eccentric people in the movie industry. In hindsight, it was pretty phenomenal.

When actors are not working or preparing for a role, they're hustling for the next project. They're always restless, studying life, their feelings, reading, prepping, examining life's motivations. Their whole world's a stage. I'd never really had much time to just hang out because since first moving to New York, I'd been working almost every day. The fast sleepless kinetic energy of New York had propelled me, but I found Los Angeles different. LA was about relationships, building connections, planning, talking about potential films, scripts, deals. It was a lot about who you knew and one person led to another.

My dear friend Bobby Shriver introduced me to Warren Beatty. We met at a restaurant on the Upper West Side, back in New York.

I loved hanging with Bobby and Warren from day one and they
became my buddies. We laughed a lot. Warren was charismatic, beau-
tiful and intelligent, and I appreciated that he made time and space
for me. Of course I never assumed he actually liked me romantically.
He was notorious with women. But I did feel like I was the only
person in the room when I was with him. We connected intellectually
and philosophically and I learned to relax about his fame and bring
my unique self to the table. Both Bobby and Warren were dynamic
rebels with a cause, without conflict.

Bobby and I remain close friends and thirty years later we still catch
up. I remember one dinner we had without Warren. We sat at the bar
at the Odeon in Downtown New York City and ate French fries. We
talked about meaningful things in life—service, spirit, God, religion,
literature and politics. And my confidence began to grow. I felt appre-
ciated. I confided in him that I felt as though I had been conditioned
by my work to morph into whatever was required by others. Beach
girl, girl next door, fitness girl, runway girl, outspoken girl, business
mogul girl, calendar girl, smart girl, good-for-dinner-numbers girl.
You name it, I was able to be it. My livelihood depended on it. My
reputation and business depended on it. We discussed the difference
between a human being and a human doing. Bobby assured me that
my soul ran deeper than the exterior performance.

Warren and Bobby were perhaps the first men who I felt saw past
my obvious exterior and demanded that I meet them on a more soul-
centred level. This inner connectedness is something that has become
non-negotiable in my relationships today.

Such significant connections came to me more and more often.
I saw them as gifts; guidance from the Universe and life itself. If
they resonated with me, I went with the flow, responding to them as
opportunities.

On one occasion when I flew back to New York from LA, I was out for the night enjoying myself when I bumped into Arki Busson.

I had met Arki, a charismatic, interesting and charming financier, a few years earlier at a dinner hosted by our dear mutual friend Johnny Pigozzi. Johnny was a wonderful host and always held great parties with the most interesting people. At the dinner party, Arki sat across the table from me. I couldn't see anybody else in the room but him. I was surrounded by notable people but only Arki captured my attention. He was elegant and cool with his infectious laugh and huge smile. After dinner, we ended up walking down to the Carlyle Hotel, where we chatted for hours and enjoyed listening to the jazz band that was playing. We came to learn that we had a lot in common and we both knew many of the same people. Arki walked me home. When we got to my door he didn't kiss me goodnight. He was married at the time so nothing untoward happened. We didn't call each other and we didn't make plans to see each other after that night.

So out on the town in New York this time, it was a wonderful surprise to see Arki again. He mentioned that he was now divorced and when he asked me out to lunch, I remember I got this feeling in my stomach like, "Ohhh, boy. This is going to be a wild ride if I go to lunch with this guy." I could just feel it.

Sure enough, it was and we started dating. We would meet at various locations but often he would come to LA. At that time I was working on set playing the role of Blanche Ingram for Franco Zeffirelli's 1996 movie *Jane Eyre*.

I managed to get away for a break whenever I could. I loved the Bahamas so I suggested to Arki we go to Harbour Island. I would go back there by myself for a couple of days, whenever I could, to relax. It's where I went to prepare for the cover of *Sports Illustrated*, and I'd spent time with Gilles there, shooting for *Elle*.

It reminded me of the Australian south coast. It was far away, off the beaten track and unspoiled. The beaches were extraordinary. Pink sand, turquoise waters; the most magical place in the world to me, outside Australia. I would spend my time meditating, reconnecting to myself and reconnecting to nature.

It was quite complicated to travel there. I would fly to Miami and stay overnight then take a little hopper to Nassau, and travel to the neighbouring island of Eleuthera by another little plane. Finally, a boat ride would take me across to Harbour Island. I would stay at a place on the beach called Ocean View; a bed and breakfast with a total of seven rooms. They were like huts really, but I loved it. There was no air-conditioning and the bathroom and shower were outside. I would get up in the morning, go for a swim and walk along the three-mile beach.

When Arki told me he'd also been to Harbour Island, together we bonded over the coolness of this beautiful remote place. There were no cars; you rode everywhere on a bicycle. It was a kind of hippy place, not like the tourist towns of St. Barts or Mustique. Nowadays, Harbour Island has grown in population and has become well known for authentic culture and beautiful homes.

On Harbour Island Arki and I spent a week getting to know one another more deeply. We had each other's full attention. We swam and walked the beach at sunset. We talked and laughed; our relationship intensified and deepened. I fell in love.

When we flew back to LA, I dived straight into making movies back to back. Meanwhile, Arki was living in Geneva and London building his hedge-fund business. He constantly flew back and forth to see me. Whenever he was in town, our time was precious and we made every moment count. During one of his visits, he bought me a beautiful vintage Aston Martin convertible from the '60s.

He wrapped it up in a big blue cover with a huge red bow on it and parked it underneath the iconic Hollywood sign that overlooks LA. He had his driver pick me up and take me to meet him as a surprise. I remember going faster and faster along the winding road until, as we drove up the hill to the Hollywood sign, I saw a mass of red ribbons floating in the wind. What an extraordinary vision it was. And then as we rounded a bend, I saw Arki in the middle of the road. He was leaning against the wrapped car wearing a pair of dark Ray-Bans, blue jeans and a T-shirt. He was smoking a cigarette and this car, that I couldn't identify, was wrapped up like a Tiffany & Co. box. It was my Christmas present. I was surprised, overwhelmed and delighted when I unwrapped it.

That's Arki to a tee: generous, spontaneous and incredibly romantic. He was unique, unlike any other man I had met before. He was adventurous and we did crazy, wonderful things together. He was the kind of guy who flew to Berlin when the Wall came down, to get a brick. He was a bad boy with good taste. And boy, did he have good taste. He constantly spoiled and surprised me. He gave me the most incredibly lavish and outrageous gifts. And he put a lot of thought and meaning into them. They were beautiful and chic, and he was creative. Arki excited me and scared me at the same time. He delighted me, enchanted me, courted me and he loved me. I loved him back with a passion. I adored him.

What a surreal time in my life that was. I'd met this incredible man, my brand was growing fast, and my life was unfolding beautifully. My movie career was shooting skyward: my next role was directed by the incredibly talented Barbra Streisand in the movie *The Mirror Has Two Faces*.

What an honour it was for me to work with Streisand. When I first read the script, my character, Candy, a femme fatale, didn't

sit well with me. Even though I was working alongside the gorgeous Jeff Bridges, I had a hard time processing one of the scenes I had to play. My head often said, "You're being stereotyped," but my heart knew that I could play this role in a way that would make a difference; a way that didn't come across as just a token pretty girl. I was determined to be strong and authentic while handling delicate situations with grace, elegance and poise, and creating my own subtext. If I couldn't play that part then I simply wouldn't do it. Most often, I chose to do things my way. And "my way" became my moniker.

Recently, I watched *The Mirror Has Two Faces* for the first time in years. I was surprised at how my feelings at the time of being inexperienced and clumsy didn't affect my performance. Barbra shot me beautifully, thoughtfully, and with humour. She was incredible on set, very respectful. Watching the opening scene, I was pleasantly surprised by how well it turned out and how I had ultimately played my part quite well. The whole movie was brilliant. Rarely before had I watched one of my finished performances. I was always too afraid to witness how self-conscious I might have seemed on screen.

One of the things I am learning in my life is to have a bit more faith in myself and not to be afraid to look back at the things that I have done. It's a work in progress. But having watched those performances, I am beginning to develop more courage to see and critique my own work. I feel more relaxed about acknowledging my accomplishments.

Shortly after *The Mirror Has Two Faces*, director Lee Tamahori gave me a script written by David Mamet. When I first read it, the script was called *Book Worm*; its title later became *The Edge*. Lee had just finished directing *Once We Were Warriors* to critical acclaim and when we met he was the industry's angel. With Lee being born in New Zealand and me in Australia, we seemed to have an antipodean connection. He asked me to share the script with Sean in the hope

that he might want to play the lead. Sean passed and the character was snapped up by Anthony Hopkins.

Before I knew it, Lee had asked me to read for the character Mickey Morse, the duplicitous wife of Charles, played by Anthony. I was astonished; I would never have considered myself for the character. It was a major role, way over my experience; playing that part seemed like such a stretch. Once I gathered the courage to audition with Anthony and we'd played an intimate scene together, I knew without a shadow of a doubt that I wanted to work with him. I wanted this role and I wanted to do a great job of it. I was aware that Mamet was not particularly noted for his writing in regard to female characters; they were normally the lesser protagonist. But I didn't care, I just wanted to work with Anthony, Lee and Alec Baldwin. I longed to play Mickey.

I closed my eyes, called on the Universe and breathed out my wish—then visualised it going out into the imaginary ocean of potentiality.

By the time the production was ready to roll, I had the part, and set about diligently creating a character with more layers than I felt it had. I spent hours in class trying to develop the skills that I seemed to lack at the time. I worked with my coach on language, accent, delivery and wardrobe. I even decided to wear lighter-coloured contact lenses so my dark, brooding regard would be softer, less suspect. I wanted Mickey to be lyrical; light but not lightweight. I wanted her to have a delightful and credible relationship with Charles, Anthony's character, my on-screen husband. I leaned into the memories of my relationship with Gilles as preparation because there was a similar age difference and reverence between Charles and Mickey.

When I eventually left to shoot in Canada I felt prepared. After arriving, I was in my trailer when a bottle of champagne was delivered by Anthony. I was touched by his thoughtfulness. He was so gracious

and made me feel welcome. First day on set, I was nervous and afraid I would forget my lines or I'd be seen as an amateur. I felt lost and inadequate but somehow I dug deep and showed up strong, willing, ready and able to play my part. Over the coming weeks, Anthony helped me feel worthy, comfortable and capable of playing Mickey. I loved working with him; he was a huge inspiration to me in my acting career and my life in general.

Every morning, I arrived on set ready to work, though there was lots of waiting around. I used that time to read over the script and review my notes. There were few mobile phones back then and very little signal reception so I used the time wisely to learn and improve my acting skills. I asked Lee a lot of questions and he became frustrated with what he felt was their triviality, with the detailed explanations I was seeking. In truth, I just didn't want to get it wrong, so I put my pride aside, embraced my vulnerability and asked how to play my scenes. Ultimately, though, I still had to have the courage to just try different ways. I learned to relax and be in the moment enough to understand the situation, all the while trusting myself to sense what was required and deliver it. I learned to trust my ability to be calm, to observe objectively, to understand the flow that I was in; to adapt and to feel the environment of what was actually required.

Great life lessons and great wisdom gained.

I'd learned so much that would stand by me as I moved further forward on my acting path. Performing in the iconic movie *Batman & Robin* was an interesting experience. It was directed by Joel Schumacher. George Clooney played the legendary Batman and I played his romantic interest, Julie Madison, a stereotypical girlfriend figure. I felt uncomfortable and way out of place among the cast of famous actors. I still felt inexperienced, as though I didn't really know what I was doing.

It was such an honour to work alongside George Clooney. When we filmed together I was trying to be cool but I didn't feel cool. And I didn't act cool either. I remember at one point we had to kiss and Joel said, "Can you two kinda show that you like each other?" It was really difficult—George's girlfriend at the time, Celine Balitran, was on the set. Acting that scene was very awkward and I felt quite tense. There's nothing worse than kissing a man while his girlfriend is watching!

It was a huge gift to be given that role but, of course, in my perfectionism, all I could do was think I'm hopeless at acting. I don't belong here. How the hell did I get this role? Which is actually what I felt on a lot of movie sets. In time, I drew on what I'd learned playing Mickey: I needed to slow down, relax, observe and trust. Exactly what was needed for my off-screen life too.

The biggest surprise of my life occurred just a few weeks after the premiere of *Batman & Robin*. It came in the form of a plus sign on a stick: I was pregnant! Surely not. I tested a few more times and each read the same way. Positive. I was pregnant with Arki's baby.

I called him and said, "Listen, I'm pregnant. I'm so happy, yet I don't know what to do. How do you feel about it?" Arki always speaks in statistics because he's a finance guy and everything is about percentages. His response was, "I'm eighty per cent excited and ecstatic because twenty per cent of the timing isn't quite right and I wasn't expecting it."

We were not married. We had only been going out for a year. Arki was never just a fling to me. I loved him like no other. I knew in my heart he was the man I wanted to be the father of my children. We'd had a crazy adventurous time together before we were pregnant, but even in his wildness he represented a stability and love I was looking for. Still, it was a shock when I became pregnant. It wasn't like we'd

decided to have a family, it just happened. I was nearly thirty-four and I had to prepare myself for the biggest change in my life. I was going to have a child. I was going to be a mother.

I was quite certain I didn't want to get married because I already felt secure starting a family with Arki: we were committed to each other. Besides, I didn't want to do the traditional thing of "I'm pregnant so now I should get married." I felt like an independent woman and I didn't want to dilute that. Once again, I walked to the beat of my own drum.

So many woman in Europe wanted to marry Arki Busson. He was *the* catch. He was beautiful, funny, smart, intelligent. He spoke multiple languages, came from a great family and had impeccable manners. Arki could speak to a waiter in a restaurant as naturally as he could to kings and queens. He knew how to entertain. He had attended school in France and Switzerland and was in the army of the Alpine Patrol. He was a fantastic water- and snow-skier. As a child, he spent his summers on the Italian and French Riviera. His mother had a house in the south of France. She was of mixed English descent. His father was French. Those kinds of things mattered—where you came from, your family, your lineage, your education, your connections, your friends, your prospects.

So there I was, this Aussie chic with the catch of Europe. I was pregnant and confident in our love. I'm not going to get married to Arki because that's what everyone thought I was going to do. Right? It was a bit like my defiance marrying Gilles and walking down the aisle by myself.

So Arki and I didn't get married. I gave up my house in LA and I moved back to New York to have our baby. It made sense to me to have our child born in America, where I'd been living for the last fifteen years. And that's what I did.

Pregnancy was enlightening for me. It was extraordinary to witness my body changing. I loved it and I was in awe, conscious of the transformation I was going through. It was actually the start of my wellness journey. I wanted to be healthy and take care of my baby. Arki was fantastic and he loved me pregnant. We went away to Portugal for a while during the summer of '97 and stayed with Farida. She'd just had a baby herself and I adored her little boy, my godson.

Pregnancy made me feel so beautiful. I wore normal clothes; I just bought bigger sizes of everything, never pregnancy clothes. I wore jeans, white shirts, blazers and loafers. I was still wearing bikinis with big boobs and thighs and showing a little bump. Around five months, I kept pushing my tummy out because I wanted to look more pregnant. I was disappointed because I didn't really show until I was at least six months. I just looked thick in the waist. I wanted to be the barefoot-and-pregnant kind of girl but I didn't have that kind of belly until much later in my pregnancy. I decided not to tell anyone, not even Arki, that we were having a boy. I was overjoyed to start my family with a son because, being firstborn, I'd wished I had an older brother when I was growing up.

One day in early February 1998, Arki came home from work and said he wanted to go to St. Moritz. He'd been invited to go skiing and had a business party to attend. I was due around 20 February. I looked at him intently and said, "Arki, if you go away and this child is born, you will never forgive yourself for not being at the birth."

He looked at me sideways.

I said to him, "I'm serious."

He reluctantly stayed in New York instead of going to the party. On 12 February I went into early labour.

There I was, waddling up Madison Avenue in the freezing cold to see my obstetrician, Dr. Radkei. I was wearing a pair of brown

corduroy bell bottoms, boots, a cashmere turtleneck sweater, baseball cap and parka. I was having to stop along the way and lean against store windows because I was having contractions. When I finally arrived at her office, she said to me, "This baby is going to be born within the next twelve to fourteen hours. Just go home and get comfortable and call me when your contractions are stronger and closer together."

I called Arki and said to him, "Listen, I think the baby is going to be born in the next twelve hours," which meant it would be born on Friday thirteenth. Arki, who was very superstitious, said, "You can't have a child on that day. It's bad luck."

I called my mother in Australia and said, "Mum, I think it's time and I'm going to have this baby. Dr. Radkei said soon." Mum started yelling down the phone, "I never saw you pregnant. You can't have that baby before I get there. I'm getting on a plane right now."

I had the two people I loved the most, stressed out and upset. My mum was freaking out that she wasn't going to get to America in time for the birth, and Arki was saying he didn't want his baby born on Friday thirteenth. Awesome.

Great . . . And breathe.

So I turned around and waddled back home and, as soon as I got there the contractions stopped! I called Dr. Radkei and said, "It's the weirdest thing but I'm halfway through labour and the contractions have stopped. Everything has stopped. What's happening?"

She said, "Don't worry, you've had a shock. As soon as your mother walks in the door, your waters will break. And as soon as Arki gets over the fact that you're not going to have a baby on the thirteenth, you'll go back into labour."

Having the perfect birth on the perfect day was important to me. I was in such a panic that I crossed my legs thinking it would slow down the birth of the baby. I had to hold on until St. Valentine's Day.

So, lo and behold, when my mother arrived from Australia, the door of the elevator, which opened straight into our apartment, chimed to announce her arrival and my waters broke. Amazing. Unbelievable. Dr. Radkei was right.

My doula advised me to go to the hospital—she saw there were complications. It was the early hours of the morning of 14 February. When I registered and checked in, I'd been in labour for hours and was extremely exhausted. The doctor induced me. That made the contractions go faster but it was very painful. By 4 p.m. I was struggling and they gave me an epidural, which I didn't want to have. And it must have been too late because it didn't take the pain away. The nurse prepared me and I was whisked away to the delivery room.

Arki had had a few drinks celebrating with his buddies the night before and had slipped out to get himself a hangover hamburger. As I was pushing the baby out, I could hear the doctors shouting, "Busson, quick, get back here. Your baby is being born!" Arki arrived, hamburger in hand, just in time to see the baby's head and to cut the umbilical cord.

Our beautiful, beloved son Flynn was born. He was perfect. I wanted to call him Valentine but, as you can imagine, that didn't go down so well. We named him Flynn—after Father Flynn who set up the Flying Doctor Service in Australia. And then there was Errol Flynn, the most notorious swashbuckling Australian actor and hedonist. To top it off, "in like Flynn" is also an Aussie term meaning "you made it" and of course Arki loved this.

Immediately he saw his son, Arki was amazed. He cried. He was overwhelmed. And he was in love from that moment. His mum was there and so was mine. My dad and Ben came soon afterwards. Mimi and Lizzie were so excited for me and wished they could've been there too but their work and life commitments didn't allow it.

I was afraid to give birth. Having been living such a rock 'n' roll lifestyle before I became pregnant, I was nervous in case something might be wrong with the baby. For the first six weeks, I didn't realise I was pregnant, so goodness knows what I was doing during that time. These are the formative weeks of a baby's development so I was worried. I felt guilty and, frankly, scared. Of course, I was trying to do it all perfectly. A rush of pure love engulfed my heart when I held Flynn for the first time. I felt so blessed.

After spending a couple of days in the hospital, Arki and I took Flynn home. And from then, we did it the English/European way—with a maternity nurse. She would take the baby at night. And I would go ballistic. She would close the door and say, "Mummy has to sleep."

Arki would say, "And I have to sleep too, so give the baby up. The nanny will take care of him. We will sleep through the night and you can have him back in the morning."

Often I would fall asleep outside the nursery door sobbing from separation anxiety. The nurse would tell me gently, "Go back to bed. You need your sleep. You need to be with Mr. Busson right now."

Arki thought I was nuts. I should be so happy to have help, especially during the nights. I was mortified that not only was I being separated from my son but also I felt there was nothing I could do about it. I was so strong in my work life but when it came to my personal life I tried to please others by compromising things that were important to me. Though Jane, the English nurse, did an amazing job, because at the end of six weeks Flynn was sleeping through the night and not even waking up for a midnight breastfeed. He never slept in the bed with me and he never slept in our room. From the minute he was born he was independent.

I also wanted my independence. I was Arki's lover and playmate and I was still juggling being half of a super-couple. Also, we really

hadn't been going out that long; we were still at the beginning of our relationship. Yet I was trying to do it all perfectly. I wanted to get back into shape and into the swing of things pretty quickly with Arki, but my heart was aching to be with my newborn son. Those huge maternal instincts were so strong that I was inconsolable; the anguish was overwhelming as I was desperate to hold Flynn and be with him all the time. My head was telling me, "Yes, be independent. Have your baby sleep through the night. Have him adjusted to the perfect schedule, breastfeed perfectly, do everything perfectly, lose your baby fat really quickly." Yet my mothering instinct screamed that I just wanted to stay in bed and breastfeed my child and be nurturing. And all the time I was trying to be super-mum, super-wife, supermodel. Superwoman.

A week after I gave birth, Arki took me out to dinner. I was skinny as a rake. It was like I was never pregnant. I was quite proud of that at the time but what I didn't realise was that I wasn't eating properly. I ignored my inner knowing that you have to eat healthy food for your baby's breastmilk. My breastmilk was very acidic because I wasn't eating enough fats or good carbs. I was eating food such as broccoli and I later learned that it gave my baby wind. I didn't really know how to nourish myself properly, let alone nourish my baby.

Dressing Flynn in posh Bonpoint clothes and pushing him around Central Park in the fresh winter air, in a big English pram, made my day. Sometimes I'd take him to see Arki at his office. Arki was always in awe of his son. He loved his child more than anything. I would pump milk so that when Arki came home from work, he would have a bottle to give to Flynn. He would feed him once a day. He'd be dressed in his business suit with the shirtsleeves rolled up and feed his son. That was his big thing: he wanted to be a hands-on father. He wanted to be at the birth, he wanted to cut the cord. It was

actually quite modern because Arki was born into a society where
children were seen and not heard. The children were always around
but they were raised by nannies; the mothers didn't really breastfeed.
He wanted me to breastfeed and he wanted to be present. He broke
out from his own mould of how he was raised. He walked to the beat
of his own drum too.

Flynn was my first real love. Born on the day that celebrates love.
Arki said to me, "You can't go back and forwards to Hollywood while
raising Flynn. One of them is going and, let me tell you, it's not going
to be our son!"

And that was it. Two months later, we moved to England.

10

LONDON

London Bridge is falling down . . . My fair lady

Though it was daunting and overwhelming, Arki and I agreed that moving to London from New York made the most sense. Arki was working in Geneva and I wanted Flynn to be close to his dad. My Australian heritage was steeped in English tradition, which inspired me to want to raise Flynn with some sense of Anglo-Saxon culture and values. Of course, I was ready to give it a go.

I don't remember packing up my apartment on 68th Street in NYC; I think I just left and jumped on a plane to London with my newborn son—ready to be a new mother, ready to start a new life and a new dynamic with Arki, in a new country. Our home for the first few months turned out to be a suite at Claridges Hotel. We hired a nanny to help while I adapted to motherhood.

Arki and I had different views about how to raise Flynn. We struggled with that. I wanted to uphold my Australian values: respect for nature, respect for the individual and individuality, authenticity, bold

courage and freedom of expression. While we were a team, I desperately wanted to be Aussie earth mother while Arki was European and traditional. I was trying to do it Arki's way and I learned how to integrate the two. I had a naturopath doctor and an English nurse from London to help me take care of Flynn. I taught him to swim and I dressed him in hippy beads and let his hair grow long. So he was an unusual combination of this English aristocratic French boy blended with a kind of Aussie hippy surfer dude. I think that was the beauty of the relationship between Arki and me. We were so far apart that we actually created a really interesting life for our child and for ourselves, though it was very difficult to navigate as a couple.

Adjusting to being a new mum and being part of a new family unit with Arki was beautiful. And I was in love. However, adjusting to London was something else. I remember feeling so panicked the day Arki said to me, "While I'm away working in Geneva, find a house to rent in London." I didn't think to ask him simple questions like how much to spend on rent. What do we need, space-wise? Where in London to look for a place and for how long should the lease term be? I thought I should know the answers to such questions but I didn't. I'd always made my own decisions for myself and trusted the flow of my life but now I was considering someone else's needs as well as those of our child. I didn't want to get it wrong. I was angry at myself because the things that had come so easily to me as a single independent woman now seemed much more complicated. I found myself looking for Arki's approval and at the same time rebelling against feeling dependent on him.

One of Arki's best friends lived in London with his beautiful wife. She later became one of Flynn's godmothers. The family had a daughter the same age as Flynn and a son a little older. I found a detached house not far from theirs in South Kensington. What

a relief! At least I would have friends close by. Sadly, within a short space of time they moved and I was bereft. Before I met Arki, I had my rock 'n' roll friends who I partied with, travelled with and had fun with, but none of them had children. Now I was in a totally different mindset. I had a family yet suddenly I felt so alone. My single life making movies in LA and modelling in New York seemed like another world. I just wanted to have a friend to share my mother-hood years with. More than anything, I wanted support. And I missed my mum.

Not long after we moved into the house I'd found, we hired an interior decorator. I recollect the first day she came to see me. I heard the doorbell ring and when I opened the door, she smiled and asked, "How are you?" I burst into tears. I'd felt so alone and I didn't know what to do. I was extremely embarrassed because I barely knew her. She hugged me and said, "Let's get started making this house a home." And that's what we did.

Soon after, my culinary skills were tested when Arki announced he had invited some good friends for dinner—a prince and princess. We had been to a shooting party with them in Austria. When he asked me to prepare a meal, I was beside myself.

"Arki, it's four o'clock on a Sunday afternoon. And you're telling me they'll be here at six? I don't know how to cook or what to cook for a prince and princess."

He said, "Don't be silly. Just make a spaghetti. We'll eat at the kitchen table."

I was mortified. I didn't know how to make a tomato sauce. I had never tried. Ever! I'd lived a single life in New York where one doesn't cook in the apartment. Living in New York, I was always going out to restaurants or eating trail mix and yoghurt from the fridge. How could I entertain at home? I didn't have the slightest clue.

I panicked and Arki was frustrated with me. "Come on. You can do it! You'll figure it out."

I did figure it out. With his help. And by trial and error (a lot of error). In time, I learned to be relaxed. Giving it a go was again the secret ingredient! I had this illusion that distinguished people want lots of pomp and glamour. In fact, simplicity is where it's at. As long as they have good wine, simple food, great music, gentle lighting and are surrounded by fun people with interesting conversations, dinners flow smoothly.

As time went by, I began to adapt to the flow of life in London. The feeling of being a fish out of water there subsided slightly, enough for me to get on with being a present, conscious mother. I stepped into a mature role as Arki's partner, building a home, finding a community of friends in London, still retaining my working identity, modelling and acting, looking after my lingerie business, feeling good, being fun to be around, yet all the while being a responsible wife and mother. Looking back, I don't know how I did it all but I managed to. Until I didn't.

In the summer of that first year in the England, we went to Ibiza for two months, as Arki had done in previous years. This time, though, he would be spending the time with his new family. He'd left Geneva the day before and was already in Ibiza waiting for us. I remember walking through Madrid Airport with ten bags in tow, a baby, a nanny and the excitement of spending time in the sun, away from the stresses of London. I was looking forward to taking Flynn swimming in the Mediterranean. I had stopped breastfeeding him; I timed that especially for our vacation. I knew I wouldn't be able to keep up with his feeding routine so I had weaned him off my breast after six months. Although I wanted the freedom that comes with supplementing feeds with formula, I remember feeling a little sense of

loss. I missed that close, deep contact of nursing my baby, but I knew Flynn was ready; I could sense he wanted his independence too.

While waiting for our flight, I gave him a little piece of dry cracker. It was one of the first times he'd eaten solid food. I watched his face and smiled as he savoured the salt on the cracker. Then, quite suddenly, he didn't seem himself. His lips began to swell and his eyes started closing. I said to his nanny, "Something's wrong with Flynn."

She looked at him and said he was fine, he was just tired. But I insisted, "No. Something is wrong."

She calmly replied, "You're just nervous about feeding him and travelling. He's okay."

He wasn't okay. And I knew it. I grabbed him out of his pram and ran to the airport pharmacy. In half-French with a Spanish accent, I said to the woman at the counter, "Something's wrong with my child."

She looked at him and straightaway pointed, saying, "First Aid, down the hall."

I ran to First Aid. By the time I got there, Flynn's lips were swollen, distorted. He looked like he was passing out. First Aid quickly examined him and advised me to take him immediately to the city's emergency paediatric hospital. Holding Flynn in my arms, I ran through the airport and out the doors. Jumping into a taxi, I tried to explain to the driver where I wanted to go. He looked at Flynn, saw my panic, and no more words were necessary.

We sped off to the hospital. On the way, Flynn was having trouble breathing and I prayed that he wouldn't die. My beloved boy. It was heart-rending to see him in distress and I kept thinking, "Arki is going to kill me. I haven't looked after his firstborn son." I was in such a panic, I could barely breathe myself. I kept putting my finger into Flynn's mouth to keep his tongue in place while everything swelled

beyond recognition. The adrenalin raced through my body. I had never felt fear like that in my life. The stress was excruciating and I sobbed, I was so scared.

I had rushed out of the airport without my phone, wallet or passport. When we arrived at the hospital, I couldn't pay the taxi driver. He was so kind and understanding, he let me go without having to pay. With Flynn in my arms, I ran through the Emergency entrance shouting, "Something's wrong with my baby."

Three nurses came running to me and quickly took Flynn. I couldn't understand anything they said in Spanish, which made matters worse, but I did hear the word, "Alergia." I suspected Flynn was having a reaction to wheat or something that was in the cracker I'd given him. I watched as they gave him a huge injection. It was so distressing to see him like that. I honestly didn't know if he was going to make it.

Miraculously, within a few hours he returned to normal. His lips had been blue, swollen and looked ready to burst, but after the shot, they started to look more relaxed. He even began to smile in a lopsided way. I felt such relief and gratitude for the fast actions of the team at the paediatric hospital in Madrid. They saved Flynn's life.

Now I had to deal with the messy situation of no passport or money in a foreign country. Flynn's nanny had been waiting at the airport with no idea of where I was—without my phone I couldn't call her or Arki. Finally, I managed to make a collect call to Stu and he arranged all the payments and paperwork and rebooked us on a flight the following day to Ibiza. I didn't want to tell Arki over the phone what had happened, as I didn't want to worry him, so I explained when we arrived. From that day on, I could never rest and was always watching Flynn's face as he tried new food. What a powerful influence that must have been on our son, having to witness the anxiety of his

mother every time he put something in his mouth. It's a miracle he's so well adjusted today!

Despite what had happened at the airport, we had a truly wonderful holiday. We were excited as new parents and loved spending time together. We rented a house from a friend of Arki. It sat on a cliff overlooking the sea. That house became the mecca for the fun people. They came from throughout Europe. Our days were spent entertaining with long, wine-drenched lunches and late nights. Arki had a little rubber dinghy. We called it the *Elki*—a mix of our names. Of all the amazing boats I've been on, *Elki* was my favourite. The simplicity of a rubber dinghy, a pasta dish made for a picnic lunch, my son, the sun, my love, smiling, snorkelling, freedom. Wonderful. Those days rest deep in my heart as some of the best in my life.

Following the anaphylactic emergency with Flynn that summer, he developed asthma and eczema, so much so that his cheeks sometimes bled. I didn't know what was causing these issues. He was in and out of hospital because he had pneumonia or he couldn't breathe. I would take him from doctor to doctor and they would say he's fine and that I was a nervous mother. But I knew something was going on. My inner voice whispered to me, my inner sense kept telling me; my intuition knew that Flynn needed help.

It was after another particularly acute allergic response to something he ate or was exposed to that I had the opportunity to take him to the paediatric ward in Miami on our way to the Bahamas. I wanted to see if American doctors could find out why he seemed so poorly. They did more extensive allergy testing than had previously been done in London. The tests came back listing nearly 100 sensitivities—dust, dust mites, mould, mildew, disinfectant . . . you name it, Flynn had it. The biggest trigger was peanuts. I remembered that day in Madrid Airport, two years before, when I had eaten peanuts and the oil must

have still been on my hands when I gave him that cracker. Finally, a diagnosis that made sense. Now I had the information and tools to help my child. I could stop fretting and wondering what caused his episodes. Whenever we travelled, it was always with an EpiPen, and as soon as Flynn learned to talk, if anyone offered him something to eat, he would say, "No nuts." It took quite some time before I became reasonably relaxed about his condition and certain that another emergency could be dealt with confidently.

When I finally felt that Flynn was stable, I decided to go back to acting. My last role, just before I became pregnant with Flynn, was *With Friends Like These.* I felt it was my best performance and it had given me some confidence, so by 2000, two years after Flynn was born, I was inspired to return to film work. This came in the form of a role on the sensational American sitcom *Friends.* I played the character of Janine Lecroix.

I'd never actually seen the TV series, though it was a huge success in the US, but Stu had said it was incredible and I was cast. I had to do it. I didn't see the show or script before leaving as I was too busy getting organised. I packed up Flynn and flew to LA to start filming the next day. Once I got to my hotel, I watched a DVD of the show. OMG, that cast—Jennifer, Lisa, Courteney, David and Matthew—was incredible and the show was filmed live! How could I ever hold the stage with them? I wanted to throw up from my combination of fear and anticipation. Thank god I hadn't seen any episodes prior to flying because I probably would have passed on the offer, thinking I was not capable.

As it turned out, it was one of the greatest working experiences in my life. I remember the first day pulling up to my carpark space at Warner Bros., thinking, "I could get used to this." Lisa Kudrow had a child the same age as Flynn and they played in the crèche on set,

while we worked. The team from *Friends* was so kind and patient with me. They embraced my raw sitcom inexperience and helped me learn how to perform to a live audience and with a script that changed at every take. It was almost improvised. They were amazing actors and I watched them, studied them and learned so much.

I felt out of my depth having to remember my lines instantly— and I didn't want to let the team or the show down. Some of the jokes I didn't understand as they were distinctly American references. I played Matt LeBlanc's roommate (who became his girlfriend) and he was such a gracious acting partner, encouraging me in our scenes. The show was brilliantly written by Marta Kauffman. Working with this amazing team gave me the confidence, companionship and a community I'd so missed when I was in London.

Off set, I had a lot of fun with everyone and I especially loved the nights we would go out for Mexican food and margaritas. Jen was with Brad at that time and I loved seeing them together. Lisa and I went to Mommy-and-Me classes. After six weeks, the team asked me to stay on for more of the series but Arki wanted me to come home, understandably. He missed Flynn and I don't think he really wanted me embroiled with acting life in LA. Very difficult to keep a family stable under those circumstances.

Those first few years, just after Flynn's birth, were crazy. I stepped up and into the groove of London. Arki's business was flourishing. Having had a long history and deep commitment to philanthropy, he and I co-founded an initiative called Absolute Return for Kids (ARK), an international children's educational charity which became a large charity in the UK. This meant we were constantly organising events to support the initiative and this required publicity and exposure. As a result, Arki and I were becoming the "It" couple of London.

We featured in glamorous society magazine *Tatler* as the most charismatic couple and best hosts. Achievements of that kind seemed important for business.

And then there were the parties. And parties and parties. Parties for work, parties with friends, parties for fun, parties to get to know people. Philanthropy, family, friends, Arki's business and mine, the never-ending press and engagements ... it all blurred into one, creating ever more pressure to perform.

Pheasant and partridge shooting in certain circles in England is a huge sport and an important networking exercise. We were invited to go to shooting parties all over Europe. Arki would say, "Elle, take note of all the details. We are going to have a shooting property. Let's incorporate the best from every shoot we see."

So we went to Austria, Spain, America and Germany, and I observed everything from the way the table was set to the service and entertainment, the dress codes, the food, the shooting gifts, everything. Sure enough, on our return we decided to lease a property on the North Yorkshire moors, near Whitby, the town Bram Stoker drew on when he created Dracula. Our residence was a stunning castle and in it we set about creating the most fun, interesting, spectacular four-day parties. Magicians, musicians, fireworks, themed dinners, murder-mysteries, kids' parties, caviar, black tie, billiards, walks in the country, lots of drinking. Bullshots at nine a.m., Bloody Marys at eleven, great wines at lunch and then long, drawn-out dinners that sometimes ended in the classic English food fights and drinking games. Arki would compliment me on my ability to host with grace, but really what I was good at was setting the stage for him. And even though I was uncomfortable and panicked a lot of the time about guests and meals, I got such pleasure out of creating a beautiful space in which to play.

We'd visit Arki's family in Europe. His parents, by then divorced, were well known in the social set, particularly his mother for her joie de vivre, vibrant personality and love of backgammon. When they were young, she travelled with Arki and his sister between Paris and Switzerland during the winter, and on the French and Italian Rivieria during the summer. Arki was a master in any social setting and he glided through that life with grace. I, on the other hand, felt clunky despite my profile and years in fashion and at times I still froze, unable to remember people's names. Arki would graciously look at me and say, "Elle, you know so-and-so, you met them at such-and-such." But still I would panic and blank while he would be silently exasperated.

I found myself leaning into the confidence that drinking gave me. Arki had the constitution of an ox. He was relentless and I wanted to keep up. He'd return from his weekdays working in Geneva, and grab London life by the balls. He lived with such exuberance and a delicious savouring of every detail, never wanting to miss out. To cohabit with that was exhausting, especially when you have a baby, and the whole situation became a rollercoaster. And chaotic. We're going here, we're doing this, we're doing that, we're meeting so-and-so; in the end it was very difficult to keep up. I don't know how he did it. He still walks into a room and the room stops. Either he's brooding and he commands attention from his smouldering intensity, or his delight is so infectious you wonder who that charismatic guy is in the corner laughing so loudly.

So Arki and I had a vibrant, kinetic social life. We loved our friends, who were from all walks of life. Arki was always inspired by variety and cherished socialising, spending time on holidays and special occasions with other families. I did my best to adapt to the constant stream of people and events; finding companionship with other women who had common interests and a sense of humour.

My business career was quickly evolving. The lingerie licence with Bendon was thriving and I had become creative director of the company. Elle Macpherson Intimates had expanded from Oz into the UK, US and Europe. I longed to see it blossom and yearned for my own business identity as I found myself blending more and more into Arki's world. I wanted to establish an identity outside the whirlwind of super-coupledom he and I were living. Arki seemed oblivious to it all. Still, my family was my priority; they always came first. I took on work opportunities that paid well without consuming too much time. For example, in 1999 I found myself on a postage stamp of Bermuda and Antigua—how random.

That year, Stu called me and said I'd been invited to participate in the closing ceremony of the 2000 Olympics in Oz. I was thrilled— what an honour! I went to my fittings and was given a showgirl-type outfit to wear. There was barely anything to it. I was to parade on a huge lens of a giant camera that made up the float, surrounded by dancers on the tracks below me.

Rehearsals for the ceremony, whose theme was Australiana, went well, but I was tense. I was nervous enough walking a runway when it was on the ground, let alone sixty feet in the air! There were so many stars taking part in the ceremony, including my friend Kylie Minogue, who sang "On a Night Like This" near the end of the show.

When the ceremony kicked off, I nearly froze to death, having so few clothes on while a bitter October wind blew. And to top it all off, I missed the closing song, "Down Under" by Men at Work— I got lost on my way back to the stage and missed my cue. I had drunk enough champagne or vodka to calm my nerves that it had disoriented me. I will always regret messing up my part in the finale. I arrived late and was out of time and rhythm for the last dance with all the celebrities who were performing. Of course,

nobody noticed or cared, but I was mortified. I carried that embar-
rassment with me for years.

Life in the spotlight intensified. Arki, Flynn and I travelled
constantly. Of course, when you get to the airport you've got cars and
photographers waiting for you, but it also came with pressure. We
attended many dinners and social events. We would spend winter in
Gstaad, summer in Ibiza, spring in the Bahamas, London during the
"season" and everything in between. Each trip, I was absorbing my
surroundings, still paying attention to how my hosts would entertain,
flower arrangements, guest lists, table settings, arts, museums, music,
languages. I fully immersed myself in a multi-faceted European and
English lifestyle as a corporate wife.

I was part superstar, part super-mum, and a whole lot of barely
coping underneath it all. I was also very proud. I didn't want people to
find out that I didn't know half the things they thought I did. I asked
questions when I felt I could, but most of all I was a quick study.
I remained determined to retain my own identity through all this,
so I kept working movies and securing public appearances. Anything
I could get my hands on just so I could feel I was always connected
to myself. Of course, that was all on the outside. Underneath, it was
difficult not to feel fractured as I straddled the differences between
Arki's life and my own; between my dreams and desires, and his. My
dreams and desires, and the dissonance between those and the life
I was actually living.

It was easy to walk in Arki's charismatic shadow but I continu-
ally challenged myself in an effort to feel independent, me. When we
lived in England, photographers camped outside our home. Every-
thing I wore was dissected on the front page of newspapers. "Today
she wore these shoes, she carried this bag, she had these sunglasses
on"; "How to dress like Elle." I would panic as I felt like I never really

knew how to dress. Often I still felt like I looked wrong, unfashionable. I couldn't settle into being that girl who looked cool coming out of a nightclub, no matter what I did. I felt like I made an impact but I didn't photograph well. I was self-conscious a lot of the time.

In 2001, I was asked to host *Miss Universe* with Naomi Campbell. Promoting a beauty pageant was so far from what I really wanted to be doing, even as glamorous as it seems. I felt deeply conflicted. I didn't enjoy women being portrayed in such ways but I did love working with Naomi. She's feisty and fun and sees opportunity wherever she goes. Something about the supermodel collaboration always interested me and we had a long history dating back to the Fashion Cafe debacle in the '90s.

By this point in my career, I had the cool experience of having a wardrobe and fashion stylist for my appearances. She came to the house and created a wardrobe for me for two weeks at a time. Every morning my wardrobe would be ready for the day and that took a lot of pressure off. Paparazzi would snap pics of me and the next day the clothes would be returned to the designers who'd let me borrow them for visual credit. They were happy that my name was attached to their label. Finally I looked great! Being a celebrity requires an incredible amount of organisation and attention to detail. On the upside, the attention to detail is what I'm really good at; on the downside it can become a fixation—I would pick myself apart.

I also did movies back to back. I took the role in *A Girl Thing*, playing a woman exploring her sexuality and sensuality and discussing this with her therapist (Stockard Channing) and eventually exploring a relationship with another woman (Kate Capshaw). Acting these scenes was so liberating. It stretched me way beyond my comfort zones physically, although intellectually I was at peace with the subject. Actually kissing another woman and being physically

intimate with her on set was something else. The scene was deeply respectful and Steven Spielberg (Kate's husband) was very supportive. It was tastefully shot and we felt the subject matter was beyond its years. Films like this were not as common as they are today. I think a part of me was trying to stretch beyond the conventional mum/wife paradigm, expressing myself and my desire for freedom in film.

I starred in the Italian-British romantic comedy *South Kensington* with Rupert Everett. I phonetically learned Italian for my part of Camilla, taking me out of my comfort zone again, and putting my language skills to the test.

All through this time, I was struggling with Flynn being unwell. My heart ached for his well-being and it was distressing to watch him struggle. Nursery school wasn't easy for him, being asthmatic with anaphylactic allergies and a profoundly compromised immune system. He was also diagnosed with and had to learn to overcome dyslexia and dyspraxia, and all they entail. In time he developed a brilliant understanding of computers, as he found it hard to write, and learned touch-typing to help him with his schoolwork. Through it all, he never complained. That's Flynn—independent, determined, resourceful, polite, strong-willed and deeply capable of anything he sets his mind to. He has a wicked sense of humour, grace and elegance and this was evident even as a young boy. I always say "he is himself"—the best of both Arki and me.

When Flynn was a baby, I would put him to bed at 7 p.m. I was extremely disciplined, ordered, responsible, reliable, organised, structured. Not 7:15 p.m. Not 6:45 p.m. Bedtime was 7 p.m. With clockwork precision. I was secretly motivated by my 7 p.m. vodka on the rocks—reward for a day well done.

Although, it was never for one drink. As often as Flynn was unwell, so was I. I had enlisted the help of two naturopaths, Guilia

and Isabelle. Whenever Flynn and I were poorly, they'd help restore us back to health. They would come to the house late at night when I called, panicked about Flynn or myself, or both of us, having pneumonia or difficulty breathing. Truth be known, mine was probably self-induced. Too much of everything and not enough quiet downtime. Too tired, too lonely, too anxious, too many vodkas and too many long hours in the day juggling, juggling, juggling while making it all look effortless.

In February 2003, beautiful, angelic Cy was born peacefully and quietly at St. John and St. Elizabeth Hospital in London. The room was bathed in tranquil candlelight. It was as though Cy and I had created a telepathic communication between us: we didn't make a sound. My contractions came only when I was ready as if, even then, he knew the perfect rhythms of my being. I felt such profound connectedness then and I've always felt a soul connection to Cy ever since in the most pure and aligned way. It was a powerful experience. It seemed so totally natural, like notes from the same sheet of music. That connection during our blue-eyed, blond-haired boy's birth accentuated our family nucleus of love right then.

My obstetrician and doula were present to help me with the birth. After a couple of hours in the bath, I recall getting out of the water at one point, and standing naked in front of my obstetrician while he practised yoga. Hands on hips, I looked at him with all the fiery determination I could muster and said, "Are you going to help me deliver this baby or what?"

He opened his eyes and, while still in the tree pose, calmly said, "Get back into the bath and on your next contraction, push. You will then feel the crown of your baby's head."

"Is that it?" I asked. "Why didn't you tell me? I didn't know I had to push during the contraction."

"Always believe in yourself.
Never give up on your dreams."

"I was a fast study, always looking
to apply what I learned, and what
worked and what didn't."

"Understanding the journey from fear to Love is a daily, sometimes moment to moment, practice."

"I thought I'd feel secure and stable building structures around myself such as a huge house."

*"I learned about working
so hard in life that you miss out
on what's really important."*

"Fear of the unexpected; fear of uniqueness.
It is that fear which requires to be healed."

"Connection is created by allowing
each other the freedom to express
and live our uniqueness."

"I wanted to find the rudder and sails
within me to navigate out of the
storms and into calm waters."

So I did. Within three pushes Cy was born, peacefully and quietly, five years and ten days after Flynn. Arki leaned over the bath and kissed my forehead while cutting the umbilical cord to save for stem cells. I was furious as he cut it too soon and we were supposed to wait until it stopped pulsing. The empowered feeling I had from my natural birth dissipated. My doctor was mortified as we had a birth plan and Arki's early cut was not what we'd agreed. But I didn't want to argue and Arki, as always, made a compelling case.

Soon after, Flynn came in, quietly shining the little light of his favourite torch, a gift from "Pops," my dad, as if to say, "The light is here too." My mum had come over from Australia to care for him while we were at the hospital, and they arrived together.

The moment Cy arrived, I felt my heart open like never before. I often worried that I could never love another being as much as Flynn, but the magic of Mother Nature is that your heart capacity just grows to accommodate another soul's new birth.

Later, Guilia and Isabelle came to perform a cranio-sacral adjustment on Cy. I loved those two women who had stood by my side treating Flynn and me when we were unwell, and now in these hours. Once they finished their treatment, Isabelle looked me in the eye and said, "Don't drink that bottle of champagne the hospital gave you to celebrate Cy's birth. Your hormones will be all over the place." She held my eyes for a beat longer than was comfortable. Guilia looked at me as if to reiterate Isabelle's statement.

I felt a hot flush rush over me and I smiled and said, "Of course not."

After they left and I was alone with Cy in my arms, all I could think about was that bottle of champagne in the ice bucket.

Cy and I returned home from the hospital and once again I contracted pneumonia. Arki lovingly took care of Flynn while Cy and I spent the first month of his life in bed. Isabelle and Guilia were constantly by

my side. I shared with them—part osteopaths, part naturopaths, part therapists—my thoughts on everything I was fearing: would I be able to handle two kids and my lifestyle with Arki, work, looking good, travelling? I still felt alone, isolated and overwhelmed even though, outwardly facing, everything seemed perfect and nobody would have guessed the truth of how I was living or feeling. Not even Arki.

As I had done with Flynn, I lost my baby weight within a few weeks. But this time I was eating even less due to the pneumonia. That suited me fine, but Cy, as Flynn had, struggled with the acidic quality of my milk. After some weeks, we finally started to heal and Arki and I were off and running again—travelling, endless parties, work. I loved spending time with Arki and once again I wanted to prove to him I could be his partner in fun and business while being the mother of his sons. And I wanted to prove to myself that I could perfectly juggle my work and the children as well as the household.

Yet there were so many nights I dreaded first light. Desperate to be home and asleep before daybreak to disguise the fact that I'd been out. Often I would get back in time to pretend it was still night but would lie tossing and turning, watching the slits of dawn break through the curtains, panicking that I had to get up for work or the children an hour or two later. That sick feeling of dread would wash over me—guilt, fear, anxiety.

Eventually, after about three months, it all came crashing down.

Isabelle and Guilia were constantly coming to the house. They had spotted inconsistencies with my health and what I claimed I was doing in general. I would get pneumonia and they would work for hours providing natural healing. I would be fine for a day, then sick again. And they became exasperated. Isabelle and Guilia recognised that there was a core issue but they didn't know what it was. In the end they realised that whatever it was, it was not natural.

One day, they came to me and said, "Elle, we are not going to continue to treat you. We do all this work on you and your children and you just abuse your body. So, we won't come and treat you and put you back together every time you are self-harming." Firmly but lovingly they said, "Elle, you know why."

My heart beat so fast, my mouth became dry. Panic gripped me—I had been found out. They were healing me but when I felt well again, I would go out and drink, party and become sick again. It became a constant repeat: I was in a horrible downward spiral. I was beside myself because these women were the cornerstones of my life. They were the women I looked up to. They were women I trusted and now they were applying tough love.

I begged them to stay with me but they suggested I see a therapist and referred me to a woman called Lois, who I later found out specialised in addiction crisis.

I clung to Lois as I watched the pieces of myself gradually come crumbling down. I talked to her about my fears around Flynn's health, Cy's lack of sound sleep, my love for Arki and my inability to keep up the charade of being "perfect."

Lois listened as I also shared with her my devastation and anxiety over Isabelle and Guilia leaving. I felt abandoned but knew deep in my heart it was the greatest act of unconditional love. We discussed my fears around parenting, highlighting my concern that I didn't know how to play with Flynn. I said to Lois, "I love my son. I know how to look after him, bathe him and feed him. But I don't know how to just hang. I don't know how to play with him, Lois."

I never played much as a child because I had responsibilities. I never seemed to have the time or the inclination to play; I was always so serious and intense. By the time I was three and a half years old, my mother had another child; and by the time I was seven, she'd had

two more. I was feeding my siblings breakfast and changing nappies, all while I had one on the hip. I was a little mum very early on, trying to help my mum, who had her hands full. And my mum was a good mum. Being a mini mother was how I bonded with her—trying to be just like her and helping her.

"Go to the school and watch how other mums are with their children," was the advice Lois gave me.

And that's what I did. There was one mother I noticed who was French. Marie-Laure. She was the last woman in the world I wanted to have tea with in the afternoon but Lois suggested I do it. So I did.

Marie-Laure actually reminded me of Mary Poppins. When I saw her at school she was always perfect, her hair up in a big bow, a full skirt to her knee, and wearing Mary Jane shoes. Her children were always perfectly groomed, too, and they were smart high achievers. And she got along with them easily, naturally. In fact, I noticed she had an amazing relationship with her children. I asked her if I could come over to her house and just sort of watch and see how she did things. And she agreed. The day I went to visit, her home was chaotic and disorganised but she was relaxed and there was lots of laughter as Marie-Laure multitasked, doing homework, music lessons, baking cookies, making dinner, bath time. Somehow they got it all done with joy and that fascinated me.

I watched Marie-Laure and took it all in. I'd always thought everything had to be perfect. The fact that her children didn't have their bath at a certain time didn't matter. That was perfect in itself. The fact that they didn't take off their uniforms as soon as they got home from school didn't matter either. I thought everything had to be structured. What I realised, though, was that chaos, not control, is where the love is. Hers was a very different kind of chaos than I had. I was trying to do everything on schedule, by the book. She didn't do that, yet her children were happy and Marie-Laure went with the flow

and took each task in hand with gusto. It looked effortless. Through that visit, I began to understand how a parent played and interacted playfully with their children. I had no idea how to be that way and so I learned a lot from her. I could see that I needed to surrender some of my control, and I said to myself, "Oh wow, that's how you play!" Marie-Laure and I actually became good friends and our children became great playmates.

I was now a mum to two little boys. Despite Lois's counsel, I didn't really know how to readjust and slow down, focus on healing after Cy's birth. Lois was like a mother in many ways. She even called herself my "godmother in light." My mum was on the other side of the world and I missed her terribly. I missed the mother–daughter connection and being able to turn to her when I needed help and advice. Lois eased that void. I met with her once or twice a week. Sometimes three times a week when I was inundated with the pressures of life.

It was a few months after Cy was born that Lois said to me, as Guilia and Isabelle had, that she felt I was not committing to the emotional and spiritual work she was trying to do with me. She said I could never make any progress because I was escaping through alcohol and other harming behaviours. She recognised I was numbing my feelings, so we could never really get to the core depth of what I needed to address: I simply wasn't present. She basically said to me that she was getting very close to the point where she wasn't going to continue to work with me. We had reached a plateau. Essentially, she felt she had done everything she could and she wouldn't continue our therapy sessions unless I stopped drinking.

Lois suggested that I go to rehab. The thought of losing her was unbearable so I finally agreed to get help and go to treatment. Not because I thought I had a problem but because I didn't want to lose her support.

Going to rehab had actually crossed my mind a few years before Cy was born. I'd mentioned to Arki that I was concerned about how I was handling life. Or more to the point, not handling life. I told him I felt like I needed to go to rehab and he said, "No, you don't. You're fine. You're just having a bad time at the moment." I think he was afraid. He didn't want me to be away from him and I think he was also afraid of change and concerned about what I would be like when I returned home.

So I heeded Arki and I didn't go. I tried to do things differently. I also tried to stand up for things that were important to me, which created more conflict between us. I didn't really have the strength to keep doing that, and nor did I know what I wanted. Back then I just ignored my inner sense when it whispered to me that I needed help.

After Cy was born, Arki knew I was really struggling. So when I told him that Guilia and Isabelle had left because of my drinking and Lois had suggested I seek help, he accepted that there was a problem. Professional practitioners were advising me to get treatment. And I believe that by then Arki was also ready for me to go to rehab. I was unwell and unhappy. Even though he saw undergoing rehab as showing weakness, he wanted me to do whatever it took to get me back on track. He just wanted the problem fixed. I was scared to tell him, in a way, because the first time I had mentioned it he had been so resistant, afraid of it.

We are all like that. No criticism of Arki. We often do not want to do what it takes to stop the pain. It's one thing to want to fix things and another completely different thing to grasp what it's going to take to make that move. Often we are closed to change. Sometimes it seems to feel better to accept the devil you know. But for me, I listened to my heart this time. The Universe had whispered once before to go to rehab. Now I was going to take the steps that would change my life forever.

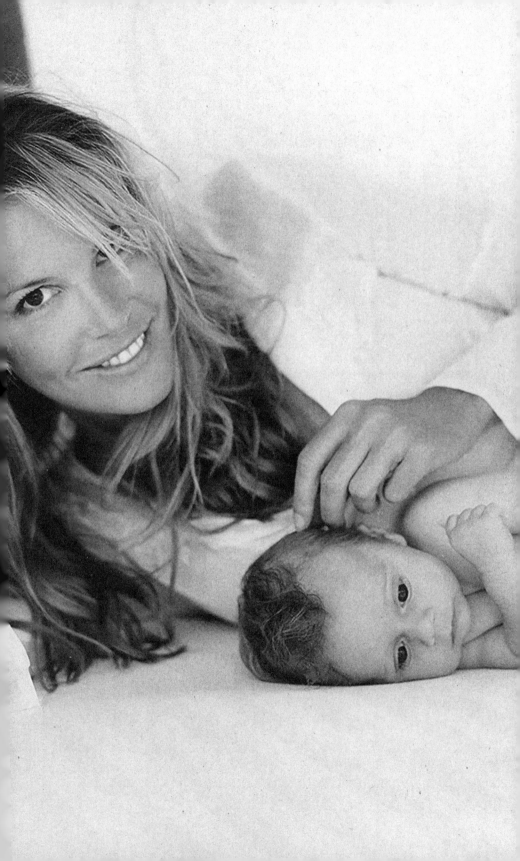

11

RECOVERY

My name is Elle
and I'm an alcoholic

God, grant me the serenity
to accept the things
I cannot change,
The courage to change
the things I can,
And the wisdom
to know the difference.

My heart was beating fast as I walked into the AA meeting being held at a church in London's Knightsbridge.

When I was first asked to share my story with the group, it was near the end of 2003. I was two months sober. There's an unspoken rule in AA that when you are asked to do something, you don't say no.

I said yes.

I was feeling a mixture of anticipation, excitement and trepidation going to this particular meeting. Like walking into an exam, I wondered if I had studied enough to pass. Today's meeting was different. It wasn't in the big hall of the church, where most meetings were held, it was in the children's crèche, downstairs in the crypt. It was quite apt that this is where my first share would be because it was really my love for my children that had got me here. And I felt as though I was a child learning to walk all over again.

We sat around in a circle, which was unusual because normally we would sit in rows with the speaker at the front. When I'd first started going to meetings I'd sit at the back of the hall trying to blend in, be invisible. But I'd arrived late one night and as the room was packed I had to sit at the front. I was told after that to always sit there so I could be truly present and not be distracted by others; I would be able to totally concentrate on the speaker, eyes forward, ears and heart open.

At that meeting, when it had come my turn to introduce myself, I said, "I'm Mac, and I'm an alcoholic."

An AA friend sitting next to me had looked at me quizzically and asked, "Mac?"

"Yeah," I whispered. "I was Mac at the rehab I went to and the name stuck. My sponsor even calls me that."

He raised one eyebrow and I felt hot and flushed. I knew then I shouldn't try to hide any more. But still I tried to convince him otherwise by saying, "No, no, it's not what you think. It's just a nickname."

He looked at me and smiled.

His questioning resonated with me, though, and the next time I went to a meeting, I took ownership. When it was my turn to introduce myself, I said, "My name is Elle."

This evening—my sharing evening—I was talking to another packed room. A few people were making themselves a cup of tea and everyone was chatting. I went and took my seat next to the secretary. The mere prospect of sharing my story was nerve-racking, mainly because I didn't quite understand it myself.

The night before, I'd dreamed about what I would say. Of course, I wanted it all to make perfect sense and to speak with warmth, wisdom and clarity, like so many of the other people's experiences I'd heard in AA meetings, all of which had touched my heart.

My hands were clammy and I was starting to sweat. Afraid my voice would tremble and betray the strength I actually felt in my soul, I wondered if I would make sense. Would I remember the points I wanted to make? Would I blank before the end? Would I cry when I got too close to my heart truth? Would I be able to stay in the moment or would I rush into my head to formulate the story in a "nice" way?

Nervous, I got up and went to the bathroom. I stared at myself in the mirror, wondering who this girl was looking back at me. In my hand, I clutched a chip that I'd received in rehab. This chip was precious to me as it signified that I'd been sober for thirty days. That in itself seemed a miracle. Just for a moment, I took the time to say a prayer. I asked for help from the Higher Realms to give me the clarity and strength to share my truth.

Before I left the bathroom, I called my sponsor. "Hi, it's Mac. I'm about to share for the first time and I don't know what to say. I don't know where to begin. I'm so nervous. I want to get it right."

My sponsor replied, "Just let go and let God speak through you. Share your story just as it feels today. Be the Light. Be you."

She reassured me that all I had to do was be myself.

Be me? I still wasn't sure who "me" was in this new-found sobriety. The me I was?

The "me" I wanted to be? Or hoped to be?

I figured all I could do was be the me I was that day. Solved.

I went back into the crowded room and sat down. I saw a few of my new AA friends in the group. Just knowing they were there helped me and I was grateful for their love and support.

A hush fell over the meeting immediately before 6 p.m. I could feel the energy in the room heighten. Then the bell rang.

Breathing deeply, I clutched my chip and, scanning the room for reassuring, smiling faces, I tried not to tremble. I prayed not to cry. But I did. I always do. Something deep inside of me is always moved by the desire to help others by sharing my personal experience of life.

The tears rolled silently down my face and my heart was pounding as the energy washed over me. I heard the chairperson say, "Welcome to the six o'clock meeting of Alcoholics Anonymous. Today we have Elle sharing her experience, strength and hope. Please welcome Elle."

Everyone clapped as I nervously smiled. I swallowed hard. I was so tense my voice felt blocked and I began to sweat again. I took another deep breath, recalled the first few words of what I wanted to say, and then it all flowed.

"Good evening, everyone. My name is Elle and I'm an alcoholic.

"A little bit about myself. In 1998, I came to England with my partner and my three-month-old son after living in America for fourteen years. My son became sick. He was in and out of hospital from a very early age. He had a fragile immune system and as his health deteriorated, I became worried something serious might happen to him. My partner was away during the week, so it was only my son and me at home. In the evenings, after I put him to bed, I'd find myself relaxing with a vodka."

Getting to that admission opened a flood of thoughts and real-isations from some deep well of memories and the words seemed to

continue to flow forth. I explained how, as the months went by, I had become overwhelmed; how, along with the father of my children, I had lived a fast-paced life and attended a lot of social engagements and, whenever we could, we also travelled. Our life was so big. Through it all, I'd tried to be a good mum, not forgetting that I had a business to run.

Looking into the faces of those at the meeting, I carried on. "My life looked amazing to everybody. On the outside I was doing a beautiful job but, deep down inside, I was really struggling. My inner sense was telling me that something was terribly wrong, but I wasn't sure what. I wanted to find out and I wanted to understand why I felt the way I did. I also wanted to know more about myself; to understand who I was. So I decided to go to therapy."

These words weren't about justifying myself or making excuses, because those faces at the AA meeting understood what it was all about. The point I wanted to make was that I knew I needed help. I had sought therapy and that was actually the turning point when some part of me had realised I needed to address my lifestyle. It was the part of me that took responsibility and turned it into action.

"My therapist could see that I was going through a hard time coping with my life in general and now being a new mum to my second son." I paused . . . and looked around the room. Everyone was watching me, waiting for me to carry on. It was difficult because I didn't know most of these people. I was opening up and talking to strangers about my private life and sharing my innermost personal memories, thoughts and feelings. I squeezed my chip tighter in my hand and carried on.

"During sessions with my therapist, I explained how I was striving to be a good wife to my partner. I confided in her about my hang-ups regarding my body image and how difficult and painful my fixation on

perfectionism was. I talked to her about what seemed like obsessive-compulsive behaviour: always feeling like everything had to be in its place. I shared how painful that was. It was as if arranging everything on the outside would help me feel more settled on the inside.

"People would tell me I was so organised. I was really proud of that. I guess I had to be organised because I was drinking and I never wanted anyone to know. So I made sure the house was clean and tidy; I made sure I looked great and I made sure the children were perfect. I made sure I never skipped a business meeting or any of my sons' appointments. I ran my life like a well-oiled machine.

"After my second son was born, my drinking escalated. I started drinking more heavily, particularly on the weekends. I'd tell myself, oh, I'm just having a couple of drinks on a Friday night to relax. It's fine. But, there was a part of me that had a tremendous amount of unease because I intuitively knew it wasn't right. I strived to numb the emotions that accompanied the realisation that I wasn't listening to my inner voice. I felt fragmented from my soul. I was living my life without a conscious spiritual connection to Source.

"My life was full-on and drinking brought me relief and helped me to relax. It was always the same excuse—I wanted to drink because I'd had a hard day and needed to unwind. It was a reward to myself. Often I would drink after I put my children to bed. I would sit down by myself and have shots of vodka and then I'd write to-do lists and letters to my family. I would do the housework, listen to music until around 11 p.m., then go to bed and pass out. I would get up in the morning, run six miles and have a coffee for breakfast.

"When I drank, I was just inside the feeling of being inebriated, numb to my emotions, and I loved it. Finally . . . finally I could breathe. I didn't think I was doing anything wrong. At first, it didn't register because I was perfectly responsible everywhere else in my life.

It was also part of my social lifestyle, so for the longest time it was hard for me to identify that I drank too much.

"Drinking took away the anxiety that I felt about my child being unwell, not to mention juggling the birth of my new son, coupled with hormonal imbalances after the birth; trying to be a perfect wife and a perfect mother and a perfect model and a perfect business-woman. And it was all too hard. My anxiety was so overwhelming that, if I had a few drinks, I could relax and just enjoy some peace. But deep inside, I knew I wasn't being true to myself.

"At one point, I found myself having blackouts. But I didn't consider them to be blackouts. Or if I did, I ignored them. I would be talking to somebody and then I would forget what I was saying. They would look at me quizzically as if waiting for me to continue. Self-consciously, I'd ask, 'What did I just say?'

"Concerned, they'd ask me if I was okay.

"I'd hesitate. 'I can't remember what I just said.'

"Then they would tell me, 'You said this and this and this . . .'

"I'd been holding conversations and I couldn't remember parts of them. I'd think to myself, I don't know if vodka and other substances go well together because they seem to be doing something to my brain. Maybe I just need to be doing one or the other but I can't do them both.

"Growing up in New York City during the eighties and nineties," I continued, "recreational drugs were commonplace. It sort of went with the territory and people would always say it wasn't addictive. At times I micro-dosed just like an espresso, to keep me going during long days and nights. I guess if you have a tendency towards addiction, anything can become a crutch that takes you away from having to feel life.

"So you see, the problem was, I would want a few drinks and I then felt like I needed to counterbalance that with stimulants

'du jour'—just as toxic and mind-altering. So they were very much intertwined. They went together like Oreo cookies and milk. The result was, I would sometimes find myself not remembering things. In the morning after waking up from drinking the night before, I would look around to see my clothes were neatly folded and everything was impeccable. I wasn't sloppy in the slightest. I would unpick my memory and go, that's right, I came home and I hung my clothes up, I put my bag over there and I put my watch in the safe. I would checklist and try to recount my steps from the night before.

"I had routines, too. I would stick my fingers down my throat and make sure I vomited three times before I went to sleep. It was always three times. It was never twice and it was never just once. Then I'd drink a litre of water and go to bed thinking it would clear my system."

I laughed nervously with the realisation of how preposterous that was. The AA group smiled back at me. Encouraged, I carried on.

"That's how I organised myself, but underneath the surface I knew the truth. It was very painful because I felt like I had to try to keep all the plates up in the air. I didn't talk to anyone. I didn't even tell my therapist at first. I didn't know who to speak to about it, or if I even wanted to tell anyone. I just knew that my life couldn't carry on like that."

It was at this point in my share that more memories came flooding back. My heart was thumping in my chest as I looked around the room. You could've heard a pin drop. I wondered if anyone could hear the beating of my heart. I carried on.

"After my second son was born, my healthcare professionals would regularly come to the house to treat me for pneumonia and other illnesses. They were very concerned about my well-being, but no matter how much they tried to treat me, I was always getting sick again. Over the course of time, they suspected that what was afflicting

me was self-induced, so they chose not to treat me any more. I was very upset. I felt abandoned; disconnected even more. I understand now this came from a place of profound tough love, but at the time I felt bereft. They suspected I was alcohol dependent and referred me to a therapist.

"After only a few visits, my new therapist also told me that no matter how much she tried to help me, I was damaging myself by drinking. She said that it needed to be addressed; she was aware that I was numbing my feelings and we could never really make any progress because I was so shut down. She also said that she wasn't going to continue our sessions unless I sought treatment. She advised me to go to rehab.

"So not only had my doctors told me they would not treat me, but now my therapist was telling me the same thing. I had quickly formed a bond with this therapist and the thought of not being able to continue to see her troubled me deeply. I considered what she said and spoke to my partner about it.

"I agreed to go to rehab, but before I went, I decided to spend the summer in Ibiza with my family. My therapist told me, 'Elle, I don't think it's wise to go on holiday before you go into treatment. If you do, and you've been drinking all summer, you're going to have to go into detox. That means instead of staying in rehab for forty days, you'll be staying for fifty. You'll have to spend ten days detoxing. Do you want to be away from your children that long?' I didn't want to hear this. I knew what I was doing. So I said, 'Cool. I get it. I got it! I'm going to go to Ibiza and I'm not going to drink,' to which she replied, 'Okay, let's see how that works for you.'"

I could tell by the faces in the AA meeting that they all related to controlled drinking. I could see the acknowledgement in their eyes. A few of them smiled knowingly. I clutched my chip tighter.

"The first few weeks in Ibiza, I didn't drink. I phoned my therapist on Tuesdays and Thursdays for our sessions. Each week I told her, 'I'm fine. I'm not drinking.' I thought and believed I had it sussed. And then one weekend everybody went out for the evening. I knew they were going to Space nightclub, which was one of the trendy, popular places in town. I said to myself, 'I can't go.' I was miserable as I was feeling left out, and I put the boys to bed that night feeling lonely and missing my partner and friends. I was upset and wallowing in self-pity, thinking to myself that my life had come to an end. I knew what I was going to do before I even did it. And I chose to ignore the whispers of my inner voice saying, 'Don't do it.'

"I went into the kitchen and tried to open a bottle of vodka. The vodka bottles are very strange there. They don't open easily. I had to get a knife and kinda break the foil seal. I twisted the lid and it went round and round but it wouldn't open. Once I'd decided to drink, I became really annoyed when I couldn't open the bottle. I tried and tried and began shaking the bottle out of frustration. And I was shaking to get the alcohol into me. I was also shaking because I was so upset with myself for wanting to have a drink.

"I couldn't open it so I smashed the top off the bottle. I hurriedly poured myself a shot that could have been littered with shards of glass. And I drank it. Ahhhh. That warm feeling came from the top of my head and all through my body. I remember thinking, I love this feeling. I'd missed it, sooooo much. All the anxiety and all the feeling that I was not good enough, all the feeling of being lonely and left out and not coping, drained away. That warm feeling came over me and I wanted another shot. So I had another drink. And another. Then I realised I'd had three drinks and wanted more.

"That thought alone sobered me up. I was so infuriated with myself. I spat through gritted teeth, 'What the hell am I doing? That's

it.' I grabbed the bottle and emptied the vodka down the sink. I was shaking the whole time I was doing it. I was horrified.

"Thoughts and memories raced through my mind as I consciously started to recall my life. I remembered I would go out to dinner with friends and have a couple of vodkas and be fine. It wasn't like I had to finish off the bottle. But then I realised that if you inflame drinking with an emotional response, it was like a trigger went off and there was never enough alcohol to fill the emptiness. I had just kept drinking, thinking it was going to take away the feeling of not fitting in. But it just never does until you pass out, basically. It was like, if I wasn't emotionally charged, I could drink normally. But I could drink and drink if I was feeling lonely. I could drink and drink if I felt over-whelmed and I could drink if I felt like I had nothing else to do. So there was always a reason that I could just drink and drink.

"I also realised that often, once I had started, I didn't want to stop. I hadn't registered that before. I didn't know if it was the combination of the emotional trigger plus the alcohol which meant that I didn't stop. But that day I had a wake-up call and I sobbed and sobbed. My therapist was right. It seemed that, without help, there was no way I could stay not-drinking. I realised that alcohol was the symptom of a much more intense underlying issue within my soul. I realised that I used alcohol as a crutch; that I used it to numb myself so as not to address the pain of my lost self. I really did need to go to rehab. And I wanted to find out why I felt spiritually barren, fragmented and disconnected.

"Right there and then, I changed within. With conscious clarity, I knew I was ready to go and that I had to do this for myself. I knew I couldn't last a whole month without drinking. I couldn't do it. I flew back to London while the family stayed in Ibiza. My youngest son was only six months old and my eldest was five and a half.

"I wanted to leave on August thirty-first. I chose that date because it was my grandmother's birthday. She was my spiritual connection. She was the one who taught me about God and she was the one I was closest to. Honouring my grandmother, I felt like I was given strength to do it that day and I sensed her beside me, helping me. My going was almost like a birthday gift to her. My grandmother was a powerful spiritual influence in my younger life. Now I realised that I had not listened to my inner sense and had gone against that inner knowing she introduced me to. All of the emotional turmoil had clouded my sixth sense . . . until it became so loud that I couldn't ignore it any more.

"My first sober day was September first, this year. I arranged to go to a place in Arizona. My mum came to London to see me before I left. She was so loving and supportive. I packed my suitcase the night before leaving and realised I had no clothes that were appropriate and I wanted to look cool in rehab. Yup, that's the model in me! I was given a list of things I was allowed to wear or not to wear. I couldn't dress in anything that was too revealing or showed my cleavage. If I wore leggings, I had to have a shirt long enough to cover my crotch and butt because sex addicts were also patients at the treatment centre. I had some casual gear so I took what I could.

"The morning I was leaving, before I went to the airport I had a few beers. That's the only thing I felt like I could drink without upsetting my mum. I really wanted to drink vodka but I didn't. I actually wanted to drink champagne on the rocks or maybe champagne and vodka, but I certainly didn't want beer. And just like that, my time was up and I had my last unsatisfying drink. I grabbed my bag with nervous determination and headed out the door. My mum saw me off at the airport. I hugged her close and she looked at me and said, 'I love you, Elle. You can do this.'"

Hot tears fell down my cheeks. I took a deep breath and carried on with my share.

"I couldn't wait to go to rehab because I just wanted and needed time to myself. I wanted a break from my life. I needed to consider what I was doing and the person I had become. So I felt kind of excited. There was trepidation, of course, because it was all so unfamiliar, unknown. I sensed that this was going to be a whole new beginning to my life.

"On my arrival in Arizona, I was met by one of the staff. When I checked into the treatment centre they asked me why I was there. I didn't say, 'For alcohol or addiction.' I said, 'Because I want a heightened sense of spirituality; I want to understand who I am and I want to feel connected to something meaningful, rather than disconnected as I feel right now.' My inner self knew that alcohol was just the symptom and I had much deeper underlying issues that needed to be addressed.

"That wasn't what they wanted to hear. I didn't fit any of their checkboxes. I actually understood deep down that sobriety really is a spiritual journey and the beginning of a new life. There are no mistakes in life and it's really apt that I chose to go to Arizona: just like the Phoenix rising from the ashes, I had the potential to start again. Being connected to my intuition, I did not lie when I said, 'I'm looking for a spiritual connection and I'm looking for purpose in my life.' I wanted my life to be grounded in something more than it was. I felt isolated from my true self. But I also knew that alcohol was a symptomatic crutch. What I did know for sure was that I felt barren spiritually, mentally, emotionally and physically. I felt completely separated from myself, from the Divine and from God. And that's what I was looking to repair in rehab—that connection to the Source within me that I once had when I was a child.

"My dad and his girlfriend flew across from Australia and stayed with my family in London for six weeks," I continued. "The boys' father was great. He was very present while my dad helped out with the boys. For that, I will always be grateful. It was a time of bonding for my children and their grandfather. And I know he cherishes that time with them to this day.

"Leaving my children was extremely painful but I knew that if I didn't get sober, I was never going to be the parent I wanted to be. As hard as it was for me to leave, I knew in my heart of hearts I was doing it for myself, but that they were going to be receiving the benefit. I was going to be a better mum because of taking this action; a more whole, unified individual. A hundred per cent present.

"First day in rehab, the staff cleaned out my bags and checked them for drugs and alcohol. They took everything they thought I could harm myself with, like my tweezers and razors. They also took my phone. But before they did, I called my partner and my parents to tell them I was okay. I also called my manager. He really helped me and was very supportive.

"During my stay, there was a public phone I was allowed to use; I could make a fifteen-minute phone call once a week. I would call on a Tuesday but had to be careful who it was to and I had to reverse the charges. It was really old school. They kept me on watch for the first twenty-four hours, after which I moved into a dorm with four other females. I didn't want to as I wanted to be by myself, but I ended up having to share."

The faces looking at me from the room expressed such compassion—I could see their understanding of what I had experienced. Many were nodding in agreement.

"So I was the best AA girl. I went to every AA meeting. I went to every therapist meeting. I contributed to all the group lessons.

I spent my days in group therapy, acupuncture, art class, enjoying yoga and healing circle. Every morning I woke up early. I would get down on my knees and say my prayers and then I would make my bed. After breakfast, I attended the nine o'clock morning minutes meeting. Somebody would do a reading, somebody would talk about the chores. I remember being nominated to be the board keeper and cringing with embarrassment because I thought everybody would know who I was—like I was a star."

I laughed at myself.

"I didn't even know if I was or wasn't. I was living in London at the time so my profile in America wasn't that high unless you'd read *Sports Illustrated*. But the reality is, everyone was messed up and nobody was thinking about magazines. They were trying to get clean and sober. They were trying to heal from addiction. They were trying to rebalance—to reconnect all their pieces back into one whole.

"There were things I didn't love. I was surprised that I was put into a group for anorexics. I felt humiliated and angry that I was being stereotyped. I kept saying to them that just because I was a model and thin didn't mean I was anorexic. Later, though, I understood why they had made that decision. I would have to take my plate to the nutritionist to show her my food. She would ask me in a condescending voice, 'Do you understand what you have on your plate? What food is nourishing and what's not? Do you know how many portions you have?' I was also told I couldn't work out because anorexics often abused exercise to stay thin. But I would sneak into the gym and work out anyway as I wanted to stay fit while there. The last thing I wanted to do was go back home out of shape.

"In my times of denial, I'd think to myself, this is so weird. I came here for drugs and alcohol. And maybe not alcohol, maybe just drugs, because *is* there anything wrong with my drinking? I'm Australian

and all Aussies like to drink, but maybe sometimes doing drugs is not so good! I kept telling the therapists, 'I am not anorexic.' I'd be angry that they had put me into this group.

"But they were right. I was somewhat controlling what I was eating, thinking I had to for my work. And so it was very hard for me. I didn't usually eat much at home anyway as I was by myself a lot of the time.

"I was told to read *The Big Book*. I was trying to get Step 1: 'We admitted we were powerless over alcohol—that our lives had become unmanageable.' And for twenty-one days I would pray, 'Please God, help me understand the first Step because I don't understand it at all. My life wasn't unmanageable. In fact, it's only going to be unmanageable when I get out of here.'

"Frowning, I'd think to myself, my house is perfect, my children are perfect, my work is perfect, my partner is perfect. Everything is perfect. So what am I going to do? I don't understand these Steps.

"I was told that if you didn't get the Steps, you couldn't stay sober. I remember being on my knees praying so hard, 'Please God, help me understand,' when suddenly I burst into tears. I realised the pain of keeping it all together, juggling and juggling, and how I had juggled everything from pumping milk during the week for my newborn son so I could drink freely during the weekend, to making sure I drank alcohol only after putting my children to bed, to making sure I was counting this and counting that and remembering this and remembering that. And lastly, my continuous strive for perfection in all I did since I was a little girl. The floodgates to my heart opened up and I let go completely.

"On that day, the pressure of trying to keep it all together came crashing down. I felt I was running out of time because if you haven't made progress in twenty-one days, you've only got a couple of weeks

left before you go home. There was also the threat of being sent to a halfway house for six months if they thought you needed more time to anchor sobriety. I'd expected it all to click into place on the first week, but it didn't. I did the work but I didn't understand. I knew I had a problem but I never felt right saying, 'I'm an alcoholic.' Why? Because I thought to myself, is that all I am? There's so much more to it. There's so much more to me.

"I thought maybe I didn't have a real problem and maybe I shouldn't be there. Maybe it was just a question of discipline. I'd never really tried not to drink. Maybe it wasn't bad enough or I wasn't bad enough. I would see people who were addicted to oxycontin, heroine addicts and people who had been abused in all sorts of ways, and who had lost everything. Their stories were so haunting, while mine were like elitist pretend problems. I thought to myself, I like to drink vodka. So what?! I felt I didn't fit in with all these people who were really struggling. But most of all, I knew in my heart of hearts that I was a soul trying to live in the limitations of an embodiment, not simply an alcoholic. Alcohol was just the symptom, not the actual root cause of what was really going on within me."

I wanted to make an important point to the meeting through my share. I wanted everyone in that room to know without doubt that I really did get it.

"So, on day twenty-one, I lay on the floor of my room, curled up in a foetal position sobbing. I cried tears of utter relief in the full realisation of what Step 1 was and what it meant to me. I whimpered to myself, 'I get it. Thank God, I finally get it.' I unburdened my soul and all the hurt and pain came rushing from my heart. My mind exploded with the realisation of how full of pain and split into pieces I had been feeling. And my inner life, too. I had been keeping myself together all my life and all my life I had been afraid. All my life I had

tried to be the best person I could be. I had always felt like I'd never made it. And all my life I felt I had been trying to live up to everyone's expectations, including my own. It had been so tiring and I just couldn't do it any more.

"I realised I didn't have to be the best me possible in every moment of every day. I just needed to be me—the real me. I sobbed until my tears were spent and my heart became still. A sense of peace came over me."

I looked around the AA room again. I had been lost in my memories as I'd been telling my story. With my Aussie courage and determination, I continued my sharing.

"I picked myself up off the floor and went and saw my therapist. I said to her, 'I think I'm getting this Step thing.' In the following days I stopped fighting against the system. I began to understand the relationship between food and my addiction. I did the Steps on alcohol. My therapist at the clinic wanted me to do the Steps on perfectionism. I found that weird and thought to myself, that's just a behaviour. That's not like a drug or anything that can hurt you. But then I understood how the false belief called 'perfect' and the false belief that I have to be perfect and, most importantly, the false belief that I wasn't already perfectly me, had led to so many other things that I found really painful—from believing that I couldn't be loved for who I was, to having obsessive-compulsive tendencies, to being harsh and inflexible in any circumstance—like having the boys be absolutely perfect in their matching clothes and perfect manners, to the fear of not being able to live life on life's terms; from not knowing enough, to not being able to do enough. It was all so tiring and it was so misconstrued; so un-self-loving.

"For years I thought, if I meet everybody else's expectations then they will love me. And if they love me then I will love me. I have

always felt that I can sometimes be too intense to be around people. I'm too intense to be loved. I have felt that many, many times in my life. Now I know that if I'm authentically living my truth, then I will be available to be loved by others.

"So that was an interesting phase of my journey. My real Steps were on perfectionism and the misunderstanding that I had to be something other than my already perfectly unique manifestation of love in life. All this time I was looking outside myself for the love only I could give myself. It's that inner peace, inner sense, inner connection. That inner knowing that I am light; I am love. I finally grasped the root cause of the spiritual disconnection and fragmentation within myself.

"It's my own uniqueness; I'm actually meant to be this unique me experiencing creation itself, right here, right now—that's what 'perfect' means, in fact. Everything else is just personal opinions.

"On the fourth week, my family arrived in Arizona: the father of my children, my mother, my father and my eldest sister. It was terribly traumatic because everybody had their piece to say and everybody was living their own traumas. Everybody was being confronted with their own truth and healing, because that's the way it works. I remember my therapist saying to my partner, 'You know, if you drink she will find it very difficult to stay sober,' and he said to her, 'I'm not the one with the problem so don't tell me what to do.' And he was correct. And he was angry. I can understand because he didn't want to give up his lifestyle and he certainly didn't want to give it up for me. And he didn't have to. It was like I had to adapt. And wasn't that the reason I was in treatment?

"My dad realised he had trauma. He actually stayed and did a course on trauma and addressed some of his own personal issues. My mum was confronted by the painful experiences she had gone through in her life and my sister was confronted by hers. It was a big hot mess.

Family week in rehab—it's so difficult for everybody. I kid you not. Lots of healing gets done but not without a lot of pain. So you really have to walk across hot coals in order to see the rainbow at the end. It was awful and not everyone was willing to do it, but each of my family told me over the following years that they ultimately really benefited from it. At the time, though, it was terribly uncomfortable. You have to talk about what's on your mind, and, of course, families have secrets. Nobody wants to talk about the elephant in the room, or the elephants in the room, or just the things that are perceived elephants. It was very complicated."

Glancing at the clock, I saw my time was almost up. I looked at the faces staring back at me and brought my share to a close.

"When I flew back to London, I made a conscious decision about what I must do for myself, my family and my life. I embraced my sobriety with a passion. I'm doing what was suggested to me and I'm attending ninety meetings in ninety days. It's strengthening and stabilising my commitment to myself."

I finished speaking to the group by confirming that being part of the AA community, going to meetings, having a sponsor to support and help guide me through the Twelve Steps, *The Big Book*, service to others . . . it was all vital to keeping me grounded, especially after just getting out of rehab. It added up to a road map for life.

I thanked everyone in the room for supporting me, inspiring me and holding space for me while I navigated this new path. I told them how grateful I was and, yes, scared—but with their support, I knew I would make it.

Everyone clapped and the chairperson thanked me for my share. I wondered if I had given too much detail. I wanted to understand my own journey through voicing it. I hoped some there had identified with my feelings and my story would help them.

We are all on a journey to recognise our uniqueness, embrace it, live in the world, and see the perfection in that; to find our connection to our true selves, to our innermost powerful being, and to the Source of all life.

When I finished, I didn't feel relieved, like I'd just had a religious confession. I felt resolute and strong. I had shared my truth of what had brought me to my knees, as well as what I had discovered to inspire my way forward. I felt clearer about my purpose in helping others by sharing my own experience, strength and hope so that they, like me, could gain courage in knowing they are not alone, they are always connected.

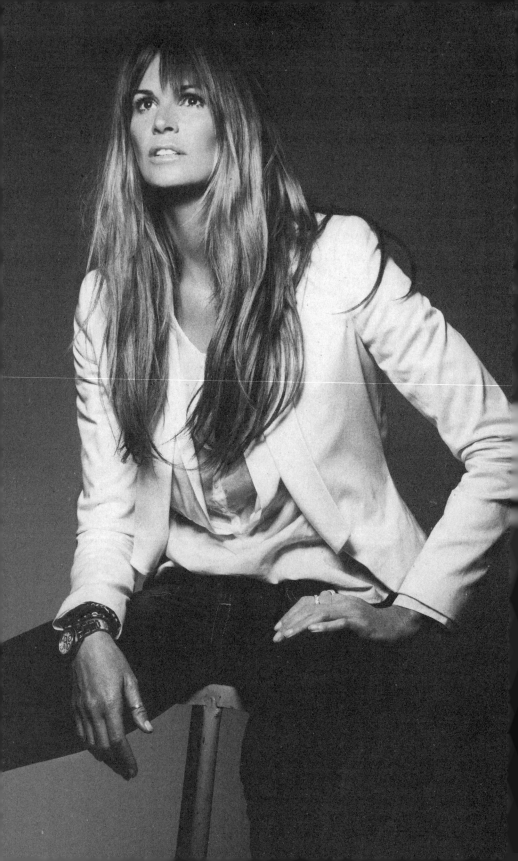

12

H.O.W.

"Honest. Open. Willing."

For those who are struggling with the "how," this is for you.

Stopping drinking is one thing. Staying stopped is another thing altogether.

Coming home to London from rehab was daunting. I wasn't sure how to live life sober with my family and friends; I wasn't sure how to integrate sobriety into my life, a life that was anything but sober. I didn't know how sobriety was going to affect my life. I certainly didn't know it would create quite so much dissonance in my relationship with Arki.

During the first few months, I met up with people I loved. They saw a difference in me, a change in my attitude towards our social life. They made remarks and passed comments. At times it was uncomfortable and I thought to myself, what do I say? Do I have to say anything? Do I make light of it? Or do I earnestly answer their questions? Do I divert the conversations?

There was so much I didn't know how to do and I wasn't sure how to manage.

I think I was also scared because I realised I'd have to make changes and say no to a lot of things that didn't work for me any more; things that I'd never had the courage to say no to. I wasn't confident and I didn't truly believe that I was empowered to make grounded decisions and have the strength to persist with them, but I was determined to do my best.

My moods were up and down. And it was difficult when Arki was home after being away on business because I started going to bed early, and Arki went to bed late. I wasn't attracted to a lot of the things I'd previously done. Alcohol had given me the courage to get out there and socialise. I drank to feel a certain way, but never enough to behave a certain way. I drank to feel relaxed, outgoing. My tolerance for alcohol was very high. I could consume a lot before its effect was even noticeable. I never wanted to be seen as drunk. I didn't slur and I wasn't belligerent; I just felt I needed alcohol to put up with a lot of situations I didn't want to be in.

Sometimes my faith waned and in dark times, when I felt lost, I lay in bed at night praying to the Universe for the strength to stay sober, hoping that I didn't slip and I could keep it all together. In the beginning it only took a glimmer of hope. Just the willingness to believe it was possible. Just enough to hang on to for a moment. And I found grace.

In the rooms of Alcoholics Anonymous, I was given practical skills and tools on how to embrace sobriety and live life on life's terms. These tools would be key to guiding and helping me, especially in the early days.

Being Honest, Open and Willing—HOW—is the crux for any spiritual growth and I was told that anything I put ahead of my

sobriety, I would lose. "Oh, I can't go to a meeting because I have to put the kids to bed," or "I can't go to a meeting because I'm tired after work." And, "I can't go to a meeting because I have a function to attend." Whatever it is, whatever the excuse, unless you are sober, you probably won't be able to keep those things in your life. That for me was such a sobering concept. It touched me to the core. So I dove right in.

Fellowship and friendship are what I felt after sharing my story for the first time in that little room downstairs in the church. After the meeting, three long-time sober women took me out for dinner. They told me that I was going to be okay and to keep coming back. These women were so compassionate, grounded and full of grace. I felt held by them. They reminded me that we have all done things we have later regretted. They said, "Yeah, we did that." So I realised then that the things I thought were so terrible were things other people had experienced too. When I think back to that time, I'm reminded of a quote from C. S. Lewis: "Friendship is born at that moment when one person says to another, 'What? You too? I thought I was the only one!'"

The day I chose to stop the cycle of addiction and started practising a Twelve Step program is the day I began reclaiming myself. Having clarity of mind gave me hope, strength and determination to make different choices in my life—self-loving choices instead of self-harming ones. I didn't always know the answers but I was willing to face whatever they were, big or small.

I'm not just talking about drinking. I'm also talking about living life differently, practising self-love, practising self-honesty; practising self-discipline and a willingness to look at myself as the spirit in embodiment that I truly am; a willingness to believe that I am worthy, powerful—that I am loveable; that I am loved and I am loving. In fact,

that I am love. Love is the energy of which my body, emotions and mind, my entire being, spiritual and material, is made. I don't have to find it, I already am it. As are you and all others. I just forgot as I became distanced from that truth. Outer influences told me something different—a lie about being powerless and ignorant and not enough, and the lie made me fearful. I now know without doubt that the powerlessness and ignorance and lack are not true. Now I live with the love, power and wisdom that constitute my true nature.

AA has been at the foundation of my spiritual growth and development. I was told that if I was struggling with the concept of God, then I would find God in AA (GOD: Group Of Drunks). In AA they call it a Higher Power, but for me, I see God as a loving energy source that flows through me and guides me through life. And I have come to embrace the fact that it is within me and not out there somewhere, so I cannot be truly disconnected from it. Ever.

My first connection with God and Jesus was initiated by my grandmother, my mother's mother. Just after my parents divorced, my mum, Mimi, Ben and I spent time living with her. My grandmother and I would say our morning prayers to her idea of God every morning at seven o'clock and read the Bible. On Wednesday nights, we would go to the cathedral in town. My grandmother was a volunteer and I would often help her with her tasks. Thursday nights was choir practice and Friday nights I had fellowship. Saturdays, we had some sort of community service and Sundays, of course, was church.

Sometimes I would go away with my grandmother for the weekend on Bible retreats in the country. These were some of my favourite times because, although the study was skewed towards religion and Christianity, I really felt a deep sense of something I could only think of as love. It had to be the Love of Source because it seemed infinite and beyond my comprehension to absorb its effect totally. I just

appreciated it. I felt immersed in Christianity. It was very important to me at the time because it gave me faith, hope and courage. And it gave my life meaning.

Today, I believe there is a loving force in the Universe that is on my side. I can tap into it at any time without needing any permission or special dispensation. I tapped into it as a child and I've tapped into it as a sober adult.

The Twelve Steps are the tools I used to get to know myself and glean a deeper understanding of who I am. I embraced sobriety with a passion, as if my life depended on it. And to some extent it did. As I said I would during my share, I attended ninety meetings in ninety days, and I repeated that ninety-in-ninety for many years. This gave me a grounded and strong foundation to build upon. AA was a refuge for me because I was with like-minded people who shared similar experiences and we could relate to one another. They supported me where I'd previously felt like I had no one to turn to who understood; when I had been drinking and doing life "alone."

Instead of opening a bottle of vodka at 7 p.m., I'd go for a cup of tea before the meeting and have a chat with my fellow members. I'd get to know them. In the beginning it was daunting to walk into an AA meeting with a room full of people I didn't know, but it got easier in time.

So I went to meetings daily and took on service commitments. I helped set up before the meeting and clean up after it. I spoke at meetings, handed out literature, made tea and at one point was asked to be secretary, which was a huge honour. These service commitments helped me to get out of my head and turn my attention towards others; and that's what I wanted to do—give back and help.

Today, I speak to all sorts of people who are wanting guidance on how to live their life sober, or how to get connected to their true inner

sense as well as their common sense. They ask me how I did it and I share my own experience, strength and hope with them. I let them know that AA is a simple program for complicated people and that it takes time; one day at a time. And it's worth it. I want to show up for people and I want to make myself available to them. So I do.

There were people from all walks of life at the meetings. We all came in on different ships yet we are all in the same boat. Some were hanging on and trying not to drink because alcohol truly had taken over and devastated their lives. Some were not necessarily knowing they were on a spiritual journey, they were just trying to get through the days. And for those people, I had extra compassion. They were the ones I would often hold space with and sit beside. I'd recognise faces from the film and music industries. Like me, they had a public persona, but in those rooms, what I saw were honest, wise, heart-led people sharing wisdom bombs and helping others. They were articulate about their feelings, they were warm, loving and charming. And I said to myself, "Yeah, I want what they have."

I see some of the same faces today I saw twenty years ago when I first started going. They're like family. I have a very dear friend in AA, we share the same sober birthday, and although we only see each other in the rooms, he's always there for me. When I call and say, "I'm having a difficult time," he reminds me of my light. He says, "Elle, God doesn't give you anything you can't handle." Then he tells me to keep it simple.

What I have come to know is that people in AA focus on the solution. When you focus on the problem, the problem gets bigger. When you focus on the solution, the solution gets bigger and the problem becomes resolved. Where attention goes, energy flows. What you focus on expands. I know now that I create my own reality; it's how we all create our own respective lives. If I can create problems

in my life then it stands to reason that I can create solutions too. Problems or solutions . . . it's just a matter of choice, backed up with self-discipline.

As suggested at the meetings, I chose a wise older female sponsor who I could turn to for guidance. It's a very intimate relationship between sponsor and sponsee because together you walk a spiritual path. You are asking someone to witness your journey so you are accountable. A sponsor will always be truthful with you. You may not like what they have to say at times and that can be a bit tricky. So it requires a lot of trust, patience and open-mindedness.

My sponsor was a Canadian woman who has now passed. From our very first meeting to the end of her days, she called me Mac. That's the name I had in rehab and the name I gave at that first meeting. I don't think she knew my real name.

My sponsor mentored me through the AA program and helped me navigate and integrate the Twelve Steps, the Promises and the Principles into my life. When I shared life experiences with her, she listened and didn't judge. She gave me *The Big Book* of Alcoholics Anonymous and told me to read it. And I thought to myself, what? All of it? The book was blue, had really small writing and looked like a bible. She explained it was written by William Griffith Wilson, who was known as Bill W, and its purpose was to show other alcoholics how to get sober. I'd heard somewhere the book was channelled from a higher realm of consciousness, which sparked my interest; so I opened it and began to read. I particularly loved the stories of how other alcoholics became sober and, while I didn't necessarily relate to the details, I related to the feelings these people had about their life.

What's the best thing about getting sober and the worst thing about getting sober? The best thing about getting sober is that you get

your feelings back. The worst thing about getting sober is that you get your feelings back. And I had to deal with those feelings when they came up. There was no relief and no numbing. So how do I deal with all that? I was nervous and anxious a lot of the time. It was tough but I stayed focused and pushed through the rough days and counted every single one until I collected my next chip. First, thirty days, then three months, six months, nine months, and then that ultimate one-year chip.

Around nine months, when it came to doing my Fourth Step ("Made a searching and fearless moral inventory of ourselves") and the Fifth Step ("Admitted to God, to ourselves, and to another human being the exact nature of our wrongs"), it was a daunting process. I'd heard these Steps were the most challenging and if you didn't do them it was going to be very difficult to stay sober. They were pivotal towards physical and emotional sobriety. My sponsor gave me an action fact-finding worksheet that goes with the Fourth Step and she asked me to fill it out. Me being so exacting, I did a spreadsheet. It took me months!!

They say that the spiritual awakening mentioned in the Twelfth Step ("Having had a spiritual awakening as the result of these steps . . .") occurs when the obsession with alcohol is lifted from you. And sometimes even when you have the willingness to believe it's possible that the obsession can be lifted. But in my case the obsession of the 7 p.m. drink was replaced by my obsession with staying sober and immersing myself in a sober and spiritual way of life. My sponsor said to me, "Mac, there's more to being sober than just being physically sober and having the obsession with alcohol removed. Sobriety isn't much fun unless you can be happy and thriving *while* being sober. This is what practising the Steps and being of service will do for you."

During the seven years she was my sponsor, she helped me find clarity in so many situations. She did it in such a gentle and loving yet firm way, and would often say, "First things first. HALT. Are you hungry? Angry? Lonely? Tired? If so, take a breath, pause, eat something, do the next right thing, be of service to someone." Simple but effective.

But I didn't know what the next right thing was and I seemed to need guidance on everything. From "What exactly is the next right step?" to "Should I take on a service commitment at AA?" And "What do I say to people when I want to go to a meeting and don't want to go out for a drink?" I would listen to her advice and I would ask myself, "Does that resonate with me?" And if it did, I would act on it.

When my sponsor moved back to Canada, I wanted my new sponsor to be in the same time zone so we could talk face to face in my daily meetings. I waited a few months while I looked for the right person who I felt drawn to. Then I plucked up the courage and asked a regular at my meetings to be my sponsor. She was younger than me but wise beyond her years. Plus, she had six more years of sobriety than me. She was articulate, beautiful inside and out, and really honest about the way she felt about things and how she saw the world. I admired and respected her. When I asked her to be my new sponsor, I knew I ran the risk of feeling embarrassed, humiliated or even rejected if she were to say no. It was almost like asking someone out on a date, with the proviso that the relationship would be long term before it had even begun. It was one of those awkward moments. No pressure, right? Anyway, she said yes, and to this day she's my sponsor.

Having already been through the Twelve Steps with my first sponsor, I didn't need to do them again formally. The relationship with my second sponsor allowed us the freedom to share and discuss

in real time how I would implement all the Steps into my daily life. I gained hands-on tools to deal with life circumstances, which I found valuable while developing a deep trust with another woman.

Through working the Steps, I've come to understand that the relationship I have with myself and Source is the most powerful and fulfilling relationship in my life. It's the one I wish to nurture at every moment.

While I was doing the Steps, I had to dig deep and ask myself some serious questions.

Why did I drink—what's behind the pain?

What was the trauma?

What was the root cause?

Why was I numbing my feelings?

What situations were happening in my life that I didn't want to address?

Why did I feel unable to deal with life's situations?

How do I stop my feelings triggering my desire to drink?

How do I feel instead of numbing my feelings?

How do I handle what I am feeling without drinking to disconnect myself from those feelings?

What is more important—my life or alcohol?

Do I need to feel what I feel? Is it even important, anyway?

By asking myself such raw, simple questions, I hoped to find clarity. It wasn't just about not drinking, it was much deeper. Releasing the need to drink was a turning point in my life. It was the by-product of the inner desire to change my life; to look at myself and my life differently. I wanted to feel my life differently and I wanted to feel differently in my life. And I wanted to reconnect with my true soul being and purpose. Originally, I drank because I felt disconnected and I became disconnected because I drank. I drank to numb

my feelings of disconnection and my feelings became more numb because I drank. It was as self-perpetuating cycle.

Now I've learned that no matter what the situation is, first, just stop and be still, breathe, relax, listen and trust. And only then take action, because only then will the actions be wise ones. To stop and be still first is vital. It stems the flow of the frantic distractions of the outer world. Having stopped, I take a few long deep breaths as though breathing in stillness. That settles inner energy that is agitated or distracted by the circumstances around me or their implications. I relax into that stillness and, in the calm, I listen—not to words in my head but to the inner hints I feel within; the sensory information that gently flows into my awareness; subtle urges like yes, no, not yet, move on that, wait a while then decide. I now trust those impulses deep within and act on them to the best of my ability with full commitment. And it becomes a more powerful, reliable guide, getting stronger every day, every time I trust it.

Today, as I travel the world, I often ask the hotel concierge where the nearest AA meeting is. I'm not embarrassed to be a member. I'm grateful to be sober. And I admire those who have found sobriety. Some people ask me if I'm afraid of the stigma around going to AA meetings. That always makes me laugh! What about the stigma of losing your beauty to the ravages of drugs and alcohol?

What about the stigma of not being there for your children?

What about the stigma of losing the gifts you've been given in your life to the compulsive behaviours that take you further from your true essence, from your heart and from love and joy? From your innate wisdom and power in life? And from God?

I know many people who suffer from the false belief that they are unloveable.

They suffer from not being there for their children.

They suffer because they won't risk committing to relationships—it's just too raw and chaotic for them to do so.

They suffer from not having a life filled with love, abundance and joy; not being connected to their higher purpose. Or God.

Those are the things that concern me more than any perceived stigma of being a member of AA. Being willing to embark on a spiritual journey that began with getting sober was the springboard to the rest of my life. It was a turning point to self-exploration, health and well-being. From a better understanding of my body, to having better relationships with people and stronger relationships with my children. Most importantly, a better relationship with myself. Being accountable and self-responsible. Being self-loving and integrated.

Committing to being sober has taken me on a completely different path; a fulfilling path. In my early days of this newfound way of life, I was trying to incorporate my new understandings, learnings and ways of being into my life. It's not like you just go and *get* a realisation. It's not like it's a case of, "Okay, now I'm cured." Every day I worked diligently at aligning and grounding new perspectives into my life. I still do that today. It's an ongoing journey that gets easier as I continually learn.

There are some people who have tried multiple times to get sober. But I wasn't willing to take that risk. They say that alcoholism is progressive. I've witnessed that in meetings, when people who have stopped drinking for many years relapsed. They've gone right back to where they left off, or worse: when they've made it back into the rooms, they tell of their experiences, and most often they are harrowing. I was once told in AA that if you are lucky enough to get sober the first time, it's a gift. If you slip and slide, it gets harder every time you go back out. And I wasn't sure I'd have another "getting sober"

in me. I thought to myself, "If I start drinking, I may never stop." So I learned *how*, through all the wisdoms in AA.

When I went to rehab in 2003, I was advised not to make any big changes for a year. After one year, in my union with Arki and our lifestyle, I was feeling more and more dissonant. When I thought about making a change, my sponsor said to me, "No, you need more time. You need to be stronger and you need to check in with your heart because maybe things will change in your relationship. You love the father of your children and you love your family. So start manifesting consciously and working towards miracles."

Trying to manage the disparities in the lifestyle Arki and I both shared was tough. I may never have gotten sober if somebody had told me, "You are going to get sober, separate from the father of your children, go through ten years of fighting to come to an agreed parenting arrangement; there will be no personal divorce settlement because you're not married; your boys are going to spend 50 per cent of their time with their father so you won't be with them 50 per cent of the time. So the fallout of you getting sober comprises divorce, only half the time with your boys, plus a lot of sadness and arguments. And trauma for your children."

But my decision was to get sober. The rest is history.

Arki and I hobbled on for two more years. One morning we woke up and he said to me, "It's over, isn't it?" It was that simple.

We announced our separation on the fourth of July because it was a sign of independence for both of us. He didn't want to be under the control of my lifestyle and I didn't want to be the victim of his.

We tried couples counselling before we separated. We really did try. We went through phases where things were easier and phases that were really difficult. I think in the end we both just lost hope. And when you lose hope, that's the hardest part.

I believe Kirk Douglas, when asked how he stayed married, said, "Because we both didn't want to be divorced at the same time." I think there's a lot to be said for that because when one of you has a lot of hope and the other one doesn't, you can jockey that back and forth for some time. But when you both get to your "I don't want to do this any more" place together, at the same time, and you both look at each other and agree "We're done," then it's much harder to recover from that.

We had a whole sequence of how we were going to tell our boys and of course it didn't come out the way we wanted it to. Probably it never does because the emotions are so intense. It all came out wrong from everybody's point of view. It was another big hot mess. There's no right way to do it.

I was deeply shattered in many ways and it took me years to get over separating from Arki. I felt like a failure for my children. I felt I let Arki down. Yet at the same time I felt incredibly free because I could finally breathe and be me, and be the parent I wanted to be—not oppressed or compromised. And to be fair, Arki did not oppress me—that's simply the way I responded to my life with him. I pedestalled him, I subordinated myself. It's not his fault. These were the choices I made. Maybe I'd seen my mother do it or maybe I was trying to repair the relationship with my father. I can't be sure of what the psychology behind it was, but I thought that if I could just learn to cope with everything then everything would be okay. In fact, I didn't have to because our partnership simply wasn't resonant any more. I believe it's super destructive to stay in any kind of relationship that is not for your highest good. Arki and I had more to learn from our separation than from our time together. It was better for us to separate than to risk damaging our children with our constant conflict.

And I loved Arki, but living together with our different lifestyles was not a relationship. It was a sort of arrangement. Also, our boys were receiving a diluted version of us. We were trying to meet in the middle but neither of us was being true to ourselves.

After two years, I finally felt strong enough to make the changes I felt were necessary in order for me to be the parent I wanted to be. I was finally honest with myself and I understood that Arki and I couldn't live in such dissonance any more. So we separated. I left to live my life being true to me and I think that's one thing my boys have seen me be—fearlessly authentic in the choices that I've made, even if they weren't popular.

After this, at times Arki would date and I would be so beside myself, but I knew it was a hiding to nothing. There was no point getting upset. I couldn't go back. But I was always wishing that things had worked out differently between us. And of course, potential relationships that came my way were always compared to Arki, in the good ways and the bad ways.

A part of me was under the illusion that because I came from a divorced family, I should not put my children through all that. There was a part of my heart that wanted to preserve the dream of a family that stays together, grows together. And so every time I saw Arki with somebody else, or every time we argued, it pierced that dream a bit more. Reality was, I knew there was no way we could be together. I did miss him terribly but what I missed even more was the dream of us raising our sons together.

For many years following our separation, I didn't really date. I enjoyed not having to be mindful or explain myself to anybody. It was extremely liberating to wake up, make my bed, say my prayers, meditate, go to a meeting. I was making different, self-loving decisions in my life. I was a single mother to my children. I didn't want

my boys to have a series of men in their home. I wanted them to only ever see me with their father until I was ready to have a loving relationship and was able to demonstrate that loving, committed relationship to them. I didn't want them to ever feel their dad was dispensable, replaceable. I also wanted them to know that a woman is capable by herself and not dependent upon a patriarchal figure for foundation or support to complete her family dynamics or her life. I wanted to be loving, to be present, to be there for my sons. They had their dad, they had me, and they were loved by us both independently.

Flynn and Cy were too young to realise that I went to rehab, but one of the things I heard that inspired me to get sober was, "You can break the cycle of future generational addiction. By staying sober, the chances are that your kids won't have a drug or alcohol problem, and if they do, they will know where to get help and how to become sober."

Arki and I were both devastated when we separated. We spent ten years barely speaking to one another while trying to agree on a balance of parenting styles. We both love our boys so much and we both wanted to parent our own way completely. That was traumatic for the boys because they felt torn between our two completely different parenting styles and these parents who were at odds with each other and were struggling to get to know themselves after the separation. No doubt at times they felt abandoned as we tried to work through our stuff in a dynamic that was very difficult. We were so concerned that they would suffer. But the very fear of them suffering was what caused suffering. The greatest gift we could give our boys has been the gift of letting them truly know who we are. We cannot protect them from life but we can guide them and we can teach them to trust their own inner sense and inner knowing, which will never lead them astray.

Now Arki and I work together as a team, but separately. The boys received 100 per cent of undiluted energy from each of us. We made

joint decisions on schooling, extracurricular activities and all other major matters. We worked together in the best interests of our sons.

Parents are responsible for guiding their children to be their true selves, not the version of themselves that their parents, or anyone else, want or think they should be. Instead of trying to save them from life, it is our responsibility to teach them to thrive as they immerse themselves fully in their own lives—teach them self-love, self-power, wisdom, and the courage to walk through their lives, experiencing all they long to experience; not just fitting in but questioning everything to see if it resonates with their heart, so they become all they can be—their unique living fingerprint of life. Our task is to guide them, not control them.

When I became sober, I could see and understand the difference and I worked towards it. I still do. As Kahlil Gibran wrote, "Your children are not your children, they are the sons and daughters of life's longing for itself. They come through you but not from you. And though they are with you, yet they belong not to you." That quote has rung true ever since I first read it.

The journey from my head to my heart is an ongoing journey to unconditional love—unlimited love, joy, fulfilment and purpose. My whole life has been a journey looking for that. I have experimented with many degrees of sex, drugs and rock 'n' roll. I've done the depths and the heights of them. The way I see it, I came to Earth to experience life and I have experienced it with bells on.

Every experience, every circumstance, every situation is valuable insofar as each teaches us something. No matter the situations I've been in, I know now without doubt that I created the experience. Even if I cannot yet see what the lesson is, that does not devalue the experience; it just means it'll be some other time that I see it. And that

will be the exact time I need to know that lesson. This has proven itself to me many times. I trust it. Implicitly.

Repeating painful circumstances over and over again is of no benefit. Learn the valuable lesson and put that into action in your everyday life. That is how to stop the hurt, the pain, the struggles that seem to weigh us down and test our resilience and stamina—prove to life that you have learned. When you act on what you have learned, you prove you don't need that lesson any more and it stops appearing in your life. Real mastery in action, in real life.

All experiences are valuable and worthwhile, not meaningless or senseless or pointless. Life is valuable and meaningful. All life.

Every addiction starts with pain and continues with pain until you learn to live in self-love.

Your choice; your decision; your life.

What will you choose?

I chose life, freedom, joy, abundance, happiness, fulfilment, connection.

I chose Love.

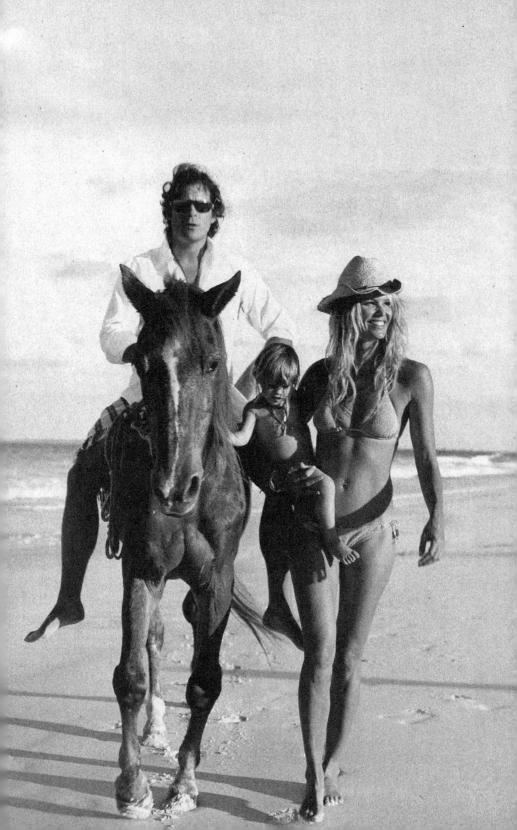

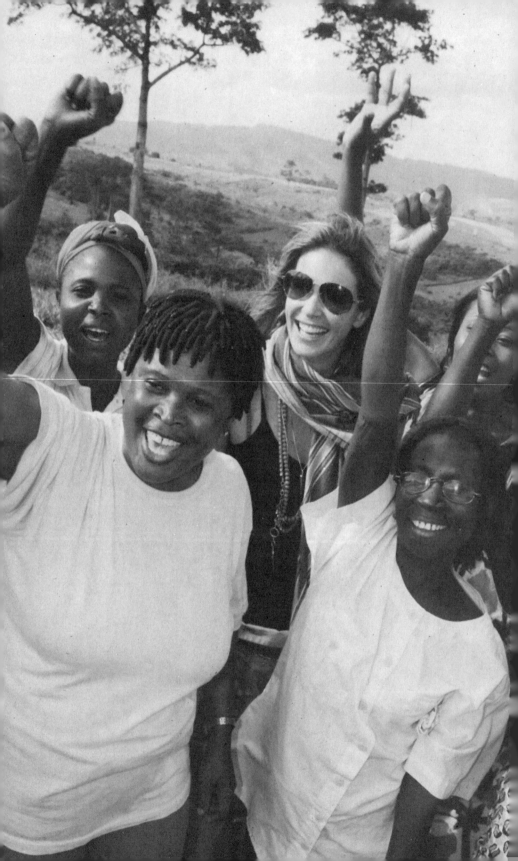

13

CREATION TIME

Make every step a step closer to your dreams

Getting sober takes time, and gives time. Time to be spiritually, mentally, emotionally and physically present in life. Time to go to meetings. In these years, I found I had the time to make new friends, to continue to heal and to introspectively process and discover aspects of myself. An emotional consequence of actually being sober was that I had to slow down, process. As the Zen proverb beautifully says, "You can't see your reflection in running water, only in still water."

Having spent a lot of my life racing from situation to situation, drama to drama, I had often doubted my inbuilt Aussie strength of character. And I had been doing everything I could to distract myself from feeling or being the optimum version of myself. When I became sober, I wanted to be an autonomous sovereign woman. I no longer wanted an external influence to be my authority. The irony is that initially I rebelled against myself and made poor choices in establishing myself as independent. I filled my life with distractions that

helped me through the unfamiliarity of separating from Arki. It didn't matter that I was sober or that I was on a spiritual journey, I still had blindspots.

I was single and two years into my sobriety and still making these seriously clunky, non-recovery kinds of choices, which hurt. If you're really in balance, you don't spend more than you have. So I was still doing rock 'n' roll; living larger than life, though in different ways. In 2006 I bought a seven-storey house in Notting Hill, the part of London where we had been living since 1998. It was my dream home. It overlooked a park the boys loved to play in and was close to their school. I hired a prestigious London designer to help me renovate and decorate it. I was over-extending financially, and improvements to the house were spiralling out of control. I thought it didn't matter. But it did.

What I wanted was to feel secure. However, instead of finding my security within myself, I built structures around myself, such as a huge house, in an effort to feel that stability. At the time, I thought it was cool, but what the boys and I needed most was to be together, cosy. I chose a house that separated us from each other, one floor to the next. How bonkers was that?! The boys' bedrooms were on the top floors and the kitchen was on the bottom. If Flynn forgot his tie for school, he'd bribe Cy to run up seven flights of stairs and get it.

It was a misaligned choice from the head and ego, not from the heart. I still didn't listen to my inner sense at times. I heard it, I just didn't abide by it. It seemed easier to defer, procrastinate or even ignore it completely. It's important for me to recognise and acknowledge unsupportive choices when they occur in my life. Healing is a journey. It doesn't all happen in one go and you can't heal in your head. As country artist Kacey Musgraves sings, healing doesn't happen in a straight line. You have experiences in order to learn from them

and those learnings are wisdom tools to apply to future experiences. That process creates evolution towards living the highest version of yourself.

Another blindspot was the Aston Martin Arki had given me. Remember the car under the Hollywood sign? Well, I had it refurbished to its original glory. It was a never-ending money pit as there was always something more to do.

I also rented a lake house in the Cotswolds; a beautiful area in the south of England. Really, I started living life like a gazillionaire as my highly ambitious, driven character hurtled through life, pedal to the metal. I was working to support the boys and myself. I was trying to be both mum and dad while doing my best to make up for my decision to become a single mum. The boys were my main focus and I was extremely diligent about looking after them as I didn't want them to suffer from my separation from their dad. So I doubled down on love and parenting the boys. I doubled down on life and I doubled down on every aspect of it.

I was exploring who I was while endeavouring to let go of the past. In business, and personally, I had breakthroughs and breakdowns, huge successes and huge disasters, like losing nearly everything on the house in Notting Hill. I would overspend and overcommit. I would overwork and then be depleted and exhausted. I was learning to stand on my own two feet again, just as I had done years before when I'd separated from Gilles. This time, though, it was with the added responsibility of two children.

Creative expression was extremely important to me. It allowed me to stream my energy into something I loved. Having learned from Arki by watching his brilliance in business, I finally felt able to incorporate those learnings into my own career. Without realising it, our separation made me even more determined to be an independent

entrepreneur and businesswoman. So this was a time to focus on Elle Macpherson Intimates. I decided to reimagine Elle Macpherson Inc., the company that managed my brand. It was a time of rebirth in every area of my life. And it was absolutely relentless.

I became super focused and super successful. I felt a sense of detachment from my old life that equated with a sense of freedom, so I used that in ways to re-energise creative projects that supported my healing, growth and inspiration.

Throughout my life, I've found it very empowering to withdraw my energy—in the form of time and attention, emotion and thought—from what was self-harming or redundant. I could then repurpose that time, attention, thought, emotion and action into projects that were supportive. That was me learning alchemy—recycling what was no longer supportive or nourishing for me; dissolving the obsolete aspects of my life and using their energy to create something I wanted, instead of recreating the past in the hope that it would eventually support me. This reminded me that all life circumstances have meaning and purpose. I found that this was the best way to propel me through discomfort and loss and come out with something really valuable and tangible at the other end.

I looked for ways to bring deeper spiritual support into the other areas of my life. I was reeling after the loss of not only our family unit but also my wise health-guides Guilia and Isabelle, which I didn't understand as even though I was now sober, they remained firm in their principles to no longer treat me.

At times, when I wasn't working, I studied spirituality and attended retreats. Although I was slowly building a support team among my therapist, my sponsor and my friends from AA, I felt a yearning for new perspectives and tools that would help maintain a happy, healthy life. And a purposeful one.

One day I found myself reading a book entitled *From Atoms to Angels: The Spiritual Forces Shaping Your Life* by Paul Darrol Walsh. I've always been interested in the angelic realms, especially since my childhood times with my grandmother, so the title caught my eye. Once I started reading it, I couldn't put it down. I think I finished it in two evenings flat. I found it changed my perspective as it introduced me to the concept that life doesn't happen to you, it happens through you—by you and for you. Paul's straightforward explanations showed me how I can be in the driver's seat of my own life, consciously creating my own reality by staying mindful of where I put my attention. As I flicked through the book, I noted the chapter titles: Reality, Purpose, Separation, Creation, Synchronicity, Power, Love, Responsibility, Healing, Life Force, Mastery, Reunion, Fulfilment. Yes please!!! Tell me more!

I decided to contact Paul. He was living in India at the time with his then wife, Alexandria. I informed them that I was newly separated, sober and, although I knew I was going through a period of rebirth, I was longing to make some sense of my life. I wanted to find the rudder and sails within me to help steer my journey and navigate out of the storms and into calm waters.

Paul and Alexandria agreed to come and see me for intensive spiritual guidance. We settled on a seven-day retreat in the Bahamas. By the time they arrived, I was excited to begin. Their teachings included grounded day-to-day teachings and tools that I could apply along with AA. They deepened my commitment to AA in a way because they filled in the gaps and made sense of my life while they gave rebirth a greater meaning, value and context.

The retreat opened the doors to subjects including energy and frequency; life balance; high consciousness; mastery principles; understanding reality creation; meditation; discovering innate

attributes and skills; learning love and self-love and living them with real meaning and power. Paul and Alexandria offered a view of myself and life that would resonate deeply with me and support my self-realisation and healing. Importantly, they taught me tools to begin applying unfamiliar new understandings and powerful principles in practical, self-loving ways to my real-life circumstances that were unfolding. This was something remarkable and transformational and I knew it.

Our days were certainly intense. They consisted of two four-hour teaching sessions, with a break in between for nourishing food, reflection and discussion. Since the course was residential, the teaching flowed from direct lessons each day into meal-time conversations and even walks along the beach and evening relaxation. We had plenty of laughs that were very heart-opening. It was full immersion, and I loved the soul nourishment. Paul and Alexandria had prepared copious notes and exercises, but most of all, they came with hearts of unconditional love and depth of experience. I had never encountered that kind of energy before. Well, to some extent with Guilia, Isabelle and Lois, but Paul and Alexandria's teachings actually gave an infrastructure and process for change, along with tools to help me shift consciousness. The course was a gift from the Universe and was life-changing.

Right there and then I realised that I was not a victim of my life and that I am responsible for participating in it, what happens in it and, most importantly, how I respond to my circumstances. I learned how my free will ensures I always have choices in life, choices that I can make to be either self-loving or fearful, self-empowering or self-harming. I realised I could choose to allow life to flow and trust it to be my support and co-creator, not distort or resist it by my fear or conditioning.

I felt so uplifted and empowered to know I was not separate or inadequate or wrong, and that I was not alone on my journey. I now

know that my own spirit has a beautiful roadmap to a life full of joy. And life is full of signposts along the way if I stop, listen, observe and trust with a quiet heart.

My relationship with Paul and Alexandria has had a profound effect on my life. They have been invaluable guides through the rich tapestry of my experiences over the years. They've helped me deepen my understanding of myself and my life. Until I met them, I'd had a tendency to choose the most difficult and self-punishing route. Now I am kinder to myself and aware so that when faced with difficult situations, I make decisions that are ideal, not just idealistic. The greatest lesson I continue to learn, initiated by my studies with Paul and Alexandria, are around Love—authentic Love, higher Love, Universal Love; Love Consciousness and how it manifests in life alongside the human love we generally think of experiencing. Phew, what a subject! Understanding the journey from fear (False Evidence Appearing Real) to Love (Learning Oneness Via Experience) is a daily, sometimes moment to moment, practice for me.

The quest to understand unconditional love has permeated my life. My first experience of this was with the birth of Flynn and then Cy. They taught me the true meaning of motherly love. There are no imperfections in the love I feel for my children. Understanding self-love has been a life-long journey for me.

Paul taught me to think of love as allowance; that when you allow yourself to be who you are without hesitation or conditions, you are in Unconditional Love of yourself. Self-love. Only then can you experience that release of so much pain and doubt and misunderstanding. Only then can your authentic self come forth as a conduit for unadulterated Light in the world. Only then can you gift others the experience of receiving unconditional love. You and others in your life will then learn what it is to be truly loved and truly loving,

not just loved for meeting expectations or confirming conditioned ideas. And only then will you begin to live Universal Love—not for an individual or even for yourself, but for life itself with all its wrinkles and distortions and quirks that might ever have irked you. No longer is there any requirement to fix, correct, judge or resist what is ... just to be aware, observe and make self-loving choices. Any conflicts, inner or outer, are simply misunderstandings. I am, and have always been, my absolute and perfectly unique self in every moment to get to where I am now; experiencing what I have chosen to explore, and facing whatever my next experience may be—specifically, my next opportunity to learn unconditional love and put it into in action in my life in my own unique way.

Through unconditionally allowing others to be themselves, compassion led me to understand that they are doing whatever they came here to do in their own unique way. I am not required to know what that is, just to allow them their choices and to honour their uniqueness without interfering. I am not required to accept their choices as my own, or even agree with them, but it is vital that I allow them, since they are part of Divine Creation simply by being, by existing, and I magnetised them into my life for a reason—to observe and learn.

It is others' responsibility to learn their own lessons in their own unique way. We can only support them on their journey and learn our own lessons. Whatever they learn is added to the collective consciousness of which we are all part. They are a reflection of me and vice versa. They being themselves is a divine gift to me; and me being myself is a divine gift to them. We are mirrors for each other. Each sees in the other what they need to be aware of within themselves. We are of compassionate service to each other, with or without our knowing. Another aspect of authentic love.

I have found that it is vital we learn such foundational principles so as not to suffer from the wider simplistic perceptions of love that prevail, unwittingly creating conflict and pain in our world.

As a parent, I believe it is my role to guide, not control, my children; to guide them in understanding the universal principles of authentic love, and to encourage them to live by those principles and learn from the experiences they have. This takes courage and wisdom, which they are developing as they grow. And I commit to lovingly supporting them in that growth. As a parent, I am the one to introduce them to the awareness of their self-love and the respect they and others deserve of their own uniqueness in the world. And to teach them that their actions have consequences, regardless of whether or not they can yet see or appreciate those consequences.

I don't know how I would have managed without Paul and Alexandria's steady guidance and loving support. They have always encouraged me to trust—trust my inner sense. Trust that the Universe is on my side and everything that is happening is in my best interest. Trust that I have the innate ability to create my own life. Trust that I will know how to respond to life's next circumstance just by being true to my unique self. Trust that I magnetise into my life the experiences I require to take my next perfect steps into alignment with Unconditional Love.

My continuing studies with Paul and Alexandria deepened my spiritual growth in practical ways and steadied my journey into self-understanding, self-responsibility and living mastery. This growth actualised the journey from my head to my heart, making it real experience leading to a joyful life; trusting myself at every moment along the way to the best of my ability.

Our journey deepens as time goes on. We work together on a variety of areas—from business, health and well-being to creation,

turning dreams to reality, and understanding love, life, personal values and, most importantly, parenting—all as I walk my path in life.

Paul and Alexandria's guidance has been purposeful, profound and proactive. They have always placed the responsibility for change and growth squarely in my hands and heart while giving me the knowledge and understanding, support and tools to actualise it in my life. As I deepen my own spiritual connection to the Divine Source within, I continue to practise in ways I feel are aligned with my values and dreams as I discover new life opportunities and business projects that resonate deeply within me.

After my transformational first retreat with Paul and Alexandria in 2005, I worked avidly for many months. I decided to take a break when my dear friend Lawrence Stroll invited me to Mont-Tremblant in Canada on a pheasant shoot. Tim Jefferies, with whom I remained good friends, was invited too and we thought it might be fun to go together. Tim cancelled last minute due to work commitments and I was left going alone—bugger. I flew anyway.

Shooting parties traditionally start on a Thursday night and span the weekend. There are usually eight to ten guns and their partners. I was a single girl. The first night is often black tie or velvet jacket for the men. I wore a little fur shrug over an Azzedine dress. I'd recently cut my hair very short and it was quite blonde. Although I loved it, I felt slightly self-conscious because it was so different from what people expected of me. I was sitting at the bar in Lawrence's exquisite home when in the door walks a tall, good-looking guy with a shock of dark wavy hair, strong face and big blue eyes. As soon as I saw him, incredulously I said to myself, "Don't tell me I'm going to marry that man." In a way, he reminded me of John John Kennedy from Brown University, the boy whose apartment was filled with photos of his mother.

Now, I'm not the marrying type, having spent ten years not married to the father of my children. So the inner-voice comment on marriage shocked me almost as much as the vivid premonition. Jeffrey Soffer, the Miami real estate mogul, walked over to me, introduced himself, and we started chatting. Jeff, like me, was newly separated. We bonded over the sadness and disappointment that each of our marriages had not worked out and the desire to be hands-on parents while trying to make peace with our former partners. During our conversation, we found that he had two children who were each born within four days of each of my two children and, furthermore, he had a third child, a beautiful girl, who was in between those two pairs of "twins." It was as though there was some remarkable connection.

On that shoot, Jeff and I were the only two single people out of the group, so we were paired by our host. At the end of the weekend, Jeff offered me a lift in his plane back to New York, where he was heading for work. Although we flirted, I can't say we hit it off. Both of us were still reeling from our past experiences in relationships and both of us were focused on our children.

Over the next three years, neither Jeff nor I were interested in pursuing anything other than friendship so we became friends. We often spent hours on the phone chatting about our kids, and whenever he passed by London on his way to Germany, where he was building his boat (a ship, really), he would drop in and we would have an early meal together.

Jeff was such a mix of brilliant mind, sweet manners and awkward teenager clumsiness. He was direct and bright, funny and serious at the same time. He wore sweatpants and custom-made Italian suits with the same ease. He laughed about practical schoolboy jokes he played with his friends. I found him very endearing. Often he would bring me books, such as one on Alberto Pinto, the interior designer

of his boat. As our friendship grew, I stayed focused on co-raising my sons and deepening my spiritual and personal growth.

I began expanding my life in diverse directions and reaping the fruits of my labour. Elle Macpherson Intimates was thriving in Australia and internationally. I was named Entrepreneur of the Year by *Glamour* magazine, landed my fifth *Sports Illustrated* cover, and featured in the BBC's *The Money Programme* series in a documentary about my entrepreneurial career. In 2008 I received an award for Lingerie Designer of the Year and accepted invitations to share my experience in licensing and business by speaking at forums and events.

When it came to Elle Macpherson Intimates, Stu knew how to create a brand and I knew how to listen and apply. Together we were a brilliant team. At one point, Stu moved back to Oz from the US and managed the business from there. I took on more senior management roles with Bendon, my licensees, and eventually people wanted to deal directly with me. This shift demanded that I learn to adapt. It was monumental, very empowering and it gave me a sense of fulfilment, achievement and accomplishment. But it seemed incongruous to be managed as talent when I was working more like a CEO of a brand, both my own and with the licensees. I decided to go it alone. In June 2008 Stu and I parted ways. It was painful for both of us but I knew I had made a decision that was true to me.

Becoming global ambassador for Revlon that year was significant in my life. When Mark Dowley, then at entertainment company Endeavor, came to me with the proposal when I was nearly forty-five, I was blown away. Revlon had expanded the image of the beauty brand and helped redefine the conventional view of beauty. They were ultra-modern in their approach. For the first time, I noticed a company challenge the

perspective that youth equates with beauty, a false paradigm that I had already begun reimagining and establishing in my own business.

I had dreamed of being a Revlon girl since I was in my twenties. When I'd auditioned at that time, I'd missed out as Cindy Crawford took the role. Twenty-five years later, here I was shooting in New York with brilliant photographers Patrick Demarchelier and Mert and Marcus for a brand I had longed to represent. Timing is everything. Don't give up on your dreams, just make sure each step you take is somehow in their direction.

Work, work, work. It was relentless. I needed some fun time to kick back and chill so I headed off to the snow in Aspen, Colorado, and hung out with a buddy. One day we were up Ajax Mountain and as I climbed out of a gondola, I crashed into someone and found myself crumpled on the floor of the ski-lift exit. I looked up to see whose skis I had smashed into. With the bright light behind his head, I saw that goofy Jeff smile.

"Looks like you could do with a ski lesson," he grinned. "I'll race you down the mountain."

Furious, I leaped to my feet. I prided myself on my reasonable skiing ability but all of a sudden I felt like the girl back in school, who wasn't cool, and the school jock was teasing. Arggghh.

The challenge was on! I skied so frigging fast down that mountain, I was breathless. But I kept up with Jeff, who is a remarkable skier. We reached the bottom, climbed back into the gondola together, and didn't say a word. He sang along quietly to "Rocky Mountain High" by John Denver and he shared his earbuds with me. And that was it. We stayed together for ten years.

Our first date was in his kitchen at his home in Aspen. He said he would cook me dinner. We laughed as we ate peanut butter and jelly sandwiches, which he made. Dinner! Our love blossomed over time.

We dated for a year and then we finally decided to introduce all the kids to each other. What bonded us was seeing in one another the love for our children. Together we enjoyed sports, nature, design, travel, simplicity and realness. Truth was, we chose simple. Jeff and I were happiest in nature, with each other and, even better, with all five kids.

Our first summer together was 2009. He invited me and the boys to spend time with his kids on his boat in Europe. I was worried. I didn't want Flynn and Cy to be uncomfortable, but it had been three years since I'd separated from their dad, so maybe it was time. I was nervous. Lots at stake. Jeff was relaxed about his wealth, almost cavalier, whereas I was wary. Once, in the early days, I told him that I didn't want to consider him for a boyfriend because he was so wealthy and I saw him change cars, boats and planes like T-shirts. I didn't want to be just another acquisition, only to be discarded when he found something better. He looked at me with his big blue eyes and gentle face and said, "It sounds like you're no different from all those girls who want to go out with me for my money. But you don't want to go out with me for my money . . . either way, you're putting a price on love."

We moved on together and coordinated our parenting schedules. During the ten days when Arki had the boys, I would fly to Aspen from London and Jeff would usually have his children five of those days. I was really impressed because he never missed a five-day week with his children in all the time I knew him. Jeff's home was in Miami, his kids lived in Aspen with their mum, and he would fly from Miami on a Thursday night to see them for his parenting time, returning the next Tuesday morning.

Those days in Aspen were some of my happiest times ever. Hanging out with Jeff's children, skiing, hiking, ice hockey, ballet practice, horse-riding competitions—Jeff, like Arki, was a hands-on, loving father.

After two years of me flying every month to the US, Jeff and I discussed the possibility of me and the boys moving to Miami. It seemed to make sense as I thought we would all benefit from a change in lifestyle; plus, Arki was in a serious relationship and spending lots of time in New York, so I naively assumed it could all synchronise nicely . . . Mistake!!

Arki went ballistic and so did the boys. I tried to explain how amazing I thought a move would be for us all. It could be full of opportunities, new insights and experiences, new ways of doing things . . . like a fresh start. But Arki didn't agree. He preferred to raise the boys in London as he felt they would have a better education staying in the UK. Also, it was easier for his infrastructure and it would be less complicated for his parenting time. What's more, his sons were not moving in with a Miami-based billionaire, no matter how generous and down to earth he was! He said they were not to be exposed to that kind of excessive privilege and laissez-faire culture. I respected his opinion and I could see the situation from his perspective, but I couldn't see the boys flourishing in the tight restriction of the British education system and the pomp of European class structure.

Our difference of opinion was a reflection of what each of us thought was best for our sons. We couldn't come to a balanced agreement, even after a year of painstaking negotiations. I was devastated. Over the following months I slowly came to terms with the disappointment of not moving to the US to be with Jeff. I had even sold my house in Notting Hill in anticipation of the move. The boys and I were staying in a temporary mews house in Pimlico.

I began transmuting all that disappointment I felt, channelling it into new business, but of course nothing replaced the dream I had of building a new life and family with Jeff and all our kids in America.

The Universe is so benevolent and in this case it came in the form of an exciting opportunity.

In 2010 I had the honour of closing the Louis Vuitton show for Marc Jacobs. I remember it vividly. I was sitting in my little mews office opposite my wonderful assistant Donna Rooney, when we received the call—would I come to Paris the following day to walk the show for Marc Jacobs?

Of course, I accepted. At the same time, I wondered who'd dropped out. Did they really want me? Could I arrange to leave the boys in a few hours, jump on the train from London to Paris and arrive on time for the show? What exams, tests, sporting activities did the boys have? Was their dad in town? I didn't like to leave them without a parent if possible. How were my hair, nails and weight? What if I didn't like the clothes or they didn't fit? What if I got there and they thought I was too heavy or not cool enough? What if I looked stupid in the collection? After all, I'm a tomboy and Marc's clothes were notoriously feminine. So much to organise and consider.

We called and verified the true interest level. Donna said the show was titled "And God Created Woman." Women of all ages, sizes, types. They said I would be well received but they wouldn't disclose who the other models were, what the clothes looked like or give me any description of the visuals. Donna urged me to take a risk and give it a go. She loved fashion and always encouraged me to step out of my commercial, business comfort zones to play in the fabulous space of fashion. I felt uncomfortable and nervous; so much so that my stomach ached. Yet having less time to prepare, procrastinate or worry worked best for me. I had to take the leap, get on the Eurostar and go do my best.

Upon arriving in Paris, I went immediately to the fitting, hoping for flat shoes, and clothing that was the right size for me. I recall

entering the dressing room and, for the first time ever, looking at the young Brazilian girls' bodies and wishing I had their shape—long waist, nipped in tight between sporty breasts and sexy butt. My body was long-legged, broad shoulders, natural breasts, soft and round.

Marc's clothes were extraordinary—corseted and reminiscent of the 1950s. My hair was drawn tightly back into a ponytail (horror of horrors—so exposed). Pat McGrath did an incredible fresh, flawless make-up on my face. While I had been concerned that I was being asked as a substitute, in case someone cancelled or to fill in the gap, my biggest honour was to close the show!!! It was a wonderful surprise to see my name as the final walk.

Backstage, I heard beautiful music swell in the auditorium and it touched my heart. I walked out onto the circular runway and felt tears well up in my eyes. My heart exploded with the joy of being 100 per cent present in the moment. I felt embraced and encouraged by the smiling faces of the editors who I had grown up with throughout my time in fashion. I saw the surprise, respect and appreciation in their eyes and on their faces. Typical me, I smiled the whole way until the closing. I felt welcomed, accepted, appreciated and honoured. It was truly magical.

That show was groundbreaking and inspiring. It was my last walk and, perhaps more than that, I was part of the conversation Marc was initiating, namely "Beauty is for everyone." Beauty is femininity—strength yet gentleness. Beauty is beyond the stereotypes; honour of a woman and honour of the Divine Feminine—those historical, powerful attributes of fearless uniqueness; womanly with will and without weakness; fineness and elegance without the femme fatale. Women of resilience and beauty such as Joan of Arc or Princess Diana—courage and purpose in an unwavering package. I'm talking boldness without buckling. And Marc captured that.

After that wonderful weekend in Paris, I headed home to be with my boys. The following months saw life between Jeff and I become strained. Towards the end, Jeff asked me to marry him, perhaps hoping to cement our relationship as if marriage would be the glue to bridge our distance and dissonance. But I knew it was unwise—I'm a great believer in starting how you mean to go on.

In 2011, we separated. I just couldn't see the point of continuing our relationship knowing there was no chance of harmony and alignment. I was tired of trying to straddle two lives, two families and two countries. And still manage to work.

I was bereft. I felt as though I had lost love, my dreams, my soul. Suddenly life felt so small and meaningless without love. Now what?

But of course love is everywhere. Love isn't a person, place or thing it's not even liking or agreeing, and certainly it's not needing or fixating. Love is allowance—allowing your own and others' unique self to be, without judgement, hesitation or discrimination. It's a journey combining beneficent motivation with heartfelt action. It calls for respect, integrity, compassion, kindness, gratitude and a deep appreciation of individuality and its value. And the courage to live those qualities. Love is letting go of control and even the need or desire for it.

Authentic love demands a blend of courage and trust—trust in self, trust in life, trust in an infinite magnanimous cosmos. And on another, more simplistic level, it is affection, care, respect, belonging, intimacy and so many other traits of personal relating on the conventional level of women and men and families and friends. It will ebb and flow in life as those involved either learn or resist learning from their dance with love.

It was not long after I separated from Jeff that I was approached by the producers of *Britain and Ireland's Next Top Model*. They asked me to be the host and executive producer of another series. Thank

you, Universe! Speedy income and long hours. Just what the doctor ordered. It was the distraction my heart needed so it could mend from missing Jeff.

I loved working on this type of project, co-creating with the team and mentoring those young girls. I was passionate about helping young women find their inner beauty and helping them learn how to express it. It was the beginning of me moving from finding my own beauty to enabling others to find theirs. It was transformational for me, and for them too.

Early mornings are my thrive time. Welcoming the new day always energises my spirit, so waking up at 4:30 a.m. for hair and make-up was easy. I had a trusty team. Eamon and Sarah oversaw my hair and make-up, while Anna, my incredible stylist, tackled my show wardrobe. I woke the boys at 6 a.m. for breakfast and then took them to school, dropping them off on my way to the studio. There was always paparazzi outside the school gates and every day there was a comment on my show wardrobe in the tabloids. They honestly thought I got dressed up like that for the school run!

The boys, Arki and I eventually got back to a stable, predictable routine. The boys flourished in our little home in Pimlico. As their academic workload increased, Arki and I shifted our time-sharing of 50/50. Flynn and Cy spent twenty days with me—two school weeks and two weekends; and ten days with Arki—two weekends and one school week. I was the academic, exam prep, structured stable routine, manners-enforcing mum; and Arki brought creativity, fun, exploration and adventure; as well as that elegant beautiful European way of being. We were a good team.

Even so, I know the boys suffered deeply from the constant discord between Arki and myself. I wish I had handled our separation differently because I know now our sons really struggled. I found

out years later that they didn't care about us separating. What pained them was witnessing their dad and me fighting. It was devastating for them and affected their little hearts. Had I known how much they internalised it, I think I would have found a way to be more harmonious with their dad.

Arki and I didn't fight when we were all living together but we fought after we separated because we both had fear around the different ways the boys were being raised. To other parents going through this, I would say, "It's not worth fighting after you get separated or divorced. You separate so you won't fight."

Separation causes pain. Any division, isolation or disconnectedness brings pain as the heart feels broken. But it can be mended. Never assume divorce harms the children involved as they can become more damaged by remaining in a situation of conflict and animosity. Healthy divorce requires an enlightened mindset that marks the end of conflict, not the cause of more; the solution to difficulties, not the source of them. The key is to maintain openness to connection in some form or other that preserves your own inner sense and truth and self-power. Such connection is possible, even natural, though maybe not normal. And it is wise because disconnection is where the ego can incessantly cause unnecessary agony and trauma. Finding and preserving some form of connection will always be of benefit to all concerned. There is no benefit to anyone if pain persists. As the Buddha once said, "Holding on to anger is like grasping a hot coal with the intent of throwing it at someone else—you are the one who gets burned."

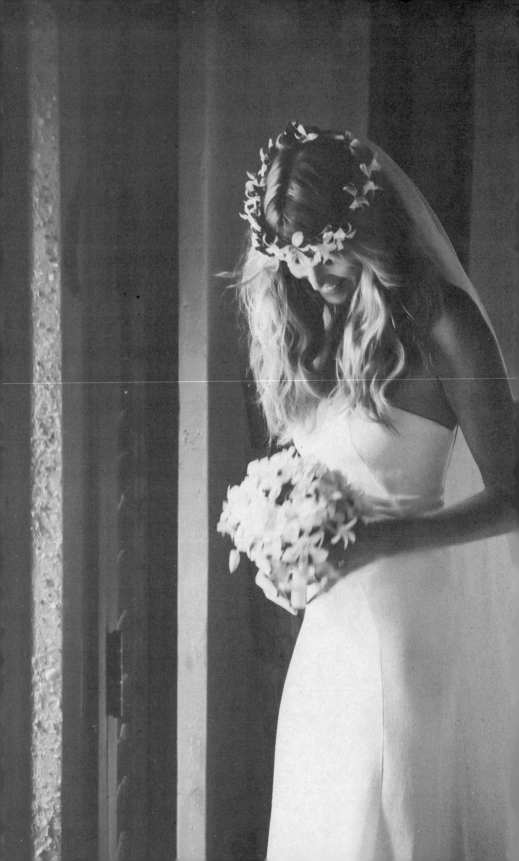

14

THE MARRIAGE

It takes two

Something didn't feel right. I inexplicably felt sick to the stomach, like a feeling of foreboding. It was so strange. I was staying at my lake house in the Cotswolds, and I remember being unwell all day. Late that afternoon, I received a call from a close friend saying that Jeff had just been in a fatal helicopter crash in the Bahamas. He and several others were severely injured and a mutual friend of ours had tragically died. It was a terrible shock, devastating.

My friend encouraged me to phone Jeff, even though he knew we'd been apart for nearly a year and hadn't spoken for most of that time. Flynn, who had remained close to Jeff throughout our separation, urged me to make contact. As I dialled Jeff's number, a cold fear washed over me and my heart began to race. Miraculously, he answered and I managed to briefly speak with him. He told me he was on his way to the hospital from the crash and then tearfully said, "Elle, when that helicopter was going down, my life passed before me

and all I could think of was my kids, you and your kids. That's the only thing that mattered to me." He surprised me as that was the last thing I expected him to say. Jeff's words touched my heart and I was moved by his tenderness.

I flew to Miami a few days later on my way to our friend's funeral. Jeff was unable to attend due to the injuries he'd sustained from the crash, so I went to see him at his home. I never believed you could fall in love with the same person twice, the second time more deeply and intensely than the first. But I did. We did. Three months after the crash, Jeff proposed again and this time I said yes.

This time my heart felt different and his did too. It was a knowing that we wanted to be together. We didn't want to have a long-distance relationship and, between us, we wanted to heal some of the mistakes we felt we'd made in the past. We had both grown. Jeff had spent the year by himself exploring a different way of "being" in his life after our parting. I had too. I'd been learning and practising how to go with the flow and chill, while exploring my own freedom and creative expression.

The crash was a huge life-changing experience and wake-up call for Jeff. It put what was important in his life into perspective. It changed him. And because it changed him, our relationship and time together was very different. I saw a tender, open-hearted man.

When Jeff asked me to marry him, just before my forty-ninth birthday in March 2013, it was a bittersweet moment. It should have been one of the happiest days of my life. Instead, I felt panicked at the prospect of approaching Arki and the boys again about moving to the US. I prayed that Arki would agree. A move to America seemed to make even more sense this time round. Arki was spending more time there, as he had a newborn daughter and she and her mum were living in New York, while Jeff's family home and huge functioning infrastructure was based in Miami.

I wished too hard, too soon. Two years later, Arki was still adamant that the boys remain in London. It was traumatic, painful, debilitating. And. I. Felt. Conflicted. I didn't want to leave the boys in London and I didn't want to separate them from their dad. Arki had no intention of spending more time in the US and I didn't want to let go of Jeff again. So it was an extremely difficult situation.

I've noticed that life-changing events happen in threes and I'm a great believer in that. Jeff had proposed marriage; I was trying to find some kind of resolution around the boys' residency, and the prospect that we might be living in two different continents. And, if things were not already complex enough, I felt a lump in my breast one day while I was in the shower.

I called my friend Kath as she specialised in cancer. She'd started her journey in medicine and had focused on breast cancer after her mother died from it. Kath went to Harvard, met her love, married and had a brilliantly successful practice in New York. I loved her. She was bright and funny, strong and smart. She was New York cool and I trusted her implicitly.

My mind raced and I was worried when I called her. "I found a lump in my breast," I said. "'It's hard and shaped like a pea. It's just come up and it hurts. I'm scared."

Kath said to me, "Elle, cancer usually doesn't hurt at this point but let's get it checked out."

All I could think of was, I've just become engaged. I'm starting a new life. Please, please, please don't let it be cancer.

Shortly after our call, I had a mammogram and biopsy. The following day I travelled to Barbados for a few weeks to shoot and produce *Britain and Ireland's Next Top Model*. While I was there, I was interviewed by a remarkable journalist, Karen Hockney, who had recently finished substantial amounts of chemo for breast cancer. Was it a

sign? She told me she had put herself under the care of an amazing Australian doctor in London who'd helped her through treatment, including completely changing her diet and way of living.

"What's the doctor's name?" I asked, thinking to myself, I'll contact her immediately.

I called from Barbados and spoke with Dr. Simone Laubscher, PhD, an esteemed naturopath, nutritionist and wellness expert on Harley Street in London. She was renowned for her work in hormone rebalancing, cancer, diabetes, well-being, stomach and eating disorders, stress, depression and metabolic resetting.

Dr. Laubscher listened as I described the lump I had felt in my breast. I informed her that I was waiting on my mammogram and biopsy results and explained that I'd been feeling listless, rundown, lacking vitality, my skin was dry and I was surviving on coffee and a few hours' sleep at night. On top of that, I felt depressed, worried and anxious about marriage repercussions and the boys' residency. My emotions were all over the place; I was trying to manage *Britain and Ireland's Next Top Model* and, most importantly, be there for my kids. Just talking to Dr. Laubscher made me realise that I had a lot going on in my life. We made an appointment to meet when I returned to London after filming in Barbados.

The days crawled by. Every day, I patiently waited and tried not to think about the lump. When the results finally came back, they were negative. The relief I felt was immeasurable. The lump in my breast was diagnosed as a benign cyst. Even so, it started me down the path of questioning why I got that lump? What was going on in my body? I took it as a sign to reflect.

Being continually stressed, I realised I needed to change my lifestyle; how I was looking after myself was just not working any more. I didn't know where to begin but knew that I needed help.

My inner voice reminded me that there's no change without change, so I started my research to find out exactly where and how to make adjustments.

Even though the cyst was benign, I still went to see Dr. Laubscher. From the moment we met, I knew I was on the right path. I tearfully told her I was sick and tired of feeling sick and tired. We spoke in depth about my health, physically and emotionally. I told her I didn't smoke, drink or take drugs and I followed a healthy daily fitness regimen but still felt overwhelmed and drained and didn't know why. When I gave her a list of the vitamins and minerals I was taking, she said to me, "Elle, you are not what you ingest, you are what you absorb. Your body is not recognising those synthetic supplements."

Dr. Laubscher went on to explain how modern farming practices deplete our soil of essential ingredients, directly reducing the nutritional value of the food we eat. She said I wasn't getting enough nutrients and I was dehydrated and malnourished.

She also spotted my hormonal fluctuations and said my body was changing and needed support. I thought I was mainly stressed about my dispute with Arki, work, my engagement to Jeff and planning the wedding, plus the benign cyst in my breast. I didn't consider for one moment that I might be going through menopause as well.

I didn't want to take hormone replacement therapy, preferring to find a natural way to ease the symptoms and support myself through these changes I was experiencing. As I neared fifty, I knew I couldn't rely solely on genetics and my fitness regimen; I needed profound support and understanding.

Dr. Laubscher started me on a program to alleviate inflammation. It would help lower cortisol and reduce the acidity in my body. This helped balance my rollercoaster hormones that were making me feel

all over the place emotionally. I also took copious amounts of her curated supplements throughout each day and rigorously incorporated her health protocol into my life. It consisted of bio-available vitamins and minerals, herbs, proteins, raw live foods, only organic fruit and vegetables, and some simple lifestyle changes.

Within a few months I saw a huge change and so did everyone else. Many of the physical symptoms dissipated. I was balanced emotionally. My skin texture had improved and I was radiant, glowing. My weight and digestion had stabilised, giving me a leaner stronger body, and my sleep felt more in sync. My hair was growing so fast and my nails were too. I was nourished on a cellular level and my body had started responding, kickstarting a new phase of well-being.

Half-jokingly, I asked Dr. Laubscher if she could simplify all the pills I was taking and combine everything into a "something" I could take in the morning. Easy. She thought about it and said, "Yes, I think I can!" Amazingly, she went on to formulate a unique "one-and-done" greens powder comprising almost fifty ingredients—a multivitamin and mineral complex with probiotics and adaptogens (active ingredients in herbs, roots and plants such as mushrooms, which are thought to help your body combat stress). "The Super Elixir" alkalising greens was born.

A friend and work associate of mine in Australia, Andrea Horwood, noticed my new sense of vitality and vibrance and could see that I felt fantastic. She also noticed the difference in my appearance and said I looked ten years younger. I mentioned to Andrea that I'd been taking this greens powder and I really wanted to share with others what I had learned through my wellness discoveries, particularly over the previous months. Andrea was excited and wanted to explore how we could make this dream a reality.

WelleCo was inspired by my own wellness experiences, physically, emotionally and spiritually. From navigating the profound and

miraculous changes in my body through pregnancy with both of my children, to learning how to healthily nourish them and myself while staying in shape physically as a model; from letting go of soul-compromising and body-destroying addiction and getting sober, to addressing the scare of the cyst in my breast and the recognition of how the onset of menopause can affect the body . . . all this laid the foundation for me wanting to create something profound in the wellness space; something that would make a positive difference for people in all walks of life. A strong urge was driving me, establishing a powerful purpose to contribute in such a way to a world of wellness.

This inner desire to help others became a passion, driving a purpose that became bigger than myself. In 2014, I decided to create a company—WelleCo. Perfect. I loved the play on words with my name. Andrea and I discussed how to begin a business, starting with the re-creation of the greens, which we called "The Super Elixir," referencing my connection to the supermodel era. And it really was super.

We decided that Andrea and her husband would manage the company from Perth, Western Australia, where they lived, and I would innovate, promote and bring creative input and marketing from the UK, where I was based at the time. We started the groundwork and began to build the business. WelleCo was born!

Starting WelleCo was the most natural next step on my business path. I was also inspired by seeing my friend Gwyneth Paltrow step out of her expected film roles and into her heart's passion, developing Goop—her vision to create a modern lifestyle brand, also in 2014, after years of writing her newsletters.

Developing and building WelleCo was exciting. Andrea and I raised capital and used the money wisely to start the business, and soon we were self-sufficient. Working closely with Andrea on packaging, product development, logo, marketing and sales was wonderful.

She was inspiring and I learned a lot from her. And I loved being able to express myself by using my own marketing and brand-building experience to develop the company and its brand.

We were excited when Dr. Laubscher joined us as a formulating partner. She brought with her a profound knowledge in nutrition and a vast experience of helping people with all sorts of health issues from cancer and infertility to eating disorders and depression.

Not long after having the idea for WelleCo, I began to organise my wedding with Jeff. We had originally planned for a northern hemisphere autumn wedding. I had been dreaming of a celebration at Red Rocks, Colorado, with Fleetwood Mac playing at sunset. We discovered a barn in Aspen and decided to do something whimsical there. I wanted to wear a lace dress and cowboy boots, so I went to see my friends at Roberto Cavalli to design my wedding dress. But we never went ahead with it. After months of planning, Jeff and I decided that the pressure of a huge four-day event was unnecessary and we cancelled those plans. We loved each other and really just wanted to keep things simple and be with the kids.

While taking that break in Aspen to make our wedding plans, we also planned a trip to Fiji for our upcoming summer holiday. The previous Christmas, Jeff and I had rekindled our love there and had such an amazing time that we wanted to share the beautiful island with our children. As it happened, my sister Lizzie and her fiancé were getting married that summer on the tropical island of Koh Samui in Thailand. Jeff and I decided to travel on to Fiji after their wedding and make it one big trip.

Not long before we departed, I went shopping with Jeff's youngest daughter and we spotted a simple, long, strapless, ivory crepe dress hanging in the window of Ralph Lauren. It was a sample size. I tried it on and it fitted perfectly so I arranged with the shop assistant to sell

it to me. I wanted to tell her that I was thinking of wearing it to my wedding, but I didn't. I wasn't sure myself when our wedding would take place. I think Jeff's daughter knew that this dress was meaningful and she was excited for me when I bought it. I tucked it into my luggage, just in case.

At the end of a hockey-filled season with Jeff's family and mine, plus Jeff's dad and fabulous partner, who I adore, we all flew to Koh Samui to attend Lizzie's wedding. It was a great opportunity to introduce Jeff and his family to mine. As Jeff and I watched my sister walk down the aisle, our own wedding plans lingered in the aether. We had considered discussing them with our families but decided not to as we didn't want to distract from my sister's beautiful day.

While we were flying from Koh Samui to Fiji, we talked about making last-minute plans for a wedding union on Laucala Island, where we were staying. I wanted our day to be simple, unusual and meaningful, so when we arrived, I organised a Fijian chief to officiate our ceremony on the beach. Flynn walked me down the sandy aisle. I had put flowers in my hair and was barefoot as I wore that gorgeous Ralph Lauren dress.

Everyone wore white except the Fijian chief, who dressed in traditional warrior attire. It rained and I saw it as a good omen, representing emotional flow and creativity. After the ceremony, we went to a traditional Fijian bure, celebrated, and danced all night. Jeff beamed and the kids were really happy. Our friends Laurie and Richard, and their children, had flown all the way from California with our wedding rings, which we had commissioned very last minute. Inside the bands were engraved the words "True Fucking Love."

We wrote our vows to encapsulate our unconditional love for each other. (Well, actually, I wrote them and I think that was a big sign of things to come.) During the reading, the chief added, "Elle, will you

love Jeff for richer or poorer?" And Jeff's dad yelled out, "That's never going to happen." Everyone laughed and I did too, though I didn't really feel like laughing. I didn't want that line in the vows and I don't know why it crept in; it felt foreign to my intentions. Our marriage was never about money, although in hindsight I think I wanted an emotional commitment with financial security.

The night after our wedding day, for some reason I lost my cool and started to panic. Maybe it was the stress of organising everything quietly by myself. Jeff just rolled with it but he did seem distracted. I had suddenly started to feel really lonely; like I was the only one truly present and maybe we shouldn't have married. I don't know what I expected but somehow I didn't feel like we were in it together. Had I misunderstood? Looking at our wedding photos, they betray the pain and uncertainty I felt, but they captured the joy and commitment I had for our love, our children and our aspiring future together.

I wanted our families to be united. And I wanted us to create a beautiful life together with all our children. I also wanted to be part of Jeff's extended family. I had such deep affection for them and really wanted to take Jeff's family name but, ultimately, it didn't make sense for all sorts of reasons.

Jeff and I spent the first year of our marriage living apart. He lived in Miami while the boys and I stayed in London to finish the school year. Taking that time, I also diligently prepared myself for my next effort to obtain permission to relocate the boys with me to America. Note: preparing meant that my organised, super-detailed self made such an effort to take a stand for love. It taught me to be focused and to commit, no matter how impossible the task seemed. Late at night, after I came home from the studio, I worked for many hours tackling the task in bite-size pieces. I didn't give up. I prepped and prepped

and prepped. I took notes on everything. I compiled reams of paper-work, timelines, diary entries. I was passionate, precise, proactive and persistent.

As I think back on that time, waves of tears flood my heart as I realise how painful the whole situation was for everyone—Arki, the boys, Jeff and myself. Arki fought so hard for his boys to stay in London and I fought for a new start in the US for them; for us all. In the end, Arki agreed that we were able to live in America and he would still have all his parenting rights. It was a trauma-filled year and, although I stand by my choice to move, I just wish it had gone more smoothly.

Having permission from Arki to move the boys to America was one thing—actually doing it was another. They say that moving coun-tries or homes is one of the most traumatic experiences ever. It's true. Packing up our life in London, the boys leaving their dad's home and their friends, was no mean feat. Such an upheaval. One of the things that I thought was extremely important for the boys was the power of adaptability; to be flexible. And that's what they learned when they moved to America; actually, we all did. Adaptability, flexibility and the opportunity to evolve outside of our comfort zone. I know the boys became stronger because of it and it's given both of them the tools and skills to learn to manage new situations that continue to arise in their life. I believe there's no bigger gift you can give a child.

My spiritual mentor, Paul, calls adaptability "the superpower of the future." We are intended to learn and grow into the life we are truly meant to live; be the ultimate version of ourselves and bring our higher purpose to our world. To achieve that, we are required to let life flow and guide the way. We can never imagine what our perfect future for our greater good will hold. The ideal strategy is to allow life to show us its loving support and infinite wisdom in the opportunities it presents to us in the thread of moments that make up our life. All the while,

simply navigate life's circumstances by sensing what resonates with us and courageously taking action that reflects that inner sense.

I've found the most powerful and fulfilling path is to surrender to the natural flow of life, always holding focus on my intentions to be happy, prosperous and fulfilled, no matter what material form life takes. Then, I constantly adapt to the situations that unfold. That way, I can thrive on allowance and choice, and release my attachment to control and force, ensuring I am clear and confident that my choices are aligned and true to me. It enables me to be fulfilled and at ease being in the driver's seat of my life.

Arriving in Miami during the middle of August, in the hot and humid hurricane season, to start new schools and new lives was one of the most difficult times we've ever had. The boys were miserable and I was panicked trying to make it all work. I desperately wanted everything to be okay and for the move to go smoothly.

Being newly married, and having never really lived with Jeff for more than ten days at a time, was intense; juggling five children, five schools, five states. Everyone was trying their best to adapt to all the new dynamics. Jeff's kids worried about these new boys living with their dad while they lived in Aspen with their mum. My boys worried about leaving their own dad, excelling in their new schools and making new friends.

Combining two huge lives, Jeff's and mine, was challenging, encompassing my two sons, two dogs, my wonderful assistant Donna and our beautiful Aussie assistant Jonathan, who was helping mentor the boys. It took months before our belongings arrived in Miami, carefully crated and shipped from London. Integrating them into Jeff's house was awkward and we felt we were out of place and taking up his space, despite his open arms. It was a right mess. To make matters worse, the boys' first day of school was plagued by a case of head lice. Fifteen

people in the house exposed to the drama of trying to get everyone lice-free only added to the chaos. Even the dogs were having a hard time.

Embracing each of the children's individual characters and academic aspirations, sporting skills and health, was fun but demanding. Being the Aries Dragon I am astrologically, I marched in and took the bull by the horns, thinking I was being super helpful. But in fact I was probably being draconian. Structuring education and diets was not the most glamorous of jobs and, to be honest, I would do it differently if I could do it all over again. What was needed was nurturing and tenderness, and for me to allow the children to be themselves; to respect their individual ways of being and to honour their uniqueness.

Considering all the resources Jeff had, I wanted to make my own difference and bring something to the family. Jeff seemed to have everything and there were times when I questioned myself, wondering, what do I bring? What are my skills? What am I good at? That intangible something was encouragement, inspiration, organisation and attention to education, health and well-being, social confidence and an effective and efficient routine. Feeling redundant to some extent was probably my motivation to try to make myself valuable by filling in the gaps.

I was pretty strict and had raised my boys from an early age in England with a certain degree of structure and discipline. Ultimately, they became confident, self-sufficient, self-responsible and reasonably organised, thriving in a routine. I wanted to share these qualities with Jeff's three children, although it turned out the idea was not popular.

His eldest daughter loved horses and was an avid dressage competitor. In fact, she excelled in everything she did. She's strong, diligent, stoic, quick-witted, intelligent, beautiful, and was the first to make me feel welcome. As the years passed, I discovered in her a deep well of sensitivity that wasn't as apparent when she was younger.

266ELLE

Jeff's younger daughter is heart-led and headstrong, and I love this beguiling combination. She's wonderfully warm, practical, persistent, proactive, funny, feisty, loyal, intelligent and deeply emotional. She's a beautiful girl and I love her spirit. She and I were always very close. We had a strong bond and were connected from day one. At times she was unsure of herself and I wanted to encourage and help her build confidence so I took her under my wing. I saw such beauty in her and wanted her to feel supported, empowered.

Jeff's son is a talented athlete and a formidable ice hockey player, while having a kind and gentle heart. He was often away from his siblings and parents as he was flying around the country playing ice hockey and competing in tournaments. He followed a strict routine with long hours of practice while juggling schoolwork and friendships. As much as he got out of ice hockey, he often struggled and was torn between being a great player and having a normal life. Jeff, doing his best at managing the dynamics of that, was always with him when on the road and encouraged him when he lost interest or when he felt things were too challenging.

Jeff's children were very important to me and I loved them with all my heart. And I know Jeff loved Flynn and Cy. That was something Jeff and I had in common—we both fiercely loved the children and parenting. We loved our own children and each other's and were bound together by our love for them. We each had different skills and we brought those to the table with a passion. We wanted to do the best we possibly could. Arki did, Jeff did and I did too. The interesting thing is, we all went about it in different ways, which created tension at times. But the love for our children was always there.

Being a hands-on, proactive mum has been important to me. And I wanted to be a great stepmum to Jeff's children as well. What I learned was that my "my way or the highway" attitude created

resistance. And with resistance comes pain, which was never my intention. It wasn't my place to regulate, coerce or force my views on Jeff and his children. I learned the hard way that allowing them to come to their own conclusions is much gentler, more effective and more respectful. Not everybody finds structure and routine easy or natural or helpful.

Parenting. Co-parenting. Step-parenting. They are all different skills but their common denominator is unconditional love. Allowance. Not blanket acceptance, just allowing everything to simply be at each given moment. Remembering my role as a guide, which often meant stepping back, was not always easy. Often I would say to the children, "I'm here to help guide you, even if my words are not what you want to hear." But ultimately, the more I tried to keep things ordered, the more difficult life became. In the end, I loosened my grip and ultimately let go of the reins altogether. Things settled down and found their natural rhythm. You just have to surrender—allow. Trust that things will work out for the highest good of all—even if it doesn't initially look like it at the time.

Our first family boat trip with all the children was back in 2009. I cringe as I remember some of it. I noticed the kids would start the day with an Oreo cookie milkshake. This continued four to five times throughout the day, spiking their blood sugar levels. And it always ended in tears at some point. The kids were sugar-addicted, sleep-deprived and dehydrated. I thought I would help by banning sugar. Or at least rationing it. Bad idea! All hell broke loose and although my intentions were pure, my execution lacked understanding and finesse. Conflict resulted and was very difficult to remedy.

The children were so fed up. The withdrawal from sugar was a serious shock to their system. That experience stayed with us for years and by the time we moved into Jeff's house, any organisation or planning I was

trying to implement was tainted by it. You can't just march into someone else's life and assume you know what's best for them. All our children were individuals requiring different attention, guidance and nurturing support along the way. Not all were wanting a dietary overhaul, not all were sporty, or academic—or wanting to be—and not all slept well and peacefully in their own beds through the night.

Looking back, I can see that everyone was trying their best. But truth be known, Jeff and I hadn't discussed how we would co-parent, our principles or our intentions. We were so fixated on getting to America that we hadn't really discussed what marriage meant to each other or how we would integrate our lives, values and families into our marriage.

I think Jeff's idea of being a great husband was "I provide." And I think my idea was "We are a team." But we never really discussed these thoughts between us. So while I was looking for a partner and ally, Jeff thought he was being a great husband since he was providing for everybody. Yet what I was yearning for had become elusive—the friendship element.

Jeff and I were in each other's lives but we actually didn't share our lives with each other, we just sort of cohabited. There's a big difference between being in someone's life and being "in" someone's life. And there's a big difference between being in each other's life and sharing each other's life. When you become an "us," there are three energies in the marriage. There's you and the other person, and then there's the marriage. But sometimes people forget they are individuals so they just focus on the "us" part and the "each" gets neglected.

It's a nuance in relationships that I hadn't fully understood at the time. Jeff and I never shared our thoughts, feelings or perspectives on things. We integrated two separate lives but we didn't really share our lives as a man and a woman, husband and wife. It was more so

as parents to our children. When it came to our marriage, maybe Jeff and I were married to the marriage rather than married to each other.

I thought we were compatible and our lives would be great together, especially since he had children the same age as mine. We are both high achievers and willing to work diligently towards the things that we love. We both loved nature and sports. We both like to rise with the dawn and go to sleep early at night. He likes to sleep on the right-hand side of the bed and I prefer the left. And we love peanut butter and jelly sandwiches. It's that idea of ticking boxes that look good on paper but is misleading because when you're actually living a relationship, a marriage, it's a very different story.

The intimacy and depth of a marriage commitment is easily underestimated. And the reality is that marriage, or any serious relationship for that matter, requires a soul connection with communication. But these are not found in box-ticking. It's not about liking the same things or even the same ideas. It's not even about doing the same things or liking the way they look. And it's certainly not about needing each other or grasping the other without letting go.

In hindsight, I'd say that Jeff and I married the potential we saw in each other. Fatal.

We saw only the bits of each other that we thought we wanted, and assumed the other bits would either disperse into the joy of our marriage or just become irrelevant. But they didn't. Yes, we loved the ideals we saw each other living up to, but we didn't count on the strength we each had to live our own ideals, ideals that did not match. In fact, at times they conflicted.

I've found that people seem to agree to conditions that have little to do with actual love. They agree to stay together, no matter what, or in order to make each other happy, but not themselves. Or they agree

to have children to please the grandparents. They agree to perpetuate expectations for conformity's sake.

It's a mistake to confuse loving with liking. "Like" is just a whimsical ego feeling; it's the fun, fleeting delight that skims atop the flow of life. Love is a deeper feeling, a lasting commitment to allow all the unique details and quirks, seen and unseen, that together made the whole unified package so attractive and loveable in the first place. When someone tries to change something they don't like, it is control—the polar opposite of love. The love is gone, replaced by control, need, force, conditionality. "Like" isn't lasting, it waivers with the slightest outer influence or personal bias. And I think Jeff and I confused like and love. We liked each other. We liked our lives and what each other represented, but we didn't allow each other to be our own unique selves. That elusive potential was always there.

Expectations. The view that someone or something has to be a certain way and if it isn't, then it must be put right. This demands control and force to bring the other person into compliance with personal opinions of what should be. The unique attributes of individuals who enter into a relationship, and their freedom to be those individuals who attracted each other, become disallowed; diluted and twisted. They are not free to be themselves, they are being coerced into being someone else, someone they are naturally not. The result is conflict, not love, and the relationship can only continue if one or the other is willing to be compromised. Expectation does not allow things to be okay just as they are, it inevitably demands things to change, ultimately by force or coercion if necessary. It is not love, it is fear. Fear of the unexpected; fear of uniqueness, differences; fear of who is better or not good enough; fear of not being good or right. It is that fear itself which needs to be healed, not enforced or supported.

Connection is key. There's a big difference between connection and attraction. I have learned that connectedness is vital to health. Connectedness to all things—nature, our planet, each other, community, ourselves and the direct flow of life force from the source of all life to each and every one of us in embodiment. Connection is the stuff that lasting experience and deeper purpose and meaning are made of. A deep calling; magnetism. Attraction so often becomes the transient experience as the outer attributes don't last. The connection is actually created by allowing each other the freedom to express and live our uniqueness; respecting each other's individuality and enjoying the unfolding effects in life. After all, we are each the result of that individuality when we meet and feel attracted to someone. Unfortunately, many couples try to change their partner into something else. It might be a subtle, gradual process of pressure or manipulation, or it might be forceful, but either way, control and force destroy actual love, eventually dissolving it away beyond recognition.

Marriage is a personal choice, influenced by its standing as a cultural and religious convention. I see its place in our world dwindling as people become increasingly self-aware and living their sense of what is true for them. This reflects the phenomenon of natural high-level commitment in a relationship, regardless of what might be recognised or condoned by the prevailing culture or other outer influences, none of which is truly wise, even though they might be popular. Marriage only changes the context in which a committed relationship forms and unfolds in the world. And I found that to be the case with me and Jeff.

A highly committed relationship can exist without any link whatsoever to the institution of marriage. Often, marriage has brought to bear myriad strains on perfectly healthy relationships. The strain brings the relationship to its knees under the weight of expectation,

not only of the couple but also of the families and friends connected to the couple, each having their own set of expectations, which they assume or demand the couple lives up to. Such expectations by so many build nothing short of an insufferable prison instead of a beautiful relationship based on love, mutual belonging and commitment to each other's uniqueness.

Jeff and I pushed each other's buttons. It's as though we knew exactly what triggered our fears, resistances, conflicts and reactions that we both would rather have kept hidden. Those "buttons" are issues that were in the shadows waiting for a chance to be released into the light to be seen; to be understood and resolved so that we may live a greater experience of love, the love we had magnetised into our life in this very relationship. But we never saw it that way nor had a deeper understanding of it.

In truth, life is experiential. We learn through experience. No amount of discussion can predict what actually takes place. In some ways it's a case of "you can't make an omelette without breaking eggs." And that's what we did, we broke eggs.

Speaking of eggs, I felt like I was walking on eggshells those first few years, so afraid of making a mistake. The pressure I put on myself to make everything perfect for everyone was unbearable.

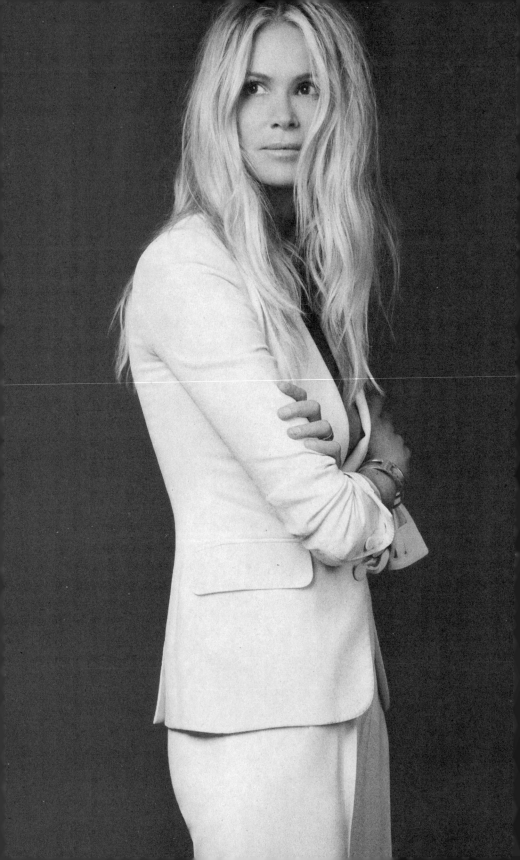

15

THE BIZ

As one door closes, another door opens

A key strategy for my career was always to stay focused and grounded through the changes I made in my life. This was driven by my burning passion for tangible results. Back in 2005 was no exception. That was the year I decided to grow and expand the reach of my lingerie business to include international markets.

The brand was thriving in Oz. Elle Macpherson Intimates had gone from strength to strength for fifteen years. Now it was time to evolve the collection into sub-brands and territories spanning the US, UK, Europe, New Zealand and Australia. I believe my licence with Bendon, lasting twenty-five years in total, was one of the first in my industry and one of the longest surviving licensing deals in the modelling world. And I loved it!

Over the years, my lingerie styles reflected where I was at in my own sensuality and understanding of femininity. They were an expression of myself on so many levels. In the beginning my designs

were sporty Aussie cotton. Later, they became inspired by subtle, sexy, French women and the time I spent in France. I loved lace and I liked to have accents of colour, so I brought in steel blues, exotic oranges and soft golds; colours that would wear well under white. This was unlike American lingerie, which was white or nude under white. The one colour I didn't love was red. I reluctantly sold it on St. Valentine's Day because there was such a strong demand for it.

Mothers bought their daughters' first bra from Elle Macpherson Intimates and one for themselves. We expanded into sleepwear, menswear, and eventually I was able to design a maternity bra. My CEOs to date had told me that sexy women don't want maternity and maternity isn't sexy. I began my quest to redefine what was beautiful. And a mother nurturing a child is beautiful to me. So I decided to make an easy, comfortable and, yes, sexy maternity bra. I wanted to launch it when I was pregnant with Flynn but it took five years to get Bendon's CEO on board and to start production. It was finally ready by the time I had Cy.

My bras were immensely popular and highly profitable. We were the number one brand in Oz and from 2005 grew rapidly globally to approximately $70 million in sales. They even featured on *Oprah* when I was a guest on her show. She gave everyone in the audience a selection of my bras. It was a big hit. I loved working with Oprah— she's such a powerhouse and it was wonderful being accessible to a wide variety of women.

Even now, people stop me in the street and say they love my bras and still have them. Making a product that lasts is, on the one hand, brilliant, but on the other hand not so great for recurring sales in business. But I'm into quality not quantity, and I love that people still have lingerie ten years on that I helped to design and create, especially the maternity bras.

In keeping with this, I spearheaded a breastfeeding campaign shortly after Cy was born. I had become UK ambassador for UNICEF, visiting hospitals all over the country. At the time, a growing number of English women were not breastfeeding their babies at all, or were giving formula as a supplement. They were told that breastfeeding was unrefined, not cool, and the public display of a mum breast-feeding her baby tended to be shunned. I wanted to support women to rediscover the beauty of breastfeeding, and help them understand how important it was for their babies to have that colostrum after birth, as it gave them a healthy beginning to their life and immune system. I was fortunate enough to be able to breastfeed both my sons and I believe it's the best start I could have given them. Creating a nursing bra that supported women while they were breastfeeding brought great joy to me. It was a business combined with purpose. I found it deeply fulfilling.

I supported my businesses with interviews and appeared as a guest on morning and late-night TV shows. These were super helpful because when the editorial side of modelling was in a lull, I was able to use personal appearances to promote my growing entrepreneurial endeavours. Warren Buffett, the hugely successful American business magnate, once said, "Always have two sources of income," and that had always resonated with me.

Diversifying into licensing and brand-building allowed me to create and grow my business, which provided me with an income through licensing fees. It wasn't wise to be reliant on other people booking me for jobs, so I created this as an insurance to protect myself from the modelling industry's sometimes fickle whims and wants of who or what was fashionable at any given time. That way I could rely upon myself to fully support my family and be financially inde-pendent. I didn't enjoy the photographic part of modelling but I was

good at it. And just because you're good at something doesn't mean you have to do it. It means you can use what you're good at to do the things you really love and want to do. That's what's important. And that's what I did. The gem is, if you don't like what you do, then find what you love and do that. My fear of being in front of the camera was alchemised into business.

I did it just enough to build a brand and then I applied that brand to products. Licensing. The lingerie became the feature; the product became the star, just as Gilles had taught me. Having designed a product that was successful, Bendon—by licensing my name, image and product designs—became profitable. Department stores' sales soared, providing me with an income, giving me the freedom to do other things. Utilising skills in interesting ways, I was able reap the benefits. So my joy shifted from doing what I was good at to doing what I loved. And that was not being in front of the camera, it was working behind the scenes.

Today, I don't often wear a bra. I want to feel free. How I went from obsessively articulating sensuality and sexuality through beautifully designed French lingerie to barely wearing knickers beats me.

The company had a total of seven CEOs through the years. I learned to adapt, evolve, be flexible and listen to each one as they came with their hopes and dreams of how they would grow the business. Some wanted my involvement and valued my input. Some wanted a fresh start, while others were uncomfortable with the years of experience I had in design and marketing. With a growing yet relatable public persona, I remained creative director for most of the twenty-five years the business ran, overseeing the advertising, marketing, design and creative expression of the brand.

Navigating the changes of management and CEOs taught me many business skills. I learned to appreciate how to communicate in

ways that each one would hear while remaining true to myself. Being open to their ideas, even if I didn't agree or had tried them before, taught me patience, open-mindedness and diplomacy. Moreover, I recognised that things change and there is benefit to allow that change. I didn't always have the answers, and working in a team taught me to listen and allow ideas to flow—to watch them in action. Sometimes they worked, sometimes they needed refining, but they always brought me learnings and a deeper understanding of the business.

After twenty years, I decided to stop modelling for my own brand and stepped aside for different models to become the Elle Macpherson Intimates girl. I loved mentoring those beautiful women and was passionate about guiding them and sharing the vision I had for the brand and the modern expression of sensuality. And I loooooved beautiful lingerie. I still have boxes of my designs from the early years, which, surprisingly, still remain relevant today.

When my licence was due to be renewed by Bendon for another ten years in 2013, I wanted to become a shareholder and have a seat on the board. A licence felt too restrictive; I wanted to have some real input into the company's growth as the brand bore my name. And I wanted to ensure it expanded in ways that were aligned with my values. Furthermore, I wanted a tangible reward for the years of commitment that I had made to the company, which I felt was pretty reasonable.

In 2014, as I was moving to the US, I walked away from Bendon, after an economically disappointing and ultimately unfulfilling renewal offer. It simply didn't make sense to agree to the suggested terms for a new licence and the proposed business plan. Something didn't feel right. I got that "truth rush"—that trusted zing-zong sense. When I say something or hear something that truly resonates, the zing can often come in the form of goosebumps on my arms. A zong

can be in the form of an uneasy feeling, disquieting my heart, and it's a physical sign for me to listen to my intuition. And I did. What's more, I came to understand how restricted I felt in the confines of the licence, which didn't seem to foster any economic or entrepreneurial growth. I wasn't comfortable staying, but then again I wasn't comfortable leaving. It's never easy risking personal financial security, as was the case with a lesser licensing fee, for an unknown result. It was one of the biggest decisions of my career.

When I resigned, another model took over some of the role I had built. Bendon then placed her name on the lingerie labels and tags that I had overseen in design and had created for the last twenty-five years. Within a short time the whole business collapsed and, even though it was my decision to leave, the audacity exhibited in the handling of my departure left me stunned. Authenticity, honesty, timing and alignment are everything in business. It was a huge lesson in letting go. But the reality is, we own nothing in this world anyway, we just get to experience things so we can grow and learn.

Letting go was not only difficult, it was extremely uncomfortable. But I knew I had to make space in my life for new experiences and opportunities that were truer to who I was by then and not who I was twenty-five years before. In order to do that, I took a leap of faith and trusted the net would appear. It took courage not to give in to the fear of my life crashing down around me if I left the security of Bendon. Ultimately, I trusted myself. I trusted that stepping into the unknown would not put me in harm's way. Why? Because deep down inside I knew, without a shadow of doubt, that the Universe and the power of Creation is always by my side to help guide me on my path.

I read in Paul's first book, *From Atoms to Angels*, "Life is a loving friend if I care to be its loving friend." This has been confirmed throughout my life every time a shift in direction flowed in. As long

as I stopped for a moment, just being utterly still long enough to breathe and get the feel of the circumstances, I could discern anything that might obviously compromise me or my progress. That inner alignment established, I trusted that any hesitation or apprehensions I felt were then simply fear of the unknown or my lack of experience or knowledge of a next step. I always trusted that my dreams and intentions should remain the target. My logical mind might try to stop me but it only deals with known quantities in the rational world; anything creative, or even just unfamiliar, set it off on another irrational rationality rant. Which I promptly ignored.

It is a fundamental principle of growth and development that if you do what you've always done, you will get what you always got. What is safe and known and without risk never leads you to grow or develop outside that familiar box you've lived in. You know—that box that you've become oh so tired of; the one that's unsatisfying, restrictive, lacking promise and true fulfilment; so safe that you couldn't suffer it any more? That one.

That's why it pays to trust that as one door closes in life, another door opens. Shortly, if it hasn't already. The Universe knows from its higher perspective what is obsolete in your life and holding you back. It can see what you can't see so it starts encouraging you to let go, nudging you to release your grip on life's familiarity so that all you've been longing for can actually come to you, albeit in an unexpected form—a form that can deliver to you joy and satisfaction—fulfilment. I mean, you can't expect to find what you've been searching for in among everything you already have and know. It's the reason you're still searching and longing and wishing and hoping for it, not actually living it.

So it's vital to step outside the comfort of the familiar. And as long as each step is towards your dream, not away from it—not some

ridiculous risk of life and limb—you just need to trust yourself that you have the capability to adapt to whatever comes. And you do have that capability because Creation will never bring you anything that you are not capable of handling. It has no reason to.

It's simply a matter of giving it a go and being adaptable, not frightened; flexible, not rigid. And enjoying every unfolding step on your uncertain path to the clearest and utterly certain dream that you hold. As Eckhart Tolle succinctly says, "Sometimes letting go is an act of far greater power than defending or hanging on."

Having let go of the security and longevity of my licence with Bendon, I began to explore the possibility of actually owning a lingerie business. This came to fruition in 2016 with the brilliant Aussie entrepreneur and businessman Simon de Winter. Simon had thirty years' experience with his own successful lingerie brand, Fine Lines, and I had my twenty-five years with Elle Macpherson Intimates. Together, we decided to co-create and launch a joint venture—a lingerie company with a vibrant, fresh, new perspective on sporty, sexy bodies. Simon and I agreed the company name said it all—Elle Macpherson Body.

Establishing this venture came at the perfect time. It was a business that I could build in my own right. I was longing to have my independence outside of Jeff and his empire. It was also important that I have a creative outlet so I didn't pour all my energy into "creating" the kids. I listened to my inner sense and starting the business with Simon felt right. So I decided to give it a go.

I was yearning to express myself through helping others feel their best selves—Elle Macpherson Body and WelleCo both gave me this opportunity. I loved the idea of women feeling naturally beautiful and strong from the inside out, with WelleCo nourishing the body's cells right down to the mitochondria, while simultaneously wrapping the body in fabulous, comfortable, sensual and sporty lingerie.

Like WelleCo, Elle Macpherson Body was the perfect name, and I used it as a step to building the identity that was aligned with my already existing brand. It fitted beautifully in the portfolio of Elle Macpherson Inc. I kept going with the flow—not pushing the river. I was embracing opportunities that were being presented to me and that resonated with who I was, always listening to my heart and letting it guide me. It never ceases to amaze me that when I'm happy and expressing myself in my creativity, the Universe hears and responds by providing more opportunities for me to trust and follow my heart to fulfilment.

Simon and I became marvellous partners because we were great friends. When he first came to visit me in Miami, we were meeting to discuss the idea of Elle Macpherson Body as a follow-on from Elle Macpherson Intimates and a rival to the old style of overly sexy lace undies.

Aussies typically don't like sitting inside for brekky when it's a beautiful day, so for the meeting I arranged for us to eat outside on the patio. Simon was sweating buckets in his pink business shirt. We laughed at his opening line, "Jeez, Elle, it's really hot here." He later told me he nearly fainted from heat exhaustion. What I found hysterical was that he mistakenly thought Jeff was the gardener!

Designing lingerie, marketing, branding, sensuality, sexuality, feeling good in your skin is my jam, and Simon gave me the freedom to explore that and be creative. I was so grateful to have a new company to focus on after the disappointment of leaving my old lingerie arrangement. I was starting anew in many areas of my life at the time.

New marriage.

New children.

New schools.

New country.

New business—two, actually!

I definitely did "new" with balls and bells on.

Simon and I had a good run of it with Elle Macpherson Body. The designs were cool and modern—slick, seamless, unusual colours, sporty with a feminine twist: they were a welcome change from the plethora of nude and black knickers and bras that dominated the department stores.

Gilles, my ex-husband and still my favourite photographer, collaborated with me on the first Body campaign and it was striking in the way that only he shoots. It was wonderful working with him again, this time as the client instead of a model. We booked a fabulous fresh new girl to be our icon and I helped direct and create the campaign. Gilles was so happy to help me grow my own business through co-creating fantastic imagery. He did an incredible job, as always. The campaign was modern and a sexy take on a skater girl. We even had silver skateboards made with "Elle Macpherson Body" engraved on them for PR purposes. That was the brilliant idea of creative director Annabel Blackett, who was responsible for all the award-winning artistic direction for both Elle Macpherson Intimates and Elle Macpherson Body. My lovely Annabel has been an artistic collaborator with me for nearly forty years and her flair for storytelling and taste in branding is impeccable. It takes a village!

Simon and I loved working together and I cherished my trips to Melbourne, where he was based, as we brainstormed designs, styles and marketing. The clothing business, and lingerie in particular, requires a lot of cash for creating and selling before you see any return on investment. We wanted fast and we wanted successful. All this made for a lot of planning and cash to keep the business afloat. Financing infrastructure and production, materials and marketing is like feeding a rapacious beast: you burn cash upfront while trying

to guess style, buy-ins and fabric requirement; each country having different tastes and iterations of similar designs. Department stores wanted exclusive colours and styles. Each country also had different sizing requirements—some large cups with small backs, some small cups with large backs and some communities of women needed really large everything, particularly in the US. Europe tended to like smaller fits and lace without underwire. They went for feminine yet super-sexy triangle bras. Americans liked smooth (Kim Kardashian's brand had excelled in this) and Australians loved colour.

Opening simultaneously across the world proved too much for us to handle, and if I could do it again, I would focus on one territory at a time and expand more slowly. Eventually Simon felt overwhelmed and I wanted to focus on WelleCo. Managing two start-up companies, a new married life in the US, and helping to raise five children was unsustainable. Simon and I agreed to dissolve the business slowly so as not to hurt our brands, his or mine.

I wish it had been possible to maintain both businesses and have them under one umbrella but it was just too difficult. At the time, I didn't know how to do it. Closing Elle Macpherson Body came as a blow. I missed my relationship with Annabel and with the team in Melbourne. I missed the design process. But most of all, I missed Simon.

Sometimes in business, however, it's not what you do, it's what you don't do. I was now able to devote myself totally to WelleCo. It was the choice that turned it from being a start-up company into an established business and brand. So I was thankful for all my experience as I navigated the collapse of Elle Macpherson Intimates and now Elle Macpherson Body. And afterwards, I had the time and space to devote myself to my family and run WelleCo without burning myself out.

So much of my life was changing and evolving. I walked away from two companies I had been passionate about. Big ballsy moves.

Adapting to my life in Miami continued to be tough. I was no longer producing and hosting TV shows, and I missed my life and friends in London. The infrastructure and foundations I had created in the UK seemed a distant memory and I became lonely without them.

Born from my heart and inspired from my particular wellness experience, WelleCo became a purpose greater than my own healing. I wanted to empower people on their unique wellness journey so their natural beauty could shine through and into their lives in all ways, always.

As a forerunner in the wellness industry, WelleCo was revolutionary. When I was coined "The Body" by *Time* magazine in 1984, though a little daunting, it reflected to me the value of my efforts to excel at what I do. At the time, I was associating wellness with fitness, so my daily regimen involved a strong fitness protocol. Over the years, people said that beauty and youth were inextricably linked, but what I realised, and continue to believe, is that wellness is actually the key to beauty.

WelleCo was breaking ground in many ways. We delivered an ingestible product that directly amplified beauty from the inside through health and vitality. I liked to think of ingestible beauty as the fourth pillar of the beauty industry, the others being colour cosmetics, skincare and perfume. We explained the concept: "You become beautiful when you feel well." Everybody is beautiful at their core essence, making them attractive and magnetic when that essence is able to shine through. And so it does when we're well. We look our best and feel great about ourselves. Furthermore, when we are well we're able to live life to the fullest, achieving so much more because our energy and enthusiasm fuel us and our steps towards our dreams. And I wanted people to taste that for themselves; to experience it in their own unique lives.

"Ingestible beauty" was not a high-profile category and my vision of beauty originating from the inside was unfamiliar to many people, so education was a significant part of our communications. We were really pushing the boundaries, presenting beauty from a wellness perspective. It was very innovative for that time. Everything from packaging to advertising supported this strategy. And my public profile, coupled with the voyage of wellness and authenticity behind the product, and Andrea's expert creative direction, significantly enhanced the company. WelleCo's acclaim quickly grew in Oz and the UK, which were my primary markets.

I'd often fly to Perth from Miami to meet with Andrea and the WelleCo team. We had fun together and the business flourished with her creative marketing skills and my brand experience. However, there were challenges. At the time, it was difficult to market greens as they were not popular and had a reputation for tasting bitter. To counter this, we focused on flavour: a natural pineapple, clean and clear of synthetics. It tasted delicious. We decided to market the greens as a beauty product and sold it in a beautiful black glass jar created by British designer Jasper Conran. We launched online at Net-a-Porter, then Selfridges in the UK, and David Jones in Australia. We sold our collection on the beauty floor of major department stores next to designer brands such as Chanel and Yves Saint Laurent. After all, it was a beauty product!

As my own wellness journey expanded, and we'd gathered some understanding of our customers' needs and wants, we grew our amazing products. They'd started, of course, with the Super Elixir Greens, but soon included a clean, lean plant protein in my favourite flavour, chocolate; a sleep tea; and a kids' protein-and-greens blend. These became the foundation of the business and created our magic three-step daily protocol, which was unbeatable. I had finally

found a way to support myself properly as I travelled, combining this protocol with a healthy diet, sunshine, fresh air, clean water, love and laughter. My body and heart never felt better and I was in awe of how simple changes can have such a huge effect and impact, achieving a healthy life full of vitality and enthusiasm. As it turned out, our customers love these products to this day, and sales are growing constantly, making WelleCo some of the bestselling products of their ilk.

Next, I decided to see what improvements we could make to my sons' health. Cy had been losing concentration in school and eating very little. He was so lean and tired; I was worried. He was a picky eater, refusing vegetables and protein, instead living primarily on rice. I asked Dr. Laubscher to help devise a milkshake for him to have for breakfast and as an after-school snack. The kids' protein and greens was WelleCo's answer, packed full of nutrients and so delicious that Cy had no idea he was drinking broccoli!

As a result of our efforts the business continued to grow, but after a few years, running a global business from Perth was becoming untenable. It was so far from Miami and the time difference was crippling. Straddling the time zones, I would often work late into the night with the team. The distance also put a strain on my relationship with Andrea, and I started to sense a growing disharmony between the two of us as we each had different ideas and views on the essential nature of WelleCo.

Andrea wanted to take the company down a purely scientific route and I wanted to maintain the authenticity of its values and natural products to amplify innate beauty through wellness. I believed WelleCo was a company that could incorporate the importance of spiritual and emotional well-being, and not just focus on a scientific and technical approach.

It also seemed that Andrea didn't want the business to be dependent on me or my name and that affected the decisions she was making. She pivoted to a different route and was uncomfortable that I was at the forefront; she felt it weakened her business strategy. Andrea was doing what she thought was right but that excluded me being involved to any great degree. And this didn't resonate with me or our investors.

In the end, we decided to part ways. It was painfully unpleasant, super tough, and another extremely profound experience in letting go. I was deeply saddened by our separation because she had become a close friend. At the time, I wondered to myself, is this a break-up? Or a breakthrough?

With Andrea's departure in 2018, I risked losing WelleCo and was saved by my wonderful investment partners who believed in me, believed in WelleCo's core purpose and believed in the quality and efficacy of our elixirs. I have courage and trust that when something is not resonant, I am wise to act upon it promptly. Coming to that realisation was the hardest part because I had trusted Andrea and valued her. But in my heart I knew the company couldn't be well if there was dissonance between us. I was disappointed with the way things had turned out.

Today, WelleCo functions strongly as each of our team members contributes their own gifts and talents that help nurture and build the business to flourish and to support a greater global benefit. We have a living, wellness-centred and purposeful business with a thriving family of customers we now call our WelleCommunity. Today we offer a collection of over thirty award-winning products that support hair, skin, immune system, hormonal and nervous systems, mental acumen and clarity, and menopause. WelleCo is thriving and so is the health of our community. My dream is to see the company grow and expand so more people can enjoy affordable access to our amazing

collection. I long to see our soils flourishing through regenerative farming so we don't need extra vitamin and mineral supplementation. That could effectively put us out of business, but would be such a powerful achievement!

Building a business is deeply satisfying but even more so is the prospect of giving back. The feeling I get with WelleCo being aligned with my values is one thing, but a business that has a purpose greater than any person or product is another altogether. Through my own business, I am able to touch people's lives and help them in so many ways.

Back in 2003 when I became sober, I asked myself, "What can I do to be of service? How can I give back and help?" I continued asking that question every day and today it manifests in unexpected, extraordinary opportunities that life places in front of me, ones that I could never have planned or deliberately sought and found myself. Over the years, as I became successful, I began to put my time, my creative energy and my brand and public profile into supporting various initiatives, charities and organisations around the world that resonated with me and aligned with my values.

Becoming a patron of the National Association for Children of Addiction (NACoA) just after I got sober gave me a platform to help families and children who are affected by their parents' drinking and drug use. NACoA has become dear to my heart. Working with them was a living amends and still is to this day. It's extremely fulfilling to be part of such a worthwhile organisation.

In 2006, I paired up with Bono and Bobby Shriver on their consumer marketing initiative (RED), which enabled businesses and individuals to finance HIV/AIDS programs through the Global Fund. Various worldwide brands developed (RED) products and a percentage of the proceeds were donated to the fund.

It was with the greatest honour that I went to Ghana as European Ambassador for (RED) and delivered a cheque to the government for five million dollars. This donation was used to purchase medication for women and children living with AIDS. Visiting Ghana was an amazing experience. The joy of helping people, giving back and being of service profoundly touched my heart. It gave me perspective on life, understanding the hardship others endure. I found it was an extremely fulfilling gift to be part of such a worthwhile and wonderful cause.

Some of the most fulfilling, heart-opening times in my life have been when I've dedicated myself to people and initiatives that resonate with my values. What I have come to know and experience is that an incredible feeling happens when we open our hearts and are of service . . . and all the money in the world can be made, and all the awards and recognition are one thing, but the feeling that arises from helping women, men, children and communities is deeply moving. The power of service is profoundly enriching, fulfilling.

And it's greatly underestimated.

16

CANCER

Don't sweat the small stuff

You never expect to get that call. But I did.

Friday, 13 January 2017, to be exact. The date has become imprinted in my life forever. That was the day I found out I had breast cancer. I was standing in my beautiful mosaic bathroom in Jeff's house, in Miami. It was huge so I sometimes used it as my office, and it was my favourite room, tucked away in the far corner of the house. In the morning the sun would stream through the windows overlooking the water. It was the place where I had the most privacy. My sanctuary.

My phone is always on silent. I saw the light flash and recognised the number of my breast oncologist from New York. Nervously I picked up the phone. Dr. P's words echoed in my head, "Elle, it doesn't look good. The pathology on the tumour is positive. It needs to be removed. You'd better come in for a lumpectomy as quickly as you can."

Deep down I had known what the results would be. The lump was close to where the cyst had been and I'd tried to convince myself

that it was just scar tissue. A few weeks before, I'd had a check-up and after the physical examination Dr. P was concerned about a lump she had found in my breast. She'd ordered a biopsy and a mammogram. The results now confirmed her suspicions.

She explained what the procedure for surgery was and we scheduled an appointment the following week. Thanks to my friend Kath, I had amazing resources with Dr. P and support from Mount Sinai, the hospital she was affiliated with.

At this point, my relationship with Jeff was already so strained that I didn't want to tell him. I believed I was strong enough, and wanted, to handle it alone—come up with a plan, find a solution and fix it. I thought the diagnosis was a burden that would stress our relationship even more. But I knew I had to say something.

Jeff had been on the road for weeks with his son's hockey team and business on top of that. We'd barely seen each other. When he answered my call, I asked him when he would be home as I really wanted to speak with him in person. I didn't want to pressure him for time or to ask him about his itinerary but I felt compelled. I had learned that he was a free spirit and I never really knew what he was doing from one day to the next. Jeff disliked feeling confined to pre-organised plans.

He was irritable on the phone as I pressed him for his return date.

"What's the matter?" he wanted to know.

"I need to speak to you," I replied.

"Why?" he urged.

I didn't want to tell him over the phone and I wasn't sure if I could hide the falter in my voice, so I didn't answer. Jeff pressed me again, more forcefully.

"Elle, why do you need to know when I'll be back? What's wrong? I don't know when I'm back in Miami. You know that. Why are you pressuring me?"

"Jeff, I'm not well," I blurted out, kicking myself.

"What do you mean, not well?" he asked. I couldn't answer. There was a lump in my throat, my eyes had welled up with tears. I wasn't sure I could even utter the words.

"Elle, what is it?" He'd become frustrated as he had another call come in and wanted to answer it. "What is it?" he demanded. "Nothing's that bad unless you have . . . cancer," he said with a despairing tone.

What seemed like an eternity was only a split second. "Yep, I do," I said. "Don't worry. I'll figure it out. I promise I'll get it sorted."

Jeff launched a barrage of questions. How did I know? What did the doctors say? Was it confirmed? Had I spoken with Kath? What was I going to do? Had I told the boys?

I couldn't answer all these questions. I didn't have the answers there and then. All I knew was the next step—go for the lumpectomy.

Jeff and I flew to New York on 23 January and checked into the Mark Hotel. He had carefully chosen a beautiful, quiet suite and I spent the night relaxing and mentally preparing myself for the procedure the following morning. He was so sweet and attentive and for a moment he seemed happy looking after me. And I loved that. We'd drifted apart in the previous year and secretly I wished that this would be a turning point for us. But I knew deep down that his heart was with someone else. All the signs were there and I had chosen to ignore them. I didn't want to believe them so I had said nothing, just waited. Why? Probably because, once the situation was addressed, there would be no going back, and if I ignored it then it might not turn into reality. It was another one of those elephants in the room that none of us wanted to talk about. And I don't think Jeff really knew what he wanted to do about it. I didn't want to push that.

The next day, since I would be undergoing a general anaesthetic, I checked in early at the hospital and was prepared for surgery. I remember wearing a green utility gown, disposable cap and booties, walking down the hallway to the operating theatre. It was surreal; like a scene from a movie. There were rooms to my left and right and as I passed by I glimpsed surgeons on the other side of the round windows operating on people and I thought to myself, that's going to be me in a minute.

I don't know why I thought I would be wheeled on a gurney but walking down that hallway to the operating theatre, taking those steps myself, was profound. They gave me a feeling of empowerment. It was a sense that I was in command of my life and there was something fiercely independent about that. It set the precedent for what I was about to go through.

When I arrived at theatre, I hopped up onto the operating table. The room was freezing cold so the nurse covered me with warm blankets. Music was softly playing and Dr. P was already there with her team. She did her best to calm me by talking to distract my attention. Actually faced with the seriousness of surgery, my courage began to falter. As I lay there on the table, I began to feel so small, fragile and vulnerable; it reminded me of the time I had my tonsils out when I was a little girl.

My beautiful, funny anaesthetist also tried to relax me by saying, "Today's your lucky day. You get to have a cocktail at 8 a.m."

That made me laugh as I was fourteen years sober at that stage and had barely taken an aspirin in all that time. I hadn't wanted to alter my mind or body in any way. I was a purist when it came to my sobriety. Suddenly the idea of a cocktail was very appealing. I was afraid. Very. I was afraid of what they would find when they sliced into my breast; afraid of the effect the anaesthesia would

have on my body and mind. And afraid of the scars I would be left with.

A needle was inserted into my arm but the vein was too small. I felt warm liquid and at first I thought it was the drugs spurting out from the needle but as I turned my head I saw bright red blood. I quickly looked away and tried not to throw up. I didn't want to freak out or panic that something may be wrong.

I worried that the anaesthetic would not be strong enough, it might not work, or I might come to during the procedure, feel pain and not be able to say anything because I was drugged; I'd heard stories about that. What if the procedure didn't succeed? What if I woke up and I had no breast? What if the lump had progressed, enlarged and Dr. P decided to take the whole breast off? That was my darkest fear and the scene that had played out in my mind. My imagination had run riot. Hot tears slipped down my face as I looked back at the IV they had finally put in my arm and for a split second before I fell asleep, I felt a warm flood of peace.

When I awoke, Jeff was beside me holding my hand. I had been sleeping off the anaesthetic and was feeling groggy. At one point, he answered his phone and it sounded like an intimate conversation. When he finished the call, he turned to me and said that the husband of a close friend of his had just taken his own life. His words jolted me fully awake. I didn't know what to say. But I knew who he meant when he referred to his close friend, so I remained silent. And that silence was deafening.

I stayed in bed, going in and out of sleep and pain, watching Jeff come and go from the room. I noticed his moods change and I watched the clock tick by until I could take a Percocet. The label on the bottle read "Oxycodone" and I worried that I may become

addicted. When the pain got too intense, I swallowed one of the pills. It was the first time I had taken a drug since I'd been sober and I began to feel that heady, numbing buzz. I became relaxed and nothing bothered me.

Two days after the surgery, Jeff and I flew back to Miami. When we arrived home, Cy cried when he saw me and my heart whimpered for my son as my eyes filled with tears. Later that evening, he came to give me a hug. He sat on my lap wearing his checkered pyjama pants and favourite T-shirt, his head buried in his phone pretending to text, avoiding eye contact in case we both cried.

"What's wrong, Mama?" he softly asked.

I did cry as I tried to explain to him the reason for my operation. He said he knew I had travelled to New York but not for work and explained that he'd noticed me talking to doctors on the phone before I left. He knew something was wrong, something was up . . . And my heart ached for my son as I also knew he could sense the tension between me and Jeff.

The first week I was home, I stayed in bed recovering as I could barely move. I desperately struggled not to take painkillers. Having had a taste of that feeling of bliss and having any emotional pain numbed, I craved to take another pill. I justified it to myself that it was doctor-prescribed so that meant it was okay, but I knew in my heart that wasn't the answer.

Opiates were never part of my story but at this time nothing felt better. They dulled the pain physically and emotionally. I knew my marriage was falling apart and I wanted to escape my heartache. I called an AA friend who lived around the corner. She helped me through the days. I'm so grateful for her words of advice, encouragement and loving care. Resolute and determined, in the end I flushed the pills down the toilet.

Time dragged on as I waited for the results. A week later, Dr. P called with the pathology of the lumpectomy. There were no clean margins to indicate successful removal of all cancer cells so we scheduled a second lumpectomy. Dr. P wanted to get a result totally clear from cancer in the surrounding tissue. A few weeks later, I travelled back to New York. This time I was alone.

During the procedure, radioactive dye was injected into my body to locate the lymph glands. Dr. P removed half of my breast tissue. The recovery from this second operation was intense. I wanted to take a Percocet but I didn't.

I waited on the results, which seemed to take forever. When Dr. P finally called, she told me the diagnosis was HER2 positive oestrogen receptive intraductal carcinoma. She suggested that I should undergo a mastectomy with radiation, chemotherapy, hormone therapy, plus reconstruction of my breast. She concluded that the whole process would probably take about two years from start to finish, maybe.

I felt stricken. The call ended and tears streamed down my face as I tried to process what I had just been told. How was I going to tell Jeff? How was I going to tell the children?

Panic, fear and confusion flooded my being.

Researching medical options was all-consuming. I decided to contact Dr. Laubscher, who had many patients with cancer. She helped me understand and sort through various alternative and pharmaceutical treatment options. She was an angel and was relentless in assisting me to research the most suitable modalities for my diagnosis. These included chemotherapy and conventional allopathic medicine combined with natural and traditional medicine.

There were a few options for places to have treatment. I could be treated at home in Miami at the local outpatient clinic, or I could go to one of the prestigious clinics in Europe or Australia as an inpatient.

We researched and researched. Dr. Laubscher also designed a bespoke bridging plan, which I immediately implemented into my life. It combined detailed organic menus, nutrition and supplements based on her seven pillars of health.

Though the bridging plan and research were happening, I felt distraught. I didn't have the answers, I didn't have the solutions and I wasn't sure what to do. I felt I needed to decide whether to have one breast removed or two. Should I undergo chemo, radiation, mastectomy, then follow up with expanders and reconstruction of my breasts? Or, should I have a mastectomy first, then have the chemo and radiation after that? Did I want to have saline or silicone implants? And was I going to wear a "cold cap" to try to avoid losing my hair?

My thoughts were leaning towards the conventional pharmaceutical route and deciding which doctors were going to perform each surgery and the reconstruction of my breasts. Facing these momentous medical decisions was daunting.

I flew to Nashville to speak with a reconstructive surgeon. We discussed whether my nipple could be spared or not. Afterwards, I flew to New York to speak with the oncology specialist regarding the mastectomy surgery and treatment. It was like herding butterflies. Each week there was new information and decisions to be made accordingly. Everything was evolving, changing, and there was so much to take in. That first month, I was manic and obsessive. I prayed that I could let go of my fear and of feeling helpless—feeling like a victim of my circumstances. That victim consciousness was so powerful, yet somewhere deep inside me, I knew that I create my own life. I was not actually a victim, and there was valuable learning in this experience.

When I looked back at the previous few weeks, I realised that undergoing lumpectomy surgery was not the big deal I had thought

it would be. My first operation had seemed so formidable but it promised to be nothing compared to what was eventually suggested. Mastectomy, chemo and radiation. I was in disbelief and said to myself, "This cannot be possible."

My resounding inner strength rushed forward. I became charged. I was dedicated and relentless in my research, determined to find a solution, driven to find answers. A month later, my awareness of what I was facing had grown greatly. I had researched and reached out to a multitude of professionals and specialists for information. For years I had consciously considered the decisions I was making in my life so they'd be grounded—practical and effective. But having been diagnosed with breast cancer, I felt as though I could no longer make clear decisions or find the answers in my head. I couldn't control the outcome of my choices and nobody would guarantee recovery. I was so frustrated, frightened. I didn't know what to do as I became aware of the profound effect and changes breast cancer would have on my body—and my entire life.

My brain picked me apart trying to find the answers I didn't have. It kept me awake at night. I bounced from worrying to being a warrior. At one point I asked my assistant, Ly, to open a new file on a doctor I was speaking to in Israel. She quietly and gently said to me, "Okay, Elle, but just so you know, this is number thirty-two. Maybe, it's time to make a choice?"

Tears streamed down our faces. I was trying to get the "right" answers; the answers that would have the highest probability of success. The one solution—the smartest way to treat this type of cancer; the newest way, the cutting edge, the tried and true. My brain wanted answers and I was willing to go to any lengths to find them. Not being sure what to do was agonising.

The doctors I met in New York, Miami and around the world were extremely sympathetic to my case. They smoothly reassured me by saying, "HER2 is a dangerous, aggressive type of cancer. Don't worry, we might have the best treatment if you take our advice." They almost made it sound simple—seductive, even. I was so tempted to follow the encouragement of these doctors when they offered first-class, VIP treatment, best results, latest technology and a highly qualified team.

Jeff said to me, "Elle, you have to make a decision. You've seen so many doctors, you've done your research, so we need to get with a plan. You can't just sit here in limbo. If you're going to do chemo in New York then we need to find an apartment for you. We need to get the plane booked so you can go back and forth for your treatments. You need to decide if you want to do treatment in New York—or in Miami, where you will be close to the boys. Either way, you have to make a plan. We need to organise the kids. There's a lot to be done."

I didn't want the boys to see me sick from chemo and I didn't want to be sick from the chemo in Jeff's home. I didn't want to be another problem and certainly not in the house where I felt unwanted in the first place.

My mind was in turmoil and I became depressed, stressed and torn. My life-saving, intuitive friend Gabby, who herself worked in the healing field, suggested I talk with Dr. C in Dallas. She said he was a brilliant triple-board-certified cardiologist who had transitioned into cancer care, and that he was a genius. He specialised in medical and alternative treatments for Lyme disease and cancer. I called and explained my situation to him. I told him that I couldn't decide whether to do saline or silicone implants. I asked for his advice.

He said to me, "Why do you need breast implants?"

"Because I have been diagnosed with breast cancer," I said indignantly.

To which he replied, "So?"

I hesitated, feeling confused. "So I have to have a mastectomy."

He waited a moment then softly asked, "Do you think the answer is to cut off a body part?"

There was a long pause.

"I've seen people with cancer," he continued solemnly, "who have had their breast removed and the cancer grows back on their chest wall. Cancer is a systemic disease. By all means do the surgery, but understand the root cause. Without that understanding, no surgery you are going to do will be as successful as it could be. So think again if you want to do that surgery. Go and reflect if a mastectomy is right for you. Only you know."

He then told me to go to the beach, pray and meditate. He said, "Come back with an answer. You'll know what to do."

So I went to the beach, meditated and prayed. I called him and told him that I'd decided to have a mastectomy, probably a double, and was going to wear a pink wig when I lost my hair. I'd also decided to film the whole journey and tell women that they can be brave just like me. I wanted to inspire and encourage other women in similar situations.

He just said, "I think you need to go back to the beach."

His words stopped me in my tracks. I thought to myself, what? Go back to the beach? Really!?

And that's what I did. This time, while I was walking along the sand, I had a revelation about how to make my decision. It would be based not on the outcome, but on who I am and what course of action truly resonated with me on a deeper level, right down in my soul. I asked myself what my truth was. What did I believe in? I didn't believe that drugs and modern pharmaceutical medicine were the only answer.

I came to the understanding that there was no sure thing and absolutely no guarantees. There was no "right" way, just the right way for me. All this time I was trying to pin my treatment on the outcome, but when I did the list of the pros and cons, they all came to a similar result. They just offered different ways of getting there. So now what?

It was tempting to listen to others. And I was looking to others for the answers. At times I felt ridiculed by doctors for my questioning. But after speaking to Dr. C, something deep in my soul whispered that there was another way of doing it that would achieve my own best results for me. So I decided to pin my decision on the path that was most in alignment with my deepest beliefs and values.

I chose an holistic approach. Saying no to standard medical solutions was the hardest thing I've ever done in my life. But saying no to my own inner sense would have been even harder.

Sometimes an authentic choice from the heart makes no sense to others . . . but it doesn't have to. People thought I was crazy but I knew I had to make a choice that truly resonated with me. To me, that meant addressing emotional as well as physical factors associated with breast cancer. It was time for deep inner reflection. And that took courage.

After fourteen years sober, I didn't take drugs until I took the Percocet after my lumpectomy. In keeping with this, and the suggestion of putting toxic chemicals into my body twice a week for twelve weeks to kill cancer cells (and others), and five years on hormone suppression drugs, plus a mastectomy, surgery, breast implants, I asked myself, "Is this true to me? Is this what the real me would choose for me?"

Absolutely not.

"Since absolutely anything is possible, is this really the option that would most accurately reflect my essence and further empower my journey? My own highest expression in life, which I am constantly

aiming to manifest, is that of an infinitely powerful, wise and loving being. Is this conventional medical option what my own powerful, wise and loving self would choose? Or is it lack of faith in my own essence? Is it the option that most clearly illustrates my commitment to myself as an infinitely potent spirit? And if my faith in this potent being I am is in doubt, would this option still work?"

It occurred to me that I would need to have the full, unwavering support of my own belief system, which creates my entire reality. After years of practising a holistic life, this would be the route that would support me.

I'm not suggesting this choice is for everyone. I believe that whatever choice anyone makes in any situation, it's imperative that it be aligned with their deepest truth, and they must believe in it and persist with it, wavering towards no other.

And still I was unsure. Still I was wary. Still I questioned myself. But then it happened. I made my final decision in the most profound way. It came in an unexpected beautiful loving gift with the words spoken by Cy. Not long after that day on the beach, I was driving him to school. I was thinking about what to do and praying, "Please God, give me a sign." And as I pulled up to a stop sign, I laughed and said to myself, "Is that the sign to stop crying, stop worrying?"

Cy turned and looked at me and I stared back into the eyes of my son. A moment of silence passed before he gently said to me, "I love you, Mum, and I trust your decision."

He knew what I wanted to do. My son knew I wanted to choose a more natural direction, though everyone was pressuring me to do the mainstream conventional—chemo and radiation. I just couldn't find peace with that choice.

Cy is profoundly intuitive and tapped into something more powerful than logic. His best friend's mum had died from pancreatic

cancer after she had been treated with chemotherapy. Cy simply thought that chemo kills you. And so he never wanted me to do it because he thought that was a kiss of death. Flynn, being more conventional, was not comfortable with my choice at all. He is my son, though, and he would support me through anything and love me through my choices even if he didn't agree with them.

My children were extremely supportive in their different ways but I knew they felt very scared. Cy was also upset because I didn't give him all the details in one go; but that's how I received them, a little bit at a time. He thought I wasn't being honest and this made him feel even more insecure with the unknown. But I was being as straight-forward as I could and sharing with him the latest information I had been given. My heart ached for my children. It was very difficult for both of them.

When you are diagnosed with cancer, every time a procedure is performed, a test is run or blood work is analysed, it takes time for the results to come through and you don't get all the information in one go. So I did a biopsy, a lumpectomy and then a second lumpectomy, and those three procedures were spread out over a period of time. The drip-feeding of information was not only frustrating but the waiting and not knowing were excruciating. I was trying to figure out what to do each time I received information. And everywhere I turned, a new decision was to be made.

On one hand, the slow reveal of the information allows you time to process the enormity of the news you've just been given and to understand exactly what you've been told medically. So it's kind of a gentle way to receive it. On the other hand, it pushes you further along on a conveyer belt and you become swept away by conven-tional medicine and a doctor-dependent system. This dependency can become overwhelming, being super-powered by media and the

conventional thinking around you, and it easily hides other solutions that are available to you.

Nothing felt certain. I came to realise that there is nothing certain about anything in this life.

Jeff was as patient as he could be as I sorted through my options. He offered support financially and he took excellent care of the boys while I flew around the country meeting with the best of the best doctors while trying to find the most supportive solutions. My diagnosis of breast cancer, followed by my final choice of Dr. C's holistic approach to recovery, with him visiting me in Arizona from Dallas five days a month, was not one that Jeff could trust or feel at ease about. And really this process was the straw that broke the camel's back. Compounded by the death of the love of his life's husband, it opened up the floodgates and everything changed. Our marriage was over and we both knew it.

I packed my bags and left Miami for Arizona. I wasn't sure how long I'd be away but I just knew I had to begin.

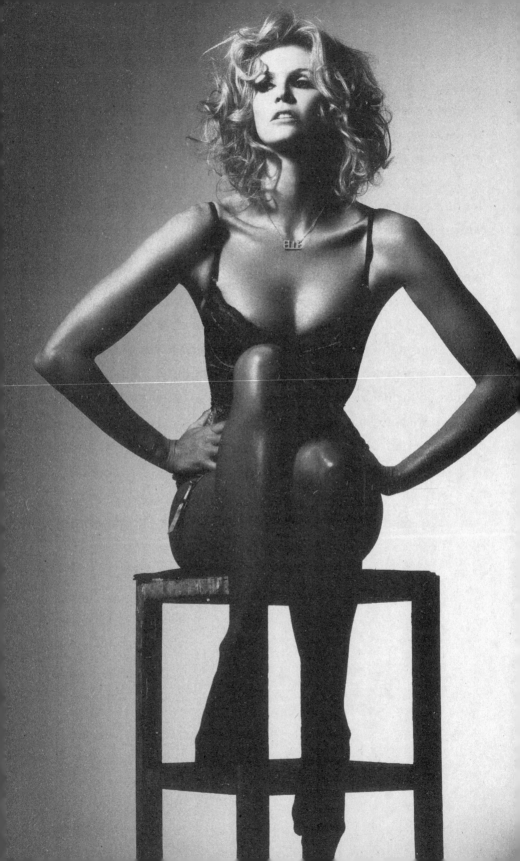

17

OUT OF THE ASHES RISES THE PHOENIX

You already have the Power within you

Anxious and alone, I travelled to Phoenix, Arizona. During the flight, I stared out the window, looking at the sea of clouds and overcome with so many emotions. Most of all, I felt hopeful. Yes, it was incredibly daunting to be doing this all by myself, but that was the choice I had made. I'd confided in very few people. I didn't tell my family in Oz, not even my parents. I didn't want to put them in a situation where they were worrying from afar and I knew that my choices were different from what they may have imagined was good for me. In some strange way, I felt I had let them down by being unwell; they had their own health issues going on and I didn't want to be facing their fears as well as my own.

I'm sorry, Mum and Dad, Mimi, Ben and Lizzie, for not telling you. I didn't want you to be upset or to fret.

In Phoenix, Arizona, thoughts of death haunted me every day. Yet Phoenix holds a special place in my heart. It's where I went to rehab

for alcohol addiction. It's also the place I went to put my mind at ease and overcome cancer.

In rehab, I learned the power of self-discipline and the effectiveness of daily commitment to a task. These skills played a huge part in helping me commit to the rigorous protocols I was about to adopt. They also taught me to have two feet solidly on the ground and a huge dose of faith. Trust. Guts.

A classic slogan commonly heard in AA is, "Don't pick up that first drink; get to a meeting." With cancer my slogan was, "Don't pick up that sugar; get to the root cause."

Cancer was a catalyst that contributed to more self-discovery. I don't recommend choosing such an extreme way of getting to know yourself, but it certainly was the way I chose on some level for myself. And I was determined to make the best of that. I was not going to leave any stone unturned. Relentless in clearing out the baggage of my past, I was determined to get to the root cause of having manifested cancer.

The mind, emotions, body and spirit are not separate. If I had been unconsciously thinking they were, this may have been a considerable cause for the dis-ease expressed within my body. I knew it would be unwise to try to solve a largely emotional or spiritual problem in a purely physical way. I had spent the last fourteen years sober. I knew in my heart of hearts that the physical manifestations of my inner imbalance were not caused by an unhealthy physical lifestyle, hereditary effects, or faulty DNA. I didn't smoke or drink and I didn't take drugs. Since the birth of WelleCo in 2014, my diet, lifestyle and outward well-being were almost impeccable, so I had to search deeper for a cause.

I'd been told that unless I had chemo, radiation, a double mastectomy and hormone replacement therapy, the chances of clinical remission were reduced. On the surface there's a lot more information

readily available on pharmaceutical solutions for a cure than there is for a natural approach. The conventional pharmaceutical approach is much more widely circulated, so if you want a natural solution, you've got to really dig deep to find the information.

Having spent months researching both types of treatment and a combination of both, I came to understand that you're just hoping the drugs and surgery will work. I was looking for a solution that would help find the cause.

Two doctors played a key role in helping me: Dr. C and Dr. R.

Dr. C is internationally renowned for his knowledge and skill in practising and teaching integrative medicine. He has co-authored many books and articles on integrative medicine and has pioneered successful treatments of cancer, Lyme disease and other illnesses. He has astonishing wisdom concerning the body's dynamics. Diagnostically, in addition to the usual allopathic background history-taking, physical exam, laboratory testing and imaging procedures, he uses evaluative kinesiology, Chinese pulse assessment, sclerology, iridology, Chinese tongue and fingernail analysis, and various forms of electro-dermal screening.

Therapeutically, he concentrates on diet, lifestyle counselling, emotional counselling, Recall Healing, EMDR (eye movement desensitisation and reprocessing), REMAP (reed eye movement acupressure psychotherapy), Thought Field Therapy, orthomolecular nutrient therapy, herbal therapies, homeopathic therapies, fixed magnetic therapies, pulsed electromagnetic field therapies (PEMF), oxidative therapy dynamics, healing herbs and many other modalities.

My beloved primary doctor, Dr. C, is the most brilliant man. Having told me to go to the beach and to pray and meditate for further guidance when I was determining which healing protocol to take, no matter what ailment my body was clearing and purging over

those months, he had an explanation and a remedy. I trusted him with my life, literally. He is the kindest, calmest soul I have ever met. A deeply spiritual man with a dedication to God, he taught me so much about my body, mind and spirit. Most of all he had faith. Faith in God, faith in me, faith in the body's innate ability to heal, and faith in himself to guide me through this process. Tears well up when I think of him and all we have experienced together. Thank you to my beautiful visionary friend Gabby for pointing me in his direction.

> *Dr. C, I am so grateful to you for being there for me;*
> *being the perfect channel for God's love while remaining utterly*
> *professional and dedicated to my wellness.*
> *The wealth of guidance and support you have given me*
> *continues to enrich my life daily, both physically and spiritually.*
> *The grace I have received is beyond measure.*
> *Thank you for everything.*

Dr. R (ND MA BA) is a doctor of naturopathy who specialises and supports health recovery with natural methods and technologies learned from Europe, South America and China. He also teaches other practitioners in his unique method of physical, spiritual and emotional recovery. He firmly believes that emotional trauma is the root cause of many health issues and uses emotional trauma resolution modalities in his assessments and programs with his patients.

He became my coach. He is my guide, confidant and friend. He listened to me cry most days from either exhaustion or fear; often both. He comforted and encouraged me and he held me emotionally, spiritually and mentally. We worked through releasing past resentments and illusions, delusions and despair. I shared things with him that I've never shared with anyone else, courageously willing to let

it all go once and for all. We had various methods of doing this and sometimes called in other practitioners to help.

He checked in on me many times a day during the rough patches. And when I asked him why, he said he was going to love me uncondizionally until I could love myself. Don't get me wrong, there was nothing romantic in this notion, but about halfway through my program I understood what it meant when I realised I'd been carried by the love and faith of others and was finally able to be my own calming support. I would then constantly remind myself, "Look for the signs, be observant, listen. You have eyes to see, ears to hear."

Dr. R, your support and wise guidance have been an invaluable gift through my journey. You have always been available when I was unsure of my next steps. I am deeply blessed by your depth of care and understanding; offering clarity to settle my soul when life felt overwhelming. I am grateful to have had you by my side. Thank you.

Dr. R sent a flashlight to me and told me to climb into bed with the light off. Once I was in bed I was to turn the flashlight on. It was a demonstration of the power of light over darkness. He said to me, "Elle, we all have this capability. The power of God's light is within us and as soon as it is turned on, the darkness will flee." He told me that when we read from God's words out loud, we are connecting to our higher self. When we listen to our own voice, we are hearing the voice of God because we are all made in the image of God and that voice is naturally such a nurturing, healing source of frequency to us.

He talked to me of the principles of Buddhism and the ancient traditions of chanting and singing. He told me it all related to "opening

up and connecting to the chakras." He assured me, "We know that while you are singing, you're also stimulating the neurotransmitters, dopamine and serotonin, and, depending on the tones and key you are singing in, you are connecting to some part of the chakra system. As you begin to focus on the heart chakra, which is the core of all healing, music appears to cause changes in mood, releasing neurotransmitters including dopamine, oxytocin, norepinephrine, cortisol, immuno-globulins and endorphins, all of which affect the sympathetic (fight or flight) and parasympathetic (stay and play) nervous systems."

These two doctors have dedicated their lives to healing using traditional, functional and natural therapies. I owe my life to them. They were totally honest with me but never once did they mention death and never once did they say "your" cancer. They described the symptoms but never gave it a name, as if ownership would infuse the very thing we were aiming to heal. I've taken this on board in my life, post-crisis, since 2017.

I believed cancer originated in outer conditions of my life and how they affected my inner responses in ways that compromised my own well-being. The point was, I believed I had the ability to create something different—wellness. My choice of treatment may not be everyone's preference and I would never assume that it is. There's no right choice, only the one that resonates with you. Choosing how to heal is monumental and people make that individual choice based on what feels right for them at the time. Whatever healing modality that is paired with a person's heartfelt beliefs, taking into consideration their doctors' advice, is the guidance to reflect on. People will have to check inside themselves and find out for themselves which healing method resonates. It's the same with everything in life.

Sometimes an authentic choice from the heart makes no sense to others. But it doesn't have to. Being in the heart means being

courageous, trusting, and listening to your inner sense—your unerring guide. And, most importantly, detaching from the pressures of the outside world's opinions while seeing the relevance in all things. It's your choice that is authentic to you, your heart and your higher self's guidance. There are no right or wrong choices, just fearful choices or self-loving choices that come from the heart, sometimes with divine intervention. I wasn't 100 per cent sure my protocol would be successful, but I certainly believed in the principles behind the choice I made. I believed that if I could commit to it with all of my being, then I would be giving my body the best chance. And that's what I did. I committed to an intuitive, heart-led, holistic approach.

When I went to Arizona I rented a house in Scottsdale, just east of Phoenix, and stayed there alone, focusing and devoting every single minute to healing myself. I saw Dr. C five days a month when he visited from Texas.

In the beginning I asked him, "How am I going to do this?"

And he said, "I'm going to give you a list of things to practise every day until I see you next."

I was shocked and replied, "What do you mean? Do them by myself?"

And that was part of the healing: to look after myself, to do everything on that list and to do each one relentlessly. The irony was, I thought my doctor would see me every day and that was going to make a difference. No, with the integrative medicine approach, it's often a month of work you do mostly yourself, and then the doctor monitors you to see how you're progressing.

I attended an outpatients' clinic five mornings a week. There, they gave me natural medications through IVs. I also consulted with a functional doctor, holistic dentist, osteopath, chiropractor and two therapists, who helped me dive deeper emotionally and work through

the accumulations of my past. In Phoenix, I also had regular visits with a beautiful, gentle, intelligent naturopath and specialist, Dr. N. I still keep in touch with her. She inspired me and kept me motivated, which helped subdue my fears.

Every day, every moment from 5 a.m., when I arose to greet the first rays of the morning sunlight, until 8 o'clock that night, my days at home in Scottsdale were intensely scheduled with healing modalities. Sometimes physical, sometimes mental; sometimes emotional and sometimes spiritual; and at times they were combined all at once. And always, I was profoundly committed to the task at hand; focused by trust, faith, self-love, prayer and the belief that my body knew how to heal itself if I gave it the tools to do so. And boy did I give it the tools.

When I first looked at the extensive list of protocols from all the practitioners, I started to panic. How could I manage them? It seemed impossible. Some areas overlapped, like prayer and meditation, but it seemed to me that everyone was addressing my well-being from different angles. Being an organised perfectionist, I felt overwhelmed. I felt as if it were a life-or-death situation and I had to get it right. I was extremely stressed. Most of the protocols were about de-stressing, detoxing, decoding, yet the very thought of how I was going to do it all put me into a total tailspin.

I decided to make a list of everything combined. It went for pages and pages, which stressed me out even more. I felt a wave of despair. Over time I found a rhythm and experimented with things throughout the day. I found I could do my protocol in bite-size pieces, often combining treatments so that I was getting a "twofer," as the Americans call it.

I began to notice that ten minutes a day, twice a day, of any practice can accumulate over the weeks and build beautiful changes

and progress. I first noticed this on the rebounder, bouncing to get my lymph system performing. A strong lymph and immune system is a focus for people diagnosed with cancer. Working out seemed so mindless before but now it had real purpose! I could suddenly see and understand how it supported my lymph and circulatory systems for detoxing and repair, and helped build strong, vital muscle mass.

When I chose a holistic path, I knew the work of healing had to come from within. So often there were little external signs of progress. Days, even weeks went by before I had a blood test, scan, or some indication of where I was on my journey. It's a double-edged sword because when I was in the middle of it, the results could be alarming, if I let them. So learning not to get too attached to the outcome of the results at a single point in time has been a big lesson for me on my journey. I reminded myself that I must believe that healing is a process, and to trust and believe I was doing all I could to create the best environment for my body to heal.

Complicated things became easier with time and practice. Results started to show through blood testing after consistent application, and this encouraged me to keep going. On the days I was crippled with fear or completely overwhelmed, I just took one step in a purposeful direction and then another, and then another. I got through the weeks by mixing things up—singing, praying and practising gratitude for the time and space to heal. Thankful for the tools, diet, herbs, detox, nutrients, music, books, expert direction and guidance. Thankful for my body that so kindly showed me what I needed to do in order to rebuild not only my physical well-being but also my emotional and spiritual well-being.

Being alone and looking after myself as well as looking after the house, the car, the specific diet and food preparation, and my business in Perth, I found myself on a tight schedule. In the

beginning, I was just ticking off a list of things I needed to get done during the day, fearful that if I missed something, my wellness would be jeopardised. I wondered if my stress levels were affecting my markers, adrenalin and cortisol, and I wondered why I wasn't feeling happier. What dawned on me was that I had made looking after myself a full-time grind and had forgotten to add to my life the joy of exploring.

I've always valued exploring. Maybe it's my Australian nature, but adventure, travel and trying new things have always sparked my soul. I'm fortunate because I'm pretty courageous and can happily give it a go. I also get great satisfaction from discovery. Have you ever felt the delight of finding something new? A little coffee shop close to home, which you didn't know existed? A piece of music you love? Twenty dollars in your pocket that's gone through the wash?

It was with wonder that I discovered the Desert Botanical Garden just outside Phoenix. I regularly went there to walk and sit with the hummingbirds and cacti and contemplate how amazing it was to be alive; how miraculous healing like mine takes time, faith, commitment and consistency; how blessed I was to be working with such a fantastic team. I took my notepaper and wrote letters of love to my children. Sometimes I wrote letters of forgiveness to myself and others, and sometimes I would write letters of anger and frustration, which I later burned.

To change my mood, I mixed things up and did whatever I felt like doing in the moment. I got creative. I walked in nature. I watched funny movies. I sat in the sun. Doing such simple little things, I felt uplifted, happier and better equipped to handle my protocol. Gone was the fear of not doing it perfectly to achieve my goal of total wellness. My heart was happy, inspired by curiosity, wonderment and surprise, which I found to be fantastic healers. Having the time

and space to heal is one thing but having the actual motivation and commitment to do it was a whole different ballgame, especially if you think for one second that it's not going to succeed.

One of the most important things I've come to understand, not just in theory but in reality, is the power of thoughts, feelings and actions. What you think, what you feel, become real. I know I am the creator of my reality with divine help and guidance, but, especially when faced with health issues, it became crucial to understand and to be deliberate, diligent, disciplined and persistent.

The worst offender was my mind. Fear of death, fear of failure, fear of being alone. I realised these thoughts often came easily into my head and seeped down into my heart. So I consciously had to choose differently, sometimes hundreds of times a day, the actual words and thoughts I was using. I observed myself carefully, making myself conscious of what had been my unconscious self-talk. Whenever I caught myself thinking negatively, I would ask myself, is this thought helping or harming me? Would I say this to my child? Of course, my answer was no. And then I'd consciously say affirming messages to myself, as I would have done to one of my boys. Loving my children unconditionally comes naturally but I realised I had found it difficult to treat myself with such love.

Instead of thinking, why am I doing this? I persistently and diligently displaced, flooded and reframed my thinking and belief systems, and said to myself, "This is worth it. It's worth me doing this. I am committed because it's worth it—I am worth it."

It stands to reason that if having negative thoughts, compounded by un-self-loving actions, can lead to illness, then the honest expression of feelings, loving thoughts and self-care can lead to wellness. I had so many protocols to follow that it was very easy to drift off into negative ideas about failing, the future, anger at the past, or simply

not being in the present through trying to do so much and stay on top of my protocols. I really had to remain focused on my thinking.

Fearful thoughts weakened my commitment as well as my immune system. I realised I had to rebuild my spirit, change my way of thinking and strengthen it. So that relentless commitment was intense and, at times, exhausting. Every day I chose to dig deep. Very deep. And I stayed determined because I knew my life depended on it. That was the fuel that propelled me through. Actually, I didn't just go through it, I WENT THROUGH IT . . . And I thrived!

My protocol was intricate. Like everything else I did in my life, I committed myself and gave it my all. I may not have "liked" it but I loved the personal growth and the miracle of healing. I marvelled at how potent the human body and spirit can be. I followed the directives that were in place and stayed focused and disciplined. I didn't skip a day unless I was with the boys and that's when I replaced my protocols with the love and joy of being with them.

Cy came to visit me in Arizona when I was at my lowest. Dr. C said to me, "Cy has got to get out here this weekend." So he would often catch the last flight after school on a Friday, which took seven hours door to door. By the time he arrived he was exhausted after such a long day. But he came with a loving heart to be with me for less than forty-eight hours. And to just snuggle.

I would plan fun things for us to do together. We enjoyed indoor skydiving, simulated wave surfing, outdoor mini putt-putt golf. Even though Cy was only fourteen, we practised learning to drive in the quiet back streets of Scottsdale. I wanted to teach him the power and freedom of exploration and discovery. One day we went to the Botanical Garden and I talked to him about me and Jeff, love and life, and to let him know he was going to be okay. More than okay. He was going to be great.

My health hung between us like a weight and it didn't help that I weighed eleven kilos less than usual. He was often very troubled about me. At one point he went to see the school counsellor and said, "I'm finding it hard to focus as I'm so worried about my mum." So his grades were up and down.

Cy was struggling at home. I sensed he felt alone and out of place in Jeff's space, unsettled and uncertain of whether my treatment in Arizona would really work. I think he also felt abandoned by everyone. I was in Arizona; Jeff was often in Detroit with his own son, who was now living there. Arki was in London and Cy missed his big brother, who by then was at college in Boston.

We were blessed with Jonathan, the boys' assistant and mentor, and my confidant. I don't know what I would have done without Jono. He was my rock and Cy's rock, and he was so incredibly nurturing and loving. Leaving Cy in Miami for eight months while I was in Arizona, and with Flynn in college, knowing that Jono was there with Cy helped me focus on my own healing even though I missed them so much. I was truly grateful. I embrace Jono as family. We worked together for seven years. We are bound by the profound experiences through the upheaval of the relocation, raising the boys together, and then by the cancer diagnosis.

Jono understood me and the choices I was making. We checked in daily with each other while I was in Scottsdale, making sure we were in alignment with how the boys were being looked after, always including their dad's perspectives. I wanted to be sure Jono consistently gave the boys both their father's and my messaging and directives. He was a loving presence who knew exactly what the boys needed and what to do in any situation; deeply principled, grounded, responsible and caring, and he brought to our family that "give it a go, no drama, get the job done" super Aussie attitude. He was a big brother and a loving

guide to my boys, particularly Cy, who always looked up to him. The boys love him and so do I.

Thank God for Jono, Ly, my staunch and grounded assistant, and my exceptional personal assistant Ashley, who later joined the team and has lovingly been with us ever since. They went to extraordinary lengths to make sure things ran smoothly at home in Miami while I was away in Arizona and that the boys felt loved and supported. The pressure on them all was enormous but they held steady. I will be forever grateful to them for everything they did for us. I'm not sure I would have made it through without them.

Though I say boys, Flynn was actually a young adult of nineteen by then. He was living his own life, fiercely independent and capable, doing his best, committed and excelling in his studies at Babson College. He did his utmost to help Cy, while staying stoic, and he supported me with love as best he could from afar.

I treasured the times we FaceTimed each other. During one of those chats, he told me he'd realised he had something of me in him. I asked him what that was and he said, "Commitment to study, to work, to achieve, and to appreciate the value of effort." I smiled inside as I heard him cherishing those same attributes I had learned years earlier from Neill.

I continued to dedicate myself to detoxing my body and strengthening my immune system. At times I would have shingles or rashes on my skin. When my liver and other organs were cleansing, I often felt like throwing up. At times my anxiety was debilitating. It was all about processing my treatment mentally and emotionally; and each emotion affects different organs. Anger resides in the liver, for example, while grief sits in the lungs. I approached the process methodically, because at every stage my body was releasing emotions that had been stored in my organs until they had become second

nature, unseen by me. Though so uncomfortable, this was clearing those familiar but damaging energies. Doing so challenged every part of my being.

And every day I learned to be joyful doing the little things. I learned to wake up in the morning and train myself to see the beauty and gifts in every moment; to be grateful until I went to bed at night; even through the hard times, even through the pain of the IVs, when my veins were collapsing and they couldn't find another; even when I was in excruciating pain having the mercury removed from my teeth without anaesthetic; even through the weeks and weeks of fasting; even when the smell of wheatgrass four times a day made me want to vomit; even after the relentless body work and emotional work; and even when I was so exhausted at the end of the day that I could barely get into bed. But more than anything, I learned to be joyful through the fear of cancer. And I became grateful for my life and to appreciate it.

It was relentless dedication to myself which I had not truly practised before. It required such strength of character. And although I had support from a dedicated and loving, yet unusual, team of practitioners, the bottom line is, it's an inside job. Nobody can do this for you. Whatever road you take to return to wellness, whether it be chemo, radiation or surgery; fasting, IVs, ozone, bio-tweaking; whether conventional or traditional or alternative practices, it is ultimately your own support and commitment to yourself and your journey that is absolutely vital. You become your own champion and your own healer. You are the one who digs deep, fortifying your inner being and belief in yourself. You are your own best friend, doctor, nurse and more. A healer is not someone who you go to for healing, a healer is someone who triggers within you your own ability to heal yourself. This is what I learned from Dr. C and Dr. R.

So, even though I was mostly by myself in Arizona, I don't remember feeling sorry for myself, despite the outward appearance of being unsupported and alone. I actually felt empowered. I was ready to dedicate every second of every moment of every day to healing my body, mind and spirit. I had the time and the space to truly dedicate myself entirely to my healing. Just me. Alone. But not lonely.

One day I uncharacteristically reached out to someone I didn't know. She was the wife of a friend of Jeff who happened to live near me. I'd never met or spoken to Maureen before, but she immediately responded and picked me up to take me on an adventure. We drove to a little vegan café at the back of an old motorcycle town opposite the rodeo. When I arrived, I saw slogans that were seemingly meant for me: "Let food be thy medicine; Let medicine be thy food." Hippocrates.

The menu was wonderful. No peanuts, gluten, corn or sugar, and no nightshade foods. The food was the best I'd ever tried— vegan and raw. I asked Sara, the owner and chef, if I could come and work with her in the kitchen. I figured if I could learn how to prepare this type of food for myself, it would help me on my wellness journey. She looked at me knowingly and brashly said, "Why? Do you have cancer?" Her straightforwardness and clarity cut through my pretence.

"Yes, I've been diagnosed with cancer, as it happens," I said.

"Well, you've come to the right place," Sara smiled. "I had stage four cancer and now I'm clear. I can teach you if you're interested."

I wasn't ready to add to my already complex and unfamiliar routine at that time, but I did follow Sara and her protocol towards the end of my treatment. It has been the foundation of my nutritional program ever since. I meet with her once or twice a year to reset my body, lower inflammation and detox from anything causing acidity.

Sara and Maureen were angels who kept me company and grounded me through those long Arizona days and months. So were the people from the local AA meeting group, which I regularly attended.

Sometimes I would go to Sedona for the weekend and stay in a beautiful hotel somewhere new each time. When I had the physical energy, I spent time hiking. I meditated and immersed myself in the beauty of nature. Sedona is such a magical mystical vortex only a few hours out of Scottsdale and I could literally feel the energy in my body as I drove closer to it. Those weekends in the red desert earth canyons were some of the most important times in my healing process; seemingly nothing there, yet so powerful. I would load up my little Porsche with my nutrients, books, meditation material, diary, hiking shoes and open heart, and drive and drive and drive until I arrived ready for the healing from the rocks and rivers there. As it was cold at night, I'd light a fire and watch the flames dance as I reflected on how incredible the whole process was. What was I learning? How did I get here? What was the way back home to my heart after abandoning myself for so long?

Every day I journalled my thoughts on how and what I was feeling. I learned so much about who I was. The following are some of my writings, which capture the essence of my thoughts and insights that opened my heart to heal my body and to finally love myself.

Scottsdale, Arizona
March 29–30, 2017. I just had a birthday.
53 years old.
Everything must change.
Trust the process within me.
The power to heal and to trust myself.

I know the body's natural state is wellness, which it will return to when given what it needs to do so, and I'm witnessing that process now.

I'm waking up to my true self that I've ignored or suppressed perhaps all my life in order to satisfy others and my ego's desire for approval.

Every day is a new challenge as I realise I need to create more joy, laugh more, have fun, do things that feel uplifting.

It's time to let go, let go of control, let go of trying to control my life through the need to know what is happening outside of me.

I must not waste valuable energy.

I am transforming and need all available energy to continue on my path.

I am creating a beautiful, heart-led life.

What is my journey of cancer teaching me about me?

I am stronger than I imagined.

I can heal myself, my body can heal itself.

Healing is 25% physical, the rest is spiritual and emotional.

My decision in trying to find my path was the most painful.

It's a marathon not a sprint.

Take each day as it comes.

There are no guarantees or outcomes but I can create my future— it just needs work.

I can receive unconditional love.

The way I think has affected my body therefore I can choose to believe differently if I want a different outcome.

I am guided.

I am scattered—at times easily distracted.

When I'm patient and methodical, I can achieve a lot.

I am really courageous.

I am self-sufficient, learning how to get help when it's for my highest good.

I don't like to write or record but I do it anyway.

I find doing easier than being.

I am open-minded.

I follow guidance and my heart.

I can explore, and I do.

I sometimes suffer from lack of faith.

I sometimes see being alone as being abandoned.

I'm so noisy sometimes, it's hard for me to hear guidance and be me.

I have great resilience.

My heart is awakened.

When I take a step towards what I believe in—my whole world opens up.

Have faith. Faith helps bridge the gap between the head and the heart.

I feel safe in routine but cancer isn't about safe.

Five minutes of happiness a day is all it takes to have a stronger immune system.

Healing simply means bringing more purpose, happiness and healthy behaviours into my life; which are beautiful things to begin right now regardless of how much time I have here in this life.

Priceless perks of persistence, promise of persistence, power of persistence, pride in persistence.

One of the greatest satisfactions I've received on this journey is the elevated self-esteem that comes from doing simple things that I've felt difficult in the past, or found complicated and avoided—like setting up a food processor!

Breast cancer is an inner evolutionary story and a very personal experience.

What is cancer teaching me?

Cancer is teaching me what is important in my life.

Cancer cells are the weakest most depleted cells in the body—why give power to them.

Purpose—to discover joy, appreciation, love, priorities, create, be unconditionally loving to self and others.

Value of peace within, look after your body, don't believe you're a victim, evolve out of ego into heart, personal growth, appreciation of what is.

Discover who I am, relentlessly being my new me.

Diagnosis of cancer led me on a journey of self-discovery—physically, emotionally, mentally and spiritually.

Cancer—the hardest part was making the decision on how to heal. The saddest part was the lack of understanding from people close to me.

I've become stronger as I've become my own cheer squad and accepting unconditional love from strangers.

Every day has new challenges.

Some breakthroughs. Some breakdowns.

Holistic healing requires complete responsibility for self.

Complete faith in the body's capacity to heal.

A belief in something greater than myself. God.

Guidance takes stillness, contemplation, time.

Slow burning sometimes.

The realisation of the power of thoughts for healing.

How to make a decision and the frustration surrounding that.

How to choose that course of action.

How to get to that course of action.

What led me to it.

I immersed myself in healing. I just addressed it in a different way.

Respond, not react.

I am stronger, braver, more resilient, persistent and more capable than I ever knew. I am living proof.

The Universe is on my side. I have been supported even if not immediately apparent.

This journey could have been my worst nightmare but instead it's been my biggest saviour.

There are no guarantees. No point in having expectations and trying to reach them. As I hang on to these, I trip and fall. Life unfolds with the greatest of ease. And the greatest ease can be felt when taking one day at a time. Easy does it. But do it.

I could never prepare myself for what I experienced so no point living in fear of "what if" because life truly is a journey that unfolds along the way. And the trick is to be able to adapt to the circumstances as they arrive in the moment.

After years of never really appreciating my body, I am grateful for my incredible body and my breasts for letting me know that I had unresolved conflicts within me that needed healing.

I discovered the toxins I'd never been aware of before in beliefs, thoughts, attitudes, emotions, actions and reactions, relationships, food, environment, habits and circumstances.

There's no point examining a singular point along the way because at that moment it might look and feel like a failure or a step back, when in reality it's a run-up to a leap forward.

I noted my progress in my journals. I became stronger according to how my emotional well-being was when my joy factor was higher. On these occasions, my immune system and blood results were better. There were times when I was deeply stressed about my impending divorce from Jeff, missing the boys and my family in Oz, or I had fear that I wasn't going to be able to make it through. At those times my

blood results were out of balance. It went in phases. I did such exten-
sive sensitive testing that any changes in my emotional biorhythms
from excessive fear, or if I was experiencing profound doubt, would
show up and mess with my markers.

Love heals. Yeah, yeah, yeah. I know it sounds like a cliché but it
has been my experience. Most notably, my own love. While in Arizona,
I found I had plenty of time and the requirement to nurture myself,
perhaps in ways I'd never done. No space for criticising my body, my
skin, my hair, my thoughts. It was time for me to appreciate every
aspect of myself and to stop participating in anything that wasn't for
my greatest good. Don't criticise it, just take actions towards creating
what I want to replace it. And that's what I was doing—grounding
the new me in my actions.

My commitment to WelleCo became even stronger as I realised
that wellness is everything. Perhaps I'd never really fully grasped this
until it became imperative and monumental in my life.

Dr. C often suggested Cy and Flynn come to visit when my
immune system and morale were struggling because he too believed
that love heals. And he was right. Each time they came, my well-
being improved rapidly. I don't know if they will ever understand
how much those visits meant to me and how much they helped my
body heal when I was at my weakest. To my children, I want to say

Your pure spirit brings light and healing to every situation
just by you being you. Never forget this. Thank you for having
enormous hearts, patience and courage in such difficult situations.
And thank you for your strength and love which
filtered through to my soul and helped me heal.
Thank you for choosing me to be your mum.
I love you.

Four months into my treatment, in May, Flynn piloted a tiny plane across the country to see me on Mother's Day. It took him two days. He had attained his licence late in his teens, and was fanatical about flying. Jeff, a pilot himself, had helped his stepson become the brilliant flight master he is today. Thank you, Jeff, and thank you, Flynn. You'll never know how much that visit meant to me. It came at one of those times when I was at my lowest of lows and it really gave me something to look forward to.

There were times when I hoped Jeff would come visit. I longed for his understanding, a smile, a hug. But I knew if he did, we would only end up discussing how to execute our divorce. We both knew by then that the divorce was inevitable, and we both knew that we would make it as simple as possible for each other. He, perhaps more honest with himself than I, wanted desperately to move on. I knew in my heart of hearts that hanging on to our marriage and wishing for his love was not the thing that would help me heal. You can't "make" someone love you, and it's unwise and painful to want to be with someone who doesn't want to be with you. And anyhow, preserving my marriage or expediting our divorce wasn't my primary concern during those months in Arizona.

Arki was really supportive. He was there for the boys and would visit them whenever he could and as much as possible. He was a rock-solid loving source for them. He didn't agree with what I was doing. Well, it wouldn't have been his choice, let's put it that way. Yet he wrote to me to tell me how proud he was of the courage I was showing, and that it was good I was sober because he didn't feel I could do this otherwise. He went on to say that the boys were lucky to have me as a guide, someone to look up to, and that in choosing to live my life this way I was demonstrating "so much." Of course he was scared because I had decided not to take a conventional pharmaceutical route. He

considered that extreme. I, on the other hand, felt that the chemo and surgery route was extreme. Nevertheless, he was profoundly supportive throughout the whole experience and that meant a lot to me.

Arki showed up, Jeff showed up and Jonathan showed up for the boys, and gave me the peace of mind and freedom to go away and heal because I knew my children would be loved and cared for. Every time I think of those months, my heart is deeply touched as I witnessed the struggles of my family trying to deal with my decisions and treatment protocols.

At the end of seven months my doctors gave me the all-clear to return to Miami. Ideally, I would have stayed an extra six months to get my strength back to heal from the fear and anxiety generated by a life-threatening disease, to stabilise myself. But I missed my sons enormously and I wanted to get back to them as they were starting a new school year and there was so much to sort out and organise.

When I decided to return home from Arizona, I addressed the dissolution of my marriage. I knew we couldn't live in that state of limbo any more. My heart ached from Jeff's lack of compassion, but in truth he just didn't know what to do. I had to love myself through this time of healing. Thank goodness for Paul and Alexandria, who supported and helped keep me strong through the most difficult moments of divorce.

During that first lumpectomy, Jeff and I were already limping through our relationship. After the second lumpectomy, we barely saw each other again. Instead of breast cancer bringing us together, it tore us apart. I went through the depths of emotions and all the horrible thinking that was right down in my core. And then I saw a

tiny flicker of light. When it filled my heart and consciousness, I came to a powerful understanding: oh my god, it's not what I thought. It's something completely different. Jeff was never here to love me; he was here to inspire me to love myself.

Only through being in the darkness was I able to see the light. My light. My inner sense whispered to me, "This is a mutual soul separation. You can now focus on what you need to do. It's really about you becoming you."

I accepted that Jeff and I couldn't go on living together. It wasn't one-sided and it wasn't just his decision. It was actually both of our souls deciding, this is not going to work. And I guess the point is that expansion is messy and it doesn't always work out the way you expect it to. But in the long run it's exactly what you need.

Those first few months after my return from Arizona were super tough but I continued my rigorous wellness program and committed myself to it fourteen hours a day. It was difficult as I had to integrate it into my life while dealing with the grief of my marriage falling apart and trying to find a new home for me and the boys. I stayed the course, though, and became super driven as I focused on creating a new life for myself and the boys outside of my marriage to Jeff.

He and I tiptoed around each other and lived separate lives under the same roof for about six months more while we finalised our divorce. It was easier for him because he was detached, and harder for me because I was afraid for my health and didn't feel at home. As Dr. C had said to me, "You can't get well in the same heart space that provoked dis-ease." That rang very true and it further motivated me to find a house and to move as fast as I could.

I remember thinking that I was so sorry for having moved everybody from England to America. I mean, barely three years and I was going through divorce; the boys had been separated from their dad,

plus the change of schools, and now cancer—it was a hot mess. Looking back, though, I know this experience was not in vain as we all learned so much and both boys have since told me they feel it was one of the best choices of their lives. They are happy and they're grateful for the experience. They value their community in Miami and are thriving.

At times I felt bereft on many levels that I couldn't find resonance with Jeff. During the last two years of our relationship, I had begun to feel extremely lonely, isolated, separated from all I knew. It became unbearable to live with that. My capacity to find joy slipped away and Jeff began to lose interest. On the outside, I had it all and I was grateful for the life we lived together, albeit separately. But inside I felt barren—longing for the love that I later realised I could only really give myself. It's nobody else's responsibility to fill that gap. Only connection to self and Source can fill that perceived vacuum.

I mistakenly expected Jeff, our marriage and the children to fulfil me. Like that line in the film *Jerry Maguire*, when Tom Cruise says to Renée Zellweger, "You complete me."

Wrong . . . In truth, that is the surrender of your innate power, giving it away to another. We are not powerless, we are all already complete and capable creators. That's our nature—completeness. We lack nothing other than awareness of the fact that we are whole and we have only to grasp and live that natural wholeness. Only in our own minds and misapprehensions are we incomplete. Only in our misguided beliefs of being powerless and separate do we find or seek anyone or anything outside ourselves that could complete us.

We just need to recognise and accept that we are infinite energy beings living a limited version of ourselves called physical life in embodiment. Once we accept and integrate the fact that we are energy—consciousness having the physical, emotional, mental

experiences through simple material lives—we will comprehend both our dilemmas and our capabilities. Only then will we fully appreciate that we encompass it all and are infinitely capable, wise and powerful.

Nothing outside of ourselves can reconcile this sacred unity. Nothing outside of ourselves can compromise or enhance the fact of our sacred connectedness within ourselves. And the extent to which we appreciate and comprehend that wholeness is reflected in our view of each other and our lives, and our connectedness with each other. Our relationships might involve discord or harmony to varying degrees, but actual disconnectedness is not possible. We are constantly connected to all things, all places, all times.

In hindsight, I know Jeff wanted the best for me. When I married him, I thought I'd married my best friend, but in truth I needed to be my own best friend. And I wasn't. The more I leaned on Jeff, the more he closed down and his light waned. Eventually, both our lights dimmed.

These were the experiences I called into my life to teach me self-love—and I learned from them. I take the wisdoms with me each and every day that I live and breathe. And it is a loving commitment to myself. I commit to my health every day. I make a choice whether to have sugar or not, and I decide whether or not to support an acidic, stressed, toxic body, or support a healthy, balanced body and remember to cultivate an observation of life and people to gain understanding, without need for judgement, blame or engagement. To have little or no concern about others' impressions or judgements of me ("What you think of me is none of my business," as Paul says). To see everything from a bird's eye view, a higher perspective, instead of wavering in doubt.

I am in command of my life and proactive in my choices. Every day I actively, deliberately feed my wellness and nurture myself.

Cancer is not an option for me any more. Like drinking is not an option for me. It's not something that I will ever do because I don't need to. And I don't need another bout of cancer to learn my lessons. I have learned them. I do what it takes and I'm grateful.

The end of 2017 was the end of the way things were with me and Jeff and our marriage. I moved out as soon as I was strong enough, a year after my diagnosis. We both began our new lives, which were more suited to each of our true selves. Looking back, Jeff and I helped each other see what was truly important in life—it just wasn't what we thought. And it wasn't with each other.

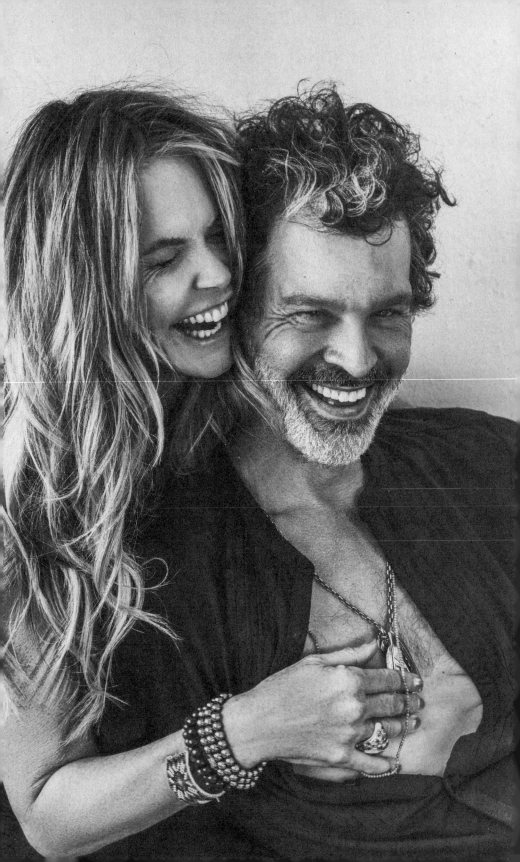

18

HINDSIGHT

Love wins every time

After months of looking for the perfect house for me and Cy, my broker took me to an apartment in Coconut Grove, Miami. The place was cool if I'd wanted to live in a building with lots of tenants. That's not where I was at and wasn't what I wanted. He then asked me to follow him to view a house nearby. We arrived at a beautiful private estate. As I drove in, I chuckled at the irony of the name on the sign—"Journey's End." Hint in the name.

What was an ending became a new beginning for me. I was starting over, rebirth complete with all the lessons I had learned through-out my life thus far, especially in the previous few years. The house represented so much more than square footage, architecture, land and light. It represented freedom. The space and freedom I craved to consolidate, keep on growing, create and nurture myself and Cy.

Decorating the house was fun. I had collected art and furniture since the 1980s, focusing on the '30s and '40s time period with a passion for

Jean Royère. I poured all my creative effort into combining such pieces with ones I'd found at Ikea to fill in the gaps. High–low, they call it. And that's a lot like life. Bringing quality and valuable learnings into life and mixing them with a good dose of practical application. Keep what works for you, the quality wisdoms, and let go of the rest. No judgement, no hanging on to anything that doesn't contribute to your highest good or your deepest desires. Mix and match. Beautiful and practical. Some old, some new. But always chosen with the heart. Such is life.

Cy's journey mirrored mine. We were both growing and changing every day. In our new house he finally had a space he felt comfortable in, close to school, somewhere he could invite friends. Most weekends, and often after school, the house was full of gangly teenagers exploring and experimenting with boundaries, hormones and all the things boys do at that age. I was in heaven. Teenagers everywhere and the house full of music and laughter—a supportive, loving environment for well-being. I was able to thrive and get to know Cy, our lives and myself with completely new foundations. Parenting is the gift that keeps on giving. Simplicity brought out the best times for us.

Watching my son blossom and pouring my heart and soul into growing WelleCo were incredibly fulfilling. I realised how powerful our intentions and creative energy can be when they are not disrupted or disturbed by trying to force things in life to work. Everything felt so effortless. It was time to go with the flow and I leaned into the whisper of my heart's desires; listening closely to my inner guidance, my inner sense. I learned to laugh. I learned to love my own company, something that had begun to crystallise when I was in Arizona.

I guess you could say I was finally on my own after having spent ten years with Gilles, ten years with Arki and ten years with Jeff. I was on my own with WelleCo, on my own with my wellness journey. And soon to be on my own without the boys at home.

Cy's inevitable departure to college came four years after we moved into Journey's End. During that time, I'd started building a life that would fulfil me when he would inevitably move out. With Flynn already graduated college, thriving on his own and creating a life and career for himself in Miami, New York and London, I found myself once again at a crossroads. Do I allow fear of loneliness to occupy my energy now that the boys are out of the house? Or do I build on all the beauty I had been creating in a meaningful flow over the years?

I chose to expand. Beginning with speaking engagements, podcasts and Instagram Lives, I keenly shared the wisdoms I had accumulated through family, parenting, business and, of course, health and well-being.

Notably, my relationships and friendships with other women deepened. An example was my friend Mathilde, worldwide PR manager of Dior Couture, in charge of celebrities. She's one of the coolest, smartest and most charismatic women I know. Deeply and deliberately, we bonded over health and well-being and realised that our breast cancer and personal journeys have been very similar, synced by timing. We discovered we both recognised cancer as a catalyst for personal growth, and although we approached our treatments differently, we effectively both found our way through our health crises by being profoundly positive and proactive; no place for doubt and despair. I found myself even more committed to choosing to work only with people and companies whose values and purpose resonate with my own. I have since formed a beautiful relationship with Dior, often going to Paris to represent them and myself during the Paris Fashion Week.

Never having spoken about my health crisis with cancer until now, I'm finding it's the right time to share the deeper aspects of my

life's journey. By the end of 2020, I was ready to write this book. So appropriate. The 20/20 vision that is hindsight began in 2020.

As the woman I am today, when I look back, I see my life has illustrated many of the principles of the spiritual-awakening process we are currently living through. A life lived through the heart. I've often said, "Let your heart be your compass," and mine has been a journey from fear to love; from head to heart; from control and force to allowance; from being attached to outcomes to letting life flow. Even when fear drove me into my head to find information, my heart still sought something more liberating and empowering—understanding. My life has been founded on qualities of the heart—courage, unconditional love . . . and trust. Trust in myself, trust in life, trust that the Universe is on my side no matter how things appear.

Yung Pueblo wrote, "Your intuition will lead you outside of your comfort zone so that you can grow." I am living proof that logic is not required to be successful. It wasn't rational for me to give up the chance of going to university to obtain a law degree, and instead to step into a modelling career. Yet I am glad I did because I learned that although it's important to have a plan, it's also important to be flexible and adaptable so you can listen to and follow your inner voice and encounter the natural miracles that happen in your life spontaneously, ones that you don't plan for.

Though I could never have imagined all the wonderful things that would come from taking those risky first steps, once I took them, it was remarkable how trust and commitment magnetised unexpected opportunity. Life is always going to be about risk, so courage—a quality of the heart—is the key to getting through the practical experiences that transform risk into success.

When your heart is in something, you'll feel it as authentic passion. Creation then responds with opportunity. It sounds simple and it is.

Only an open mind with an open heart can learn. Being open-minded means you can recognise serendipitous opportunity, which has a powerful effect on creating and realising even more potential.

Being willing to learn, to feel uncomfortable and go through the growing pains, to take risks and to give it a go when opportunities arise, all ground the potential into the actual. It is part of the journey, part of the process. When your heart's not in it, you will not be as successful as you could be. Put your energy and attention into only what you long to fill your life with. Otherwise you'll become stuck in compromise, spending wasteful, conflicting effort that cancels out your potential.

As I say to the boys, "Find what you love and do it. Love magnetises success and it won't feel like work, it'll feel effortless and worthwhile." That's why I always encouraged them to take summer jobs so they could explore and experiment finding out what they love and getting to know themselves while experiencing the power of financial freedom and independence. And of course, this would also help them in their higher education and future career choices.

You can't step outside the box until you think outside it. There's no right or wrong way in life, only choices that either resonate with you or rub up against you. Most important is to learn from every experience and put into practice what you learn. That way, nothing goes to waste. The successes, the celebrations, the compromises, the doubts. Find the empowering gift that is in everything and put that gift into action as soon as you can. In that sense, the gut is in fact the heart— same thing, different label. That inner awareness, self-communication coupled with courage, is not logical yet is vital. I know that every step on my path has led me to this moment, this grounded Here and Now. It's effortless, yet not without effort.

Originally, I wanted to call this book *How My Tits Saved My Ass*, but that would trivialise the significance of my life's extraordinary

experiences. Nonetheless, it is true—from the Tab commercial back in the '80s, a tiny piece of red fabric covering full breasts swept me from everyday model to celebrity and brought me to America. The next step on my journey led me onto the covers of *Sports Illustrated*, making me a household name and giving me a platform from which to build a brand and a life beyond my wildest dreams.

Next on my path was the opportunity to produce swimsuit calendars. This was my first foray into my own business and true financial independence. I began building a career and a brand that I later applied in a long and prosperous licensing deal with a lingerie company, creating bras and businesses, financing my freedom to explore all sorts of life passions and opportunities. Using my brand as a platform, I immersed myself in charitable initiatives such as women's health and breastfeeding. Engaging my efforts in service to projects that deeply resonated with me and were in alignment with my core values and aspirations—the authentic me—brought me an immense sense of joy and fulfilment. And purpose.

Getting sober was a turning point in my life that awakened my inner being. It was my soul's cry for help that brought me to my knees. It was with Divine intervention that I realised the most important elements of my life were me and my children. I then committed myself to living a life free from the misunderstanding that I am not enough, that anything outside myself, any person, place or thing, drink or drug could fill the emptiness I felt inside; a lack that I now know never truly existed.

In the years following my sobriety, I expanded my entrepreneurial endeavours with a joint venture in a new lingerie business. Producing and hosting *Britain and Ireland's Next Top Model* preceded a time in my life when I discovered a lump in my breast. This fortuitously connected me to Dr. Laubscher and a refreshing perspective on wellness, resulting

in the birth of a beautiful new business, WelleCo—the company and the products we offer having a purpose beyond me personally.

A massively powerful step on my life path landed in the form of breast cancer, which became the catalyst for enormous growth in self-awareness, self-love and self-knowing. I'm so grateful for the magnificence of my body and the lessons I learned. Breasts have certainly been a theme all my life!

My biggest joy in life is being a mother. It's such an honour to have been chosen to be a sacred portal to my two sons. Bringing them into this world and guiding them through their journey is a true privilege, while witnessing them become the exceptional men they are today is such a gift.

From being so unwell as a child, it's hard to believe that, at twenty-six, Flynn is now a strong six-foot-three man. He has travelled his own journey to health and well-being, overcoming the belief that he was powerless over his physical fitness and ability to thrive. Today, he relishes working out regularly and is proud that he chooses to look after his body, mind and spirit in practical and fulfilling ways. Tall, dark and handsome, he cuts a fine figure in any room he enters. He oozes Arki's European charm, dressed in his bespoke shirts and jeans, and with deep brown eyes and a warm smile. I love Flynn's dry sense of humour. He's witty and intelligent, sensitive, thoughtful, kind and loyal. He uses his creative mind to find solutions to any obstacles he encounters. I love his strength, grit and determination, his persistence and self-knowing. And I love how he loves. He tends to have long relationships with friends and girlfriends, preferring to dive deep. He values maintaining and deepening his connection to other people.

Working with his dad building a family business, Flynn contributes so much to all the projects they develop together. Having finished his studies, majoring in real estate and finance at Babson College, he

brings a formal education and discipline to his dad's intuitive skills. Arki often says he's in awe of our sons' brilliance, finishing their tertiary education with such high honours.

When he was sixteen, Flynn decided that he didn't want to have a conventional parental relationship with me so he began to make his own decisions in his life without expecting my approval. As you can imagine, in the beginning this was extremely difficult as I wanted to protect him from making "mistakes." And then I realised I was trying to protect him from his own learning, which is neither wise nor advisable. We muddled through his profound desire for independence and I let go of wanting to micromanage his decisions, freeing us both from the control drama.

He started flying when he was sixteen. Jeff, being a pilot, suggested he get his pilot licence as an activity to focus on at the weekends when other kids were doing sports. At that time, Flynn found sports too difficult due to asthma. And you can't go out drinking for entertainment if you're flying a plane the next day. It was a brilliant solution to the usual teenage distractions of weekend parties. Flynn's desire to feel free motivated him. He told me that's how he feels when he is flying high above the clouds—free.

After years of flight training, Flynn is now is an accomplished pilot with five accredited licences including commercial pilot. And he has expanded his passion to include skydiving—not an easy thing for a mother to see!! I asked him if he felt he was addicted to the adrenaline rush and he said that his heart rate actually goes down when he jumps. He finds a sense of calm in those forty-five seconds of free-fall. Go figure! This year he asked me for a parachute for Christmas. I think not! Certainly, Flynn doesn't need a parachute metaphorically. He has his own unique courage and determination. He willingly takes those jumps into life, knowing he is confident, capable, clear and calm.

Cy, now twenty-one, is a willowy six foot two (and probably a bit more if he stood up straight) with a mop of blond hair held in place by his baseball cap. He is blue-eyed with a determined gaze and has a fiery and sharp mind just like his dad. Yet he's sensitive and diligent, more like me. Deeply intuitive on the one hand and intellectually brilliant on the other, Cy has grappled with the journey between his head and his heart. I watch him oscillate between trusting his inner sense and relying on his rational mind, which is often contrary to his intuition. And yet somehow he finds his way. A beautiful combination, as he learns to listen to the quiet whispers of his inner voice and urges while still using his impeccable mind to administer action. The vital balance of masculine and feminine qualities that constitutes genuine intelligence. Many of our conversations are about trust and leaning into inner self-knowing. At times he is anxious, having been through much upheaval. His life certainly has been about adapting to change and evolving through change. Not easy but so worth it; he's learning to trust that the only constant thing in life is change.

My favourite times with Cy are when we sit quietly and chat about everything. Cy goes deep. He values friendship, especially since leaving high school, where he magnetised profound and long-term friendships and relationships. I'm in awe of how well he balances his personal life with also getting his pilot licence, all while accomplishing his intense entrepreneurial and financial studies at Babson College. Like Flynn—nose to the grindstone while flying high. Great combo.

He's learning how to make the most of his opportunities, emotionally, physically, spiritually and academically. And he's learned how much energy to put into each aspect of his life to find the balance that brings him joy and fulfilment. As he grows into adulthood, this has definitely evolved how he views and approaches new and existing relationships and situations.

Cy is humble, excelling in everything he quietly puts his heart and mind into. I've learned not to try to protect him, reminded by this wise quote from Sri Aurobindo, "As one stumbles, life perfects itself." And I would never want to take this away from him or anyone else by presuming to save (or interrupt) him from his own life perfecting itself.

Cy is so beautifully articulate and courageous while expressing how he feels and sees life. He knows himself well. For a young soul, he has a wild EQ and he gets straight to the point. I love that about him. That raw Aussie boldness and sometimes bluntness.

As I've matured, I've realised the importance of loving connections and family. And family doesn't always have to be blood, it can be chosen family, although there's a powerful bond in ancestral connection, returning to our roots, to a sense of connection to previous generations and natures. I have a deep, tender reverence for my parents, my brother and my sisters, grandparents, nieces and nephews, godmother, aunts, uncles, cousins and their parents. I find peace in being connected spiritually and emotionally to my family.

I love my sisters more than ever and often dream that we live closer physically to one another so we could drop in for a cup of tea, a hug; share stories easily and soulfully face to face, eye to eye, and be able to support each other with an embrace and loving smile. I'd love to be babysitting Lizzie's two beautiful children (she has two under two!) and, even though Mimi and I speak most days, I'd still love to be with her in real time, catching up as the years melt away like we were little girls once again.

I admire the brilliant, bold, courageous, caring and creative women Mimi and Lizzie are. Today they shine even more brightly, bringing beauty and kindness to all they do. I'm deeply moved by

how they choose to show up in their world. Mimi has a sleep and wellness business that she is passionate about. She excels in all she puts her heart into. Lizzie has earned a degree in immigration law. Writing this brings tears as I would love to be in Oz right now to hug them and tell them how much I love and miss them. Even though we text often, it's just not the same.

I'm blessed to live in the same country as Ben and we work together collaboratively for WelleCo. Having my little brother's support and input into our business has been one of my (and WelleCo's) greatest gifts. I say "little brother," but really now I look up to him as my big brother. I trust him and his specialised experience and expertise in the digital world as he guides me in business strategy. And we laugh a lot!

When I think of my mum and all she has taught me, my heart glows with tender gratitude. I know she misses me so much and, as a mother myself, I understand how that feels—the mix of joy for the unique and independent life your children are living while no longer being present in their day-to-day is a bittersweet symphony of feelings.

My dad—earnest, eager and always willing to help in every way he can. He's so fit, bright, quick-witted and quick off the mark at eighty-four. I love how he loves me, quietly and consistently checking in most days to see how I'm doing. As my parents get older, my heart also softens for the hugs I long to feel. Profound. Perfect.

And Neill, my stepfather and big brother, mentor, friend and wise guide, who showed me how to show up for myself and also for my family. A shining light full of wisdom, love and non-judgement throughout my teenage years and beyond to this day.

Australia, and being Australian, mean so much to me. My heritage, my family, my friends. And Australia has influenced my perspective on beauty. I grew up believing that beauty's in the sunset;

the waves on Bondi Beach; the sunshine and the bush. It was the smell of the eucalyptus trees and the breeze on a balmy afternoon. That was my perspective of beauty as a child. Today, I feel that real beauty emerges when we honour our uniqueness. We all have our own spirit. Witnessing and recognising it in one another is where the beauty lies. Our wholeness is the interconnection between our physical, emotional, mental and spiritual well-being; that magical weaving of all those elements in one intrinsic journey of coming to know yourself.

Confidence is also a highly attractive quality. It's that unquestionable comfort with who you are; an ease, a grace and an inner essence shining through, which makes you beautiful—magnetic, even. From being in front of the camera all my life, I've learned that we're all unique for a valuable reason, and we can all get in touch with our life purpose by leaning into our own uniqueness. One great purpose of life is to appreciate our uniqueness. Experiencing that power can give you confidence; permission to be authentically you. And that's where authentic beauty lies. It's an enlightening and enriching journey to come to understand, love and appreciate who you naturally are and then to make choices aligned with that self-awareness. Wellness enables you to make those choices, which bring you confidence, even charisma! I believe wellness is the new beautiful, health is the new wealth, inner peace is the new success, and kindness is the new cool.

I'm so grateful I now understand what it means to live well and age well; that I can live the life I long to live, do the things I dream of doing, experience the things I wish to experience. Having my body, emotional state, mindset and inner spirit intact, aligned and pointed towards my dreams. And the journey towards our dreams demands wellness because wellness supports the courage, clarity, strength and balance to follow those dreams.

I am passionate about challenging conventional perceptions that health is solely the product of scientific endeavours and beauty is simply about aesthetics. If we embrace the notion that beauty is not just skin-deep, but rather soul-deep, we open ourselves to a better understanding and greater appreciation of our bodies, emotions, minds, hearts, and overall well-being. Health is a way of being, a way of living, and wellness enables people to exude confidence, strength and presence; radiating natural vitality no matter what their age. It's charisma and it's natural for everyone. So I don't feel the pressure to look a certain way and I'm not concerned about ageing. I'm more invested in my well-being. Every phase of my life has been meaning-ful in different ways. I have never felt better than I do now.

My life is filled with love today. I fell in love with life, with myself and with an extraordinary man who allows me to be myself fully and completely without reservation or hesitation. They say "fall in love," but in truth I rose into love and found freedom through our connectedness—freedom to be me authentically and unapologet-ically. Freedom to integrate his love into my life in my own unique ways. Freedom from fear; freedom from uncertainty, freedom from sameness. And freedom from judgement, mine or his.

Doyle walked in through my door at Journey's End and in the door of my heart. He doesn't just play music, he is music. Born from Texas blues, his heart runs deep as he soulfully plays his guitar, left hand, upside down. He makes magic out of the minutia, finding expansiveness in the seemingly smallest of things, living life lyrically and lovingly. A galaxy of light, a cosmos of creativity and courage.

My soul sister, and one of my closest and dearest friends, Laurie, and her husband, Patrick, introduced us. Not in a frivolous way. Noting Doyle's authentic autonomy and mine, she felt that we should meet; kindred spirits with a kooky sense of humour. Neither of us was looking

for a relationship to fill the perceived gaps of our souls. We were both concentrating on spiritual sovereignty; claiming our energy and power to explore our sacred relationship with life; realising the ever-present Source within ourselves. Put simply, becoming who we truly are.

So when Laurie first mentioned Doyle by prefacing he was a brilliant guitarist touring and collaborating with Eric Clapton, I told her, "I'm not looking for a relationship outside the one with myself, and . . . rockstars are not my thing."

She said, "He's twenty-seven years sober. A present and loving father of four. And you have a lot in common. Think friendship and fellowship."

I trusted her, and the zing I felt in my heart when she mentioned his name. I sensed the cosmic wink when I realised I was serendipitously learning to play an Eric Clapton song, "Wonderful Tonight," on my guitar. So I reached out to him and here we are together, individually.

Travelling the world, we purposefully explore a landscape of breathtaking countries that resonate with our energies, as we simultaneously embrace our evolving hearts along the way. My long-time friend Nina calls us "nomadic lovers."

Doyle and I share a deep connection; an inner knowingness perfectly aligned with our individual pure spirits. And through his profound commitment to his own personal growth, I have found unwavering resonance in my own and our relationship. He is the physical manifestation of my journey, illustrating that I've reached a new level of consciousness, understanding and frequency. Living as consistently in love consciousness as I have been able, I magnetised a truly loving being—of course. After all this time, I walk beside the perfect partner who was able to meet me where I'm at, and where and how I want to be.

We know that a union begins with the unity within ourselves and only then is it possible to enter a sacred union with another being. The union we share is not based on a young romance or dependence or rebellion, nor a dream of having children together, nor for any type of emotional or financial security. It is based on a pure and free connection, mirroring the growth and evolution we've both experienced from past loving relationships.

I've found that Love resuscitates my innocence, freeing me to feel the expanse and breadth of my existence so I can trust my heart with no resistance as I move forward on the next stage of my journey.

Paul, my mentor and guide, shared with me a deep wisdom that touched my heart and soul. It's a writing he gave me years ago. I shared it with Doyle and now I want to share it with you.

Unconditional Love

You are unique—different from all others. Without reservation, I allow you to be in the world as you are without thought or word of judgement from me. I see no error in the things you may say and do, feel and believe since I understand that you are honouring yourself by being and doing what is true to you.

I cannot walk life through your eyes nor see it through your heart. I have not been where you have been and experienced what you have experienced, viewing life from your unique angle. I appreciate you exactly as you are, being your own unique spark of the infinite consciousness, seeking to find your own individual way to relate to the world. Without reservation or hesitation, I allow your every choice to learn in the way you feel is right for you. It is vital that you be your own self and not someone who I or others think you "should" be. To the best of my ability, without denigrating or compromising myself in any way, I will support you in that.

I cannot know what is for your highest good, what is true for you, or what you need since I do not know what you have chosen to learn, how you have chosen to learn it, with whom or in what time frame. Only you can sense your inner excitement and hear your inner voice. I only have my own. I acknowledge that, though they may be different to each other, the many ways to perceive and experience the various facets of our world are all valid. Without reservation or hesitation, I allow the choices you make in each moment. I make no judgement of this for it is imperative that I honour your right to your individual evolution because it empowers that right for myself and all others.

To those who would choose a way I can not or would not walk, whilst I may not choose to add my power and energy to that way, I will never deny you the gift of Love that The Source has bestowed within me, Love for all creation. As I sow, so shall I reap. Without reservation or hesitation, I allow you the Universal right of Free Will to walk your own path, creating steps or sitting still if and when you feel it is right for you. I cannot always see the higher picture of Divine Order and so I will make no judgement that your steps are large or small, nor light or heavy or that they will lead up or down, for that would just be my own viewpoint.

Though I may see you do nothing and judge it to be unworthy, I acknowledge that you may be the one who brings great healing as you stand calm, blessed by the Light of The Source. For it is the inalienable right of all life to choose their own evolution, and without reservation or hesitation I acknowledge your right to determine your own future. In humility, I bow to the realisation that the way I see as best for me does not have to mean it is also right for you, nor that what I believe is necessarily true for you. I know that you are led as I am, following your own path.

I know that the many races, religions, customs, nationalities and beliefs within our world bring us great richness and allow us the benefit

and teachings of such diversity. I know we each learn in our own unique
way in order to bring that Love and Wisdom back to the whole. I under-
stand that if there were only one way to do something, there would need
be only one soul.

I appreciate your unique inner Light whether or not you behave in
a way I think you should or believe in those things I believe in. I under-
stand you are truly my brother and my sister, though you may have been
born into different ideals. The Love I feel is for absolutely all that is.
I know that every living thing is part of one consciousness and I feel a Love
deep within for every man, woman, child, animal, tree, stone and flower,
every bird, river and ocean and for all that is in all the world and the
Universe. I live my life in living service, being the highest expression of me
that I can, becoming wiser in the perfection of Divine Truth, becoming
happier, healthier and increasingly abundant, empowered and joyous.

Though along the way I may like you, feel indifferent towards you, or
dislike you, I will not stop loving you—honouring your uniqueness and
allowing you to be you while honouring my own uniqueness and allowing
me to be myself. That is the key to peace and harmony throughout our
lives and our world since allowance is the capstone of . . . Unconditional
Love.

I have learned that love is what really matters.
We are all simply learning to give and receive love unconditionally.
My life, and its experiences, have been that journey.
I deeply wish that you learn love, firstly of yourself,
then of others, then of life itself.
It is your true nature.

Elle

THE BODY OF WORK

The following is a comprehensive inventory of my achievements and performances, undertakings and enterprises to date. It is not an exhaustive list but enough to illustrate the breadth and depth of my career. It is by the realisations in this book, not by the list of events and achievements, that my life has gained its profile, meaning and value, and continues to do so. I have come to understand that circumstances, situations and events in life are not actually our experience—our response to life is our experience. That is how we each learn uniquely to love and to bring forth the best version of ourselves to enrich our world. I trust that by sharing my own experiences, I will have assisted you in your own unique and valuable life path.

*

FAMOUS WORKS

Film appearances

- Model, *Alice*—Orion, 1990 (Woody Allen)
- Sheila, *Sirens*—Miramax, 1994 (John Duigan)
- Blanche Ingram, *Jane Eyre*—Miramax, 1996 (Franco Zeffirelli)
- Candice Candy, *The Mirror Has Two Faces*—TriStar, 1996 (Barbra Streisand)
- Jane Linquist, *If Lucy Fell*—TriStar, 1996 (Eric Schaeffer)
- Julie Madison, *Batman & Robin*—Warner Bros, 1997 (Joel Schumacher)
- Mickey Morse, *The Edge*—Twentieth Century Fox, 1997 (Lee Tamahori)
- Myself, *Beautopia* (documentary)—Fox Lorber Pictures, 1998 (Katharina Otto-Bernstein)
- Samantha Mastandrea, *With Friends Like These*—Mom's Roof, Inc., 1998 (Philip Frank Messina)
- Camilla, *South Kensington*—International Video 80, 2000 (Carlo Vanzina)

Television appearances

Series

- Janine Lecroix, a recurring role, *Friends*—NBC, 1999–2000
- Lauren Travis, *A Girl Thing*—Showtime, 2001 (Lee Rose)
- Myself, *Retrosexual: The '80s*—VH1, 2004
- Myself, *I Love the '90s: Part Deux*—VH1, 2005

Specials

- *The Making of a Model*—ABC, 1988
- Sports Illustrated: *The Making of the Swimsuit Issue*—HBO, 1989

- *Supermodel of the World* (syndicated), 1989
- *Dolphins, Whales, and Us*—CBS, 1990
- Host, *International Swimsuit '91 with Elle Macpherson*—NBC, 1991
- People's *20th Birthday*—ABC, 1994
- Sports Illustrated *Swimsuit '94: The 30th Anniversary*—ABC, 1994
- *A Day With*—Fox, 1995
- *Die Schönsten Frauen der Welt*—Elle Macpherson, 1995
- *A Royal Birthday Celebration*—Independent Television, 1998
- *Happy Birthday 2 You*—TV2, 2000
- Host, *Miss Universe 2001*—CBS, 2001
- *Wax Museum: History of Madame Tussaud's*, 2001
- Model, Sports Illustrated *40th Anniversary Swimsuit Special: American Beauty*—Spike TV, 2004
- In 2007, the BBC TV series *The Money Programme* aired a documentary that followed me through my day-to-day business developing my international lingerie business.

Awards presentations

- Presenter, 1994 MTV Movie Awards—MTV, 1994
- Presenter, 1997 MTV Movie Awards—MTV, 1997
- Host, 2000 World Music Awards—ABC, 2000
- 42nd Annual TV Week Logie Awards, 2000
- Orange British Academy Film Awards, 2000
- Closing ceremony, 2000 Sydney Olympics
- Presenter, Golden Globe Awards, 2012

Episodic

- Guest, *Late Night with David Letterman*, NBC, 1986, 1992
- Guest, *The Late Show with David Letterman*, CBS, multiple appearances, beginning 1994
- Guest host, *Saturday Night Live* (also known as *NBC's Saturday Night*, *Saturday Night*, and *SNL*), NBC, 1996
- Myself, *Intimate Portrait: Naomi Campbell*, Lifetime, 2001
- Myself, *Intimate Portrait: Kathy Ireland*, Lifetime, 2002
- Guest, *Rove Live*, 10 Network (Australia), 2004
- Guest, *This Morning*, Independent Television, 2004
- Also appeared in episodes of *Celebrity Profile, E! Entertainment Television*; *Good Morning America* (also known as GMA), ABC; *The Oprah Winfrey Show* (also known as *Oprah*), syndicated; and *The Tonight Show Starring Johnny Carson*, NBC.

RECORDINGS

Videos

- Sports Illustrated *1994 Swimsuit Issue* (also released as *Sports Illustrated 1994*)
- *Swimsuit Issue* video (extended version), 1994
- *Your Personal Best Workout with Elle Macpherson*, Buena Vista Home Video

Producer

- Capitalising on my success, I executive-produced my own worldwide bestselling calendars and "Making of" television programmes in 1992, 1993, 1994, and my next entrepreneurial venture *Your Personal Best—The Body* workout video, which was voted the Year's Best by *Billboard* magazine in 1995.

- In 2010–14, I took on a new TV role as both host and executive producer of *Britain and Ireland's Next Top Model*. The team and I raised the profile and extended the appeal of the show, resulting in increased distribution into more than thirty different countries and millions of viewers.
- Taking the host and executive producer format forward, I launched NBC's *Fashion Star* in 2012. The innovative reality/fashion competition series met with great success and sold to seventy-five countries at MIPTV in 2012.

BEAUTY AMBASSADOR

- Biotherm—(France) European face of the brand and ambassador (1985–95).
- Aged forty-five, in 2008, I signed a three-year global deal with Revlon as an ambassador and spokeswoman, carving the way for new demographics in the print and TV beauty industry.

PHILANTHROPIST

- I was a global ambassador for (RED), an initiative set up by Bono and Bobby Shriver to raise money and awareness for the Global Fund to Fight AIDS, tuberculosis and malaria, and to help eradicate AIDS for women and children in Africa.
- I have been European ambassador for 2007 British flood victims, and the child welfare group Absolute Return for Kids (ARK), which Arki and I helped to set up.
- In 2012, I led Sky's campaign for International Women's Day.
- I have been an ambassador for UNICEF.

- In Australia, I have been ambassador for the Smile Foundation, which helps the families of children with rare diseases and organises government research grants.
- I have been a longstanding committed patron for NACOA (National Association for the Children of Alcoholics—NACOA).
- My strong belief that women and children have the fundamental right to healthcare services has led me to campaign and promote causes that work towards achieving this. Similarly, my belief in the importance of a safe, clean environment for children to grow has led to my support of ecological charity Sierra Club.
- In my local community, Miami, I work closely with the Miami Women's Fund, and the Power of the Purse, drawing attention to women's influence through channelling spending into products or businesses that give back to women's issues and practise ethically sustainable businesses.

AWARDS

Throughout my business career, I have won many awards, including:
- Fig Leaves Entrepreneur of the Year Award (UK), 2005
- *Glamour* magazine Style Icon Award (UK), 2005
- *Glamour* magazine's Entrepreneur of the Year (UK), 2006
- *Elle* magazine International Style Icon Award (Spain), 2006
- *Marie Claire* Prix de la Mode 20 Years Business (UK), 2007
- Everywoman Outstanding Designer Award (UK), 2007
- Femmys Lingerie Designer of the Year Award (USA), 2008
- Femmys Lingerie World Career Award (Vienna), 2009
- Eco Age Award for Contribution to Sustainable Wellness, 2018 (green carpet), founded by Livia Firth

- Rising Star Awards Beauty/Fragrance Entrepreneur finalist, 2018
- Kruger Cowne Speaker of the Year, 2019
- Business Speaker of the Year, 2019
- International Speaker of the Year, 2019
- *Harper's Bazaar* Women of the Year Awards (Spain), 2023
- WelleCo has won forty-six awards worldwide for the quality and effectiveness of its collection of wellness elixirs.

KEYNOTES

- Keynote speaker—International Trademark Association (INTA) annual conference, 2009
- Keynote speaker—Ernst & Young World Entrepreneur Awards in Monaco, 2018
- Keynote speaker—six-state tour for Business Chicks Australia, 2019
- Guest speaker—Yorkshire Forward Business Convention
- Guest speaker—Newcastle Entrepreneurs Convention
- Guest speaker—Global Women in Business
- Guest speaker—International Entrepreneurs Forum
- Guest speaker—Commerce and Creativity Conference
- Guest speaker—New Zealand Fashion Week Gala
- Guest speaker—Australian Open Inspirational Women's Series, 2024
- Keynote speaker—Best Brands Awards: Building Better Brands (Munich, Germany), 2024
- More recently I spend time sharing experience through webinars, virtual events and online presentations.

ABOUT WELLECO

WelleCo is the original pioneer of nutritional greens and plant-based elixirs created from sustainably sourced ingredients that amplify beauty naturally, through wellness. WelleCo's collection of beauty-through-wellness elixirs is science-backed, formulated from top-quality ingredients by leading nutritionists.

Since its inception in 2014, WelleCo has been spearheading the online wellness industry as it supports beauty through wellness. Its foundation product, The Super Elixir™, has received praise from global healthcare professionals, media, and a growing cult customer base around the world.

Carefully curated with integrity, WelleCo handpicks farmgates all over the world to ensure their ingredients are ethically sourced and sustainably harvested, where possible from their native origin. This helps conserve and regenerate the planet's agricultural ecosystem while ensuring the nutrient profile is preserved and pesticide-free.

By highlighting the principle that beauty depends on wellness, and therefore begins within, WelleCo has redefined real beauty as being soul deep, not just skin deep, transforming the way consumers view and understand their own connection between beauty and wellness. WelleCo considers it their responsibility to provide the best possible support, awareness and wellness solutions that enable women, men and children around the world to grow into the very best versions of themselves. Furthermore, WelleCo believes that being well and thriving in life contributes—one person at a time, one day at a time—to the greater good of our entire world.

Product Collection

WelleCo's hero product, The Super Elixir™, is a revolutionary alkalising greens supplement—a special blend of over forty-five botanical herbs, antioxidants, vitamins, minerals and probiotics. When taken daily with water, the synergy of the ingredients amplify their benefits and nourish the body right down at the cellular level, promoting optimal function of all eleven systems from skeleton to skin, from hormones to hair.

WelleCo's collection provides such potent wellness support because their team has identified the highest-integrity ingredients to enable your natural beauty to radiate as a result of your inner wellbeing on every level.

The Super Elixir™ continues to be a beauty bestseller in the world's leading retailers and predominantly online through its own e-commerce stores:

- welleco.com.au
- welleco.com
- welleco.co.uk

PHOTOGRAPHY CREDITS

All photographs in black and white insert © Justin Cooper, reproduced by kind permission of Justin Cooper Photography.

*

New York City, photographer unknown, 1983/4 (page xii)

I was afraid to be seen. Truly seen.

Jeanloup Sieff, *Tatler*, 1998, reproduced by kind permission of the Jeanloup Sieff estate (page 14)

There was no such thing as Santa. Christmas 1973.

Personal collection (page 26)

Living in my very own apartment in New York.

Elle in her Greenwich Village apartment by Richard Corkery, 1987, *New York Daily News* Archive, courtesy of Getty Images (page 50)

I worked with my uniqueness instead of hiding it under a bushel of sameness and safeness.

Sports Illustrated Swimsuit issue, Argyle Beach, Saint Vincent and the Grenadines, by Robert Huntzinger, 1990, *Sports Illustrated* via Contour RA and Getty Images (page 74)

MacFierce. Circa 1984/1985.

Gilles Bensimon, reproduced by kind permission of Gilles Bensimon (page 88)

I burned my wedding dress.

With Azzedine Alaïa, by Gilles Bensimon, 1986, reproduced by kind permission of Gilles Bensimon (page 102)

Creation flows where your attention goes.

Alique, *Vogue*, 2018 © Alique, reproduced by kind permission of Alique Studio (page 122)

Our beautiful, beloved Flynn was born on St. Valentine's Day 1998.

Tony Duran, *Hello!*, 1998, reproduced with kind permission of Tony Duran Photography (page 140)

Cy (within) and Flynn. January 2003.

Dan Stevens, 2003, reproduced by kind permission of Dan Stevens Photography (page 164)

I listened to my heart. Cy, 2003.

Graham Shearer, *Hello!*, 2003, reproduced by kind permission of Graham Shearer (page 187)

We are not alone.

Personal collection (page 188)

I was told I would lose anything I put ahead of my sobriety.

Bryan Adams, © Bryan Adams, courtesy Bryan Adams/Camerapress (page 210)

I chose love.

With Arki and Cy Busson by Norman Jean Roy, *Vanity Fair*, 2005, reproduced by kind permission of Norman Jean Roy Studio (page 229)

Making every step closer to my dreams.

In Ghana, 2006, personal collection (page 230)

True fucking love. Fiji, 2013.

Wedding to Jeff Soffer, personal collection (page 252)

Sometimes it's not what you do, it's what you don't do.

Billie Scheepers, reproduced by kind permission of Billie Scheepers (page 274)

Ouch! Arizona, 2017.

In treatment, personal collection (page 292)

Living proof.

Bryan Adams, © Bryan Adams, courtesy Bryan Adams/Camerapress
(page 308)

Here we are together, individually.

With Doyle Bramhall by Randall Slavin, 2023, reproduced by kind
permission of Randall Slavin (page 338)